Contents

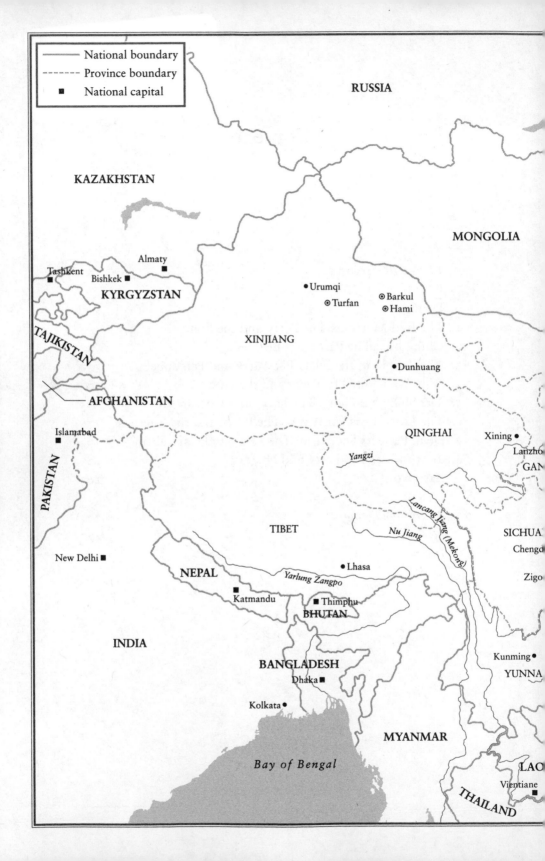

Praise for *The Party*

"Fascinating. . . . Illuminating. . . . Mr. McGregor guides readers through recent events in China, teasing out what each tells us about the Party's role. . . . Mr. McGregor does an admirable job focusing on the Party's role in business instead of getting bogged down in the factions and individuals jockeying for power. . . . A small investment of time reading this primer will help foreigners better navigate the hidden political shoals of the Chinese business world."
—*Wall Street Journal*

"McGregor does a persuasive job of sketching how communist the country really still is. . . . Anyone who wants to understand more about China would be well advised to pick up McGregor's book."
—*Newsweek*

"As informative as it is entertaining. . . . China has been transformed. There is no denying it. The system that takes the credit is brilliantly described by McGregor." —Chris Patten, *Financial Times*

"Masterful. . . . McGregor's book has a number of strengths, including clear prose and careful analysis. His bold writing leads to striking comparisons. . . . These analogies help make this an accessible introduction to the Party's power in today's China."
—Ian Johnson, *New York Review of Books*

"Revealing. . . . A skilled overview and smooth read. As China takes its place on the world stage as a rising superpower, McGregor's analysis of the party's enduring grip on power will engross—and perhaps unnerve—Westerners hoping for democracy here in China. . . . McGregor offers compelling insights regarding the party's spies and informants, a control operation that maintains extensive files on members and others." —*Washington Times*

"Astute. . . . A sober, realistic book. . . . A readable guide to how China is governed." —*Bloomberg*

"Fascinating. . . . *The Party* examines the intricate relationship between the Communist Party and the Chinese government, exposing

how a political machine subverts the will to properly govern a billion people." —*Esquire*

"What makes *The Party* valuable is not its novel arguments but the details it provides to back them up, and the fact that this information about people and policies is offered by someone who is both a stylish writer and a determined reporter. McGregor is simply good at getting unusual people to talk to him and has a knack for fleshing out big points with telling anecdotes and lively character sketches. . . . If you want a convincing, engaging, unapologetically top-down account of the country, McGregor's book is for you."
 —*Daily Beast*

"*The Party* is a careful, highly well-informed, and entertaining account of China's ruling class, chronicling the country's thirty-year rise to major economic power despite high levels of poverty."
 —Associated Press

"A compelling exploration of the world's largest and most successful political machine." —*New Statesman*

"An engrossing read. . . . McGregor's is a vivid narrative, sprinkled with humor and insightful analysis, of how the party has imprinted itself on almost every aspect of life in China, and how it has maintained its stranglehold on power. . . . He balances exposition of a heavy and intellectually demanding subject with anecdotes, lively quotes, and word portraits of amazing characters. . . . McGregor transforms his on-the-ground experience into clearheaded analysis backed by careful research. . . . His perspective is fresh but well grounded in the facts he gleans from daily interaction with the people." —*South China Morning Post*

"An engaging read, full of interesting facts, figures, and anecdotes. . . . McGregor does a great job of explaining the Party. He somehow manages to fathom the structure of a government that is so secretive it is almost invisible." —*The Spectator*

"Indispensable. . . . If you only read one book about China this year, it should be this one. And if you do not read this book, you probably do not understand China today. . . . Combining tenacious investiga-

tion, well-chosen anecdotes, and sharp analysis, McGregor teases out the Party's sticky and ubiquitous filaments in government, business, the military, and the media. . . . As McGregor's book powerfully shows, with the Communist Party in its present form, we will certainly not see a Chinese century."

—*China Economic Quarterly*

"Few outsiders have any realistic sense of the innards, motives, rivalries, and fears of the Chinese Communist leadership. But we all know much more than before, thanks to Richard McGregor's illuminating and richly textured look at the people in charge of China's political machinery. *The Party* will be invaluable for anyone trying to make sense of China's future plans and choices. It has certainly enriched my own understanding of the country."

—James Fallows, national correspondent for *The Atlantic*

"This is a marvelous and finely written study of how China is really run, and how its strange but successful system of Leninist capitalism really works. It should be read by anyone doing business with or just trying to understand China."

—Bill Emmott, former editor of *The Economist*

"Provocative. . . . A revelatory and scrupulously reported book. . . . McGregor makes a clear and convincing case that the 1989 backlash against the Party, inexorable globalization, and technological innovations in communication have made it incumbent on the Party to evolve, and this smart, authoritative book provides valuable insight into how it has—and has not—met the challenge."

—*Publishers Weekly* (starred review)

THE PARTY

The Secret World

of China's

Communist Rulers

RICHARD
McGREGOR

HARPER PERENNIAL

NEW YORK • LONDON • TORONTO • SYDNEY • NEW DELHI • AUCKLAND

HARPER ● PERENNIAL

Originally published in Great Britain in 2010 by Allen Lane, an imprint of Penguin Books.

A U.S. hardcover edition was published in 2010 by HarperCollins Publishers.

THE PARTY. Copyright © 2010, 2012 by Richard McGregor. All rights reserved. Printed in the United States of America. No part of this book may be used or reproduced in any manner whatsoever without written permission except in the case of brief quotations embodied in critical articles and reviews. For information, address HarperCollins Publishers, 195 Broadway New York, NY 10007.

HarperCollins books may be purchased for educational, business, or sales promotional use. For information, please e-mail the Special Markets Department at SPsales@harpercollins.com.

First Harper Perennial edition published 2012.

Library of Congress Cataloging-in-Publication Data is available upon request.

ISBN 978-0-06-170876-3

20 off/lsc 10 9

To Kath, Angus and Cate,
and in memory of Gwen

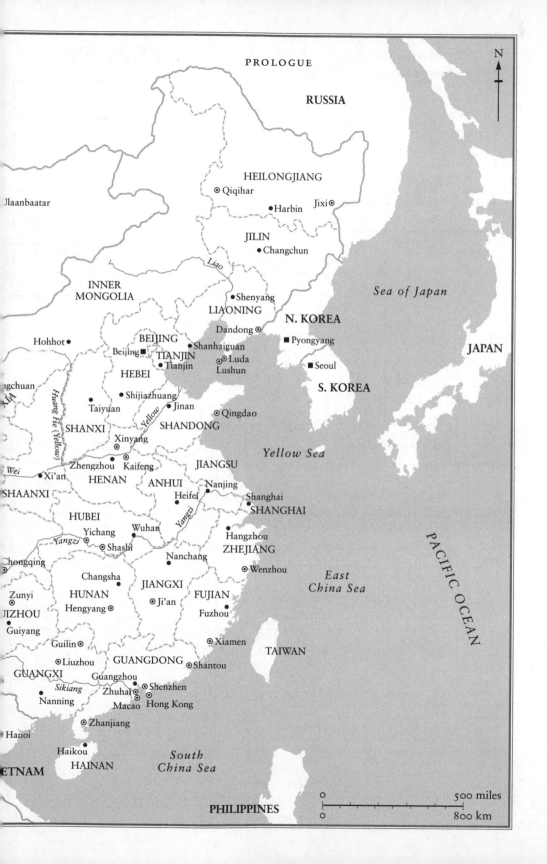

THE PARTY

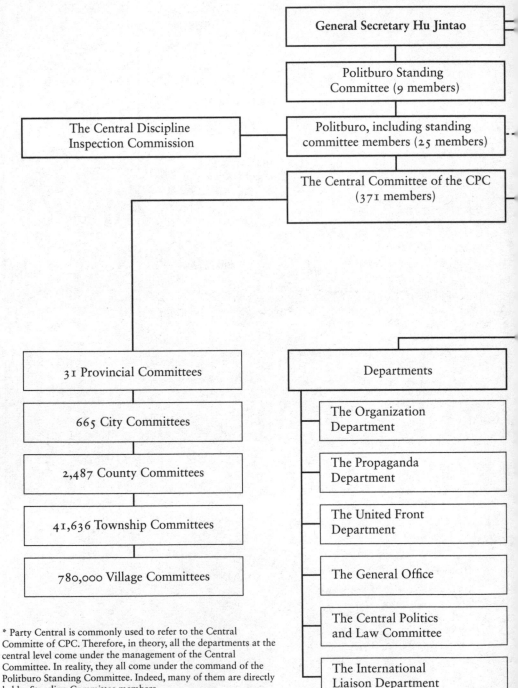

General Secretary Hu Jintao

Politburo Standing Committee (9 members)

The Central Discipline Inspection Commission

Politburo, including standing committee members (25 members)

The Central Committee of the CPC (371 members)

31 Provincial Committees

665 City Committees

2,487 County Committees

41,636 Township Committees

780,000 Village Committees

Departments

The Organization Department

The Propaganda Department

The United Front Department

The General Office

The Central Politics and Law Committee

The International Liaison Department

* Party Central is commonly used to refer to the Central Committe of CPC. Therefore, in theory, all the departments at the central level come under the management of the Central Committee. In reality, they all come under the command of the Politburo Standing Committee. Indeed, many of them are directly led by Standing Committee members.
** The other leading groups include the Central Leading Group on Taiwan Affairs, the Central Leading Group on Foreign Affairs and the central Leading Group on National Security.

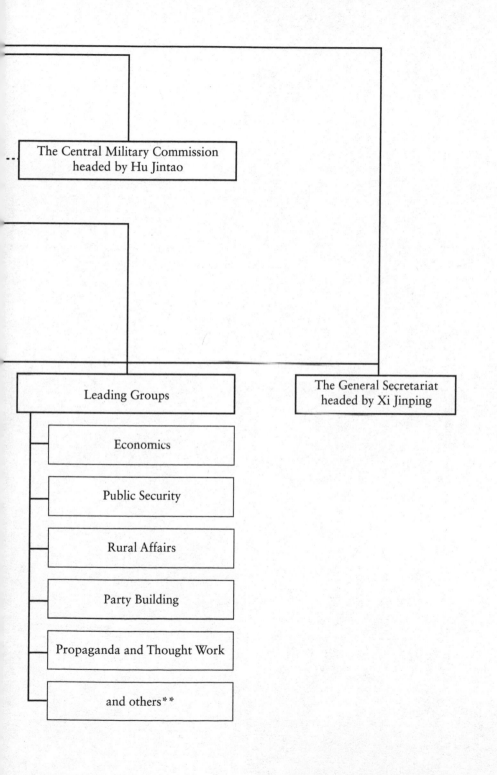

The Central Military Commission
headed by Hu Jintao

The General Secretariat
headed by Xi Jinping

Leading Groups

Economics

Public Security

Rural Affairs

Party Building

Propaganda and Thought Work

and others**

List of Illustrations

Photographic acknowledgements are given in parentheses.

1. Politburo Standing Committee, late 2007 (Bloomberg/Getty Images)
2. Central Organization Department headquarters in Beijing (Jie Yang)
3. Jiang Zemin and Politburo Standing Committee, October 2009 (Jic Yang)
4. Hu Jintao and Jiang Zemin (AFP/Getty Images)
5. Hu Jintao and the military (Song Zhenping/Xinhua/Xinhua Press/ Corbis)
6. Tiananmen Square protestors, 1989 (Corbis)
7. Deng Xiaoping
8. Chen Yun (AFP/Getty Images)
9. Chen Yuan (Reuters/Jason Lee)
10. Zhou Haijiang's name card
11. He Weifang (Peter Foster)
12. Wang Qishan and Barack Obama (Getty Images)
13. Zhu Rongji (Reuters/Andrew Wong)
14. Guo Shuqing (Reuters/China Daily Information Corp)
15. Edward Tian (Bloomberg/Getty Images)
16. Xiao Yaqing (Reuters/Stephen Hird)
17. Li Yuanchao (Reuters/Susana Vera)
18. Chen Liangyu with Bernie Ecclestone (Reuters/China Photos)
19. Tian Wenhua in court (Reuters/China Daily Information Corp)
20. Nian Guangjiu (China Today)
21. Yang Jisheng (Jin Zhong)
22. Workers in the countryside during the Great Leap Forward
23. Li Rui (AFP/Getty Images)
24. Zhou Zhengyi (Reuters/China Daily Information Corp)
25. The Shanghai skyline (Bloomberg/Getty Images)

Prologue

It was the summer of 2008, one year into the banking crisis in the west. A small group of foreigners, called to China to give financial advice, were ushered into the walled leadership compound astride the Forbidden City in central Beijing. Once in the meeting room, the visitors perched on the edges of the overstuffed armchairs, draped with antimacassars and laid out in a U-shape to create the effect of a space split perfectly down the middle, dividing the visitors from the Chinese. The decorative flowers, the steaming mugs of tea, the warm words of welcome for friends from afar – all the ingredients of the time-honoured template for respectful encounters with foreigners were on display.

For the attentive listener, the only part of the meeting that didn't follow the script was their host sitting opposite, Wang Qishan, the vice-premier in charge of China's financial sector. Tall, with flat, wide cheekbones and a sharp, imposing manner, the new Politburo member had never been one of those officials whose delphic utterances left interlocutors trying to decipher their meaning afterwards. The Chinese had once used such encounters to solicit foreign views, like bower birds eager to stock up on fresh policy ideas. But Wang quickly made it clear that China had little to learn from the visitors about its financial system. 'Mr Wang said: "This is what you do, and this is what we do", which is what the Chinese always say,' one of the participants recalled. 'But his message was different. It was: "You have your way. We have our way. And our way is right!"'

When China staged its first Davos-style event in 2001, global financiers started travelling there as keenly as they did to the annual conference in the Swiss alps it was styled after. The limousines whisking the financial elite from the airport in tropical Hainan in April 2009

to the seaside conference centre sped through a landscape unlike the usual venues for power meetings in China. The wide, imperious avenues and stiffly guarded marbled buildings of Beijing with their vast entrance portals and stylized meeting rooms were a world away. Unlike the bone-dry northern capital, dusted brown by sands blown in from the nearby desert, the Boao Forum, named after the balmy bay where it is held, was designed to match the message of warm friendship a rising China was determined to convey.

In the early years of the meeting, the courtship had been mutual. Beijing wanted western skills to overhaul their bankrupt state banks. The foreign bankers eyed access to the Chinese market in return. The down payment was delivered in a frenzy of deals in late 2005 and early 2006, when foreign financial institutions invested tens of billions of dollars in Chinese state lenders. The money came with a promise from the foreigners to the laggard locals to teach them the secrets of risk management and financial innovation. The western banks approached the exercise almost as adult education, which is why what happened subsequently was so shocking.

Barely two years after the big Chinese banking deals, the humbled Visigoths of global finance were back. This time, battered by the unfolding credit crisis, they returned, humiliated, cap-in-hand, seeking Chinese cash to shore up their balance sheets or selling their newly acquired shares to take money home. Rather than displaying their wares in Boao and Beijing, the bankers and their advisers slunk in and out of town with barely a peep. One by one, at the 2009 Boao forum, senior Chinese officials tossed aside the soothing messages of past conferences to drive this reversal of fortune home. The first, a financial regulator, lambasted a recent meeting of global leaders as 'lip service'. Another tore into the role of international ratings agencies in the financial crisis. A retired Politburo member ominously suggested the US needed to make sure it 'protected the interests of Asian countries' if it wanted China to keep buying its debt.

When it was his turn at the mike at the session in the resort's Oriental Room, the man anointed as the global face of China Inc. dropped his polite façade as well. Lou Jiwei, as the first head of the China Investment Corporation, the country's sovereign wealth fund, had been careful to project a conciliatory image since the body's establishment

in 2007. The first difficult years in the job had slowly soured Lou's good cheer. The fund's bold initial investments offshore had lost money, attracting vitriolic criticism at home. Abroad, Lou became bitter at the opposition he faced to investing in the US and Germany.

Lou recounted to the Boao dignitaries how a delegation from the European Union had demanded after the fund's establishment that he cap any stakes he bought in their companies and not ask for voting rights in return for shares purchased. Lou reckoned he was lucky in retrospect to meet such patronizing intransigence, because he would have lost a ton of money if he had been allowed into the market. 'So, I want to thank these financial protectionists, because, as a result, we didn't invest a single cent in Europe.' Now, he noted sardonically, to a mixture of stifled guffaws and startled gasps in the audience, Europeans had sheepishly returned to tell him his money was welcome, with no strings attached. 'People suddenly think we are lovable.'

The same mood of brittle triumphalism on display at Boao had begun to course through government pronouncements, official debates, the state media and bilateral meetings at home and abroad from early 2009. Behind the scenes, in ways not easily visible from the outside, the official propaganda machine had clicked into overdrive as well. The *People's Daily*, the mouthpiece of the Chinese Communist Party, usually reserved its front page for the daily diaries of top leaders, their foreign guests and the latest political campaigns. The paper, which acts as a kind of internal bulletin board for officials, relegated finance stories to the back pages, if they were reported at all. The announcement in March 2009 of healthy profits by the big Chinese banks, once derided in the west as financial zombies, made for an irresistible exception. The banner headline on the paper's front page screamed: 'China's Banking System Hands in a Fabulous Exam Paper – Stands out After Being Tested by the International Financial Storm'.

For a decade, Beijing had resisted pressure from Washington, led latterly by the former Goldman Sachs boss, Hank Paulson, as Treasury Secretary, for wholesale financial liberalization. In the seven years to 2008, the Chinese economy had more than tripled in size. But alongside China's rise, the patience with which Beijing listened to advice from foreigners had been dwindling. It wasn't until the western financial crisis that the confidence of the likes of Wang Qishan spread through

the system and burst to the surface like never before. Many Chinese leaders were beginning to voice out loud the sentiments expressed privately by Wang: what on earth have we to learn from the west?

China's post-Maoist governing model, launched by Deng Xiaoping in the late seventies, has endured many attempts to explain it. Is it a benevolent, Singapore-style autocracy? A capitalist development state, as many described Japan? Neo-Confucianism mixed with market economics? A slow-motion version of post-Soviet Russia, in which the elite grabbed productive public assets for private gain? Robber-baron socialism? Or is it something different altogether, an entirely new model, a 'Beijing Consensus', according to the fashionable phrase, built around practical, problem-solving policies and technological innovation?

Few described the model as communist any more, often not even the ruling Chinese Communist Party itself.

How communism came to be airbrushed out of the rise of the world's greatest communist state is no mystery on one level. The multiple, head-spinning contradictions about modern China can throw anyone off the scent. What was once a revolutionary party is now firmly the establishment. The communists rode to power on popular revulsion against corruption but have become riddled by the same cancer themselves. Top leaders adhere to Marxism in their public statements, even as they depend on a ruthless private sector to create jobs. The Party preaches equality, while presiding over incomes as unequal as anywhere in Asia. The communists also once despised the pre-revolutionary comprador class of Chinese businessmen, but rushed without shame into an alliance with Hong Kong tycoons when taking back the British colony in 1997.

The gap between the fiction of the Party's rhetoric ('China is a socialist country') and the reality of everyday life grows larger every year. But the Party must defend the fiction nonetheless, because it represents the political status quo. 'Their ideology is an ideology of power and therefore a defence of power,' said Richard Baum, a China scholar. The Party's defence of power is also, by extension, a defence of the existing system. In the words of Dai Bingguo, China's most senior foreign policy official, China's 'number one core interest is to maintain its fundamental system and state security'. State sovereignty, territorial integrity and economic development, the priorities of any state, all are subordinate to the need to keep the Party in power.

The Party has made strenuous efforts to keep the sinews of its enduring power off the front stage of public life in China and out of sight of the rest of the world. For many in the west, it has been convenient to keep the Party backstage too, and pretend that China has an evolving governmental system with strengths and weaknesses, quirks and foibles, like any other. China's flourishing commercial life and embrace of globalization is enough for many to dismiss the idea that communism still has traction, as if a Starbucks on every corner is a marker of political progress.

Peek under the hood of the Chinese model, however, and China looks much more communist than it does on the open road. Vladimir Lenin, who designed the prototype used to run communist countries around the world, would recognize the model immediately. The Chinese Communist Party's enduring grip on power is based on a simple formula straight out of the Leninist playbook. For all the reforms of the past three decades, the Party has made sure it keeps a lock-hold on the state and three pillars of its survival strategy: control of personnel, propaganda and the People's Liberation Army.

Since installing itself as the sole legitimate governing authority of a unified China in 1949, the Party and its leaders have placed its members in key positions in every arm, and at each level, of the state. All the Chinese media come under the control of the propaganda department, even if its denizens have had to gallop to keep up in the internet age. And if anyone decides to challenge the system, the Party has kept ample power in reserve, making sure it maintains a tight grip on the military and the security services, the ultimate guarantors of its rule. The police forces at every level of government, from large cities to small villages, have within them a 'domestic security department', the role of which is to protect the Party's rule and weed out dissenting political voices before they can gain a broad audience.

China long ago dispensed with old-style communist central planning for a sleeker hybrid market economy, the Party's greatest innovation. But measure China against a definitional checklist authored by Robert Service, the veteran historian of Soviet Russia, and Beijing retains a surprising number of the qualities that characterized communist regimes of the twentieth century.

Like communism in its heyday elsewhere, the Party in China has

eradicated or emasculated political rivals; eliminated the autonomy of the courts and press; restricted religion and civil society; denigrated rival versions of nationhood; centralized political power; established extensive networks of security police; and dispatched dissidents to labour camps. Over much of its life, although less so now, party leaders in China have mimicked old-style communists by claiming 'infallibility in doctrine, while proclaiming themselves to be faultless scientists of human affairs'.

The Party in China has teetered on the verge of self-destruction numerous times, in the wake of Mao Zedong's brutal campaigns over three decades from the fifties, and then again in 1989, after the army's suppression of demonstrations in Beijing and elsewhere. The Party itself suffered an existential crisis after the collapse of the Soviet Union and its satellite states in the three years to 1992, an event that resonates to this day in the corridors of power in Beijing. After each catastrophe, the Party has picked itself off the ground, reconstituted its armour and reinforced its flanks. Somehow, it has outlasted, outsmarted, outperformed or simply outlawed its critics, flummoxing the pundits who have predicted its demise at numerous junctures. As a political machine alone, the Party is a phenomenon of awesome and unique dimensions. By the end of 2009, its membership stood at 78 million, equal to about one in twelve adult Chinese.

The Party's marginalization of all political opponents makes it somewhat like the Iraqi army after the second Gulf war. Even if it were disbanded or fell apart, it would have to be put back together again, because its members alone have the skills, experience and networks to run the country. As a prominent Shanghai professor told me, the Party's attitude is: 'I can do it and you can't. And because you can't, I will.' The Party's logic is circular. There can be no alternative, because none is allowed to exist.

Few events symbolized the advance of China and the retreat of the west during the financial crisis more than the touchdown in Beijing of Hillary Clinton, the new US Secretary of State, in February 2009. Previous US administrations, under Bill Clinton and George W. Bush, had arrived in office with an aggressive, competitive posture towards China. Before she landed, Ms Clinton publicly downplayed the importance of human rights. At a press conference ahead of leaving, she

beamingly implored the Chinese government to keep buying US debt, like a travelling saleswoman hawking a bill of goods.

Deng Xiaoping's crafty stratagem, laid down two decades before, about how China should advance stealthily into the world – 'hide your brightness; bide your time' – had been honoured in the breach long before Ms Clinton's arrival. China's high-profile tours through Africa, South America and Australia in search of resources, the billion-dollar listings of its state companies on overseas stock markets, its rising profile in the United Nations and its sheer economic firepower had made China the new focus of global business and finance since the turn of the century. China's star was shining more brightly than ever before, even as its diplomats protested they were battling to be heard on behalf of a relatively poor, developing economy.

The implosion of the western financial system, along with an evaporation of confidence in the US, Europe and Japan, overnight pushed China's global standing several notches higher. In the space of a few months in early 2009, unconstrained by any serious public debate at home, the Chinese state committed $50 billion in extra funding for the International Monetary Fund and $38 billion with Hong Kong for an Asian monetary fund; extended a $25 billion loan to cash-strapped Russian oil companies; set aside $30 billion for Australian resource companies; offered tens of billions more to various countries or companies in South America, central and Southeast Asia, to lock up commodities and lay down its marker for future purchases.

In September that year, with western governments and companies still on the back foot, China readied lines of credit of up to $60–70 billion for resource and infrastructure deals in Africa – in Nigeria, Ghana and Kenya. In Guinea, just days after the army had shot citizens and raped women on the streets of the capital, the military-backed government, a pariah on the continent and around the world, announced it was in talks with China on a billion-dollar resources and infrastructure deal.

Beijing's ambition and clout was being lit up by flashing lights in ways that would have been unthinkable a few years previously. The Chinese central bank called for an alternative to the US dollar as a global reserve currency in early 2009, and reiterated its policy as the year went on. France obediently re-committed to Chinese sovereignty

over Tibet to placate Beijing's anger over the issue, after Beijing had cancelled an EU summit in protest at Paris's welcome for the Dalai Lama. Barack Obama spurned meeting the Tibetan spiritual leader in late 2009, to sweeten the atmosphere for his first visit to Beijing in November that year, although he did agree to meet him in early 2010. On its navy's sixtieth anniversary, China invited the world to view its new fleet of nuclear-powered submarines off the port of Qingdao. In the days before he arrived in Washington on a fence-mending state visit in January 2011, President Hu Jintao pointedly reminded his hosts that the US-led international monetary system was a 'product of the past.'

The giant Chinese market, dismissed as an enduring western dream a few years previously, had become more important than ever. Just ahead of the Shanghai auto show in April 2009, monthly passenger car sales in China were the highest of any market in the world, surpassing the US. A month later, Wang Qishan and a team of Chinese ministers met Catherine Ashton, the then EU Trade Commissioner, and about fifteen of Europe's most senior business executives in Brussels to hear their complaints about Chinese market access. Sure, Wang conceded after listening to their problems over a working lunch, there are 'irregularities' in the market. 'I know you have complaints,' he replied, as confidently as ever. 'But the charm of the Chinese market is irresistible.' In other words, according to executives in the meeting left astonished by the vice-premier, whatever your complaints, the market is so big, you are going to come anyway. Even worse, many of the executives realized that Wang was right.

China's aggressive new confidence was on display on a wide screen by the end of 2009, at the Copenhagen climate change conference. In the final fractious day of negotiations, the Chinese snubbed a heads-of-state session, sending along a relatively junior official to talk with President Obama and other world leaders. At another session on the same day, this one attended by Wen Jiabao, China's Premier, a member of the Chinese delegation loudly lectured Obama, waving his finger at the US President. Needless to say, if a relatively junior western government official had been dispatched to meet a Chinese leader and, even worse, delivered him a lecture, the affront would have been serious enough to have provoked violent anti-foreign street demonstrations at home in Beijing. China was nonplussed by criticism afterwards. 'What

the developed countries need to learn from this whole process is to make up their minds whether they want to pursue confrontation or co-operation with China,' said a senior official.

The growth and transformation of Asian countries in the wake of de-colonization after World War II, countries such as Singapore, Malaysia, Indonesia and South Korea, were important for the citizens of those countries and uplifting for the region. Japan's rise as an economic giant shook up and challenged the west. The economic transformation of China, by contrast, a country with one-fifth of the world's population, is a global event without parallel. The rise of China is a genuine mega-trend, a phenomenon with the ability to remake the world economy, sector by sector. That it is presided over by a communist party makes it even more jarring for a western world which, only a few years previously, was feasting on notions of the end of history and the triumph of liberal democracy.

More than that, the Party's momentous decision to change course in the late seventies has transformed the lives of literally hundreds of millions of its own people. According to the World Bank, the number of poor fell in China by half a billion people in the two decades-plus from 1981 to 2004. 'To put this in perspective,' the bank says, 'the absolute number of poor (using the same standard) in the developing world as a whole declined from 1.5 to 1.1 billion over the same period. In other words, but for China there would have been no decline in the numbers of poor in the developing world over the last two decades of the twentieth century.'

In just a single generation, the party elite has been transformed from a mirthless band of Mao-suited, ideological thugs to a wealthy, be-suited and business-friendly ruling class. Along with them, they have transformed their country and are helping remake the world. Today's Party is all about joining the highways of globalization, which in turn translates into greater economic efficiencies, higher rates of return and greater political security.

How did the Chinese communists do it, at a time when their fraternal parties were imploding around them? An old adage in journalism, that the best story is often the one staring you in the face, holds true in China. The problem in writing about the Party, though, is that, much as the Party might be staring you in the face, you can't easily glare

back. The Party and its functions are generally masked or dressed up in other guises. When it interacts with the outside world, the Party is careful to keep a low profile. Sometimes, you can't see the Party at all, which makes the job of reporting how China is governed maddeningly difficult.

The secrecy helps explain why news reports about China routinely refer to the ruling Communist Party, while rarely elaborating on how it actually rules. This book is an attempt to fill that void, by explaining the Party's functions and structures and how political power is exercised through them. The book has no pretence to being comprehensive or definitive. It is simply the story of a curious journalist opening, or trying to open, the system's many locked doors, and looking inside. In doing so, the book aims to place the Communist Party back firmly where it belongs, at the heart of the modern Chinese story.

I

The Red Machine

The Party and the State

'The Party is like God. He is everywhere. You just can't see
him.' (A University Professor in Beijing)

Nine men strode on to the stage in the Great Hall of the People, the
imposing Soviet-style structure on the west side of Tiananmen Square,
in the heart of Beijing, at the close of the 2007 congress of the Chinese
Communist Party. Once they were assembled, an untrained eye might
have had difficulty telling them apart.

The nine all wore dark suits, and all but one sported a red tie. They
all displayed slick, jet-black pompadours, a product of the uniform
addiction to regular hair-dyeing of senior Chinese politicians, a habit
only broken by retirement or imprisonment. If anyone had had the
chance to check their biographies, they would have noticed other strik-
ing similarities. All but one had trained as engineers, and all but two
were in their mid-sixties. In any jobs they had occupied after gradua-
tion, the nine men had invariably doubled in party roles, making them
full-time politicians for their entire working lives, even if that included
undertaking or overseeing professional tasks for brief interludes. Their
backgrounds varied slightly. Some had worked their way up from
poverty. Others were princelings, the privileged offspring of former
senior leaders. Their personal networks varied, but any fundamental
political differences between them had been purged on their ascent
through the ranks by the Party's remorseless strictures.

In the time-honoured fashion of communist-era stage entrances, the
nine had gently clapped themselves on to the podium as they walked
into position for the up-coming ceremony. For the mass of media and

government officials assembled to witness the ritual, carried out with a dark theatrical pomp, the most important thing was not how they walked on to the stage, nor the striking similarity of their appearance and career history. The key was in the order in which they appeared, as it cemented the hierarchy of the top leadership for the next five years, and laid out a line of succession for the entire decade to come, until 2022. Against the backdrop of a 20-metre-wide painting of an autumnal scene on the Great Wall, the nine stopped and stood to attention. Standing stiffly, they were ready to be introduced by the man at the head of the line, Hu Jintao, the General Secretary of the Communist Party, as the elected leaders of their country.

Ahead of the congress, the authorities had executed the well-honed security routines reserved for major political events. The guard on diplomatic compounds was doubled; police were stationed at highway intersections; and scores of scowling, plain-clothes security men materialized in the streets around the Great Hall of the People. Local scholars received circulars reminding them to keep their opinions to themselves. In September, a month before the congress, internet data centres were raided, with servers keeping literally thousands of websites shut down for weeks. On the fringes of the city, the authorities had set about demolishing the Petitioners' Village area where many out-of-towners with grievances congregated.

For centuries, the central government has maintained a national petitions office in the capital to which citizens take complaints about official misconduct. Ahead of the congress, though, Beijing threatened to mark down the careers of local leaders if residents from their cities managed to get to the capital to make use of it. In case anyone got past the security cordon, the provinces maintain a last line of defence to protect the Politburo from the public, a string of 'black jails', or unregistered prisons, where local complainants can be held before being sent home. Detaining protesters according to this formula is akin to winning political points in the west for keeping the crime rate down.

State security, local activists, government officials and the foreign and Chinese media alike have all learnt over time to internalize the seasonal rhythms of repression that turn with the political calendar. Television interviews with important dissidents are best done months ahead of time. By the time the day itself comes around, physical access

and even phone contact to critics of the Party is cut off. Wan Yanhai, an outspoken AIDs campaigner, was one of many activists whisked off the streets and taken into temporary custody. Wan was picked up and detained without charge for twelve hours ahead of the anniversary of the 4 June 1989 military crackdown, and again for a few days in August. 'My freedom was restricted,' he said, echoing the deadpan phrase that state security uses when they haul people off the streets. Wan had riled the Health Ministry by attempting to sue the government over a contaminated blood scandal. He kept himself on the radar of state security through his unabashed friendships with dissidents. On each occasion, Wan was kept in a hotel room while the authorities counselled him about his views on the Party. 'They still care very much about controlling our thoughts,' he said later.

In the years and months leading up to the choice of the leadership, there had been no public primaries, pre-selections or run-offs, and none of the noisy, blood-and-thunder clashes that are familiar events in the lead-up to western electoral contests. Following this drama for much of the time had been like standing outside a large, fortified castle surrounded by moats and guards, watching as lights were turned on and off and visitors whisked in and out. Raised voices could occasionally be heard from behind the thick walls. Once in a while there was hard evidence of conflict, as the casualties of corruption scandals, factional clashes or plain mismanagement were thrown out on to the street, to be carted off into retirement or prison. In the lead-up to the 2007 congress, the party boss of Shanghai, China's commercial capital, had been toppled – the highest-level corruption scandal in a decade, and one that had taken years of tense negotiations among top leaders before it could be settled.

The Party has unveiled its new leadership and, by definition, the leadership of the government and the country, in the same way for decades. As in any high-stakes political showdown, the leadership candidates had been locked in complex, private negotiations, and in some cases bitter battles, long beforehand, directly, or through proxies and policy debates, over the economy, political reform and corruption. The Hong Kong and foreign press tracked the infighting as best they could, but the local media, naturally far better informed, were ordered to keep silent. The shroud pulled over the event turned the announcement into

something rare in modern China, a live and public moment of genuine political drama and suspense. For ordinary Chinese, the precise identity and ranking of their new leadership was for all intents and purposes a secret until the moment they walked on to the stage into a blaze of television and flashing camera lights.

After leading the procession on stage, Hu spoke briefly, introducing each of the nine men by name. A Foreign Ministry official had described the event beforehand as a 'meeting' with the Politburo. 'So can we ask questions?' queried a reporter. 'No,' the official replied. 'It's a kind of one-way press conference.' The next day, the local media reported it strictly in accordance with the Party's dictates, along with the approved, sanitized biographies of the new Politburo members distributed by the official news agency. For anyone who lined up the Chinese newspapers side by side the next morning, or took snapshots of the home pages of websites, the effect was almost hallucinatory. The wording of the headlines and articles, and the choice, size and placement of photos, were all exactly the same.

Chinese leaders periodically express bafflement when critics suggest their ascension is somehow not democratic. A few months later, in May 2008, when visiting a school for Chinese children in Yokohama, Japan, Hu Jintao was asked by a guileless eight-year-old why he wanted to be president, a title that comes to him by rights these days, after being chosen as the head of the Party. After the nervous laughter in the classroom died down, Hu replied that he had not wanted the job. 'It was the people in the whole country who voted me in, and wanted me to be the president. I should not let the people throughout the whole country down,' he replied. Similarly, Jiang Zemin, Hu's predecessor both as party secretary and president, told a US current affairs show in 2000, that 'he was elected too', although he did concede the two countries' electoral systems 'were different'.

During the 2007 congress, delegates were allowed, or in some cases ordered, to talk to the media in an effort to fashion a more transparent, friendly image for the Party in the outside world. It is not as though the Party does not have an interesting story to sell and, in recent years, a broader class of member to present to the world. Many of the private businessmen and women who joined the Party, or were able to acknowledge their existing membership, after Jiang Zemin pushed through

approval for their presence in 2002, are ebullient figures with stirring rags-to-riches life stories. But even when the Party tries to force its best foot forward, it is evasive and suspicious.

When I met Chen Ailian, one of China's newly minted millionaires, and a party member and delegate, she initially delighted in telling me about her business. Chen had the kind of mad and wonderful entre-preneurial story you hear often across China. She said she had entered the automotive business in the early 1990s, because she 'loved cars'. Many millions of dollars in sales later, her private company had become the largest aluminium alloy wheel manufacturer in Asia and had opened offices in the US. Chen owned a Rolls-Royce (for special occasions), a Mercedes (for everyday use) and an Isuzu sports utility vehicle (for road trips). But once our conversation turned to the Party, she became more automaton than entrepreneur. To even the gentlest of questions, she adopted a reverential, whispering-in-church tone. Her answers became sombre, restrained and drained of life, consisting of little other than official slogans.

Atop of the system sits Hu. As General Secretary of the Communist Party, a position which ranks above his two other titles, as President and head of the military, he retains enormous power to set the param-eters for government policy. An enigmatic figure even to political insiders, Hu had attempted to fashion an imperial-era image for himself in his first five-year term, starting in 2002, as a kind of benevolent emperor, whose interventions in policy and politics were as wise and weighty as they were rare. At one time identified with the reform camp, the clarity that marked his personal politics clouded over as he rose through the ranks as the heir-apparent in the early nineties.

The tools to enforce the refurbishment of his image were close at hand for a man of his office. His elderly aunt who had raised him from the age of five, and who had been, for a handful of foreign interview-ers, a rare source of unfiltered information, had been stopped by local officials from talking to reporters soon after he was first named party secretary. The officials had even visited her house to remove pictures of him as a child and youth, lest they be handed out to reporters and the like, and become part of an independent narrative of his life not dictated by the Party itself. The pictures of a young Hu posted on the internet in 2009, seven years after his appointment, were harmlessly

charming, of a fresh-faced high school student on class outings, but local officials at the time of his ascension did not want to take responsibility for their publication.

Hu had been careful not to flesh out any broader picture of himself, never granting an interview to either the local or foreign press in his first term. In the lead-up to the Beijing Olympics in August 2008, Hu did give a short press conference to twenty-five foreign journalists, only after all their questions had been carefully screened. His pronouncements that appear regularly in the *People's Daily*, the Party's mouthpiece, provided few firm clues about his personal views. One Chinese commentator likened his policy pronouncements to a duck walking, with one foot pointed to the right and the other to the left, maintaining an ungainly balance which looked stable only from a distance.

Hu's severe image-management might have seemed like a conservative throwback to an earlier age of more authoritarian communism. In fact, compared to his predecessors, Hu was a bland figure, determinedly drained of flesh and blood. Deng Xiaoping, by contrast, had a revolutionary prestige, overlaid by the battle scars of years of struggle against Mao Zedong's insane political campaigns. He proudly displayed his earthy Sichuanese roots, notoriously expectorating loudly into his spittoon while delivering to Margaret Thatcher an intimidating lecture about Hong Kong at a meeting in the early eighties in Beijing. Jiang Zemin, Hu's immediate predecessor, delighted in singing in public and reciting extracts from the Gettysburg Address and other western canons in English. Mao, for all the horrors he inflicted on the Chinese people, was a charismatic figure renowned for his pithy aphorisms, which endure in China's literary, political and business landscape.

Hu displayed neither Deng's down-to-earth vigour, Jiang's clownish chumminess nor Mao's terrifying, homespun authority. He has no distinctive accent signalling his regional roots, nor any memorable quotes which have passed into everyday lore. A British diplomat arranging Hu's presence at a session of the G-8 meeting in Gleneagles, Scotland, in 2005, designed to be an informal and free-flowing meeting between leaders, was given short shrift about the proposed format by his Chinese interlocutor. 'President Hu does not do free-flowing,' he was told. The apotheosis of the professional party bureaucrat, Hu was a cautious, careful consensus-builder, a *'hao haizi'* or 'good boy', according to

his more cutting local critics. But far from being old-fashioned, Hu's low-key, self-effacing qualities made him very much a man for the times. China's modern complexities mean the Party, Hu's peers and even the people themselves can no longer stomach strong-man rule of the likes of Mao and Deng. In Mao's and Deng's days, the leaders towered over the Party. For all his power, Hu lived in the Party's shadow, rather than the other way round.

The way the Party has grown at the expense of its leaders dictated Hu's low profile long before his promotion to party secretary. After he emerged as the heir-apparent on his elevation to the Politburo Standing Committee in 1992, Hu's lack of a Politburo power base afforded him no room for error in the competition for the party secretary's job. By the time he took office ten years later, he had few of his loyalists in place as a result and no detailed political programme pre-positioned, which the bureaucracy could internalize and act on. Hu did not begin to gain genuine ascendancy over the vast party apparatus, both in Beijing and in the rest of the country, until well into the second of his two five-year terms. Most US presidents become lame ducks in the last years of their final term. So topsy-turvy is the Chinese political system that Hu, like Jiang Zemin before him, only really consolidated power by the time he was approaching the end of his period in office.

With the public shut out of formal politics, few ordinary citizens could even recognize most of the nine men in the Politburo's inner circle who lined up on stage at the congress's closure. Hu, of course, was a familiar face, if not a familiar personality. Wu Bangguo, at number two, and head of the legislature, was a colourless Shanghai functionary who had risen without a trace to the near-top of the leadership. Wen Jiabao, the Premier, ranked number three, had skilfully cultivated an image as a man of the people, in contrast to the hard-earned notoriety of his wife and son for their business dealings.

Jia Qinglin, who strode out in fourth position, was a big man, tall and flush, and bursting out of his suit like someone who had enjoyed too many banquets. Unlike most of his colleagues, Jia was well known, only because of his alleged corruption. Jia presided over Fujian province during one of China's worst graft scandals, the Yuanhua case, a $6 billion customs fraud. Numerous officials have already been executed and jailed for their crimes, but Jia, and his wife, also the target of

allegations, have never been called to account, either because there is not enough evidence against them, or, more likely, because they have been protected by political allies. As he stood on stage and stared out at the assembled media, many of whom had expected him to be toppled and disgraced in the lead-up to the congress, Jia's ruddy face had the defiant sneer of a triumphant, well-nourished political survivor.

Other members of the Standing Committee, including two in their fifties, who are Hu's designated successors, were only vaguely recognizable in the provinces they once governed. By the time he joined the Standing Committee, Xi Jinping, ranked number six, and anointed as the heir-apparent, was less well known than his wife, a famous singer with a military rank in the People's Liberation Army. Some of the men on stage had profiles in the sectors, such as the media and policing, that they had presided over. But for most Chinese, the Politburo was a distant body, bloated with power, but devoid of character and personality.

Hu's speech was brief and couched in the arcane political slogans that dominate all official public political discussion, about 'scientific development', the 'harmonious society', an 'advanced socialist culture', and so on. Heavy with import inside the Party and intellectual circles as the branding buzzwords of Hu's administration, they are largely meaningless to the population at large. After concluding his remarks, Hu led his eight colleagues off stage. In the coming years, the Politburo's inner circle would rarely ever appear in public as a group again. The whole ceremony had lasted about ten minutes.

On the desks of the heads of China's fifty-odd biggest state companies, amid the clutter of computers, family photos and other fixtures of the modern CEO's office life, sits a red phone. The executives and their staff who jump to attention when it rings know it as 'the red machine', perhaps because to call it a mere phone does not do it justice. 'When the "red machine" rings,' a senior executive of a state bank told me, 'you had better make sure you answer it.'

The 'red machine' is like no ordinary phone. Each one has just a four-digit number. It connects only to similar phones with four-digit numbers within the same encrypted system. They are much coveted nonetheless. For the chairmen and women of the top state companies, who have every modern communications device at their fingertips, the

'red machine' is a sign they have arrived, not just at the top of the company, but in the senior ranks of the Party and the government. The phones are the ultimate status symbol, as they are only given out to people in jobs with the rank of vice-minister and above. 'They are very convenient and also very dangerous,' said an executive of a large state resources company. 'You want to be sure of your relationship with whichever person you call.' Down the corridor from the executive offices is an additional tool for ranking officials, an internal communications room which receives secure faxes from Zhongnanhai, the leadership compound, and other sections of the party and government system.

'Red machines' are dotted throughout Beijing in offices of officials of the requisite rank, on the desks of ministers and vice-ministers, the chief editors of party newspapers, the chairmen and women of the elite state enterprises and the leaders of innumerable party-controlled bodies. The phones and faxes are encrypted not just to secure party and government communications from foreign intelligence agencies. They also provide protection against snooping by anyone in China outside the party's governing system. Possession of the 'red machine' means you have qualified for membership of the tight-knit club that runs the country, a small group of mainly men, with responsibility for about one-fifth of humanity.

The modern world is replete with examples of elite networks that wield behind-the-scenes power beyond their mere numerical strength. The United Kingdom had the 'old boy network', originally coined to describe connections between former students of upper-class, non-government schools; France has 'les énarques', the alumni of the exclusive Ecole Nationale d'Administration in Paris who cluster in the upper levels of commerce and politics; and Japan has the Todai elite, graduates of the law school of Tokyo University, an entry point into the longtime ruling Liberal Democratic Party, the Finance Ministry and business. In India, the exclusive Gymkhana Club symbolizes the English-educated elite. The US has the Ivy League, the Beltway, K Street and the military-industrial complex, and a host of other labels to signify the opaque influence of well-connected insiders.

None can hold a candle to the Chinese Communist Party, which takes ruling-class networking to an entirely new level. The 'red machine' gives the party apparatus a hotline into multiple arms of the state,

including the government-owned companies that China promotes around the world these days as independent commercial entities. Critics of the Republican administration of George W. Bush decried what they said were the cosy links between Dick Cheney, the vice-president, and the energy industry, to take one example. Imagine the case the critics could have mounted if Cheney and the CEO of ExxonMobil, and America's other big energy companies, had secure phones on their desks establishing a permanent, speed-dial connection with each other. In turn, to extend the analogy, what would they have made of the ExxonMobil CEO receiving a steady stream of party and government documents, available to the executives of Chinese state companies by virtue of their office and rank? The 'red machine' and the trappings that go with it perform precisely these functions.

One vice-minister told me that more than half of the calls he received on his 'red machine' were requests for favours from senior party officials, along the lines of: 'Can you give my son, daughter, niece, nephew, cousin or good friend and so on, a job?' Over the years, he had developed a strategy to handle personal requests, welcoming them effusively, while adding that the potential applicant first had to sit the gruelling test required for entry into the civil service, which few were willing to do. The 'red machine' has other uses. In the days before mobile phones, well-connected investment bankers who could not get through to top officials would try to borrow the 'red machine' in offices they were visiting when the boss was out, to put through a call directly to a potential top client. Quaint as it may seem in the age of sophisticated mobile telephony, the 'red machine' remains a powerful symbol of the party system's unparalleled reach, strict hierarchies, meticulous organization and obsessive secrecy. The phone's colour, revolutionary red, resonates as well. During political crises, the Party frets about China 'changing colour', code for the red communists losing power.

Top-ranked party members enjoy a social standing beyond the respect that officials get anyway in a country with deep bureaucratic traditions. Much as if they have been granted diplomatic status in their own country, they live in secure compounds, but also have their overseas travel restricted and mingle with people beyond official circles and their immediate family, according to strict security protocols. They answer to the Party first, not to the law of the land, if they are accused

of criminal wrongdoing. But the benefits come at a cost, beyond the personal stress and the impact on families that public officials around the world complain of. Party membership is a commitment, not a simple enrolment. The Chinese who are promoted into senior positions must take whatever assignment they are handed, and cannot easily leave the Party without grave consequences. Above a certain level, senior officials are much like Michael Corleone in *The Godfather*, who lamented, after trying to leave the family's mafia business, that every time he tried to get out, 'they pulled me back in'.

It is no coincidence that the Vatican is one of the few states with which China has been unable to establish diplomatic ties since the founding of the People's Republic in 1949. The city-state, which is the administrative centre of the Catholic Church and the home of the Pope, is the only other organization of comparable dimensions to the Chinese Communist Party, albeit on a global scale, and with a similar addiction to ritual and secrecy. The Party guards the command of its catechism as zealously and self-righteously as the Vatican defends its authority over the faith. After years of on-and-off talks, the Vatican has not been able to reconcile its worldwide prerogative to appoint bishops with the Party's insistence that it alone has the right to approve their choice for the Catholic Church at home in China. The on-and-off-again talks between Rome and Beijing have been punctuated, in private, by a self-aware black humour. One of the unofficial Chinese intermediaries with Rome joked about the uncanny similarities between the Party and the Catholic Church when he visited the Vatican in 2008. 'We have the propaganda department and you have the evangelicals. We have the organization [personnel] department and you have the College of Cardinals,' he told a Vatican official. 'What's the difference, then?' the official asked. The Chinese interlocutor replied, to hearty laughter all round: 'You are God, and we are the devil!'

Like the Vatican, the Party has always made sure top-level decisions are kept in the family. Hu's fantasy about being chosen by the 'whole country' skated around the fact that the delegates to the 2007 congress, and earlier such meetings, had been the only citizens allowed to vote. Even then, the 2,200-odd congress attendees were deprived of any choice. In the lead-up to the congress, Chinese political scholars had been teased with suggestions that the delegates would be presented

with a slate of candidates, allowing them a genuine ballot to winnow down a larger list to the final nine. A more radical idea, copying the Vietnamese Communist Party's decision in 2006 at its congress in Hanoi, to allow two candidates for the position of general secretary, had also been internally debated. Both options were quietly discarded for a traditional communist-style ballot.

The names of the bodies through which the Party exercises power, the Politburo, the Central Committee, the Praesidium and the like, all betray one of the most overlooked facts about the modern Chinese state – that it still runs on Soviet hardware. Vladimir Lenin, the leader of the Russian Revolution, designed a system according to which the ruling party shadows and stalks the state by penetrating it at all levels. Lenin presented himself as the saviour of the working class but the structure he devised was ferociously and brutally elitist. At the top of the system, Lenin prescribed 'as much centralization as possible', allowing self-appointed professional revolutionaries like himself to dictate downwards to a working class considered incapable of rising above their day-to-day struggles. In the bottom tier of the system, however, in the factories and grassroots party organizations, he prescribed 'as much decentralization as possible', so that information flowed upwards to a Central Committee about even the smallest local developments. 'For the centre to actually direct the orchestra,' Lenin wrote, 'it needs to know who plays violin and where, who plays a false note and why (when the music begins to grate on the ear), and how and where it is necessary to transfer someone to correct the dissonance.'

The Central Committee acts as a kind of enlarged board of directors for the Party in China. With about 370 full- and part-time members, the committee includes ministers and senior regulatory officials in Beijing, leaders of provincial governments and large cities and a large bloc from the military. Some, but not all of the heads of China's big state-owned enterprises are Central Committee members. An array of other interests which make up the leviathan of the Chinese state, ranging from representatives of minority communities, like Tibetans, to the head of Hu Jintao's Central Guards Unit (popularly known as the Bodyguard Bureau), the Party's secret service, makes up the remaining members. The Central Committee elects, or to be more precise, selects the Politburo, which has about twenty-five members. The Politburo,

in turn, selects the Standing Committee, the inner sanctum of the leadership, which in its present incarnation has nine members.

The nine men filing out onstage in 2007 might have been the only candidates on the list presented to delegates as eligible for election for the top leadership positions. It was a moment of great import nonetheless, because within this small group all of the levers of political power the Party deploys to maintain its hold on the government, the country and the 1.3 billion-strong population had been divided up and allocated to each individual. The core responsibilities of the Politburo inner circle are not what you might expect to top the agenda of the country's elite leadership body, at least if you listened to the daily pronouncements of the central government in Beijing. The Politburo sets the general policy direction for the economy and diplomacy and has been preoccupied in recent years with China's towering challenges in meeting exploding energy demand, environmental degradation and managing the mobile, 700 million-strong rural population. Politburo members are briefed on these issues and have the final responsibility for deciding related policies, but they do not manage portfolios day-to-day in the way that ministers in a cabinet system do.

The Politburo's overriding priorities lie elsewhere, in securing the Party's grip on the state, the economy, the civil service, the military, police, education, social organizations and the media, and controlling the very notion of China itself and the official narrative of its revival from an enfeebled power, broken apart and humiliated by foreigners, into a powerful state and resurgent civilization. More than a century after the model's invention and two decades since its pioneer in Moscow and its eastern European satellites fell apart, the core of the Chinese system, for all its indigenous modifications, still bears a remarkable resemblance to Lenin's original design. Even the 'red machine' has Soviet antecedents. The Russians used a secure internal phone system, known as the *vertushka*, which loosely translates as 'the rotater', to connect the party elite.

Mao initially adopted Soviet institutions but he always regarded the Party as bureaucratic and insufficiently revolutionary, complaining in the fifties that officials 'were tottering along like women in bound feet, always complaining that others were going too fast for them'. Instead of the Party supervising the people, Mao decided the people should

supervise the Party, a philosophy that triggered the ten years of madness of the Cultural Revolution from 1966, when Red Guards were authorized to terrorize anyone they decided had strayed from the righteous path of revolution. Mao unleashed 'a revolution on a revolution that wasn't revolutionary enough', as a documentary described the period. After Mao's downfall and death, the Party went back to basics. Deng Xiaoping threw out Mao's destructive notions and returned the party organization to its Leninist roots, as an empowered elite providing enlightened leadership to the masses.

The notion of a party controlling the government, especially when the same party effectively is the government, remains conceptually difficult for many to grasp. When I lived in Shanghai for four years from 2000, I would advise visitors confused about this concept to keep an eye out for the official cars whisking top municipal leaders in and out of the city leadership compound in Kanping Road, a stern, grey-marble low-rise carved out of the elegant, tree-lined backstreets of the old French Concession. The cars provided an easy first lesson about Chinese politics, Leninism 101, if you like, as their number-plates clearly spelt out the ruling hierarchies in the city. The Shanghai party secretary's plate is numbered 00001; the mayor and deputy party secretary's plate is 00002, one rung below; and that of the executive vice-mayor and the next most senior member of the city's party committee is 00003; and so on. The number-plates are a banal illustration of the most important guiding principle of Chinese politics, of the Party's ascendancy over the state in all its forms. Political language faithfully reflects the hierarchies, by referring to 'party and state leaders' in all official announcements.

The front stage of Chinese politics, or Lenin's orchestra, are the government and other state organs, which ostensibly behave much like they do in many countries. The Ministry of Finance frames a budget each year amid age-old jockeying between rival claimants for limited funds. Ministers meet collectively as a cabinet to battle over their policy priorities. The many fine scholars in Chinese think-tanks produce voluminous, and often influential and incisive, research reports. The courts deliver verdicts on the matters before them. The universities teach and dispense degrees. Journalists write stories. And the priests in the state-approved churches solemnly say Mass and administer the sacraments.

But it is backstage, in the party forums, where the real stuff of politics is transacted.

Under the Politburo sits a vast and largely secret party system which controls the entire public sector, including the military, and the lives of the officials who work in all of China's five levels of government, starting in Beijing. The Party staffs government ministries and agencies through an elaborate and opaque appointments system; instructs them on policy through behind-the-scenes committees; and guides their political posture and public statements through the propaganda network. The officials working in public institutions are trained, and re-trained, at regular intervals, through the Party's extensive nationwide network of 2,800 schools, before they are eligible for promotion. Should they be accused of bribery, fraud or any other criminal conduct, they are investigated by the Party first and only turned over to the civilian justice system on its say-so. Even then, any punishment meted out by the courts is at the behest and direction of party organs, which ultimately control the judges directly, and the lawyers indirectly, through legal associations and licensing.

China retains many of the formal institutional trappings that give it a superficial resemblance to a pluralist system, with executive government, a parliament and courts. But the Party's pervasive backstage presence means the front-stage role of these bodies must be constantly recalibrated against the reality of the power that lies, largely out of sight, behind them. The tentacles of the state, and thus the Party, go well beyond the government. As well as sitting above state-owned businesses and regulatory agencies, these party departments oversee key think-tanks, the courts, the media, all approved religions, and universities and other educational institutions, and maintain direct influence over NGOs and some private companies. The Party also directly controls China's eight so-called 'democratic parties', by appointing their leaders and financing their budgets.

The front-stage and backstage roles are blurred in government, as most of the senior behind-the-scenes directors, producers and script-writers in the Party also star in public government roles. Hu Jintao is party secretary but he also carries the more junior title of state president. Likewise, the Politburo, headed by Hu, sits above the State Council, China's equivalent of a cabinet, which is headed by the Premier, Wen

Jiabao, who is also on the Politburo. When Hu visits Washington and other western capitals, he is always billed as President, and head of state, at the insistence of the Chinese, and not as the General Secretary of the Chinese Communist Party, which is his most important position. Hu only flaunts his party title on trips overseas to the handful of surviving fraternal communist states, like Cuba, Vietnam and North Korea. To do it in places like the White House lawn would be unnecessarily embarrassing to his host. It would also lift the public profile of the Party, which Hu and other leaders have no interest in doing.

The division of roles between the Party and government is more than just perplexing for outsiders. It is a huge source of hidden tension within the system itself, as illustrated by the political blow-up over the spread of the deadly SARS virus in 2003. The crisis over SARS, which threatened to bring the country and the economy to a standstill, was brought under control when Hu Jintao stepped in to sack the health minister and the Beijing mayor for covering up the true extent of the virus's spread. The leadership had been shamed into action by a retired army surgeon in Beijing. The surgeon faxed details of the correct number of people afflicted with the virus to foreign journalists to circumvent the propaganda department diktats, which had deliberately minimized the figures of those affected.

Hu's dramatic intervention was hailed by local and foreign commentators as a watershed, a moment when a hitherto closed and unresponsive system was forced to be open and accountable. That was not how the sackings were viewed from the inside. The minister and the mayor, both occupying government posts, were not responsible for the cover-up, critics argued. In the case of the mayor, he was answerable to the Beijing party committee. The health minister was subservient to internal party bodies governing health policy. Neither operated with autonomy. 'Many government officials were extremely upset about this because they said they had simply been carrying out decisions made by party committees and party bosses higher up than them,' an adviser to Hu told me. 'These two were scapegoats.'

Aside from a few largely symbolic exceptions, every senior government minister or official is a party member. By contrast, every senior party official does not always hold down a government post. Many instead work for the key party departments, which outrank mere

government ministries. The Central Organization Department is responsible for personnel appointments. The Central Propaganda Department handles news and information. The United Front Department, as its name suggests, has a brief to lock in support for the Party in power centres outside of its direct purview, like overseas Chinese business communities in Hong Kong and Taiwan, and in social organizations at home.

Throughout the system, the Party has positioned itself like a political panopticon, allowing it to keep an eye on any state or non-state agency, while shielding itself from view at the same time. The panopticon was the innovative penitentiary designed by Jeremy Bentham, the eighteenth-century English philosopher, which allowed a handful of wardens to watch inmates without being observed themselves. China is not one giant prison, as Qian Qichen, the former foreign minister, used to say in an acid rebuttal of western criticism of the country's human rights records. By many measures, China is freer than it has ever been. But the Party, in retreating from the private lives of Chinese, has made sure it secures the heights of the political battlefield along the way. Like the panopticon, the Party is omnipresent in the country's politics, with the benefit of remaining largely unobserved itself. 'The Party is like God,' a professor from the People's University in Beijing told me. 'He is everywhere. You just can't see him.'

In the late 1990s in Beijing, I attended a small dinner with Rupert Murdoch, where he declared he had yet to meet any communists during his trips to China. On the face of it, it was an odd statement, because any Chinese government official of any consequence is nominally communist, or at least a member of the Party. If Murdoch wanted to do business in China, especially in the media, among the most sensitive sectors for private foreign capital, he could not avoid the Party. In fact, he would have to embrace it, as he eventually tried to do. It took many years, and much supplication, for Murdoch to secure a meeting with the then propaganda chief, Ding Guan'gen, a key figure ranked number eight in the party hierarchy until 2002. Later, Murdoch joined forces in an expensive business venture with Ding's son in an effort to find a way around China's tight restrictions on foreign broadcasting, all to no avail. By 2009, Mr Murdoch had all but given up on China altogether.

Murdoch is not alone in remarking on the absence of communists in China. It is something I have heard over many years from streams of sophisticated, no-nonsense foreign businessmen and women passing through China, mostly after coming directly from a meeting with a senior party official. Their statements are understandable, in one respect. The sole experience of Chinese communism for many business leaders who have invested in, and profited from, the transformation of the country into an economy that often appears on the surface to be a uniquely unbridled form of capitalism, are officials who want to do business. One of Murdoch's most powerful editors, Kelvin MacKenzie, was stunned by China's development under communism when he visited Beijing with a British delegation in 2000. As the one-time editor of the *Sun*, the best-selling tabloid which famously features a topless girl on page three of every edition, MacKenzie had been a scourge of the left and a champion of Thatcherism. In China, he told his bemused hosts in a booming voice over lunch that, on returning home to Britain, he was going 'to become a communist too' to invigorate his homeland. For visitors like MacKenzie, the only time they might stumble across the *Little Red Book* would be on an excursion to a weekend flea market en route to the airport to fly home.

Western elites were once familiar with the order of battle in communist politics, mainly through study of the pioneering model in the former Soviet Union, and the mini-industry in academia, think-tanks and journalism known as Kremlinology. The collapse of the Soviet empire in the early 1990s took with it much of the deep knowledge of communist systems. Sinology has always been a different beast in any case, as much dedicated to Chinese history, culture, science and language as to modern politics. The transformation of China's economy and society and its impact on the rest of the world during the same period has diverted attention from formal politics in Beijing even further. Political journalism thrives on partisan competition and the potential for regime change, both absent as day-to-day issues in China. Scholarly studies, which are enjoying a boom along with its subject, have also felt the pull of China's economy and the demand from governments and the corporate sector for insights into the once-in-a-lifetime phenomenon of the resurrection of the fortunes of one-fifth of humanity.

That the media and academia should focus overwhelmingly on

economic and social change in China is hardly surprising. Compared to China's vast political apparatus, which operates underground, the country's extraordinary economic growth manifests itself in the daily life of consumers and their political representatives around the world. China makes the clothes people wear, the toys they buy their children, and often even grows the food they eat. For politicians, China is at the heart of economic trends that both create and destroy jobs in their constituencies. In the last decade in the west, the number of column inches spent reporting just the controversy over the value of China's currency has far outweighed detailed scrutiny of the inner workings of the Communist Party.

Increasingly, it has become intuitively difficult for western visitors to China to square the razzle-dazzle of its gleaming new cities with notions of Communist Party rule. The glum Maoist state that once greeted investors and tourists, with its grim Soviet architecture, mirthless officials, surly service staff and chronic shortages of consumer goods, neatly fitted preconceptions of traditional Cold War communism. The front stage of new China, which seems to have been built from scratch in just a few years, bears little resemblance to the old model. In the lead-up to the 2008 Beijing Olympics, the *New York Times* architecture writer, Nicolai Ouroussoff, compared arriving at the city's new airport 'to the epiphany that Adolf Loos, the Viennese architect, experienced in New York more than a century ago. He had crossed the threshold into the future.' More than just the grandeur of the space, 'it's the inescapable feeling that you're passing through a portal to another world whose fierce embrace of change has left western nations in the dust'. Ouroussoff tempered his enthusiasm slightly on the drive into the city. Nevertheless, such bounding new-world optimism about a country still under authoritarian rule is a tribute as much to the Party's ability to mask the trappings of its power as it is to Beijing's adventurous developers, and their largely foreign-designed landmarks.

For western politicians, the denial of Communist Party rule can be deliberate. Before Richard Nixon set out on his historic trip to China in 1972, he worked with Henry Kissinger to expunge the use of the term 'communist' when talking about the Chinese, because of the embarrassment the word caused him with his traditional base at home. Mao Zedong was called simply the Chairman, rather than the Chairman of

the Chinese Communist Party. The State Department's official record of the trip, including the speeches, toasts and press conferences, did not mention the word 'communist' once. Foreigners in China in the twenty-first century can be forgiven for thinking they are not in a communist state. Nixon, however, landed in Beijing when China was mired in the mass bullying, death and destruction of the Cultural Revolution.

The Chinese have sowed further confusion in recent years by appropriating concepts at the heart of the liberal traditions in the west more firmly into their own political rhetoric. Mao used the term 'democracy' in his writings but the system became deeply hostile to the word's connotations in the wake of the 1989 protests. When the internet gained popularity in China, state security initially added 'democracy' to the list of banned words for web searches. Anyone searching for the words 'democracy in China' on Microsoft's Chinese site in 2005 received an error message saying, 'please delete forbidden speech from this item'. Wen Jiabao blindsided many by switching tack in 2007, declaring at his annual press conference that 'democracy, law, freedom, human rights, equality and fraternity' did not belong exclusively to capitalism, but were 'the fruits of civilization jointly formed through the entire world's slow course of historical development'.

Wen's pronouncement produced the usual flurry of stories in the foreign media about how China seemed to be embracing western-style political reform. But most missed the fact that, mindful he was addressing an international audience, Wen had left out the all-important rider carried in official documents on democracy in China, including the Party's own 2005 White Paper on the topic. 'Democratic government is the Chinese Communist Party governing on behalf of the people,' the paper said. Within the system, the reaction to Wen's 2007 pronouncement was more hard-headed. As a former senior official ousted after the 1989 Beijing crackdown joked to me, 'You need a new dictionary to understand what Chinese leaders mean when they talk about democracy.'

Like communist and revolutionary parties throughout history, formed and nurtured by underground cells and violent conflict with the regimes they sought to overthrow, the Party in China is secretive by habit and inclination. In a country which has embraced the internet and mobile telephony with gusto, the Party still does not have its own stand-alone website. Lu Weidong, who teaches at the party school in

the old revolutionary base of Yan'an, dismissed my query about its absence as redundant. 'All the important media is owned by the Party,' he said, 'so we have no need to set up a website.'

It would seem difficult to hide an organization as large as the Chinese Communist Party, but it cultivates its backstage role with care. The big party departments controlling personnel and the media keep a purposely low public profile. The party committees (known as 'leading small groups') which guide and dictate policy to ministries, which in turn have the job of executing them, work out of sight. The make-up of all these committees, and in many cases even their existence, is rarely referred to in the state-controlled media, let alone any discussion of how they arrive at decisions. The membership of these groups can only be deduced by painstaking Kremlinological compilations from scouring the Chinese press, sometimes over years. 'The only instance in the entire post-Mao era in which the [Chinese] media listed the current members of any of these groups was in 2003, when the party-controlled newspaper *Wen Wei Bao* in Hong Kong publicized a membership list of the Central Committee Taiwan Work Leading Small Group,' said Alice Miller, of the Hoover Institution.

In Hong Kong, the Party has remained underground even since China regained sovereignty of the former British colony in 1997, defying local laws which require political parties to register. Tsang Yok-sing, the normally chatty longtime leader of the pro-Beijing party in the former colony, still refuses to say directly whether he is a party member. In October 2008, ahead of elections for the presidency of Hong Kong's legislature, Tsang said he wouldn't answer such questions because the attitude of people in the territory to the Party 'is very negative'. He complained, when he founded his own party in the early nineties, that anyone associated with Beijing was branded a 'commie thug'.

The Party has been careful, too, to minimize its profile in international business, systematically playing down its presence in the large state enterprises that have been listed offshore in New York, Hong Kong, London and elsewhere. The bulging prospectuses used to sell Chinese state companies ahead of their offshore public listings are crammed with information from every conceivable angle about their commercial activities and board roles, but the Party's myriad functions, especially control over top personnel, have been airbrushed out altogether. 'The Party is

very much present in these companies but the government is savvy enough to keep it in the background,' said a Beijing-based western lawyer who has advised on offshore listings of big Chinese companies. 'There is a tacit understanding among western intermediaries to play down the Party's role because people understand that it is not going to sell well in the west.' The bankers and lawyers argue they have little to disclose in any case, because the Party has never provided them with any information or documents about its role in state companies, let alone in business generally. 'There is no basis for disclosure, because there is never anything to disclose,' said another lawyer. 'It's like a phantom.'

Over time, the Party's secrecy has gone beyond habit and become essential to its survival, by shielding it from the reach of the law and the wider citizenry. Ordinary citizens can sue the government in China these days, and many do, although they may stand little chance of success. But they cannot sue the Party, because there is nothing to sue. 'It is dangerous and pointless to try to sue the Party,' He Weifang, at the time a law professor at Peking University, one of China's oldest and most prestigious educational institutions, told me. 'As an organization, the Party sits outside, and above the law. It should have a legal identity, in other words, a person to sue, but it is not even registered as an organization. The Party exists outside the legal system altogether.' The Party demands that social organizations all register with government bodies, and punishes those which don't. The Party, however, has never bothered to meet this standard itself, happily relying on the single line in the preamble of the constitution, about its 'leading role', as the basis for its power.

In a country which claims to be building a more open society based on the rule of law, the authorities do not appreciate anyone highlighting this embarrassing legal vacuum. Professor He, for one, was almost arrested after an attack he launched on the Party at a private meeting in 2006 was leaked on the internet. 'The Party is an organization without legal basis that violates individual freedoms and tramples on the law,' Professor He had said. 'The Party is always clamping down on the media and grabbing power. What kind of a system is this? It seriously violates the [Chinese] constitution.' A transcript of this private, informal gathering, known as the 'west mountain meeting', after the location where it was held in Beijing, was posted on the web by enthusiastic

students who had attended and taken notes. The content of the meeting infuriated leftist critics of the reform camp. An anonymous reply posted soon after on the website of the China Academy of Social Sciences, one of the country's leading state think-tanks, said Professor He and the reform group that organized the conclave had conspired to set up 'a shadow political party, unregistered, but existing in reality'. In Chinese terms, this was a dangerous slander, akin to an accusation of subversion. It was also luridly hypocritical, because it so precisely echoes the criticism made of the Party itself.

Since Mao substituted revolutionary committees and arbitrary violence for due process and left the legal system in ruins, the Party has adopted a more sophisticated approach to the law, enlisting it as an ally to help manage a complex economy, rising social tensions and abuses of administrative power. Legal intellectuals increasingly have the ear of the leadership, which publicly espouses support for harmonizing Chinese legislation with global standards. The Politburo now includes law graduates and economists, chipping away at the overwhelming dominance of engineers. But while it promotes the law, the Party has made sure that it has expanded alongside it. About one-third, or 45,000, of the 150,000 registered lawyers in China as of May 2009, were party members. Nearly all law firms, about 95 per cent, had party committees, which assessed lawyers' pay not just according to their legal work, but to their party loyalty as well. Far from being a weakness, the Party considers its penetration of the legal system to be a core strength. A retired judge in Chongqing, a vast metropolis in western China, recounted the response he got when he objected to interference of party officials in his court rulings. 'You call it interference,' the official replied. 'We call it leadership.'

In the lead-up to the 2007 congress, former classmates of Li Keqiang, a provincial leader favoured by Hu Jintao to succeed him, spoke admiringly of his liberal legal education in the late seventies. A one-time university colleague from Peking University, Wang Juntao, recalled Li's open-mindedness on campus and his support for 'constitutional government', code for backing the independence of the executive, the parliament and the judiciary. What might have seemed like a compliment to outsiders amounted to a political smear within the Party itself, akin to a candidate from the religious right in the USA being outed on

election eve as pro-choice. The source of the compliment didn't help either, as Wang Juntao had been imprisoned and then sent into exile for his role in the 1989 protests.

In pronouncements on the legal system the Party regularly reiterates the law's place in the political pecking order. Judges must remain loyal – in order – to the Party, the state, the masses and, finally, the law, according to the report issued to the National People's Congress in 2009 by the Supreme People's Court. As Li discovered, up-and-coming leaders perceived to be toying with this hierarchy do so at considerable political risk. 'This was hugely damaging for Li inside the Party,' said another classmate. 'The hardliners are very suspicious of such views.' In the end, Li fell short of his ambitions at the congress, walking into place at the Great Hall of the People in the Politburo parade one step behind rival Xi Jinping, who became Hu's heir-apparent in his place.

The career of China's chief justice, Wang Shengjun, nominally the most senior judicial officer in the country, embodies the values of this legal system admirably. Wang has never studied law, and ascended to the post in 2008 through a career in provincial policing in central Anhui province and then the state security bureaucracy in Beijing. Apart from a degree in history, interrupted by the Cultural Revolution, Wang's only other education has been at the Central Party School in Beijing. To use an American analogy, it would be like appointing a former bureaucrat in charge of policing in Chicago to be the US Supreme Court Chief Justice on the basis of his success, first at fighting crime in the mid-west city and then managing a division of the Justice Ministry as a partisan political appointee in Washington. The analogy is not exact. The Chinese Supreme Court is not like its US counterpart. It has hundreds of judges and performs administrative functions as well. But, broadly speaking, the comparison holds. In the Party's view Wang's political credentials made him perfectly qualified for the senior legal job.

Wang performs another important role at the court, by hosting foreign judges and lawyers visiting China, as their nominal counterpart in the legal system. To arrange meetings with the most senior and powerful figure in the legal firmament, Zhou Yongkang, is awkward, as he does not occupy any formal government office that publicly identifies him as the country's chief law officer. Zhou, who sits on the nine-member Politburo Standing Committee, is responsible for the vast

state security apparatus, including the police. He also chairs the Party's Central Politics and Law Committee, the country's supreme legal authority which supervises the courts, the police, the Justice ministry and the legislature, the National People's Congress. His appointment as head of the committee was announced cursorily in the state media after the 2007 congress, but otherwise his work and speeches are largely directed internally, to party organs, not the public at large.

Senior leaders stand constant guard against encroachment on the Party's power through western notions of competitively elected parliaments and an independent judiciary. In the space of a few months in early 2009, two members of the Politburo inner circle made highly critical speeches about western democratic governance. In one, Jia Qinglin warned that China needed to build a 'line of defence to resist western two-party and multi-party systems, a bi-cameral legislature, the separation of powers and other kinds of erroneous ideological interferences'. Luo Gan, a member of the Politburo Standing Committee until 2007, was even more explicit. In a speech published before his term finished, Luo conceded that Chinese courts had to keep pace with international trends but rejected the argument that judges and lawyers had to be independent as a result. 'Enemy forces', he said, were trying to use the law to undermine and divide China. 'There is no question about where legal departments should stand,' he said. 'The correct political stand is where the Party stands.'

Chinese leaders have long debated the merits of a Chinese-style separation of powers doctrine that would put greater distance between the Party and the state. After years of largely fruitless discussion, they simply gave up, because a single-party state cannot countenance such a reform. The idea of a genuine split has now become a little passé, because to pursue the notion to its logical conclusion would risk gutting the Party's control over the state. 'Deng talked a lot about the separation of the Party and government and great efforts were made in this area,' said Hu Jintao's adviser. 'But basically, after it reached a certain stage, the idea stalled.'

No legal obstacle is so great that the Party cannot brush it aside. For the security services, the single line in the constitution about the Party's leadership role of the country has always been sufficient legal basis to arrest any critic. Hu Jia, one of China's bravest dissidents, used

to ask the plain-clothes police who waited on his doorstep to stop him leaving his apartment under what Chinese law he was detained. Hu Jia's questions enraged the police. Some were so angry they beat him up. One day, he said, one of them finally responded to his question, blurting out the grounds for detention. 'Under the preamble to the Chinese constitution!' the policeman yelled, before dragging Hu away.

Hu Jia was jailed in mid-2008 for allegedly working with foreigners to subvert the Beijing Olympics. The Party nailed Professor He in the end as well, with a little more subtlety. Tired by the endless politics of life in the capital, Professor He resigned from Peking University and took up an offer in 2008 to become the new dean of the law department at Zhejiang University. The authorities first strong-armed the institution in Hangzhou to withdraw the job offer. Then they forced He, who had been left in professional limbo, to take a temporary position at Shihezi University, a lowly ranked institution in Xinjiang, in far-western China. It was a deliberately humiliating transfer, akin to a Harvard Law School professor being reassigned to a small community college in rural Texas.

If the Party, locked in its ossified Leninist ways, is secretive, corrupt, hostile to the rule of law and vindictive in the pursuit of its enemies, it begs the question: how on earth did it manage to preside over one of the greatest spurts of economic growth and wealth creation in recorded history?

The Party's genius has been its leaders' ability in the last three decades to maintain the political institutions and authoritarian powers of old-style communism, while dumping the ideological straitjacket that inspired them. The Party's conscious retreat from the private lives of Chinese citizens over the same period had a similarly liberating effect on society. The dehumanization of everyday life that characterized traditional communist societies has largely disappeared in China, along with the food queues. In the process, the Party has pulled off a remarkable political feat, somehow managing to hitch the power and legitimacy of a communist state to the drive and productivity of an increasingly entrepreneurial economy.

In place of Mao's totalitarian terror, the Party has substituted a kind of take-it-or-leave-it compact with society. If you play by the Party's rules, which means eschewing competitive politics, then you and your

family can get on with your lives and maybe get rich. But the deal does not exist in isolation. It is buttressed by a pervasive propaganda system which constantly derides alternatives to the Party. The underlying message is that the Party alone stands between the country and the kind of murderous, impoverishing instability that has engulfed China at numerous times in its history. Recalibrated along these lines, the compact also reads – get rich, or else!

Even with this qualification, the space for individual Chinese to grow and prosper has expanded enormously since the late seventies. The rank and file of Chinese citizenry these days lead vastly different lives from their parents a generation ago. One by one, all sorts of things that once needed the Party's permission – where you lived, worked and studied; how much you were paid; where you went to the doctor; who you married, on what date and when you started a family; where you shopped and what you could buy; and when and where you travelled and with whom – have become the subject of personal choice for urban Chinese citizens. All you need is the cash to pay for it. The rules that long restricted the movement of rural residents are also, slowly, being unwound.

When the Party directly ruled over, and often threatened, ordinary Chinese, during Mao's murderous campaigns in the fifties, sixties and seventies, people learned to pay close attention to its pronouncements. Many Chinese remain attuned to the stiff recitations of official newspeak on sensitive political occasions, such as the 2007 congress. Government and scholarly circles, and even stock market investors, who understand that policy changes dictated by the Party have the power to move share prices, still watch these pronouncements closely. Otherwise, party declarations exist in a kind of parallel universe, like a radio left on in the background, a constant presence, but for the most part easily tuned out and forgotten altogether.

The Party's removal of itself from the many areas of life and work of its citizens into which it once crudely and cruelly intruded has been as strategic as it has been enlightened. As intoxicating as these changes have been for the Chinese people, the retreat has also paradoxically empowered the authorities. The Party has been able to maintain its own secret political life, directing the state from behind the scenes, while capturing the benefits and the kudos delivered by a liberalized economy and a richer society at the same time.

The fruits of reform in China since 1978 are palpable. China crammed into thirty years the kind of brutish, uplifting makeover that took as long as a century in the industrial revolutions in the UK and the US. The economy has doubled in size every eight years. In a comparatively short space of time, the Party has presided over an epic migration of farmers from the countryside to the cities; an explosion in private ownership – of houses, cars, businesses and shares; the creation of a middle class twice the size of the population of the United Kingdom; and the lifting out of poverty of hundreds of millions of people. In the last decade, China has managed to gallop or drag itself through multiple calamities: the Asian financial crises in 1997 and 1998; the downturns in the US in the wake of the bursting of the internet bubble and the September 11 terrorist attack; and the home-grown SARS emergency in 2003, which threatened to bring businesses inside the country to a halt. When the credit crunch hit the global economy in 2008, China was better equipped than just about anywhere in the world to handle the sudden downturn.

While the Party's political conclaves operate opaquely, the economy has been nourished by a relatively open debate. All the issues on the table in most developed countries, about the value of open markets, the cost of state ownership, the perils of protectionism and the impact of floating currencies, are up for discussion in China as well. Liberal economists are still subject to occasional waves of intimidation, because of the sense that their ideas ultimately threaten the dominance of the state. But the Party's restless search for a formula that matches its dual objectives – to stay in power and get rich at the same time, or to stay in power by getting rich – means their views are often heeded anyway.

The Party has not drawn one obvious lesson from the success of the economy – that the public policy sector that has been most open to debate and competition has produced the best outcomes. In the Party's view, liberal economics have only succeeded in China because they have been married with authoritarian politics. China's instincts in this respect are like those of much of Asia. The visible hand of the state and the invisible hand of the market, far from being contradictory, are made to complement and reinforce each other. These days, Chinese officials treat questions of any inherent contradiction between a communist political system and a capitalist economy as almost banal. In real life, China is

full of symbols of how the Party has merged the two systems to its advantage. At the Shanghai party school, one of the top four in the country, this convergence of interests is part of the curriculum.

The school, opened in late 2005 on a 40-hectare campus in the newly built Pudong district, luxuriates in modern buildings designed by Paris-based architects to resemble a red painting table, consciously echoing the place where 'the master teaches the student' in traditional Chinese culture. As ever, the Party has calibrated the way the school presents itself at home, to its Chinese students, and, separately, to the outside world. The official name of the school in Chinese, properly translated into English, is the 'China Pudong Cadre College'. In English, the communist connotations of the word 'cadre' have been excised to render the centre's name as the 'China Executive Leadership Academy in Pudong', making it sound more like an MBA factory than a pillar of the party system. The subtle name change underlines the central purpose of the party school system, which is as much about enforcing and benchmarking loyalty as imparting modern management skills.

On the first day of class in Shanghai, the students, all up-and-coming officials, with a few private entrepreneurs sprinkled into the mix, make a ritual pilgrimage to the small museum commemorating the place where thirteen activists met in secret in 1921 to found the Communist Party in China. On the way, the students pass through a late nineteenth-century city district, smartly refurbished by a Boston architect, and crawling with upscale eateries and expensive apartments with prices to rival global capitals like New York and London. Since the mid-nineties much of old Shanghai has been knocked down and replaced by high-rise developments. In 2001 a Hong Kong property tycoon was allowed to refurbish this small district, called Xintiandi, or 'New Heaven on Earth', because he agreed to preserve some of the old low-rise houses, and upgrade the party museum alongside them.

The workers and their families who used to live in the old laneway residences complained bitterly about the meagre compensation they received for being ejected for the development. The uproar over the same kind of issue in areas across the whole city led to the downfall of the powerful Shanghai party secretary, a Politburo member, several years later. But the idea that one of the Party's sacred sites should sit proudly amidst a yuppie wonderland generated much less controversy.

What once might have been seen as a fatal clash of values has been turned into an advertisement for the Party's fundamental strengths. 'People can see the progress of the Party,' Professor Xia Jianming, the Shanghai party school's director-general, said. 'This [setting] is a kind of harmony. In our society, people of different levels may have different ways of meeting their requirements.'

But the story does not end there. The flipside of the single-party state are the multiple, and multiplying, realities of twenty-first-century China. The upheaval of the last three decades has sown the seeds of conflict and change, within the Party, the economy and society at large. According to the Leninist ethos, the Party infiltrates the government and society. Now the reverse is happening. Society, with all its rapidly evolving aspirations, demands and cleavages, is now infiltrating the Party, and the Party is struggling to keep up.

China is awash with people and organizations with evolving professional interests, codes and agendas which are antithetical to a repressive, busybody state. Entrepreneurs, lawyers, journalists, religious worshippers, teachers, academics, historians and even doctors who speak out about public health problems are increasingly demanding the right to simply do their jobs or pursue their beliefs, free of political interference. China's most far-reaching reform of the past two decades, the creation of a private housing market, has also spawned a new class of potential political activists, middle-class investors who want to protect the value of their properties. To paraphrase the author, V. S. Naipaul, there are a million mutinies now, on the streets, in cyberspace, within companies and on farms, by people who want nothing more than the government to be accountable for its actions and to tell the truth.

Amidst China's successes, there is failure aplenty. At the same time as China has got rich, its society has become more unequal than even the US and Russia. There are now more billionaires in China than in any country other than the US. The rich have not just been getting richer. In the boom times, they have been doing so at the expense of the poorest people in the land. In the two years to 2003, the average incomes of the poorest 10 per cent in China fell, at a time when the economy was growing rapidly, and the incomes of the top 10 per cent of the population were rising by more than 16 per cent annually.

The Party has no compunction about arresting opponents who openly challenge the system, and destroying their livelihoods and families, but it has little stomach for violent conflict on a large scale. Revolutionary parties do not hesitate to spill blood to hold power. Governing parties, as the Chinese Communist Party now styles itself, have to learn to live by a different set of rules. 'It's not just because Hu Jintao is not Deng Xiaoping. There is a growing demand for democracy,' said Zhou Ruijin, the retired editor of the *Liberation Daily*, the official party newspaper in Shanghai. 'You can see this by the way people are expressing their views within the Party, and outside. One-man rule no longer applies.'

As a political machine, the Party has so far proved to be a sinuous, cynical and adaptive beast in the face of its multiple challenges. As society has changed in the last decade, so has the Party's membership make-up. Top leaders have systematically set about jettisoning the body's proletarian rural roots in favour of an alliance with the richer and more successful classes emerging out of the market economy. Once dominated by workers, and then by peasants – who alone made up nearly half the membership until as late as 1978 – the Party now seeks out star students and wealthy entrepreneurs. They are the fastest growing sources of new members, expanding their numbers in the Party by 255 per cent and 113 per cent respectively between 2002 and 2007. Many of them have been happy to embrace the Party, because it offers them in return access to a network that is crucial to furthering their careers.

When I met three students from China's elite universities at a café in Beijing in early 2009 to ask them about the Party, they were unanimous about its attractions. 'For many young students like me, to be a party member is a symbol of excellence,' said Ni Hanwei, a maths student at Tsinghua University, known as China's MIT. 'The second reason is that if you are a party member, you will get more opportunities with government jobs.' At both high school and university, all of their classes in different parts of China had quotas for party membership, with positions offered as a prize for the top students.

Gathered in a huddle at the Thinker's Café in Beijing's university district, the students scoffed at old-style ideology, derided the political education classes that came with party membership and freely admitted they downloaded from the internet the essay required for their

joining application. One expressed outrage at the 1989 Beijing massacre. The two others warily dismissed the event as being in the past. All of them had had drummed into them by their parents and teachers, and seemed to accept without reservation, that the state would retain a powerful role in their lives. 'The foreign countries say the Communist Party has made a lot of mistakes and maybe after several years, it would collapse,' said Huang Hongfang, a political science student at the People's University. 'But my teacher said: "Do not underestimate the government's power. The president or the members in the central government are really very clever, and they can use their power and policies to control the whole country."'

When the allure of the elite network is not enough, the Party tosses money into the mix. To attract private entrepreneurs into the club, the Party offers cash incentives for business leaders and workers who sign up new members, much as Amway and other pyramid-sales companies do for sales people who recruit new associates. In Sanxiang, southern Guangdong, the township party committee set aside a rmb 5 million bonus pool for membership drives, an example replicated across the country. Villagers who set up new party committees in private enterprises where none had existed before were paid rmb 5,000, a huge sum, equivalent to about three to four months' salary for an ordinary factory worker.*

Many entrepreneurs are like Zhu Peikun, who runs his own property and education company in southern China. Zhu said he never considered having a party committee when he set up his business in 1994. Mutual suspicion, between the Party and business, abounded. Now, he speaks of the Party with solemn respect and sees it as essential to the relationships he needs if he is to expand and prosper. 'The greatest success of the Party is its ability to adapt itself to the change of environment,' he said. 'All the best people join the Party.'

To buttress its legitimacy, the Party has also cloaked itself in Chinese governing traditions. The revival of Confucius in the last decade, the ancient sage reviled under Mao as a symbol of backward feudalism, and the methodical refurbishing of other cultural canons, is symbolic

* I have used an exchange rate of 6.8 renminbi to $1 US for conversion throughout the book.

of a broader trend, of the Party re-packaging its rule as a natural continuum of the most enlightened eras of China's imperial history. With no ideology left to speak of, selective historical antecedents provide single-party rule with an indigenous imperial lustre.

The idea that the Communist Party, far from landing in China in a Leninist spaceship, could draw on the country's deep traditions of authoritarian central bureaucracy, might be obvious to outsiders. Countries do not shed their histories so easily, despite efforts by zealots like Mao to wipe them out and start with a blank slate. In China itself, however, it was dangerous for a long time to say so. 'Many years ago, I would have considered this question a provocation,' said Fang Ning, a prominent conservative political scientist. 'We were meant to have made a fresh break with the past with communist rule.' Now, Fang insists, without a strong central bureaucracy there would be 'independence in local regions and then chaos'. 'The secret of the government in China is that all hats are controlled by the emperor,' he said. 'He can take them off and put them on. I don't think this part of the system has ever changed.'

Since Mao's demise, the Party has refreshed its Leninist roots, gingerly built up the legal system and set about co-opting wealthier, more educated members of society. In the same way that some western political parties like to style themselves as big tents, the Party now markets itself as an inclusive organization with uniquely Chinese roots. China can, in theory, have it all – democracy, a functioning legal system, a vibrant civil society, disputatious think-tanks, innovative universities and a blossoming private sector – as long as they develop within the boundaries the Party lays down for them.

China is often fêted as an economic miracle, the latest of a string through Asia. The Party's astounding survival skills make it more of a political miracle, albeit one built on economic growth. The Party has managed to refurbish its base and build its legitimacy as a governing body, all the while hanging on tightly to the core assets of its wealth and power. But without a fast-growing economy, it would have mattered little what the Party controlled. This was never more true than in the aftermath of the 1989 Beijing massacre, which shook the Party to its core.

2

China Inc.

The Party and Business

'We are the Communist Party and we will decide what communism means.' (Chen Yuan, China Development Bank)

'In China, it is very important to display the political power of the Communist Party. Management can solve a majority of problems, but not all of them.'
(Li Lihui, President of the Bank of China)

The deep personal and political wounds of the 1989 Beijing massacre were still raw when a small group of officials, academics and newspaper editors gathered in a hotel conference centre a few hundred metres from Tiananmen Square, a little over two years after the event. Soon after the meeting was held in late 1991 and its manifesto written up, some of the patrons of the event at the Beijing Hotel rushed to disown it. Years later, the list of attendees was still contested, especially the presence of Chen Yuan, then the deputy-governor at the central bank and the princeling son of China's pre-eminent central planner. The subject matter which caused a vituperative reaction was not in dispute, however. Nor was there any doubt about the morbid political atmosphere in which the gathering was held.

The Party's decision to use the military to clear the square and the broad avenues feeding into it had cast a chill over the Chinese body politic. Economic policy was fixated on a fight between hardliners, who saw the crackdown as a chance to reassert old-fashioned state controls, and the liberalizers, under Deng Xiaoping, who were plotting to grab back the initiative to entrench market reforms. Many intellectuals

remained bitter and sullen about the brutality used to suppress dissent and the punishment meted out for involvement in the protests.

Rolling over the whole system were the shock waves of the gradual dismemberment of the Soviet bloc. Just prior to the Beijing gathering, Mikhail Gorbachev had been deposed in a military coup, to great initial glee in China, and then annoyance when he was restored shakily to power a few days later. In Chinese eyes, Gorbachev more than anyone was responsible for undermining the global communist cause. His political reforms had not only fatally weakened the Communist Party at home in the Soviet Union. He had also abandoned fraternal ruling parties throughout eastern Europe as they imploded around him.

The meeting in Beijing that day had considered all these events with a single objective in mind. With communism around the world collapsing, what would ensure the Party's survival in China? The clarion call which emerged from the meeting, contained in a 14,000-character manifesto, was radical in its own way, but also prescient. 'The Party must grasp not only the gun,' the document said, in reference to the Party's control of the armed forces, 'but the asset economy as well.' In other words, the title to the vast, sprawling assets of the Chinese state, everything from giant energy and industrial companies and land-holdings, should be held not in the name of the Chinese government but of the Party itself.

In today's powerful and outwardly confident China, with its fast-expanding economy and bulging pockets of prosperity, it is easy to forget that success was never guaranteed. On the contrary, China was mired in pessimism and political gridlock in the wake of 4 June and isolated internationally by western sanctions. In the intervening years, the Party suppressed any domestic discussion of the crackdown in numerous cities across China so successfully that the event is widely dismissed these days by young Chinese and many foreigners alike as being of little import. When Zhao Ziyang, the party secretary toppled in 1989 for his opposition to the use of military force, died in early 2005, many Chinese under the age of thirty did not even recognize him, as the propaganda department had kept his image out of the media ever since his fall, for a full sixteen years.

The Party's unyielding line on its decision to send in the troops has strangled the public memory of the extent of the crackdown that

followed, and the bitterness it engendered. By some accounts, nearly one in ten of the Party's then 48 million members were investigated, in the government, media, universities, think-tanks, and in art and literary circles, in the eighteen months that followed 4 June. If they weren't jailed, sacked or demoted, they were forced to write self-criticisms explaining their stance during the protests, and pledging fealty to the Party's actions, all of which was ominously recorded on their personal employment files. This was a purge of Stalinist dimensions, albeit without a comparable body count at the end. Song Ping, a party elder and the most important early patron of Hu Jintao, backed a campaign to force potentially suspect members to re-apply to join the Party to ensure 'they would be communist in reality' as well as in name. 'They'll be the people who really want to struggle for communism to the end,' Song said. 'The Party's fighting ability will be obviously enhanced.'

The decade before the protests had been genuinely revolutionary for China. Rural households had been free to sell on the market anything they produced above the quota demanded by the state, a reform which generated a surge in new wealth in the countryside, where most Chinese live. The growth of the rural free market had come in tandem with a retreat in the power of the traditional planners in Beijing and a more decentralized and competitive economy generally. Top political leaders, like Zhao Ziyang and Hu Yaobang, encouraged discussion of political reform, including grassroots elections, a more open media and a scaling back of the role of party committees that directly managed government ministries and state businesses. Unlike today's stiffly staged photo-ops, foreign reporters were allowed to chat informally with the Politburo's inner circle at a cocktail party at the conclusion of the 1987 party congress.

The Tiananmen crackdown prompted a brutal reassessment of the free-wheeling eighties and a ruthless reordering of the leadership's priorities, drawing a dividing line between two eras of reform in China. The vanities of the relatively open political and economic atmosphere fostered by Zhao and Hu were out. With the political and fiscal power of Beijing seemingly inexorably in retreat and communism around the world in crisis, from the early nineties onwards the party centre was resolved to reassert its authority once and for all.

Chen Yuan seems to have realized long before, well ahead of 4 June, that the traditional methods would no longer do the trick. The Party needed more than old-fashioned ideology and a return to central planning to get its governing legitimacy back. At a lunch in Washington at the Cosmos Club in the mid-eighties, Tom Robinson, the late political scientist, and the host of the meal, had badgered Chen about the apparent contradictions between the state's official Marxist ideology and the free-market reforms then unfolding in China. After a while, Chen tired of the inquisition, ostentatiously put down his knife and fork, and firmly put a stop to the questions. 'Listen, Mr Robinson,' he said, 'we are the Communist Party, and we will define what communism is.'

The Party's leaders had already redefined communism more than once since taking power in 1949. Now, in the wake of the 1989 uprising and its suppression, they did it again. The latest definition had an old-fashioned spin, with an audacious twist. Instead of trying to protect the moribund state sector which was threatening to sink the economy and the political system along with it, the Party decided on a new, high-risk course of action. The Party resolved to ruthlessly streamline government enterprises, place the survivors atop the commanding heights of a profitable industrial economy under its control and pilot them into the global business arena. Chinese leaders wanted worldly enterprises that were both communist and commercial at the same time. If they could bring it off, the Party would emerge stronger than ever.

If anyone had the communist credentials to be a patron of the 1991 Beijing Hotel meeting, it was Chen Yuan. On top of the heft that his own position carried, he bore the mantle of his father, Chen Yun, a one-time close colleague of Deng Xiaoping in the early days of post-Maoist reforms. Chen Snr. was a conservative on many levels, constantly on guard against malign influences which he feared could undermine the Party. He refused to allow Chen Jnr. to study overseas, his son complained to friends years later, because of his suspicion of foreign ideas. In his famous depiction, Chen Snr. argued that the Chinese economy had to be managed like a 'bird in a cage', a metaphor for the centrally planned system. The cage could be enlarged, aired out and other birds let in, but never unlocked and dispensed with altogether. Chen Snr. eventually fell out with Deng over the pace of free-market

reforms, which he worried would chip away at the powers of the state. His son proved to be more skilful at straddling both sides of the emerging policy divide.

Visitors to Chen Jnr.'s office in Beijing in the late nineties recall how he kept on his desk a photo of Deng and himself taken during the final days of the Cultural Revolution. Deng had made a point of personally visiting senior colleagues and their families in the wake of the upheaval, to check on their health and reassure them it was safe to return to Beijing. For sharp-eyed observers, the picture was a reminder not just of Deng's gesture. The palm trees in the background were a tell-tale sign that Chen had been spared the worst of the movement's excesses for at least part of the period. The photo had been snapped in tropical Hainan, a more pleasant place to pass the period than the arctic north-east provinces, where many internally exiled people ended up.

Chen Jnr. and his fellow-travellers considered themselves to be conservatives as well, but of a more modern kind. They backed the gradual introduction of market reforms and western-style institutions, side-by-side with strong party controls and intensified patriotic education. They opposed a return to Maoist policies pushed by people they described as 'romantics', or 'traditional diehard conservatives'. In their own words, they were 'new conservatives', a tag inevitably shortened to 'neo-cons', years before the phenomenon took root in George W. Bush's administration in the US. Above all, they supported the pre-eminence of the Party as the only body with the capacity to hold the country together against the ever-present threat of subversion by the west and trouble-makers at home. What was once a revolutionary party, they said, should now be retooled, and entrenched in power as the 'governing party'.

The main targets of the neo-cons were not the Maoist romantics, who even in the dark days of the early nineties carried little weight. The greatest danger to the Party came from the political liberals, the right wing in the Chinese political lexicon. The neo-cons blamed the liberals' relentless lobbying in favour of the private economy, and their unstinting criticism of the Party, for inflaming the 1989 protests in the first place. The liberals, the manifesto said, had demanded 'total reform of the property system and finally set their sights on the political system, focusing on the Communist Party of China, unwilling to stop short of destroying the entire present order'. The neo-cons' solution was not to

back off from this fight, but to up the ante by having the Party take over the ownership of large state assets in its own name.

Stamping the Party's name on the title-deeds of state assets would have multiple benefits, they argued. Ownership had been a vexed and confused issue for years. The multiple forms of state ownership, by ministries, enterprises, the military and government entities, plus the murky and entangled rights to different assets and revenue streams on top of that, made it all but impossible to trade and extract value from any public goods. The neo-cons argued that direct ownership by the Party would clarify all of these issues with the stroke of the pen. It would be politically beneficial as well, simultaneously aligning the Party directly with growing state businesses and heading off nascent political competition from entrepreneurs.

The emerging private sector, the neo-cons noted curtly, 'had nothing to do with the Party' and had to be kept in check. As for experiments in privatization and diversifying the ownership of state companies, that was dismissed. Such changes could be restricted to 'smaller enterprises with severe deficits'. In other words, the dross of the state sector which was beyond salvation could be sold off, with the big companies in key sectors being kept for the state.

The privileged line-up of the group credited with the manifesto is one reason it was so enthusiastically denounced by their liberal opponents. Along with a long-time party activist, Yang Ping, the main organizer of the meeting was Pan Yue, then a deputy-editor at the *China Youth Daily*, who spent his days at the paper 'disregarding his editor's responsibilities, instead waving around his mobile phone everywhere'. This was in the days when ownership of a mobile phone, then nearly as large as a brick, was a sign either of privilege or of membership of a Hong Kong Triad gang. The first wave of cell-phones in China were known jokingly as 'Big Bros', an echo of the title given to Hong Kong mafia bosses. Pan Yue had no underworld connections, but he did have a privileged entrée into the system, through marriage to the daughter of a high-ranking army officer. Pan proved to be an energetic policy entrepreneur in his own right. He retooled himself in the late nineties as the most outspoken voice in the bureaucracy on the environment, before his influence began to wane after the 2007 congress.

A bevy of the sons of revolutionary immortals and senior leaders

attended the seminars organized by Pan and Yang over more than a year, culminating in the Beijing Hotel gathering in late 1991. The final 14,000-character document was later drafted under the patronage of Chen Yuan. The intellectuals and liberal commentators, languishing in internal exile or banished overseas in the wake of 4 June, took delight later at lambasting the pedigree of the attendees. They labelled them 'the Playboys' Club' and the manifesto itself as a 'White Paper for the Princelings Faction' in the Party. The proposal, one critic wrote, 'would, without ado, transfer the assets nominally belonging to 1.1 billion people to a Communist Party making up just 4 per cent of this number'. The criticisms were damaging, and the sponsor, the *China Youth Daily*, distanced itself from the conference and its papers. But the idea was killed by a more practical political objection – that direct ownership of state assets would send a fatal signal about the Party's weakness, not its strength. 'This kind of suggestion could be very risky,' said one of the meeting's attendees. 'If the Party takes over ownership, it's a signal that it is preparing a safety net, because the ship is starting to take on water and sink.'

That sinking feeling was widely shared at the time. By the early to mid-nineties, the financial pillars of the communist system and of the central government in Beijing were crumbling. Hu Angang, an outspoken Beijing economist with an eye for a headline, grabbed the attention of the leadership at the time with a comparison chilling for any Politburo member worried about their place in Chinese history. Beijing's tax take, he said, had fallen even lower than Belgrade's share of revenues in the former Yugoslavia before its break-up.

China's myriad economic problems made it difficult for policy-makers to know where to start. In a tour of Sichuan in 1993, economist Milton Friedman gave the then governor some characteristically straightforward advice about how to instantly instil market discipline in an economy dominated by the state. 'To cut the tail off the mouse, don't do it inch-by-inch,' Friedman, the high-priest of the free-market Chicago school of economics, told his Chinese host. 'To reduce the pain, the whole tail should be cut off at once.' The governor replied in kind, by extending the metaphor to illustrate how such reforms might not be as easy as Friedman envisaged. 'My dear professor,' the governor said, 'our mouse has so many tails, we do not know which one to cut

first.' According to Steven Cheung, a fellow Chicago school economist at the meeting, Friedman was lost for words in response.

Just as he had in the late seventies, it was Deng Xiaoping who eventually laid down the blueprint for a new model, on this occasion along two connected tracks. On 9 June 1989, barely days after the blood had been scrubbed from the streets surrounding Tiananmen Square, a beaming Deng appeared on television shaking the hands of the military commanders who had blasted the students out of the city centre. The single biggest mistake the leadership had made in the eighties, he said in a pep talk to the troops, had not been opening the economy, as many of his critics had begun to argue forcibly, but a lack of ideological and political education to go with it. 'We must make sure no adverse trend is allowed to reach that point [of 4 June] again.'

Soon after, the Party began to implement Deng's plan, to give it an extra line of political defence that had been lacking in the lead up to 4 June. Political departments were reinforced or re-established inside government ministries, the courts and the military, as an early warning system about potential deviants. 'They are there to ensure that the Party can have direct control over all important institutions,' said Jiang Ping, a retired law professor. The Central Propaganda Department was beefed up, lavished with extra resources and given clearer guidelines about how to sell economic reform to a bruised population. And the appointments system, through the Central Organization Department, was refined and tightened, to ensure the loyalty of cadres, not just in government, but throughout educational institutions, the media and multiple bodies under state control.

The second track took longer to lay down. In early 1992, still hemmed in by leftists in Beijing who wanted to keep a lid on liberal economic reforms, a frustrated Deng took a tactical leaf out of Mao's playbook to rally support for his cause. The Great Helmsman had famously disappeared from Beijing in times of political struggle, only to return at opportune moments to spook his opponents and take charge of the debate. While Deng's trip echoed his predecessor's tactics, his target was very different. With his symbolic southern tour to Shenzhen, a business Eldorado bordering Hong Kong and built from scratch out of rice paddies in just two decades, Deng throttled once and for all the lingering Maoist influences on economic policy.

Deng's formula, boiled down, was simple. The Party would still pursue free-market reforms, but in tandem with recalibrating and tightening political authority in Beijing. Equally, the Party might not own state assets directly, but it would maintain the right to hire and fire the executives who managed them. For the economy to prosper, the huge state firms that communist commissars had once directly managed would have to be turned upside down and the role of party operatives inside them reined in. Instead of simply producing goods to plan and providing cradle-to-grave employment, knowing all along that the Finance Ministry would cover any losses, the state had to make money to survive.

Deng's market reforms, launched in 1978, had already paid off handsomely for China, generating the kind of indigenous wealth and entrepreneurial energy in the eighties that the oil-dependent Soviet Union had never managed to produce for itself. But 4 June and the collapse of communism in Europe had been a wake-up call, signalling that mismanagement of the free market could bring the Party toppling down as well. The Party's internal slogan for the new era was simple: 'On economic matters, relaxed controls; for political matters, tight controls.'

The economy, shedding its sullen, post-June 4 funk, took off in the wake of Deng's southern tour. Foreign investment poured in. Local entrepreneurs were emboldened. The workshop of the world, the factory belt in southern China that supplies billions of dollars' worth of goods to Wal-Mart and its ilk across the globe, was beginning to gain critical mass. But along with a surge in growth came a wave of entangled problems, of inflation and social unrest fuelled by mass lay-offs from state companies and anger at official carpet-bagging of the assets left behind. The Party looked anything but in control in the extraordinary upheaval starting in the early to mid-nineties. Far from unifying the country and putting the centre back in control, the initial impact of Deng's rebooted reforms was chaos.

Over the next ten years, the government would lay off about 50 million workers in state enterprises, equal to the combined workforces of Italy and France, and redeploy another 18 million into firms which no longer carried the benefits of their old jobs. The 'three irons' – the 'iron chair' of a lifelong job; the 'iron rice bowl' of the promise

of employment; and 'the 'iron wage' of a guaranteed income and pension – were all dismantled. Workers at centrally controlled urban state enterprises dropped from a peak of 76 million to 28 million in just ten years from 1993. The state sector, which had always been the heart of the Party's control over the economy, seemed to have been decimated. The hard-nosed implementation of these reforms prompted a backlash against Deng's policies and doomsday-like warnings that China was on the brink of violent, systemic turmoil.

Overseas, many foreigners thought that the Party had embarked on fundamental change as well, mistakenly equating the state sector overhaul with western-style privatization. Zhu Rongji, the blunt, dynamic Deng protégé who had taken charge of economic policy in the mid-nineties and was elevated to Premier in early 1998, recalled that year being shocked when asked by George Bush Snr. how China's 'privatization' programme was proceeding. Zhu protested that China was corporatizing its large state assets, which was just another way of 'realizing state ownership'. Bush responded with a nudge and a wink, saying that no matter how Zhu described the process, 'we know what is going on'. Bush was not the only western leader to misread Zhu, widely seen in foreign circles as someone dismantling the very roots of the state economy. Such depictions, viewed as compliments in the west, exasperated Zhu and placed him on the defensive at home where they could be used by his domestic enemies to undermine him. When he had toured the US as the Mayor of Shanghai he was praised as 'China's Gorbachev'. The same phrase, repeated in China, amounted to a grave political slander. An irritated Zhu replied: 'I am China's Zhu Rongji, not China's Gorbachev.'

Zhu faced legions of critics within the Party over his abrasive style and, according to his boss, Jiang Zemin, 'his inexhaustible capacity to rub people up the wrong way', but no one was able to pin on him the crime of privatization of large state enterprises. For all their divisions, the top policy-makers in Beijing were largely united over the need to consolidate and strengthen the power of the Party and the state, not let it wither away. The proposal from the Beijing Hotel meeting about direct party ownership had died, but the principle that the Party and the state should maintain control of the commanding heights of the economy lived on.

Zhu, in pithy Chinese fashion, boiled down the blueprint for state enterprise reform to a single phrase at the 1997 party congress – 'grasp the big, let go of the small'. The Party and the state would retain control of the large companies in what were deemed strategic sectors, such as energy, steel, transport, power, telecommunications and the like. In a formula that was rolled out for scores of state companies, a small number of their shares were listed overseas, while the government kept about 70 to 80 per cent of the equity in its own hands. Many foreigners often mistook these sales of minority stakes to be privatization. Smaller, loss-making enterprises in turn were to be sold off or left to be managed by local governments, much as the neo-cons had envisioned six years before. Zhu's policy largely still holds today, of strengthening the state sector by streamlining it, professionalizing its management and demanding that companies take responsibility for their own balance sheets.

From afar, 'Boss Zhu', as he was known at home, gave the impression of being all-powerful. The foreign press tagged him 'China's economic tsar', an odd, pre-Soviet title which was meant to signify his seemingly unfettered authority. Zhu, a master of the stirring soundbite, was famous for his table-thumping rages directed at local officials who he thought were trying to derail his reforms. 'I have prepared 100 coffins,' he reportedly cracked after being promoted to vice-premier. 'Ninety-nine for corrupt officials, and one for myself.' Zhu later denied this quote, explaining that ninety-nine coffins weren't enough for all the corrupt officials in the country, anyway. Zhu gave every impression that he could wield the power of the centre to get his way in the rest of the country. In truth, his reliance on the bureaucracy in Beijing was the flipside of his weakness outside of the capital. 'To survive, he had to launch attacks nationally to firm up support for himself inside the central government. He was harsh because he had no other options,' said a prominent Beijing academic. 'Otherwise he would not have lasted long.'

Zhu could not simply wave his magic wand in Beijing to get his way in each of China's far-flung provinces and cities. Just as the economy had been decentralized in the previous two decades, so too had financial power been effectively devolved to the regions. The demise of central planning had accentuated a similar divide in the financial system. The

big banks were national institutions and brand names, but the appointments of senior executives were largely controlled at the provincial and city level. Regulation was localized as well, through the thirty-one provincial offices of the central bank. China did not have a stand-alone national bank regulator until 2003.

Imagine HSBC in the United Kingdom ceding control over appointments of executives to run its branches outside of its London headquarters to local politicians, who could then demand loans in return for their patronage. Similarly, financial regulators in London would be powerless to enforce their writ over regional branches because they had no way of monitoring what was happening away from the capital. Once you replicated this scenario scores of times across a country as vast as China, the scope of the challenge that faced Zhu and the central government becomes clear. Zhu knew that unless he could wrest control of the far-flung branch networks of the big five lenders, the lifeblood of industry across the nation, at the time accounting for more than 60 per cent of all loans, his grand plan for the economy would die in a ditch. From his perch in Beijing, Zhu had long complained that intervention from governments at all levels had turned the banks into virtual 'ATMs for officials and official businessmen'. From now on, if Zhu got his way, the only state ATMs would be in Beijing itself.

Zhu needed a crisis to galvanize the system. Luckily, in the first year of his premiership, there was one close at hand. The Asian financial meltdown, which began in mid-1997, hit the Chinese economy and its already creaky financial institutions hard. By 1998, more than half – about 57 per cent – of all the loans issued by the Industrial & Commercial Bank of China, the country's biggest lender, were unrecoverable. For the whole banking system, 45 per cent of loans made before 2000 had gone bad. The legacy of years of poor and often corrupt management of the state banks was now more than just a drain on the exchequer. It was a lethal threat to the entire economy.

With the system in crisis, Zhu quietly reached into his Leninist toolkit to bend the banks to his will. A great centralizer, Zhu persuaded the Politburo to establish two top-level party committees to return the decentralized economic system to Beijing's control. The two party committees, both headed by Politburo members, took control of the

financial system in the late nineties across the country through a very simple mechanism. The party apparatus in Beijing, in tandem with the Central Organization Department, shunted aside local bigwigs by placing the power to hire and fire senior executives in banks and other state enterprises with the centre, no matter where they were in the country. Any regional bank offices which refused to sign up to the Politburo's programme were threatened with closure. Put crudely, Zhu's strategy echoed the saying popularized in the Vietnam war to explain the US military's programme to pacify Vietcong villages. The Party decided it first had to get bank executives by their b***s to enforce Beijing's writ. Their hearts and minds could come later, if ever at all.

The front stage of the government's regulatory system remained intact on the surface. The local banks and regional regulatory authorities were outwardly undisturbed. Backstage, however, the Politburo had created an entire parallel policy universe, 'a powerful yet mostly invisible party body for monitoring financial executives'. Zhu and the Politburo did not bother to give these all-powerful party bodies any legal status, by putting bills through the legislature. Nor did they give them the stamp of government authority by publicly announcing their formation through the cabinet. The fact that these two committees had no lawful basis did not matter. The backing of the Politburo and the direct threat to the jobs of provincial bank executives were more than enough to galvanize local officials to sign up to Beijing's plan to secure the Party's economic base.

After the Hong Kong-based *Far Eastern Economic Review* pointed out in May 2001 the uncomfortable fact that the central bank governor had been left off the Party's finance committee, the response was swift. The clear implication was that the shadowy party body had totally usurped the central bank's functions. The Party quickly appointed the then governor to the committee, without, however, changing its overarching powers. Acutely sensitive about the issue, the Central Propaganda Department had directed the local media to refrain from discussing the committees, let alone their make-up. The first substantial reports in the Chinese press about these two enormously powerful party bodies, which had taken over the running of the banking system, did not appear until their job was largely done, five years later, in 2003.

It might seem strange that the Party would respond with such alacrity

to a single article in a regional, English-language magazine. But from the moment Beijing decided to restructure state enterprises and sell parts of them offshore, the Party had deliberately downplayed its role in their operations, hiding it from its own people, and the rest of the world as well.

The slick investment bankers from Merrill Lynch found themselves in another world when they arrived to inspect the operations of Shanghai Petrochemical Corp. in 1992. Nestled on soft soils of reclaimed land on the outer arches of Hangzhou Bay, the enterprise supported 40,000 employees and their families with onsite housing, schools, shops and health care, and also paid pensions on retirement. 'There was everything except a funeral parlour there,' said one of the advisers to the company's stock market listing in 1993. 'They even had a police station, which operated under the management of both the company and the police itself.' A self-contained economic eco-system, Shanghai Petrochemcial was an old-style state enterprise down to its bootstraps.

When Beijing decided to restructure companies like Shanghai Petrochemical – at the time the ninth-largest enterprise in China – and sell part of its shares offshore, it faced many difficult, threshold decisions. What would they do about all the social services the companies supplied, like health care, schooling and pensions? Would they just sack the thousands of surplus workers, or siphon off the funds raised offshore to pay them off? How would they respond to the tight auditing requirements imposed by foreign stock exchanges and the scrutiny of overseas fund managers? And, most sensitive of all, how would they explain the role of the internal party bodies, which for years had run the companies, free of any of the inconvenient strictures of corporate reporting and governance rules?

The same qualities that made Shanghai Petrochemical seem an unlikely candidate to raise money on the New York and Hong Kong stock exchanges in 1993 made it a perfect choice for Chinese leaders intent on launching an overhaul of the state sector. By selling a portion of the company's shares on overseas stock markets, the Party was in effect recruiting allies for the upheaval to come. When thousands of workers were laid off and Shanghai Petrochemical's accounts were prised open, the Party could say it was the foreigners' doing as much

as their own. But when it came to disclosing the role of the Party, which directly controlled the enterprise, everyone associated with the deal baulked. It was a battle that would be fought many times over the years to come, with the same result every time.

'Right back at the very beginning, the first question was – what do we disclose about the CCP? Aren't they really calling the shots? We struggled over that a long time,' said one adviser to the Shanghai Petrochemical deal. Another adviser was more frank. 'Things have changed now, but it was pretty clear that back then the Party was the grand puppeteer for everything that happened in every section of society, and the company. The only force was vertically driven decision making.'

The prospectus drawn up by Shanghai Petrochemical, with Merrill Lynch in Hong Kong and their legal and accounting advisers, was the size of a pre-internet-era telephone book. The document groaned with detail about the product lines, resource use, property holdings and the numbers of employees. The risks associated for a company, as an entity owned by the state, and operating in an environment buffeted by both market forces and powerful, capricious bureaucrats with control over energy prices, were laid out in full view. But apart from declaring the party positions held by one or two directors on the supervisory board, the prospectus was otherwise silent on the role of the single most important decision-making force in the company.

At the time of the 1993 listing, the 1989 Beijing crackdown was still a fresh political memory in Washington. Bill Clinton's winning presidential campaign the year before had accused George Bush Snr. of coddling the 'butchers of Beijing'. It was hardly an opportune time in the US to highlight the control exercised by China's communists over an enterprise raising money in New York. But the notion that the shadowy party bodies with a role overseeing state enterprises, all of which had secret lives at home, were going to advertise their powers overseas was never going to fly anyway. 'There was an extreme reluctance on the part of the company to do this,' said the second adviser. 'Once you start discussing that issue, it is a slippery slope. It is extremely unappealing to document how one entity is responsible for all personnel and all production decisions.'

The determination to purge the prospectus of the Party made the

document comically misleading in parts. The relative novelty of the listing of a Chinese government-owned enterprise overseas at the time required an explanation in the Shanghai Petrochemical prospectus for foreign investors of how the Chinese political system worked. But even here, in a country in which the Party controlled the government and all state businesses, the body's existence was banished altogether. In a section entitled 'Political Overview', purporting to describe China's political system, the prospectus does not mention the Party at all. Instead, it artfully says that 'pursuant to the Constitution, the National People's Congress is the highest organ of state authority'. The highest organ of political authority, according to the constitution, was, of course, the Party itself, which in turn dictated the policies and personnel of the government and enterprises to the state.

Chinese companies and their advisers cite the letter of the law to explain why they don't disclose the Party's role in their operations. The board and management have the legal responsibility to make decisions about business strategy and personnel, they say. 'To the extent that the board is listening to outside influences, they are not disclosed,' said a lawyer who has advised numerous Chinese companies on offshore trans-actions. 'Nor are such things disclosed in the US. Citibank doesn't say in their disclosure documents that before we fire the CEO, we go and talk to the Saudis.' Such lawyerly arguments skirt the fact that the Saudis are mere shareholders who could sell their stock and walk away from Citibank tomorrow. The Party has an institutionalized, albeit undis-closed, presence in state companies that is not for sale. As the lawyer admitted: 'In corporate law, the boards [of Chinese state companies] can choose to disregard the Party's advice. As a fact of life, they cannot.'

Chinese state businesses have changed dramatically since the Shang-hai Petrochemical listing. Scores of other enterprises have sold shares and developed businesses overseas in a commercial environment more challenging than anything contemplated by Chinese companies even a decade ago. Many have forged partnerships offshore and appointed foreign directors to their boards. Party bodies have had to take a step back from detailed involvement in day-to-day business decisions, because the companies are far too complex to be micro-managed as purely polit-ical entities. Throughout, however, the Party has remained unyielding on a number of fronts. Its control over personnel appointments has been

inviolate, and discussion of its role in the companies overseas has been minimized. By the time the big state banks came to raise funds on overseas stock markets from 2005 onwards, however, the *omertà* surrounding the Party's role at home began to spring some leaks.

It is no exaggeration to describe the overhaul and subsequent listings of Chinese banks overseas as a momentous event for the global economy. If the banks' restructurings did not succeed, then the grand project of Chinese financial and economic reform would be irrevocably damaged. The state's investment in bank restructuring was immense. The total cost to the Chinese taxpayer of bank reform was an estimated $620 billion, equal to about 28 per cent of Chinese economic output in 2005, and becomes even greater once capital injections announced in 2008 are taken into account. To put that into perspective, the Bush administration's highly contested financial rescue plan in late 2008, known as TARP, also cost $700 billion, but was much smaller in relative terms, equal to about 5 per cent of GDP that year.

Beijing did not raise and spend the bailout funds in a single up-front transaction. It was spread over many years, funded in a variety of ways, and did not have to pass muster with a powerful Congress. The Chinese plan was hugely controversial within the system nonetheless, and took significant political resolve to push through. Collectively, the big state banks cut the number of branches from 160,000 in 1997 to 80,000 in 2003. ICBC got rid of about 200,000 employees. Even then, it was left with about 360,000 staff and 17,000 branches. The Bank of China and the China Construction Bank laid off 100,000-plus employees each.

In interviews with state bank chief executives, I had always been surprised about their refusal to discuss the job cuts made to get their enterprises into shape for overseas listings, naively thinking it would be a selling point for foreign fund managers. It was only later I discovered that the authorities had classified information about the mass lay-offs as a state secret and restricted detailed reporting to internal publications. Party discipline forbade the bank executives from answering my questions. On other topics related to the Party itself, however, some top executives, like Guo Shuqing at China Construction Bank, were much more forthcoming.

Guo was an unusually open official, ebullient and chatty where most

of his peers were stiff and formal. Instead of the kitsch replicas of the Great Wall and packs of green tea that many Chinese companies would give to visitors, a beaming Guo would hand out his books on macro-economic management and currency policy. Born in Inner Mongolia in 1956, Guo had been marked for higher office for many years. By his early forties, he had already served as a vice-governor in Guizhou, one of China's poorest provinces, a sure sign he was being groomed by the Party, which increasingly insists that rising stars do time in government posts far from the more affluent coast. As a deputy-governor of the central bank, Guo had been parachuted in to run the body which managed China's foreign reserves after his predecessor had committed suicide by jumping out of the seventh-floor window of a military hospital in Beijing. Guo landed at the China Construction Bank in 2005 in eerily similar circumstances, in the wake of its chairman's detention for taking bribes. As befitted a political fixer, Guo had never worked in a commercial bank when he took his new job. 'Ask him if he has ever made a loan in his life,' one of his colleagues quipped when Guo got the job.

With so much riding on the CCB restructuring, many people were taken aback by Guo's outspokenness after taking up his new position. Guo began to criticize the Party's role in the bank almost as soon as he took over as both party secretary and chairman. In an interview with *Caijing*, a financial magazine famous for pushing journalistic boundaries in China, Guo and a second official complained the bank's party committee had been usurping the board's role. The party committee had held 'dozens of meetings', scrutinizing loans and interfering in executive appointments deep into the ranks of management, 'contrary to the bank's corporate by-laws'. Guo promised this would change under his leadership. 'The principle is clear: a check and balance between the Party and the policy-making body has to be established,' he said.

For good measure, Guo added that 90 per cent of the bank's managers were 'unqualified'. It is possible Guo did not expect all his comments, particularly this last one, to be reported. Some months later, he attended a small lunch in Beijing hosted by senior executives from a foreign newswire service. Also in attendance was Hu Shuli, the then *Caijing* editor credited with building the magazine into China's

most independent and formidable publication. After the usual assurances had been given by his foreign hosts that the lunch was off the record, Guo replied that he was not worried about his hosts. 'I am more worried about the scandal lady over there,' he said, pointing at Ms Hu. Still, Guo repeated his criticism of the Party when I interviewed him soon after. 'The Party is not a commercial organization,' he said. 'There has been a misunderstanding of the Party's role in the past and wrong practices inside the bank as a result.'

Morgan Stanley bankers underwriting the CCB listing were caught by surprise by Guo's comments. A number quietly suggested that if the Party wielded such influence in CCB, perhaps its role ought to be declared in the prospectus as well. They were quickly set straight. 'Ultimately, no one was under any illusions that the state controlled the companies,' said an adviser to the deal. 'To get into details about the party committees in a way that was provocative and tendentious was neither productive nor necessary.' Another adviser scoffed at Guo's comments. 'He was appointed by the Party. How can he tell the Party to take a back seat?'

If the prospectuses were to be scrubbed clean for foreigners, Chinese bank executives took a different approach at home, discussing the Party's role in interviews with *Caijing* and local university researchers in 2005 and 2006. These bank chiefs struck a more respectful tone than Guo, but, by Chinese standards, they were remarkably frank. Whatever the prospectuses might say, the executives were clear that the banks were not just commercial institutions. They were instruments of national economic policy, a fact that would be borne out in the global financial crisis three years later.

At the Bank of Communications, China's fifth largest bank, Jiang Chaoliang, the chairman, said the party committee was in charge of strategy as well as personnel. Far from being driven solely by making a profit for shareholders, the Party had to act in accord with social 'stability' and national 'macro-economic' policies laid down by the government. The bank's foreign partner, HSBC, apparently had no trouble with this, even though its purchase of a 19.9 per cent stake in the Chinese lender had been partially marketed to its own shareholders as a chance to change the old-style corporate governance. Jiang remarked that Sir John Bond, the then head of HSBC, had told him

he understood that since he was chairman, he had to be party secretary as well. 'This guy didn't think it strange at all,' Jiang said.

When a Chinese journalist interviewed Li Lihui, the president of the Bank of China, he relayed a joke about how the bank's independent British director had wanted to attend party committee meetings, 'but since he was not a Communist Party member, he had tried to find a British communist to participate on his behalf'. Li mirthlessly defended the Party in reply, and its indispensable role in setting the bank's business direction and liaising with other arms of the government. 'In China, it is very important to display the political power of the Communist Party,' he said. 'Management can solve a majority of problems, but not all of them.'

There is little debate in China itself these days over whether the Party's backstage role in Chinese state enterprises should be disclosed outside of the communist club. That issue has been settled since the days of the Shanghai Petrochemical listing, which set a precedent of non-disclosure that has been followed ever since. The real conflict inside China is the one that Guo alluded to before he was put back in his box. It is within the system itself, between the traditionalists in the Party on the one side, who want to keep a tight grip on the enterprises, and the increasingly ambitious chief executives of state companies on the other. Guo Shuqing's complaints about the Party were a harbinger of an important trend with far-reaching implications for the global economy. If the Party expects us to run these companies commercially, these executives argued, then it should allow us to manage them solely on business lines.

The corporate animal that emerged from the protracted and painful birth of China Inc. was a strange new beast. Just as the Party had ordered, it was both commercial and communist at the same time. The split personalities of the powerful, reconstituted state enterprises were not just difficult for the rest of the world to deal with. China has struggled to adapt as well.

As often happens, when change comes, it seems to arrive out of the blue, though the conditions for it have been carefully laid out in front of your eyes over many years. That was the case when Beijing made its first big splash in mergers and acquisitions in the west in 2005, with

the $23 billion bid by CNOOC, China's offshore oil company, for Unocal, the California-based company with energy assets in the US and Asia. The idea of a company ultimately controlled by the Communist Party being allowed to buy oil and gas assets owned by an American company was always going to be a hard sell. But the roots of the eventual failure of the deal went deeper than the predictable political uproar, to the way CNOOC's chief executive, Fu Chengyu, had mismanaged the competing demands of the Party and his board in configuring the bid.

Fu's life traversed the same sweep of history as many leaders of his generation. Born in 1951, his studies were interrupted by the Cultural Revolution in the mid-sixties and he had joined the Red Guards, an exhilarating experience, he later told colleagues, with free food and travel all over China. By his early twenties, he was back on the straight and narrow in China's north-eastern oil fields. Fu rose through the ranks to become one of China's most cosmopolitan state CEOs, but not so worldly that he understood how to handle the international board the company appointed when it sold shares overseas in one of its subsidiaries.

Ahead of the Unocal bid, Fu had won approval from the government to proceed, and had also cleared the deal through CNOOC's party committee, which he headed. But his decision to present the bid to the board as a fait accompli angered the independent foreign directors, poisoning CNOOC's position from the start and shackling Fu's ability to respond nimbly in the ensuing takeover battle. With opposition to the deal on national security grounds mounting in Congress, the Chinese complained bitterly about protectionism and dropped out. But throughout the controversy, Fu had never been able to address the deeper issue, of the way the party committee had tried to sweep the board aside. No matter what Fu said, there was enough evidence to make a case in Washington that CNOOC represented the political priorities of the Chinese state, rather than a commercial enterprise in its own right.

Most foreigners dealing with large Chinese state companies in the early days of economic reform felt much like the Japanese executives from the giant Mitsubishi conglomerate negotiating to build a power plant for Baoshan Steel, a pioneering project near Shanghai in the early eighties. The Japanese were aggrieved when the Chinese side got the

better of them during the talks and they were forced into concessions. 'Yes, you win the negotiations,' the Mitsubishi executives exclaimed. 'But it was your national team fighting our company team!' Chen Jinhua, a titan of state industry who recounted this story in his biography, said the Japanese were right. 'We had invited many capable experts from China's electrical power system to join our negotiating team, but Mitsubishi, as a single company, had been unable to do so,' Chen wrote. 'This example showed the superiority of our wide socialist co-operation.'

By the time big state companies like CNOOC were heading offshore two decades later, socialist co-operation, now re-branded as China Inc., had become as much an embarrassment as an advantage. To add to the confusion, there was no longer much socialist co-operation between state enterprises in any case. In its place, the Party had instituted a form of socialist competition to get the best out of the state sector. Far from being the monolith portrayed by Chen Jinhua, China Inc. revamped for the twenty-first century was more akin to a large, ravenous school of fish. Alert to the movements of their neighbours and inclined to swim in the same direction, Chinese companies competed individually for local and offshore deals like fish chasing the same tasty morsel of feed. Collectively, under the guidance of the mother fish of the Communist Party, China Inc. was as competitive as any large creature in the sea.

The transformation of China in the last three decades owes much to the animal spirits of the ordinary Chinese, many of whom have grabbed the chance to make money for the first time in decades. Much less understood is how the Party has unleashed the state's animal spirits at the same time, with a force few anticipated. The pendulum swung so fast and so violently that the problem the Party faced with state enterprises was turned on its head. In the nineties, Beijing had worried about keeping the companies afloat. Early in the new century, the restructured enterprises, many of them built from scratch, were so big, wealthy and ambitious that the problem now was not how to keep them alive, but how to keep them in line.

Once written off as dinosaurs of a crumbling communist system, the structure, solvency and profitability of scores of big state enterprises were transformed in a decade. The giants of communist industry were suddenly throwing off billions of dollars in profits,

courtesy of government protection from competition, surging economic growth, cheap capital and efficiencies wrenched out of the companies during their overhaul. In 2007, the year which marked the historic high-point of fast economic growth in China, the combined profitability of centrally owned state enterprises reached about $140 billion, compared to close to zero a decade previously, and triple the earnings of five years before. In the Fortune 500 list, which grades companies according to revenues, Chinese enterprises now hovered towards the top, where once they were also-rans.

But if China was getting rich in this period, the Chinese were not. In the ten years from 1997, a period which saw an astounding economic boom, the share of workers' wages in national income fell dramatically, from 53 to just 40 per cent of GDP. The transformation of the state sector had far-reaching benefits for the Party, just as the convenors of the Beijing Hotel meeting years before had forecast they might. The swelling profits eased the burden on the fiscal budget and strengthened the state banks' balance sheets. But the preferential policies meted out to government companies, of cheap land, resources and energy, ensured that the profits of China's boom were captured and kept by the state, at the expense of the population at large. The state's accumulated war-chest was not only about self-enrichment. With an eye to soaring raw material demands decades into the future and its declining stocks of oil at home, Beijing began to push the big, cashed-up state companies to head offshore in earnest around 2002 to 'go out and become bigger and stronger', in the parlance of top leaders. Not surprisingly, the firms at the front of the queue, in the oil and resources sector, created controversy almost wherever they went.

Fu Chengyu's maladroit tactics in the failure of the 2005 CNOOC deal had angered many within the system, but he kept his job, saved by the shrill and occasionally xenophobic reaction in parts of the US to the Chinese bid. By the time the next big deal came around, China Inc. showed it had learnt many lessons. The fundamental problem, though, of the Party's lurking backstage presence in large state enterprises remained untouched and unresolved. The same veil of secrecy the Party threw over its own affairs at home obscured the government's role in state companies as they went abroad. As a consequence, working out where the state ended in government

companies and the commercial enterprise began was often nigh impossible for foreigners.

When it was formed in 2001, the Aluminium Company of China (Chinalco) had all the characteristics of the thoroughly modern, and comfortably bi-polar, Chinese state corporation. The parent company had been formed during the upheavals of the nineties by aggregating a sprawling collection of bauxite mines, alumina refineries and aluminium smelters, and their marketing arms, into a single entity, instantly creating the second largest company in the metals sector in the world. To ensure the new company didn't develop the sclerotic habits of the old state sector, the government added the market to the mix, directing Chinalco to hive off some of its most valuable assets into a separate entity (known as Chalco) to be listed on overseas stock markets later the same year.

The 'red machine' sitting on the desk of the company's chairman, Xiao Yaqing, signified Chinalco's status as one of the fifty-odd core companies which the state regarded as essential for its national security and economic development. Next to the hotline connecting Xiao to the party elite was the new symbol of the Chinese corporate state, a screen displaying the stock price of the company's overseas listed enterprise. Together, the two devices conveyed a mixed message. Front stage, companies like Chinalco bristled with commercial ambition and tracked their stock price as ardently as their western competitors. Backstage, however, the Party sat quietly out of sight, tugging on the reins when need be, safe in the knowledge it retained all the levers needed to control the company. Executives like Xiao juggled a difficult brief. They had to manage the company's, and what the Party deemed to be the country's, interests at the same time. One benchmark was business performance; the other was political; and neither of them was clear.

Very much the new face of Chinese state business when he became CEO in 2002, the then 42-year-old Xiao was a decade younger than Fu Chengyu and most state enterprise bosses. Like CNOOC's Fu, Xiao carried all the political baggage of a top-level state business executive. He was a member of the Central Committee, and he served as chairman and secretary of Chinalco's party committee. He was also a smart, aggressive businessman. He took the company in different directions, diversifying into copper and rare earths at home and getting involved

personally in sensitive negotiations with indigenous landowners at a bauxite project in Australia's deep north in the company's push offshore. It wasn't long, however, before his country came calling with a task that dwarfed anything that Chinalco, or any Chinese state business, had ever successfully taken on.

The alarm bells went off in Beijing the moment BHP-Billiton, the largest mining company in the world, launched its takeover bid for its Anglo-Australian rival, Rio-Tinto, in November 2007. China saw the $127 billion bid, later lifted to $147 billion, the second biggest takeover in history at the time, as an unambiguous threat, because of the way it could create a near monopoly in the seaborne iron ore trade in particular. The international price of iron ore, used to make steel, had increased fivefold in the five years to 2008. The exponential growth in Chinese demand was one driver. But so was the lack of supply, which China believed had been manipulated through under-investment by the big miners. The Politburo quickly decided to oppose the BHP-Billiton bid, a decision which would push China Inc. on to the world stage as never before.

In a matter of hours on the London stock market, Chinalco made China's biggest ever overseas investment, a $14 billion share raid on London to scoop up 9 per cent of Rio-Tinto. With CNOOC's mistakes in mind, Xiao went on the front foot immediately, giving interviews to the foreign media in a fashion unprecedented for the head of a Chinese state company, and flying down to Australia to reassure nervous polit-icians in person about Chinalco's intentions. Xiao's message in public was consistent. Chinalco was a state-owned company, but run without interference from the state. 'All management and commercial decisions are taken independently,' he said. From the outset, to Xiao's chagrin, and that of his political masters, his assertions of independence during the two stages of the bid for Rio-Tinto kept running into the same wall of disbelief that confronted CNOOC at Unocal. As the extra-commercial aspects of Chinalco's tilt at Rio-Tinto added up embarrassingly as the deal progressed, it was not hard to see why.

For starters, Chinalco had emerged as a bidder for Rio-Tinto only after going through what investment bankers call a beauty parade, so called because of the way corporate contestants line up to pitch their wares to win business mandates. In this case, the contest had been

conducted in secret by the Chinese government itself. So many state companies in the energy and steel sectors had responded to the Politburo's patriotic call to take on BHP-Billiton that the government put the choice of the Chinese bidder to an internal tender. Chinalco won because of the commercial competence the company had displayed at home and its steady game abroad. But the government's interest meant that Xiao had the leadership's hand on his shoulder at all times.

Critics also pointed out how Chinalco had chosen its parent company to make the bid, instead of the overseas listed subsidiary in the case of CNOOC. The decision had compelling commercial reasons, as Chinalco was a diversified mineral group like its target, Rio-Tinto. But there was also a strong political incentive. The parent company was 100 per cent state-owned, which made for rapid decision-making, without the kind of interference from the pesky international directors that had tied up CNOOC's tilt for Unocal. Then there was the way Chinalco's bid had been financed. The money came from a consortium led by the China Development Bank. Initially established to fund local infrastructure projects, CDB had lofty ambitions to follow China Inc. abroad. The political heft behind the Rio-Tinto bid was evident from the way the financing was approved, directly by the State Council, or cabinet, without CDB's board even discussing the loan.

Finally, there was Chinalco's ability to sustain its bid at a time its international rivals had to retreat because of the global credit crunch. In barely half a year, a once-in-a-generation bull market in commodities had turned sharply sour with the world economic downturn. The giant BHP-Billiton retreated, dropping its takeover offer for Rio-Tinto in late 2008, and momentarily withdrawing from the battlefield to reassess strategy. When it launched its offer to double its shareholding in Rio in February 2009, Chinalco was bleeding as badly as other resources companies around the world. On paper, Chinalco was down a cool $10 billion on its initial $14 billion outlay on Rio-Tinto shares. The Chinese company's core businesses were losing money as well. With the backing of the flush Chinese state, however, Chinalco still had the firepower to press ahead, offering $19.3 billion to lift its stake in the debt-laden Rio-Tinto and gain control of prize mining assets.

Chinalco's costly tilt at Rio-Tinto was already the target of internal sniping within the government. Lou Jiwei, the head of China's fledgling

sovereign investment fund, then under attack for making poor offshore investment, had been flailed on the internet after defending his fund's initial offshore investments, then sharply down on paper. 'Corrupt, despicable and shameless, he has used money earned from the blood and sweat of the people to realize his personal objectives,' scrawled one netizen after Lou's speech at Tsinghua University in late 2008. Privately, Lou complained that people should examine Xiao Yaqing's record at Chinalco instead. They are down $10 billion, he said, and I am being attacked for losing a fraction of that! In the public market place, Xiao had fallen flat on his face. Backstage, however, Xiao had been nimble enough to play up his political achievements and take credit, however misleadingly, for derailing BHP-Billiton's bid. 'Xiao has said repeatedly that his goal was to stop a merger of two [foreign] mining giants,' reported *Caijing* magazine, 'and that he had succeeded.'

The most blatant public display of Chinalco's cosiness with the state was yet to come. While Xiao, the businessman, was negotiating to double Chinalco's investment in Rio-Tinto, news began to leak out that Xiao, the politician, was also in discussions over promotion onto a powerful new government job attached to the cabinet in Beijing. Foreign advisers to Chinalco noted Xiao's nerves in the final tense days of talks with Rio-Tinto in London. If the deal didn't get done, Xiao joked darkly, it mightn't be worth his while to return home to Beijing at all. The moment it was sealed, Xiao's promotion to the cabinet position was formally confirmed. In China, the deal and the promotion were tied together. Without the second agreement to increase Chinalco's stake in Rio-Tinto, Xiao would have lost billions of dollars in state funds and failed to secure a new resource base for both his company and his country at the same time. In other words, he would have fallen short on both commercial and political grounds.

Chinalco's attempt to double its stake in Rio-Tinto foundered a few months later, in June 2009, on largely commercial grounds, but it might have run aground anyway, for reasons similar to those for the CNOOC debacle. Xiao's promotion to the cabinet position was the last straw, ensuring that any genuine commercial rationale for Chinalco's investment in the Anglo-Australian miner was overshadowed by suspicion about the hidden hand of the Chinese state. Chinalco had been hand-picked to do the deal by the government; its funding had been approved

directly by the cabinet; its bid had come from the parent company to minimize outside scrutiny; and its CEO had left the company for a party-approved government position days after negotiating the final deal, to be replaced by another state business executive also chosen by the Party. Not long after the deal collapsed, four of Rio's China-based executives were arrested in Shanghai by state security on allegations of bribery and commercial espionage. It was no wonder that political opponents of the deal in Australia were able to portray Chinalco as an agent of the state. For a Party on a mission to convince sceptics that Chinalco was an independent entity, it was another wrenching own goal.

Chinalco executives at least tried to engage with their critics and respond publicly to their concerns. Not all state enterprises endeavoured to make their case in public, however misleading it may have been. For companies like the China National Petroleum Corp., better known as PetroChina, thumbing its nose at its detractors at home and abroad had long been second nature. PetroChina is best described as the ExxonMobil of China, a big, bad oil company with an aggressive corporate swagger, tight political and military connections and a couldn't-care-less attitude about the views of others. The company's rough-and-tumble streak had been bred producing oil in some of the most inhospitable parts of the country, far from the bureaucratic confines of the capital, in Xinjiang, in the distant west, and in Daqing, in the north-west.

At the start of the enterprise's restructuring in the late nineties, PetroChina had been ten times bigger, by employee, than any other oil company in the world. 'The best way to describe PetroChina, as it was then, was the Ministry of Petroleum,' said Paul Schapira of Goldman Sachs, which underwrote the global listing in 2000 of China's largest oil producer. In the process of repackaging itself to sell a portion of its shares to foreign investors, the group shed one million staff and the ministry disappeared altogether, leaving the company with little direct oversight from the government. Many of the once powerful ministry bureaucrats took new positions staffing the revamped company's executive ranks, making the enterprise more independent than ever.

Few outside of the industry had heard of the company until it went

offshore to Sudan in the late nineties, in search of new sources of oil
to replace the ailing Daqing fields. The investment put the company,
and Chinese overseas investments in general, on the map in a way
Beijing had not anticipated. When human rights activists campaigned
to draw global attention to Sudan's suppression of a rebellion in the
country's Darfur region, they trained their sights not just on Khartoum.
They went after PetroChina, which they said had become Khartoum's
chief enabler, as well. The campaign depicted PetroChina and its parent
company which held the Sudan assets as one part of the monolithic
hulk of an indivisible China Inc. The Party appointed the top execu-
tives of the parent company and its overseas-listed subsidiary. A
government agency held its shares. Common sense dictated that
the company and the state were fused together as a single entity. The
obvious conclusion was that the company was in Sudan solely on
the Chinese government's business.

The controversy, which reached a peak ahead of the 2008 Beijing
Olympics, masked a much more complex reality evolving inside China
over the politics of state enterprises. The bids by CNOOC and
Chinalco were initially largely uncontroversial at home because they
had broad backing across the government. That was not the case with
PetroChina. It turned out the company was just as unpopular in parts
of the foreign policy establishment in Beijing as it was overseas,
although not for the same reasons. Chinese officials and scholars were
not much concerned with PetroChina's investment in a country with
an abominable human rights record. They could point to the long
western engagement with decidedly undemocratic Saudi Arabia and
other oil-rich states. They were critical because they saw a single
company taking over Chinese diplomacy on a sensitive issue in the
name of finding oil.

Even worse, PetroChina then managed the oil solely in its own
profitable interests, indifferent to the foreign policy implications. A
brace of academics I interviewed in 2007 volunteered criticism of how
Petrochina, far from benefiting China, had sold much of the oil
produced in Sudan to the highest bidders in the international market,
especially Japan. 'I am not worried about whether [the Party] controls
or directs these companies. It is what these companies do that worries
me,' said Zhu Feng, at Peking University. 'These state-owned companies

have become very powerful interest groups. They even hijacked China's foreign policy in Sudan.'

PetroChina did less than brush off this highly unusual public criticism from highly placed scholars. In typical style, the company did not even bother to reply. With China increasingly dependent on oil imports, PetroChina had a strong hand to play against its critics at home. But when it came to throwing their weight around in the domestic economy, however, China's big oil companies confronted a more perilous political environment. 'The secret to success is to demonstrate managerial prowess, while not causing problems for the Party,' says Erica Downs of the Brookings Institution. In a fight over fuel prices in 2005, the oil companies pushed their interests too far.

PetroChina, along with Sinopec, China's largest oil refiner and the country's biggest company by revenue, had long bristled at tight controls on domestic oil prices. When the government refused to match the precipitous rise in global petrol prices in 2005 at domestic pumps, the two companies played hardball in an effort to change the policy. Sinopec was particularly under pressure. As the country's largest oil importer, it was losing money on every litre of foreign fuel it sold into its home market. In a high-stakes game of bluff, several large refineries were suddenly mothballed for what the companies called 'scheduled maintenance'. The companies' actions, as ruthless as any corporate behaviour in the west, created serious shortages of fuel in southern China, which relied almost entirely on imported oil, and also in the Yangtze delta around Shanghai. The threat of angry truckers and taxi-drivers being forced to queue to get petrol in the summer heat, not to say businesses being forced to close down for lack of fuel, backed the authorities into a corner. Wen Jiabao, the Premier, personally stepped in to negotiate an end to the dispute, approving a lump-sum subsidy to the companies to solve the shortages.

Much as the scholars had criticized PetroChina for putting profits ahead of the national interest, furious local commentators complained the oil giants wanted the benefits from being state-owned semi-monopolies without any countervailing responsibilities. This time, most of the criticism focused on Sinopec, which supplied most of the fuel in southern China. Behaving badly overseas was one thing. Running China's industrial centres out of fuel was much worse. As

Sinopec's CEO was to discover later, the company's tactics made him some powerful enemies.

When Chen Tonghai, the Sinopec CEO, was detained on corruption charges two years later, in 2007, the press was full of lurid stories about his mistress, a woman who acted as a courtesan for a number of ministerial-level officials and brought them all down. Senior industry executives I spoke to, however, traced his fall to the oil crisis two years beforehand. Chen, a princeling, had long been corrupt. His personal expenses amounted to about $5,880 a day, according to his colleagues, not much less than his official monthly salary. But when Chen took on senior leaders during the fuel crisis, he handed his enemies an excuse to bring him down. 'As the head of a state company, you are expected to fight your corner,' said one industry executive. 'But you also have to know when to quit.'

That Chen's downfall was about more than just corruption was evident from his party-appointed replacement. The corruption inquiry into Chen left Sinopec, a key state company, in a mess. Chen's replacement, Su Shulin, had just the kinds of skills the Party required to clean it up. His role was not unlike that of Harvey Keitel in *Pulp Fiction*, the clean-up man who scrubs a car of blood to remove all evidence of a crime. Su had worked in the oil industry but his main experience was in party bodies. In a similar way, Su was sent into Sinopec as a kind of fireman, to re-install the party discipline which the authorities felt Sinopec had lost under his predecessor. Su's priorities were evident when he began visiting Sinopec's numerous joint-venture partners. He seemed to know little about the businesses themselves. To the irritation of the company's partners, Su seemed most agitated about something else altogether. Why, he kept asking, had their joint ventures not established Communist Party cells inside the companies?

In little over a decade, the Party had pulled off what few had predicted was possible, the construction of a profitable state sector, with independent commercial aspirations, but still ultimately under its control. For Chen Yuan, his freelance policy-making of the early nineties far behind him, the new century had been something of a triumph as well, politically and personally.

Chen had been removed by Zhu Rongji from his position as a

deputy-governor at the central bank in 1998, severely denting his ego and setting back his career. But Chen bounced back in his new job, as party secretary and president of the China Development Bank, a so-called policy lender established to finance favoured state projects, such as the Three Gorges Dam and local infrastructure works. A thoroughly modern communist, Chen managed to turn it into the biggest job of his career, and the bank into one of the country's most global institutions. Chen first extended the development bank's largesse domestically, providing loans to oil and car companies which aspired to be national champions. The bank backed a host of politically popular projects, funding rural infrastructure, environmental schemes, loans for poor students and low-cost housing. Unrestrained by the kinds of restructuring the state banks were undergoing, CDB's outstanding loans rose from $73 billion in 1998 to $544 billion a decade later.

By 2006, emboldened by the Politburo's go-global push, CDB had headed offshore in the slipstream of China Inc. The bank won the mandate to manage a $5 billion fund Beijing had established to invest in Africa, and bought into Barclays Bank in the UK. CDB led the financing of Chinalco's bid for Rio-Tinto and other offshore deals. The ambitious Chen even pushed to buy a share of Citigroup when the US bank was raising new capital in 2008, but was overruled by senior leaders fearful of investing in shaky western institutions. In private, Chen boasted that his bank had grown into the largest development lender in the globe, towering over, he said, the iconic World Bank in Washington. Perhaps mindful of 'hiding his brightness', Chen would not repeat such comments for the record on the rare occasions he met foreign journalists.

Even as he emerged as a sophisticated standard-bearer of Chinese state capitalism on the global stage, Chen retained a canny sense of his party's proletarian roots. When I was in the foyer of the five-star Peninsula Hotel in 2007 ahead of a meeting of the bank's international advisory board, I noticed a man in a cloth cap and a plain Mao-era jacket, resembling an old state factory manager, striding through the foyer, surrounded by smartly dressed, bustling secretaries and advisers. The outfit was so at odds with the surroundings that I didn't realize it was Chen until he disappeared into the lift.

The proletarian look was not favoured by his daughter, Xiaodan.

Unlike her father, she had been allowed by her parents to study overseas, at Duke University in the US. In November 2006, she represented China at the Crillon Ball in Paris. The annual debutante ball traditionally features the offspring of European royalty, multinational industrialists and Hollywood movie stars. That year, the ball was also graced by a representative of the globe's newest power player, the Chinese Communist Party, in the form of Ms Chen. All the debutantes were decked out in haute couture loaned to them for the evening. Ms Chen wore an Azzedine Alaia pink cotton dress, which, if she had had to pay for it, would have cost as much as her father's official cash salary for a few months. Her appearance at the ball nonetheless neatly symbolized the trajectory of her family, and of the Communist Party along with it.

The Chen that I chanced across in the foyer of the Peninsula Hotel may have been unique in dressing like an old-style cadre for a meeting with rich and powerful foreigners. These days, Chinese leaders usually reserve their Mao suits and army attire for party and military occasions respectively. Still, Chen's style and his family's trajectory were redolent of how top Chinese officials have learnt to speak out of both sides of their mouth. No matter how rich and powerful they have become, they are masters at calibrating their support for Marx, Mao or the market, depending on who is listening. The dexterity of officials in this respect remains one of the truly dizzying things about China Inc. The same official who one minute will be lecturing you about how the west should abide by the strictures of the market, a spiel usually delivered in defence of China's competitively priced exports, the next minute will be assuring a Chinese audience of the horrors of unfettered capitalism and his or her deep belief in Marxism. The change of political attire is akin to a Wall Street banker disappearing Clark Kent-like into a phone box, and emerging swiftly a few minutes later dressed as Karl Marx.

Few were as adept at switching stride as Liu Mingkang, China's bank regulator. Becoming a banker in 1979, aged thirty-three, after the Cultural Revolution, Liu was quickly promoted through a range of state business and government positions. He worked at the Bank of China, in the Fujian provincial administration and at the central bank, before founding the regulatory body in 2003. In between times, he completed an MBA at City University in London, where he still sends up-and-coming finance officials from China on scholarships for an

education in liberal finance and economics. When the state banks were being restructured, Liu relentlessly drilled his subordinates on the importance of global regulatory norms, like capital ratios, risk returns and non-performing loan rates. On lazy Friday afternoons at the regulator, lower-level officials joked that Liu would terrify them by landing unannounced in their departments and putting them through an impromptu grilling on 'Basel II', the formula named after the Swiss city which dictates the optimum level of bank reserves.

Long considered to be one of the country's most westernized officials, Liu wowed foreign visitors with expositions in flawless English about financial reform. Whether he was spinning you a line or not, Liu cut a deeply impressive figure. On important political occasions, however, Liu, the smooth global banker, dropped out of sight and reappeared, reprogrammed, as a sombre student of Chinese Marxism. At the time of the 2007 party congress, Liu eschewed the nostrums of liberal finance and Basel II and lectured staff about the great invention of 'Sinified Marxism'. Speaking to leading cadres at the opening of a new term at the bank regulator's party school in late 2007 ahead of the congress that year, Liu urged his officials to 'use the latest fruits of Sinified Marxism to guide our practice'.

Around the same time, Guo Shuqing, of the China Construction Bank, intoned that 'the only way to put the latest communist principles into practice was to maximize returns for shareholders'. Guo at least had a concrete point to make. The largest shareholder in the bank was a central government agency, which was in turn controlled by the Party. It was certainly in the Party's interest that the bank make a sustainable profit. Indeed, the economy depended on it. But the notion that shareholders' returns could be so directly tied to communism was novel, even for China.

Easy as it is to mock these utterances, they cannot be dismissed as mere ritualistic incantations of faith, like the lapsed Catholic who still goes to Sunday Mass from habit and a desire to maintain valuable social networks. The rhetoric about the Party is backed by the full force of its political institutions that make and break careers. At times as sensitive as that of the party congress, these statements are timely genuflections at the feet of the Party by officials, and indicative of political loyalty and reliability, both essential to a career in public life.

The financial restructuring of China's vast and sprawling state sector embodies such contradictions perfectly. The overhaul of these companies was done in plain and often painful view. Entire communities and their families, whose lives had once been entirely dependent on the iron rice bowl the enterprises provided, were upturned. The companies' executives had been exposed to pressure from global investors in ways never thought possible. And a conservative political class whose entire lives had been built around old-style state ownership had been swept aside.

The political restructuring of these enterprises, however, and the role of the Party, has not been nearly so clear. With the need to be profitable and compete globally, top executives of state enterprises these days have a relative freedom to run their businesses inconceivable a decade ago. Human nature being what it is, many have exploited that freedom to build personal empires of their own. But throughout the reform of the sector, the Party has retained its influence by maintaining power over all senior appointments. Through personnel, they can in turn direct corporate policy.

The Party's power was on display in late 2008 and early 2009, when the deepening global financial crisis threatened to engulf China, as it had the rest of the world. The central bank, the bank regulator and even the banks themselves, all counselled caution in formulating a response to the crisis. All three had battled hard to build a credible commercial banking system over the previous decade. The Politburo, however, staring into the abyss of a sharp slowdown, issued an edict from on high for the money pumps to be opened. Once done, the banks had no choice but to race out of the blocks. In the first six months of 2009, Chinese banks lent nearly 50 per cent more than during the whole of 2008. Just 15 per cent went to household consumers and private businesses, compared to a peak of one-third in 2007. Most went to state companies.

The behaviour of Chinese banks was instructive compared to their counterparts in the developed world. Many western banks were by that stage controlled directly by their respective national governments. In Washington and London, the US and UK administrations were imploring financial institutions to restart lending to revive their respective economies, but they possessed few concrete tools to force them to do so. In China, by contrast, the banks were both state-owned and state-

controlled. When the Party directed the banks to lift lending, the senior executives had a political duty to comply. More than business was at stake. 'Top executives [at the big state banks] are also government officials with vice minister-level positions,' reported *Caijing* magazine. 'So in addition to caring for their banks, they are responsible for supporting the central government's economic stimulus policy.'

The Party's control over personnel was at the heart of its ability to overhaul state companies, without losing leverage over them at the same time. So important does the Party rate its power to hire and fire government officials that it places it on a par with its control over the media and the military. Zhou Tianyong, a relatively liberal political theorist at the Central Party School in Beijing, laid out the Party's absolute bottom line in a book published in early 2008, *Storming the Barricades*. 'To uphold the leadership of the Party in political reform,' Zhou wrote, 'three principles must be followed: that the Party controls the armed forces; the Party controls cadres; and the Party controls the news.'

The party body with ultimate power over personnel, the Central Organization Department, is without a doubt the largest and most powerful human resources body in the world. Barely heard of outside China and little known inside the country itself, beyond official circles, its reach extends into every department of state. Much like the Party itself, the department is a fearsome, secretive hulk, struggling to adapt to a vastly more complex world which has grown up around it in the last three decades.

3

The Keeper of the Files

The Party and Personnel

'The cadres all know where we are. It's a bit like knowing where your parents live.'　　　　　(Wang Minggao, the Organization
Department of Hunan province)

'The system is all from the Soviet Union, but the CCP has taken it to an extreme.'
　　　　(Yuan Weishi, Sun Yat-Sen University, Guangdong)

'Li Gang paid 300,000 [for his position], but within two years, netted in 5 million. The return is 1,500 per cent. Is there any other profession as profitable as this under heaven?'
　　　　(An official from the Central Discipline Inspection
Commission, quoted in *China News Week*)

The moment I sat down in the coffee shop of the party leadership compound in Changsha, I handed over my name card. It was a polite, reflex act, part of an introduction ritual so seemingly indispensable in Asia that business consultants still solemnly peddle advice about the culturally correct way of making the exchange. Wang Minggao, the man sitting opposite me, initially played out his role to a tee, studying my card from all angles, and nodding intently at its contents, but then did not round out the ritual by offering his in return. When we had finished chatting and were about to leave for dinner, I asked directly if I could have one of his cards, to contact him in the future. 'I don't carry a name card,' he replied, folding his arms to end the matter. From his point of view, there had been no slight. Mr Wang didn't use a card

when dealing with outsiders. His employer, the Organization Department of Hunan, only faced in one direction, inwards, at the Party.

Wang had picked me up at the gates of the sprawling complex in Changsha, the capital of Hunan, in central China. Like entrances to all official estates in China, the security reception was officious and intimidating for obvious outsiders, but seemingly porous for privileged people and their vehicles, the status of which was indistinguishable to the untrained eye. The green-uniformed paramilitary guards at the gates glared at my assistant and me on approach, lifted their hands stiffly in the form of a stop-sign and barked directions to stand to one side, together with other assorted ne'er-do-wells congregating nearby. While we waited, the local elite, in sharp, late-model cars, often with no number-plates, glided into the compound without braking, let alone pausing to acknowledge the guards. Mr Wang whisked us inside in his vehicle unchallenged as well, a tell-tale sign of his own elevated status, driving past the stately red-brick government buildings abandoned by the former Nationalist administration of Chiang Kai-shek in their flight into exile in Taiwan ahead of the communist victory in 1949. In a moment, he had deposited us at the compound coffee shop for our interview.

The appointment with Wang had taken many months, and much gentle flattery and harassment, to secure. 'As long as it is nothing to do with state secrets, it should be OK,' he eventually said. Wang had endured our courting with impeccable politeness and sat cheerfully through the two-hour interview before inviting us for dinner. To have not invited his guests to eat with him would have been inexplicably rude in China, where any out-of-town host will instinctively ask visitors for a meal, and protest noisily if the invitation is refused. But in failing to hand out his name card, Wang breached just about every other protocol for first meetings. A trivial issue at the end of the day, his handling of his cards was symbolic of how his employer viewed the world. The rest of the universe outside of the organization department was peripheral for Wang. Any cards that he had were handed out inside the communist club, and nowhere else.

It was rare to secure a meeting with an official from a department which keeps itself firmly out of sight even in China itself. The national headquarters of the Central Organization Department occupy an unmarked building in Beijing, about a kilometre west of Tiananmen

Square along the broad sweep of Chang'an Avenue. No sign hangs outside indicating the business of the building's tenant. The department's general switchboard number is unlisted. Calls from landlines in the building to mobile phones do not display an incoming number, as is customary for ordinary phones, just a string of zeros. The only way a member of the public can make contact with the department in Beijing is through its sole listed number, 12380, which has a recorded message, allowing the caller to report any 'organizational' problems above the county level. From early 2009, a website was launched, offering the same complaints service. Around the same time, the department appointed a spokesman. But for the first six months of his tenure, he did not utter a single word in public. Friends of the latest head of the department in Beijing, Li Yuanchao, a relatively liberal figure appointed at the end of 2007, once joked that they wanted to ask him about what they considered to be the absurd level of secrecy surrounding the body. 'Are we still an underground party?' exclaimed one of his longtime friends, before admitting he could talk to Li about anything except his work.

The department is accurately, if blandly, described as the human resources arm of the Party, but this does not do justice to its extraordinary brief and the way it is empowered to penetrate every state body, and even some nominally private ones, throughout the country. The best way to get a sense of the dimensions of the department's job is to conjure up an imaginary parallel body in Washington. A similar department in the US would oversee the appointment of the entire US cabinet, state governors and their deputies, the mayors of major cities, the heads of all federal regulatory agencies, the chief executives of GE, ExxonMobil, Wal-Mart and about fifty of the remaining largest US companies, the justices on the Supreme Court, the editors of the *New York Times*, the *Wall Street Journal* and the *Washington Post*, the bosses of the TV networks and cable stations, the presidents of Yale and Harvard and other big universities, and the heads of think-tanks like the Brookings Institution and the Heritage Foundation. Not only that, the vetting process would take place behind closed doors, and the appointments announced without any accompanying explanation why they had been made. When the department knocks back candidates for promotion, it does that in private as well.

In Beijing, the Politburo decides on the most senior of appointments

but the organization department is the gatekeeper that all candidates must get past to take office. 'All official positions of a certain rank on the public payroll are covered by the organization department,' Wang said, with the kind of pride that comes from being a member of an elite, powerful and secret club. 'From 1949 onwards,' he added with a wink, 'we even covered some journalists.' Wang and his ilk at organization departments across China have no problem in distinguishing who can come and go from party compounds like the one in Hunan. Encoding and decoding hierarchies and the privileges attached to them is their daily bread. The Party has been tentatively experimenting with ways to make the system more transparent, by allowing the public into some areas of the local people's congress to express an opinion about officials up for promotion, a process that has been creatively labelled 'democratic recommendation'. By and large, though, the department works in a shroud of secrecy.

If I needed any reminder of the closed universe the department and its officers lived in, it came when I suggested to Wang that the body was unnecessarily mysterious. The question left him nonplussed, as though he had never even considered the issue. 'Government departments hang their plaque outside their buildings because they have to face the public. We are only here to service the cadres,' he said. 'The cadres all know where we are. It's a bit like knowing where your parents live.'

The department maintains files on top-level officials in the public sector, to keep tabs on their political reliability and past job performance, making it indispensable to the Party's control of the country and the nation's vast public sector. With their colleagues in the Party's anti-corruption unit, the department cross-checks for any black marks recorded for graft or sexual misdemeanours. The breadth of the department's role is a source of pride. 'Our Party's organizational working resources have no equal with other political parties in the world,' internal documents boast. The system is replicated in China at each of the remaining levels of government. To simplify a complicated system, the centre supervises appointments in the provinces; the provincial organization departments supervise the cities, and so on, right down to the lowest tier of government, at the township level. In practice, the party secretary at each level retains a huge amount of power over appointments in the area over which he or she rules.

A Chinese official-turned-private-equity-investor once compared the department's work in conversation to the confirmation process officials nominated to work in the US administration go through. In both cases, potential candidates for jobs are interviewed: in China by members of the department, which also sends teams of people around the country vetting potential candidates for promotion; and in the US, by congressional confirmation panels. Otherwise, it was a slyly misleading analogy, in the way that direct comparisons between western and Chinese governing systems usually are. One process unfolds in a partisan public forum and the other takes place almost entirely behind closed doors, buttressed by a managed media which is not allowed to report details of appointment battles, even if they find out about them. The ghostly, undocumented presence of the Party, which sits behind the government in China and manipulates its staffing, makes most of such comparisons redundant.

The patronage dispensed through the department, in the form of the most powerful party and government positions in the country, have turned it into a make-or-break forum for the system's toughest internal political battles. Politburo members, factional groupings, the centre and the provinces, and individuals aligned to different ministries and industries – all struggle to place their people into positions of power and influence in state institutions. 'If the job of a bureau chief becomes vacant, then a lot of senior officials in Beijing will want to have it filled with their person. In times like this, the organization department will have a very difficult task,' said Wu Si, the editor of a prominent liberal magazine, *Annals of the Yellow Emperor*. 'It is meant to be about virtue and talent but it becomes a test of your relationship with the department and the seniority of your patron. At the end of the day, the department cannot be bypassed.' In the absence of elections or any overtly public competition for government posts, the behind-the-scenes battles to secure appointments are the very stuff of politics in China. As the clearing house for these disputes, the organization department has become the institutional hub of the entire political system.

The alumni of former leaders of the organization department are testament to its status. Deng Xiaoping and Hu Yaobang both headed the body during their careers. Zeng Qinghong, a political fixer who acted as a kind of cardinal-at-the-elbow for Jiang Zemin during his years in power, also led the department. When Hu Jintao began to gain

control of the party apparatus by the start of his second term in late 2007, he was able to secure leadership of the body for a loyalist of his own, Li Yuanchao.

Scratch the surface of this colossus, however, and you find incipient panic at the way the system is being subverted by multiple trends outside of the department's control. Since the upheavals of 1989, the organization department's oversight of potentially suspect institutions, especially universities, has been formally tightened, but the ideological foundation of its work has drifted. Party members are 'losing belief', the department's own secret documents complain. 'Some individual party members and even cadres in leadership positions no longer have a clear head and doubt the inevitability of the ultimate triumph of socialism and communism.' Many individuals have begun to believe in 'ghosts and deities instead of Marx and Lenin', a reference not just to the spread of western religions, but to the revival of traditional Chinese superstitions stamped out after 1949.

The department is plagued by a constant tension that bedevils most political systems. The Politburo has striven to professionalize the selection of top officials through the department, while undermining the process at the same time by fixing appointments in favour of loyalists and relatives. Powerful officials presiding over local fiefdoms have swept aside the rules even more crudely, establishing market places in which government positions are bought and sold for huge financial gain. 'The older senior officials who survived the wartime were different from the younger officials who tend to think about themselves and are mainly after power, salary, status, housing and medical care,' said Zhang Quanjing, who headed the department for five years until 1999. 'This thinking triggers jealousy and encourages the buying of official posts to get promoted.'

At the local level, the party secretaries and the heads of the organization department run the grassroots administration like a franchise, selling government jobs for vast sums of money.

The value of the market was illustrated by a case in Sichuan in 2007, when a man passing himself off as an organization department official secured a payment of $63,000 from a local bureaucrat under the guise of finding him a senior government post. 'While they jeered at the miserable unlucky bureaucrat who paid the bribe,' the local media

reported, 'people were astonished by the influence of the department over Chinese officials.'

Enamoured of its rituals and privileges, the department is still powerful and feared. But it is resented in equal measure, as a static relic of a bureaucratic system that has battled to keep pace with a more fractured and open society, and the demands and temptations of the moneyed new world that has grown up around it. One vice-minister who has to jump through the department's hoops every year to stay in his job used a Chinese aphorism to describe the body: 'It's not good enough to make for a success, but more than enough to make for failure.' Much of the debate about China focuses on how the Party can control the people. The organization department is at the heart of an even bigger challenge – of whether the Party can control itself.

Soon after the Red Army holed up in Yan'an after the Long March in the thirties, Mao Zedong decided he needed a body to ascertain the political reliability of the supporters flocking into the mountainous retreat to join the communist cause. A fraternal model for such a gatekeeper was close at hand, in the Soviet Union. The Orgburo in Soviet Russia was one of the two original bodies established by Lenin under the Central Committee in 1919, to direct the daily business of the Party. Stalin was quick to see its usefulness. He made the Orgburo his 'first base of operations in building his own machine' in the early 1920s, as he began to steal power away from an ailing Lenin. Stalin's command over the personal dossiers of senior party members earned him the nickname, 'Comrade File Cabinet'.

Mao feared, not without justification, that the scores of outsiders arriving in Yan'an from outside the Party's battle-hardened ranks included spies dispatched by the rival Nationalists. Mao staffed the department with acolytes and instilled in it the culture that still survives today, as a gatekeeper that ensures the total loyalty of senior cadres to the Party and its leaders. As the initial revolutionary idealism of Yan'an gave way to vicious infighting within the small band of communists bunkered down there, Mao found the body similarly useful in consolidating power in his own hands.

The Orgburo was one of the most important Soviet imports used by the Party in China to establish communism at home. But far from

landing in China like an alien being, the organization department found fertile soil in the middle kingdom. In China, the tradition of using a single body to systematize central control over government officials dates back nearly 1,000 years. Through long periods of Chinese history, provincial rulers have been appointed from the capital. 'There were no professional guilds which formed cohesive forces and structured society, no self-governing units as in medieval Europe,' according to Laszlo Ladany, the veteran China-watching Jesuit. 'There were no balancing forces that could mould their own opinions in the face of a central power. China could only be kept together by a powerful central ruler.'

As early as the Han Dynasty (AD 25–220), the imperial system had something resembling an organization department, a body which later came to be known as the 'Li Bu', or the Civil Service Ministry. The head of the 'Li Bu' was known respectfully, because of his power, as 'the Heavenly Official'. Throughout successive dynasties, the department was one of six core ministries advising various emperors on appointments, dismissals, civil service entrance exams, promotions and transfers. Tang Dynasty (AD 618–907) histories record officials being benchmarked on nine different grades, which checked their diligence, virtue, integrity and the like. Magistrates were similarly scrutinized on whether they 'judged and sentenced with equity and sincerity' according to a checklist known as the 'Twenty-Seven Perfections'.

The Party increasingly likes to conjure up the past, as if to display an unbroken thread in Chinese political culture tying its rule to imperial officialdom. The organization department these days cites a Tang Dynasty maxim about the need to promote officials in the capital only after they have had experience in rural areas. 'No experience at the local level, no nomination for the centre,' the phrase goes. 'If the [old Tang] saying is better followed in the future, it could revitalize the bureaucratic system and support development of the countryside and national prosperity,' the department said in a 2008 paper.

In modern China, the Central Organization Department as we know it today did not come into its own until 1937, when the communists and nationalists formed their second united front against the Japanese. The fledgling organization department in China began to build thick files on individual party members, who were forced to write and rewrite their personal biographies, some hundreds of pages long, providing

detailed histories of their family members and friends. The evaluation
by the department, in tandem with the Party's intelligence arm, was
brutal for anyone considered potentially suspect. In this respect, it was
at one with the temper of the times. Yan'an is often idealized as an all-
hands-to-the-wheel pitstop for a youthful band of revolutionaries before
they were able to relaunch their campaign to unite China. In reality, it
was the venue for waves of power struggles, followed by deadly purges.
Party members who had been jailed by the Nationalists, and then
released under the temporary ceasefire and allowed to travel to Yan'an,
had to provide written evaluations of their behaviour in prison and also
of their fellow cadre inmates. Each was then cross-checked against the
other and any differences pursued mercilessly in interrogation.

A man who would later become a well-known author, Liu Baiyu,
became delusional during his vetting in the middle of this counter-
revolutionary campaign, known as the Yan'an rectification. At the
direction of a party school official, he wrote and rewrote an autobiog-
raphy of thousands of characters in length, starting from the day of
his birth. He feverishly detailed all he could remember about his past
exploitative behaviour, recalling eventually even his remorse at pulling,
as a child, the skirt of a maid when she was doing the family washing.
Liu later claimed to have seen the light as a result of this treatment.
He said the enforced writing of a total of nine drafts of his life story
had been the 'right medicine for the sickness' of intellectuals like him,
and forced him to see the world 'objectively'. 'Spiritually, I had under-
gone my own personal revolution,' he wrote. The Party approved of
his transformation. Under Mao, Liu would later become a vice-minister
for culture and party secretary of the Chinese Writers Association.

For all its imperial antecedents, Mao's organization department
replicated what was known in the Soviet Union as the *nomenklatura*
system. This was the 'list of names' of party members who formed the
communist ruling class and were eligible to fill prized jobs in govern-
ment, industry and elsewhere. The system allows the Party to control
'the appointments, transfer, promotion and removal of practically all
but the lowest ranking officials'. China differs crucially from the Soviet
Union in one respect: the system is far more pervasive, penetrating
deeper into lower levels of government and other state-controlled insti-
tutions. 'China is more radical,' said Yuan Weishi, of Sun Yat-Sen

University in Guangdong, because of the way the Chinese Communist Party exercised authority down to the lowest residential committees and schools. 'It wants to lead everything. This is the greatest difference.'

In universities and other key education institutions in the Soviet Union, for example, the party secretary's job was to oversee party members. In China, says Yuan, the party secretary has the ability to control both party members and appointments and also oversee the curriculum, outranking the titular head of the institution, the president. 'Things in China are quite ludicrous. Take the hundredth anniversary of Peking University in 1998. Jiang Zemin gave a speech in the Great Hall of the People, instead of at the campus itself. And the person chairing the meeting was not the president, but the party secretary,' Yuan said. 'Many of the professors there told me what a funny spectacle it was. The party secretary was waving his hands and moving his feet, at the centre of the action, while the president sat in the corner like a mouse. The system is all from the Soviet Union, but the CCP has taken it to an extreme.'

Everything from the leadership of associations for the elderly and disabled to appointments of scientists and the heads of national engineering projects, such as the Three Gorges Dam, must pass through the department. The head of the umbrella group for the private sector, the All-China Federation for Industry and Commerce, is part of the elite *nomenklatura*, making the body a poor independent advocate for business, which, of course, it is not meant to be anyway. On top of its responsibility for appointments, the department acts as a kind of mini-ministry of multicultural affairs, helping allocate positions in government to well-behaved members of China's 55 designated ethnic minority communities. Tibetans, Uighurs from Xinjiang, Muslim Hui people and the like, all pre-screened for their loyalty to the Party, are handed a small number of largely symbolic posts to give the vast sprawling state a more inclusive lustre. The department also oversees the allocation of the small quotas set aside in government and academia and elsewhere for members of China's eight so-called democratic parties. These jobs are allocated, without irony, as a reward for the acquiescence of the democratic parties to single-party communist rule.

The genesis of the unseemly spectacle witnessed by Yuan Weishi at the Peking University anniversary, of the bossy party secretary and the

craven president, can be traced to the Party's response to the 1989 upheaval and the way it played out through the bureaucracy. The department had begun to exercise a lighter touch in the eighties with institutions of higher learning, only requiring universities and the like to consult with the Party on senior appointments. That leeway did not give them a free hand and turn them into hotbeds of democratic liberalism, but it did help to keep direct political pressure at bay. By a single stroke of the Party's pen in May 1991, the *nomenklatura* list was expanded to give the department greater control over universities. Around the same time, the Party gained extra leverage over students and intellectuals, by requiring university leaders to attend an annual conference to strengthen party-building in their institutions. This last measure offered some added-value for the Party, by giving it a better platform from which to recruit the brightest up-and-coming brains in the country to its ranks as new members.

A flurry of other diktats issued around the same time increased the department's grip of the propaganda network, elevating the journalists' federation and a number of media outlets into the formal *nomenklatura* register. The various party bodies controlling trade unions, the youth league and the women's federation returned to the organization department's high-level watch-list. The party groupings in government departments, which had been scaled back and in some instances abolished by Zhao Ziyang, were also revived to replenish the political core of the system.

The secrecy surrounding the precise number and identity of elite positions covered by the Central Organization Department has been tightened at the same time. John Burns, an academic at Hong Kong University, obtained the 1990 list of *nomenklatura* positions in the early nineties, through access to material from the Ministry of Personnel, the agency which acts as the government front for the party department. A second academic, Hon Chan, also of Hong Kong University, obtained a later list, of the 1998 *nomenklatura* jobs, but he had to get it through his own sources, as the Ministry of Personnel no longer publishes the information. The increased secrecy, Dr Chan noted, is counter to the Party's 'professed interest in increased transparency and open administration' and the commitments made on its accession to the World Trade Organization in 2001. Dr Burns estimated that in the

early nineties the centre directly controlled about 5,000 key party and government posts. Dr Chan, perhaps hamstrung by the heightened secrecy, did not make any estimate at all.

Outwardly, the twenty-first-century organization department is a very different animal from the arm of state security as conceived in Yan'an. The rules for appointments are codified in more than seventy articles that read much like legislation. Promotions are tied to length of service, education levels and mandatory classes at a party school every five years. Officials holding government posts, such as a governor or mayor, are rated according to an impressively lengthy list of numerical indicators which look like they were drawn up by management consultants. Economic growth, investment, the quality of the air and water in their localities, and public order all theoretically count in benchmarking performance.

The department has all the trappings of a sophisticated, multinational headhunter, using psychological tests, lie detectors and confidential interviews with colleagues of officials up for promotion. Judging how these rules work in practice, however, is more difficult. The same regulations contain loopholes large enough to push the numerical benchmarks aside. Officials judged to be 'exceptionally talented young cadres', for example, can be promoted regardless of seniority. 'It all depends on whether you get noticed at the end of the day,' said an adviser to the department. 'There is no scientific system. Nearly everyone gets the same points in all of these elaborate assessments anyway, because for you not to do so would reflect badly on your superior.'

Senior leaders in China have long held sway over jobs in select ministries and industrial sectors. Li Peng, the Premier who declared martial law in 1989, was the longtime tsar of the energy sector, in which two of his children rose to hold powerful jobs. Zhu Rongji held sway in the finance sector, which allowed him great influence in choosing the heads of large Chinese banks and also helped his son become the highly paid head of China's largest investment bank. And Jiang Zemin reigned over the technology sector, ushering numerous loyalists into important jobs, and allowing his son to become a key wheeler-dealer within the sector in Shanghai in the early part of this century. More recently, Zeng Qinghong, together with Zhou Yongkang, from 2007

the Politburo member in charge of the law and state security, have been key players in the so-called petroleum mafia and influential in senior appointments in China's energy sector.

When the Politburo chooses to focus on an issue, the benchmarks set from Beijing can matter a great deal. Jiang Zemin's directive to wipe out the Falun Gong spiritual movement in 1999 after its followers surprised the leadership with a sit-in outside its Beijing compound galvanized regional party chiefs. Handed responsibility for breaking the movement and preventing its practitioners from coming to Beijing to protest, city and provincial leaders resorted to brutal methods, including torture and murder, to crush Falun Gong at the grassroots. The Politburo has pressed so hard on another issue in recent years – improving mine safety standards – that the city of Linfen in the coal-rich Shanxi province was left without a party secretary for six months in 2009. The potential candidates for the position were all too scared to take it up. A county governor from the city, which regularly disappears from satellite photos because of extreme pollution, said the pressure from Beijing to prevent mine accidents had made being an official in the province 'a profession of extreme danger – you could go to jail or to your death if not careful'.

Economic growth, which in the Party's eyes translates into job creation and social stability, is the most important benchmark throughout China, but it is not enough by itself to ensure a stellar career. If growth alone was the main criterion for promotion, officials from the localities which have outpaced the rest of the country for years, like Wenzhou in Zhejiang province, where the private sector rules the economy, would dominate the senior ranks of the central government. In fact, very few officials from these areas have advanced into the top echelons in Beijing. The performance benchmarks are kept in reserve, to be enforced when they are needed, a Chinese academic explained. 'Above a certain rank, these tables do not mean much,' he said. 'It is in the interest of senior officials to keep it that way, because they can enhance their own individual power and standing. Otherwise, they are hostage to the system.' The regulations are much like laws in China, he said, for reference purposes only.

The Party's most effective tool in elevating competence over cronyism during the last decade has been a practical and resolutely old-fashioned one. The department stress-tests promising officials by

rotating them through jobs in diverse parts of the country and in different administrative units, before hauling them back to Beijing into the big league if they pass muster. By the time Chen Deming was tapped to be Commerce Minister in 2007, for example, a key government post which put him in charge of trade policy and negotiations and foreign investment policy, he had already served in three positions with distinct responsibilities.

In Suzhou, as mayor and party secretary, Chen helped build the city in the Yangtze delta near Shanghai into one of China's most advanced manufacturing hubs, winning kudos on the ground by standing up for local interests even when it embarrassed Beijing. After the central government had signed an agreement in 1994 to set up an industrial park in Suzhou with the Singapore government, Chen authorized the establishment of a rival locally owned business zone across town. When the furious Singaporeans demanded an explanation, Chen replied that foreign investors had to take into account 'cultural differences' when doing business in China. It was an answer that combined palpable disdain with, perhaps unconsciously, deep irony. Singapore's leaders had spent much of the nineties promoting themselves as the spokespeople for the region, extolling the unique virtues of so-called harmonious Asian values, which they had haughtily contrasted with the crass, confrontational west. Chen displayed both creativity and cynicism to play the culture card against Singapore in return.

After Suzhou, Chen was dispatched to Shaanxi, where his reputation survived the dirty, corrupt and accident-prone coal industry, an achievement in itself. Finally, Chen was brought to Beijing, and put in charge of the sensitive energy policy area in the Economic Planning Ministry, before being eventually promoted to take charge of the trade portfolio. Carlos Gutierrez, the then US Commerce Minister and his counterpart in the Bush administration, met Chen in late 2007 for the first time and remarked how impressed he was by his grasp of his portfolio after a short period in the job. Chen's career path, Gutierrez remarked, reminded him of the rigours successful multinationals put their up-and-coming executives through, sending them first out into the field, to difficult regional offices and underperforming divisions, before bringing them back into head office to see how they performed there. It was an astute observation but one Gutierrez could have taken further.

The organization department moved Chen Deming around as if he was an employee of a company, in this case, the Communist Party of China. Equally, the department treated the heads of state companies in China as if they were apparatchiks as well, to be shifted around at will, whatever commercial conflicts might arise. At a time when the executives at state enterprises had been ordered to behave more like entrepreneurs than politicians, it was inevitable a new set of conflicts would rise to the surface.

By the time Edward Tian arrived at the Mandarin Hotel in London in November 2004 for a meeting with potential investors in his new Chinese telco company, he had steeled himself for some tough questioning. The day before in China, the Central Organization Department had announced without warning a reshuffle of the top executives at China's three big state-owned telecoms companies, China Mobile, China Unicom and China Telecom. Two of the Chinese companies were listed on overseas exchanges, and another was preparing to sell shares offshore. The move left investors, and the executives of the companies themselves, agape.

It was the equivalent of the CEO of AT&T being moved without notice to head its domestic US competitor, Verizon, with the Verizon chief being appointed to run Sprint, at a time when the three companies were locked in a bruising battle on pricing and industry standards. Tian, a returnee from the US lured to head China Netcom, a fourth, fledgling state telco, was in the midst of a global roadshow to promote his company's upcoming share sale. Tian had heard rumours about the changes but didn't know for sure what was coming. 'It was very hard to explain to western investors,' he said. Over the coming years, it would take Tian a while to understand the appointments system himself.

Most of the aggrieved foreign investors had never even heard of this strange body with the vaguely Orwellian name, the Central Organization Department. Certainly, the companies, and their bankers and lawyers, had made sure never to mention it ahead of the companies' billion-dollar share sales. The anger was even more palpable among the many Chinese who had spent years trying to build a genuine commercial corporate culture in the refurbished state enterprises.

The problem was not so much the disregard the organization

department displayed for the edifice of company law and governance painstakingly constructed in large state companies and sold to foreign investors over the previous decade. According to a prominent Chinese banker, it was ignorance. The Party did not even stop to think about the board and its legal responsibility for choosing the chairman and senior executives. 'The proper process is that the chairman submits his resignation and then the board discusses it,' the banker said. 'The Central Organization Department is totally ignorant about such processes. This is not just about protocol. The issue goes much deeper than that. It goes directly against Chinese securities law, enacted by the National People's Congress, which says the chairman's job cannot be influenced by any outside body.'

'The idea that the boards really run companies is basically as credible as the constitutional guarantee of free speech and religious freedom in China. It does not happen in reality,' the banker said. 'At all the major state companies, the party meetings are held regularly before the board meetings. Operating costs, capital commitments and the like are discussed at the board meetings, but personnel remains in the hands of the Party. No matter how many independent directors there are and what oversight they provide, at the end of the day, if all management are appointed by the Party, nothing will change.'

One of the reshuffled telco executives, Wang Jianzhou, who was shifted from China Unicom to manage rival China Mobile, told friends he had had no forewarning of the move. Nor had any of the boards of the companies been consulted beforehand. As an executive of a company listed on the New York and Hong Kong stock exchanges, with all the legal duties such a role entails, Wang hurriedly sought legal advice about the implications of the move. The advice of the lawyer was succinct. He was told: 'Don't talk about your old company.'

The deliberate element of surprise in many of these moves, much as it might enrage the executives and investors, serves the Party's purposes perfectly, by reminding them who's boss. The reshuffle sent a simple message to executives of the state companies. Overnight, China Mobile had become the world's biggest mobile company and the rest of the sector was booming alongside it. Power was increasingly accruing to the companies' CEOs in a strategic industry with important national security implications. 'The view was that we have to keep these ones

in the box; we are better off running these companies with politicians and not entrepreneurs,' said an adviser to the companies. 'The idea was to break emerging centres of power.'

The fiction that the Party is not involved in such decisions is carefully nurtured, by ensuring that public announcements of new appointments are made by formal government bodies, such as the State Council, the government body which regulates state enterprises, known as SASAC, the ministries themselves or the parent company. The announcements are invariably heralded in newspaper headlines as 'job changes', masking a subtle but fundamental difference in how the appointments are portrayed inside the system itself. From a party perspective, the officials moving between enterprises or in and out of government are not so much changing jobs. They are being shuffled within the same system.

In the first few years of this century, the chairman of China's offshore oil company, CNOOC, was made the governor of Hainan province; the head of PetroChina joined the chief economic planning agency as a vice-minister; the chairman of Huaneng Power was appointed deputy-governor of Shanxi province; the vice-governor of the central bank was appointed to head the China Construction Bank and the chairman of Chinalco was elevated to a cabinet advisory post. Even the head of the country's only nominally private bank, Minsheng Bank, the subject of many fawning media articles for being an entrepreneurial upstart in a state financial monopoly, is cleared through the party process.

Edward Tian, the founding CEO of China Netcom, is one of the few people who has been able to view the system from both sides, first as an outsider, and then later, when the Party ushered him into the *nomenklatura* ranks, as an insider as well. Tian was already a wealthy and successful private businessman when he was approached in the late nineties to run Netcom, then a fledgling telco state start-up. His Chinese colleagues at AsiaInfo, a private company he had co-founded and ushered through a listing on the Nasdaq exchange in New York, thought he was crazy to contemplate working in a government enterprise. For a while, Tian found himself agreeing with them.

By Chinese government standards, Netcom was an enlightened project, an attempt by four state investors to deregulate the local telco

sector, then dominated by the giant China Telecom and its ministerial patron. The new Netcom aimed to bring broadband to China, shake up the industry and at the same time allow investors, such as the Railways Ministry, an entrée into the then hottest sector in the global economy. The recruitment of the US-educated Tian from the private sector showed the system, including heavyweight backers like Jiang Mianheng, the son of Jiang Zemin, thinking outside of the box as well. But when Tian insisted that as CEO he should join the board of the new company, he was told no. The other directors were all vice-ministers, whereas he was just an entrepreneur. The club was not ready to admit someone without the requisite rank. 'I was very disappointed and thought about quitting,' he said. 'They said calm down, work at it for a year and see how we go.'

A year later, Netcom was showing promise. Hundreds of managers had been hired. Thirteen cities had been linked up to its broadband network. Revenues were rising. Finally, the investors agreed to have their CEO on the board. 'This was a big moment. I felt that the system recognized me,' Tian said. Real recognition did not come until about two to three years later, though, when the once small state start-up company took over the operations of ten provinces from China Telecom. For Tian to stay as CEO of the expanded Netcom, he now had to pass muster not with his board, but with the Party, in the form of the organization department. For both sides it was a novel experience.

Tian wanted the job, but not some of the privileges and restrictions that came with the position, which had the rank of vice-minister. He didn't want a 'red machine' on his desk. And he didn't want an official passport, because that would have restricted him to two overseas trips a year, the limit at that time for people with a vice-ministerial ranking. Any trips above this number required an elevated level of approval. 'I didn't want to join the political system,' Tian said. 'It would impinge on my freedom.' The organization department, because of his foreign education, agreed to make an exception for him. Once he had passed his internal review and revived his membership of the Party – his membership from his university days had lapsed while he was overseas – the department was satisfied. It confirmed him as the CEO and allowed him to join the inner sanctum of the party committee.

However, the night of the long knives in the telco industry, when

the department reshuffled the industry leadership, still rankled with Tian and his chairman and party secretary, Zhang Chunjiang, who also sat through the embarrassing London roadshow. When the pair returned from overseas, they wrote to the Party and the government to register their concerns about the game of executive musical chairs. After the Netcom listing, Zhang went even further in an effort to prise open the Party's control over the company. He recruited John Thornton, the former president of Goldman Sachs, then teaching in China, to sit on the board, and McKinsey & Co., the management consultancy, to advise him about how the internal processes should be run.

For Thornton, who already had experience of taking Chinese state companies to international stock markets, Zhang's introductory lecture on the role of the party committee was an 'eye-opening' moment. 'There are six functions for which the party committee was responsible,' Thornton said, 'and they were the ones that mattered.' The project laboured for months over how to run the company in a more transparent and accountable fashion. Should the evaluation and appointment of senior executives be the direct responsibility of the board, as Netcom had promised in its overseas listing documents and as Chinese law stipulated? Or should the power over personnel remain with the party committee? Netcom eventually agreed that the board would approve senior executive appointments. But there was a catch. The committee which recommended the appointments to the board had to have a majority of its members appointed by the Party. The board's role in evaluating and appointing was strengthened in theory, but in practice the directors only saw candidates cleared through the party system. The efforts to open up the company's personnel system, after much work, ended in a whimper. 'It looked all shiny and glossy on the surface,' said an adviser, 'but if you poked around, it was very traditional underneath.'

By a year or so later, Tian had left, to go back to the private sector. Zhang had been moved on to chair another telco, China Mobile. In 2008, China Netcom disappeared altogether, subsumed by another state company in the latest industry reshuffle. In late 2009, Zhang was detained by the party's anti-graft unit on unspecified corruption allegations, bringing to a rather ironic end the career of an official once heralded as a champion of Chinese-style corporate governance. Still,

Tian left the system with a more favourable view than he had had when he joined. 'I feel I could justify this system now and understand how it has worked for 1,000 years,' he said. 'Ten years ago, I would not have had a similar feeling.' Tian compared his time at Netcom to his experience on boards in western companies, where he said CEOs were chosen by busy directors in consultation with headhunters. However political the process in China might have been, he maintained the vetting of CEOs was generally more thorough in his homeland. As an insider, Tian had even come to rationalize the industry reshuffles. 'The competition was very furious. It's like three brothers fighting each other for no clear objective,' he said. 'The parents say: "Let's change your seats. You will see each other from another angle. You had better behave yourself from now on."'

The organization department hasn't stopped disciplining errant state business executives in the meantime. In early 2009, the heads of the three state airlines were all rotated overnight into rival firms to keep competition in check. The telco heads were switched a couple more times as well.

The organization department's responsibility for choosing the bosses of about fifty of the largest state enterprises makes it relatively easy for it to play stern parent with these companies. But the lower the level of government, and the further they are from Beijing, the harder it is for the centre to instil discipline into the ranks. The experience of Li Yuanchao prior to his elevation to head the Central Organization Department in the capital was proof of that.

About six months ahead of the 2007 party congress, the Tai lake (Taihu) in Jiangsu turned green. A crucial source of water for tens of millions of people and the heart of ancient China's fertile 'land of fish and rice', the Taihu had been blanketed by an algae bloom created from the discharge of raw pollutants from chemical plants around its edge. The algae had been a recurring phenomenon for some years on the lake. This time, the pollution was so bad the lake was smothered altogether by a thick green growth. The event galvanized the leadership in Beijing, which used it to demand, as they had many times before, that local governments more strictly enforce longstanding environmental laws. The desecration of an iconic waterway also raised

sharp political questions closer to home, questions about its impact on Li Yuanchao, at the time the up-and-coming Jiangsu provincial party secretary.

Li's prospects for promotion to the Politburo at the congress scheduled for later in the year were already well known. The local media had never been allowed to report that he, along with a few other rising stars, was slated to be elevated into the Party's ruling council. But in the strange way such news seeps out in China until it becomes common knowledge, as if it had been carried on the front page of the newspaper all along, everyone somehow seemed aware Li had been anointed for higher office, although to exactly which position and at which level was not clear. The provincial staff accompanying Li during an interview in March 2007, only months before the Taihu incident, joked about his potential promotion when their boss wasn't present. Li himself was less relaxed, pleading at the end of the discussion for any mention of his future to be left out of any article whatsoever.

Li had another message to deliver that day, talking at length about the performance benchmarks he was enforcing as party secretary in Jiangsu to grade officials. These days, he emphasized, the environment was ranked as highly as the economy. Li compared the excessive focus on economic growth at the expense of the quality of air and water to a child who over-indulges on lollies. 'If a child has too many sweets, he will have rotten teeth. GDP is the same. [Sweets are] a good thing but you can't go to excess.' A few months later, Li found himself responsible for handling the fallout from exactly the kind of untrammelled growth he had been complaining about. The response of the authorities in Jiangsu to the algae-covered Taihu, however, was much more traditional than the modern benchmarking system that Li had been advocating beforehand.

In public, Li railed against the waterway's polluters, saying he would sacrifice '15 per cent' of economic growth in the province to clean up the lake, and ordered the closure of more than 2,000 small chemical factories. It was an attention-grabbing response in a country obsessed with economic growth, but it also ignored the fact that the disaster had happened on his watch in the first place. In the county where most of the polluters were based, the grassroots authorities had other ideas about how to handle the issue. They did not include throttling the output of chemical factories which were big local taxpayers, nor pandering to

critics who wanted the area's money-spinning businesses to be closed down. Rather than sacrificing economic growth, the local authorities focused their attention elsewhere, on a local activist, Wu Lihong.

Wu had been agitating for years for the polluters around the Taihu to be brought to account. His efforts had already won praise in Beijing, with his recognition in 2005 as one of China's leading environmentalists. Along the way, he had amassed a mountain of evidence about the condition of the Taihu, in photos and physical samples, and made countless representations about the lake's condition to the local, provincial and central governments. His worst fears had now been borne out by the algae spread thickly across the waterway. But far from being lauded for his pioneering work, which coincided with Beijing's urgent policy emphasis on the environment, Wu was arrested. His conviction soon after, on charges of extorting funds from local companies by threatening to expose their pollution problems, was based on a confession which he said he signed after being deprived of food and kept awake for five days and nights in succession.

After his initial headline-grabbing burst on sacrificing growth to protect the environment, Li remained silent throughout this period, acquiescing in Wu's detention and conviction. It was soon clear why. In November, at around the time that Wu's appeal against a three-year jail sentence was being rejected, Li was formally appointed to run the Central Organization Department in Beijing. If Li was reprimanded internally for the despoliation of the waterway and the loss of a vital source of potable water, according to his own high-profile performance benchmarks, it was never made public. The incident certainly did not impede his career. With his long-expected promotion, Li became the tenth ranked leader in the country, one position outside of the nine-member Politburo Standing Committee, a body he could now reasonably expect to ascend into at the next congress in 2012. Li showed a keen sense of what was what from the moment he arrived in the capital. One of the first senior appointments under his watch was the elevation of his provincial propaganda chief from Jiangsu into the Central Propaganda Department, as a vice-minister, giving Li a powerful ally at the heart of the state media. As a longtime supporter of Hu Jintao, Li's broader role was to secure as many senior jobs as possible for his leader's camp, to tighten his hold on the party apparatus.

On the surface, Li's elevation to the Politburo after presiding over an environmental catastrophe in the Taihu made him look like a hypocritical crony. But this criticism hid a larger reality about the political system and the way that power over the economy and personnel had been devolved down to grassroots administrators. Li could have sacked and disciplined the officials with on-the-ground responsibilities for the waterway's pollution, but he would have created a political firestorm in the process that could have entirely devoured his career. The letter of the law was no help. There was no system of injunctions that he could have served on the recalcitrant polluters of the lake, let alone enforced. Local courts exist within the local party system and are not independent of it. In some ways, Li could do little until an emergency transformed the issue into a national crisis and galvanized the entire system, from Beijing down.

The weakness of a seemingly mighty provincial party secretary like Li Yuanchao in dealing with cadres appointed several levels of government below him was vividly brought home to me by another shocking pollution case, in Hunan province, around the same time. The narrative was familiar – tonnes of poisonous metals had been discharged into the Xiang river, the source of drinking water for millions of people in one part of the province. In trying to get to the bottom of what had happened in the county where the pollutants had been dumped, the biggest obstacle was not the central and provincial authorities, which were quite open about the problem, and anxious to fix it, but their subordinates on the ground.

The landscape around the Xiang river was littered with scores of large and small factories – China's largest zinc factory, decades-old, was nearby – separated by pools of rancid water and vegetable patches. Local villagers joked sardonically that no one would buy their vegetables once they knew where they were grown. 'We always offer tea, but no visitors will drink it when they come here,' one villager told me. The most recent cause of damage to the river was discharges from fifty to sixty small indium factories in early 2006, built in just a few frenzied years of ramshackle construction to take advantage of the soaring global price of the metallic element used in the manufacture of semi-conductors and liquid-crystal display screens. Most indium had previously been produced by factories operating in Guangdong in southern China, but

the entrepreneurs had decamped north to find greenfield sites after a spill had polluted a large waterway there.

The most striking moment of a dismal trip, however, had come beforehand, en route to the Xiang, in the office of the provincial head of the State Environment Protection Administration, in Changsha. An accommodating, straightforward man, he had told me that he was shuttering the offending indium factories. 'I am signing the order to close them today!' he declared. But when his office phoned the chief environmental officer near the epicentre of the problem, at the Xiang river, at my request, to take me around the area, he was instantly rebuffed. Permission for any such visit would have to come from the local township government, the province environmental chief was firmly told, and there was nothing he could do about it.

The Hunan provincial head of the State Environment Protection Administration, a government entity, far outranked the local environment officer but that was not where the real power lay. The officer near the Xiang river looked to his own local party secretary, who was the person who would ultimately decide whether he kept his job. The local party committee had better things to do than facilitate publicity for their lax pollution controls at precisely the time that Beijing was demanding they clean up their act. The local officials in the area around the Xiang had another reason for refusing access. They had a direct interest in keeping the indium factories open because the entrepreneurs who had established the businesses had gifted them shares in the plants. The officials in charge of the Xiang and the Taihu alike were in business too.

The officials brought a lot to the table in their dealings with business. They could open and close their factories at will at a time when the businesses were highly profitable. They could impose fines, or not, on polluters. They could calibrate the level of pollution allowed as well, and how and when it could be discharged. They controlled the police, who could keep any protesters at bay, or not. They were in charge of the judges in the local courts. They might even have been able to help arrange loans through the local bank. And with such largely unaccountable powers, they could, and did, demand a share in the businesses, for themselves or their relatives or cronies, in return for allowing a factory to stay open. This combination – of wide administrative discretion amidst unprecedented economic opportunity

– means that on-the-ground officials can make or break businesses, especially in localities far from larger cities, where there is less scrutiny and accountability. The potential for corruption is obvious, but in China it takes a twist.

Many officials have been arrested for taking bribes in return for approving business deals. Of equal concern for the Party, and the organization department, is what is known in the US as 'pay-for-play', the thriving trade in official jobs themselves. The positions with the most monetary value are those of party secretary and the head of the organization department, because they ultimately decide who gets which government post. The trade in jobs makes a mockery of the organization department's mission to find and promote virtuous and competent officials. It means that the department, which shadows the government, has become shadowed itself by an elaborate, underground black market in the very jobs it is meant to control. There are many documented instances of 'buying and selling official posts', as the phenomenon is called in China, none as blatant and far-reaching as the Ma De case, in Heilongjiang province.

Conventional bribery cases usually involve public officials seeking cash in return for favours. The way Ma De and his wife tell the story, he began taking bribes for the opposite reason, because so many people had pressed them on him, without him ever suggesting they needed anything in return. When Ma first took over as one of the vice-mayors of Mudanjiang city, in the far north-east of the country, near the Russian border, his wife said that he sometimes dared not turn on the lights when he returned home, tired out, at the end of the working day. 'Once the lights were on,' she said, 'those gift-bearers would queue up outside.'

At the beginning of his stint in the city in 1988, Ma and his wife would not open the door to visitors bearing gifts. Later, they were chastised about their behaviour by a colleague. 'So you don't eat earthly things or what?' Ma's wife said they were asked. 'If you do not accept the things which are brought to your doorstep, those people will think that you do not trust them. Are you pushing them into the arms of the other people? See how other people eat, drink and take massages. If you are going to become a lone commander, how can you do your work? If you do not accept the gifts, Ma De's regime will not be stable.'

The belief that you cannot be successful without being corrupt is commonplace enough to have been the theme of a best-selling novel in 2007, called *Director of the Beijing Representative Office*. The book, part of a series about the Beijing-based lobbyist for an unnamed city government in north-eastern China, pits a clean official against a corrupt one at a time when they are competing for the vice-mayor's job in a run-off in the local people's congress. The work's author gave the tome an extra level of credibility. It was written by Wang Xiaofang, who served as the political secretary to the vice-mayor of Shenyang, an industrial centre also in the north-east, at a time when the city government was infiltrated by the mafia in the late 1990s.

The Shenyang vice-mayor took millions of dollars in bribes during this period and also collected huge wads of cash from subordinates, who would compete to give him gifts at Chinese festivals to ingratiate themselves with him. He was caught when the Party's anti-graft body was cracking down on officials gambling in the former Portuguese enclave of Macau, adjacent to Hong Kong. The vice-mayor was filmed in the high-rollers rooms, where he is estimated to have lost rmb 40 million over a few short months. He was eventually executed in 2001. The Shenyang mayor, who received a suspended death sentence for corruption in the same scandal, died soon after of cancer.

In Wang's novel, the first official, Li Weimin, is an upright and principled cadre who cares deeply about the community he is serving. Parachuted into the municipal government, he bristles with integrity and makes sure his family members do not exploit his position for personal gain. Far from endearing himself to his colleagues, Li's austere lifestyle infuriates them. Drivers and secretaries do not like working for him, because they toil for long hours with no extra benefits thrown in. His colleagues feel embarrassed by his decision to stay living in an old residential building instead of moving into the gleaming new official compound where they are housed, rightly sensing that he has made them look bad in front of ordinary people. And he spurns sumptuous government banquets, opting instead for a simple meal at his desk, forcing his colleagues to follow suit. His behaviour, the narrator says, makes him seem 'an unreasonable man who has no sympathies for his colleagues'.

Li's fictional rival could not be more different. A gambler and a womanizer with connections in the business community and the

underworld, Xiao Chaoxuan runs rings around Li in the competition for the post of vice-mayor. While Li abides by the official rules banning campaigning for such elections, remaining aloof from the contest, Xiao operates like a real machine politician, visiting members of the local people's congress personally, proffering promises and gifts. Xiao gains the enthusiastic support of former colleagues, who have all benefited financially from working with him in the past. 'Working for Xiao is considered desirable and pleasant, as he likes to share the proceeds of his job,' the narrator of the book says. Not surprisingly, Xiao wins the election – in which the only voters are other officials – hands down.

Wang, the novel's author, worked in the vice-mayoral office in Shenyang for about five years until his boss was arrested. He spent the next three years in the city government with no real work to do, other than to assist the Party and police in the subsequent corruption investigation. 'I screamed at my boss until I was red in the face at one point about his gambling trips,' he said. Wang's experience in government left him deeply disillusioned. 'The last thirty years have been great on one level. The economy has advanced, but culture, society and politics have not,' he said. 'In essence, it is the same old system. People just go up level by level. In the west, a politician might be elected for just a few years. In China, they have a lifelong career. We are stuck with them for life.'

Wang displays an affectation still common in China, a finely manicured, half-inch-long nail on his little finger, a traditional symbol that once distinguished the scholar from the manual labourer. In his case, it also seems to symbolize his plea that writers and artists be given the respect that society now offers only to officials. Wang is not holding his breath. He compares the elevated position of officials in China to the deference encapsulated by an old saying from the former Soviet Union: 'Let comrade Lenin go first!' If a writer, an artist and an official were seated next to each other, 'then everyone will defer to the official,' Wang says. 'Power-worship has become a national religion in China.' The system of supervision of officials, through the organization department and then the internal elections in the local people's congress for the mayoral positions, was largely a farce. 'It is like the granddad supervising his son who then supervises his own son,' he said. 'Changing the political system is like asking a warrior to cut off his own arm to stop further bleeding, even when there is a risk he will lose his life.'

The bribery, corruption, treachery and sheer desperate self-interest that characterizes pay-to-play in China was detailed with dripping sarcasm in remarkably frank internal documents written by the organization department in Jilin, another province in the north-eastern rust-belt. The documents depict the competition for promotions as the 'four running races', which all conspire to subvert the department's own in-house rules to professionalize the process. In 'sprints', officials opportunistically grab chances at the moment of leadership reshuffles to intensively lobby superiors for promotion. In the 'long-distance' races, they 'suck up to leaders through all means, and make emotional investments, like providing hospitality, gifts and helping to solve the problems' of their bosses. The 'relay' race requires drumming up 'multi-layered recommendations from relatives, friends, classmates and people from the same local area' to get close to leaders. In the 'hurdles', officials go over the heads of their immediate bosses, often using retired cadres to put pressure on the organization department on their behalf.

Ma De himself was initially unpopular in Mudanjiang, and was forced out of the vice-mayor's job after losing a vote at the people's congress, much like the fictional character Li had been in the *Director of the Beijing Representative Office*. Ma learnt his lesson in the process. As he was to confess under interrogation after his arrest, he secured the biggest job of his career about a decade later, in 2000, as party secretary of Suihua, in Heilongjiang, after paying a one-off bribe of over $100,000 to the head of the organization department in the province. Ma had honed his craft well by that time. Rather than crudely thrusting the money into the official's hands in the office, where it might have been rejected, he handed the first tranche to the organization chief in hospital, where she was recuperating from an operation. That way, the money was as much a gift symbolizing his sympathy for her illness as simply a crass bribe.

When he arrived in Suihua, Ma De performed to a tee the rituals required of party leaders across the country. In October 2000 he gathered municipal officials together to watch a documentary film about a corrupt official from Jiangxi, *Cautionary Lessons from the Hu Changqing Case*, distributed by the anti-graft bureau. (Hu, convicted in the late nineties of taking 5 million in bribes, was the first provincial-level leader to be executed since the fifties. Many more have been

executed since.) Ma delivered a speech after the film, telling cadres to 'reflect profoundly . . . and strictly adhere to the party regulations and the laws of the country'. Ma also made a fetish, in public, of running a transparent and credible appointments system, with all the modern trimmings recommended by the Central Organization Department in Beijing. The numerical benchmarking system, soliciting the opinion of the public on cadres before promotions and open votes within the Standing Committee – all were offered up by Ma as essential for a true 'responsibility system' in Suihua. 'I will never trade power for my private interests and money,' he said in a speech to the party committee. 'We must form a good *esprit de corps* [in the committee], of daring to speak the truth, and weeding outbad tendencies, such as base flattery, behind-the-scenes networkingand fraud.'

With his purchase of the job, Ma had in fact bought directly into the heart of a long-established, corrupt system, in which all the ills he had been railing against were well entrenched. 'Three inches of ice do not form from the cold of a single day,' said Shao Daosheng, a corruption expert at the Beijing party school, in a commentary on the case. The system of selling official posts in the region had begun years earlier under Tian Fengshan, who by 2000 had ascended into the central government in Beijing, as Minister for Land and Resources. All Ma would do was refine the operation, turning it into a complete, all-encompassing system. By the time Ma and scores of others were detained in 2002, prosecutors said that about 265 officials – or about half of all the *nomenklatura*-level bureaucrats appointed by the local organization department under Suihua's administration – had either bought or sold positions, trading them as if they were companies on the share market. The Ma family bank account, set up by his son in Beijing, accumulated rmb 20 million in just three years.

At the lower levels of government in Suihua, there were 'dozens of little Ma Des' feeding at the appointments' trough. They included an official called Li Gang, who paid rmb 300,000 for the job of party secretary of a small county in Suihua, with a population of 330,000. Li Gang's mostly rural county was poor and getting poorer. Thousands of students could not afford to go to school in the area; tens of thousands of unemployed workers, laid off from bankrupt state enterprises, were milling around the streets, in search of jobs; and about 3,500

households needed welfare funds to stay afloat. In the two years before Li Gang was arrested, the county's economy contracted, and tax revenues fell by nearly 30 per cent. By collecting money for official appointments during the same period, Li Gang emerged from the recession a rich man. The anti-graft investigators, when totting up his bribes later, would marvel at the successful investment he had made through the purchase of his position. 'Li Gang paid 300,000, but within two years, netted in 5 million. The return is 1,500 per cent. Is there any other profession as profitable as this under heaven?' an investigator said.

Ma De himself owed his life after his arrest to his bitter rival, the mayor of Suihua, Wang Shenyi, who was ranked number two in the Party in the county. Ma and Wang disliked each other intensely. 'Ma De is cold and rough; he'd bite off meat in huge chunks and gulp down alcohol,' said one person who knew both men. 'Wang is delicate, not unlike a woman. Even the money in his wallet is stacked neatly like in the bank.' The two established a modus vivendi for part of the time, dividing the city in half for a major project to refurbish the main urban centre's sidewalks with tiles. They then used easily issued administrative orders to extract fees from businesses and residents who worked and lived along the road, a policy that was billed as the 'unified planning of municipal infrastructure buildings'. Ultimately, they were each other's saviours when they were arrested for corruption in 2002, as both agreed to inform on the other. In Ma's case, according to his lawyer, his full confession meant he received a suspended death penalty rather than being executed.

In detention, a philosophical Ma claimed the appointments system – and the absolute power it placed in the hands of the party bosses – contained in-built incentives for corruption. 'In practice, in any local region, the party secretary is the representative of the Party and the organization department,' he said, 'and as the secretary, has the final say on personnel matters.' The system which fast-tracks promising officials has the same effect, because the Party is basically announcing in public that everyone else will not rise any further. 'Those who are left out concentrate on making money. And those who are on the fast-track – once they bump into a leader who's into money, they would not hesitate to pay up in order to rise up as early as possible.'

Without changing the system, it didn't matter who was party secretary,

the result would be the same. To test his theory, Ma said, the anti-graft body should conduct an experiment by sending a clean-skin from within their ranks to a local region as party secretary, and leave him or her to their own devices for one year. In the absence of outside controls, Ma said, that person would quickly be taking more money than he himself had ever done.

In the Ma De case, the foundation of the appointments system was corroded by a vast web of corruption. In recent years, the organization department has discovered that legitimate government businesses can be just as lethal in undermining the Party's grip. For any official one rung below the *nomenklatura* level, the battle to secure the next promotion, into the elite ranks of the Party, was once a career-defining moment. It is at this point of an official's career that one goes from being a mere cadre to being part of the ruling elite, and under the direct control of the organization department. In China's single-party state, it is the equivalent, in the west, of a budding politician finally winning elective office after years of working the electorate.

For officials rising through the ranks of state enterprises, a different calculus emerged in the early years of this century. When the state-owned companies sold shares overseas, their executives received stock options. The share market boom that followed suddenly landed many of these executives with a dilemma that none of their predecessors had faced. Do you wait for a promotion into the *nomenklatura*? In other words, do you decide to become a fully fledged politician, with all the scrutiny and pressure that entails, with little legitimate financial return? Or do you cash in the shares which are legally yours and remain a business executive? Not surprisingly, many in China decided to take the legal cash on offer in their executive jobs. A few years previously, the question would not have arisen, as until the late nineties leading executives at state enterprises would never have had options to exercise.

Beijing changed tack when it began to push its large state enterprises on to overseas stock markets. With so much riding on the success of the share offerings, it was then that Beijing decided to send a clear message to the market by giving its own executives stock options in the same way that private companies in the west did. That way, they could assert that Chinese executives had the same incentives as western

investors to increase profits and lift share prices. In theory, options directly link remuneration to a company's performance by allowing executives to buy stock at a pre-set price, and then to sell it at a profit later if the share price rises above the buy-in level. The message went down a treat in offshore markets, mainly because Beijing left out an important back-stage rider – that the options were never meant to be exercised at all. Rather than a tool to create executive incentives, the Chinese options were a calculated ruse to ensure that the state got the highest price poss-ible from selling the shares offshore. The options were held in the name of the executives, but were supposed to stay the property of the state. 'At the time, the government did not think too much about what might happen in the future,' said Li Liming, a journalist from the *Economic Observer*. 'They just wanted to solve the problem at the time.'

At first, not all the Chinese executives learned their lines properly about the options that had been granted to them. A foreign investment banker recalled taking a client from Shanghai Industrial to see Fidelity, the global funds manager, when the city-government-owned firm was issuing new shares in Hong Kong. The Shanghai Industrial shares had listed at about $HK7 in May 1996, and had risen nearly sixfold, land-ing the Chinese executive a potentially huge windfall at the time, should he exercise his existing options. Weren't his colleagues who didn't have options jealous, the Fidelity broker asked? The executive replied that the options were meaningless, as they weren't really his. The Fidelity broker erupted in anger, the banker recalled, demanding to know if all of the other information attached to the new issue was equally fake. The executive quickly realized his mistake and backpedalled, saying he had donated the money to the state, so as not to cause divisions with his colleagues.

Top executives in large state firms, many of them sitting on potential windfalls of millions of dollars through options granted to them after offshore listings, had little choice but to publicly observe the directive not to cash them in. The executives who were one rung in the hierarchy below the *nomenklatura* level, whose positions were not under direct party control, had other ideas. As stock markets soared in the early years of this century, these executives began to quietly take their prof-its. By 2008, a small group of executives at China Mobile had cashed in options worth US$1.53 billion.

The controversy over options was fused with another touchy internal debate, about the paltry formal pay structure for the executives of senior state enterprises. The executives themselves looked on with envy at the million-dollar pay packets of their western CEO counterparts. 'It is common knowledge that the CEOs of state enterprises in Hong Kong didn't make as much as their secretaries at the time,' said a Chinese banker. With small formal salaries, they began to find other ways to pad their pay, through bonuses, expenses, unofficial slush funds and extra wages paid through subsidiary companies.

Executives of Chinese state companies posted abroad were keen to emulate the China Mobile example. Ji Haisheng, president of the Singapore operations of COSCO, China's state-owned overseas shipping line, found himself sitting on millions of dollars' worth of options. COSCO's share price in Singapore had soared along with the country's sharply rising foreign trade volume. Like many business executives around the world in similar positions, Ji naturally thought he should get the credit, and the personal reward, for the share price rise. 'COSCO Investments performed miracles in Singapore because our share value grew from less than SG$100 million to today's SG$10 billion,' he said. 'The Singaporean media call me "superstar" because I created numerous millionaires, even billionaires.' Ji airily said he did not 'understand' the Beijing government's rules restricting the exercise of options and felt bound to 'abide by local regulations'. In other words, he could sell his options – which he promptly did.

People like Ji made a conscious trade-off. They could either obey the rules and keep themselves eligible for promotion into the top ranks of the Party; or remain in senior middle management and make money. 'If someone doesn't intend to climb into the official ranks, then the restraints on them will not be effective,' said Li Liming, the journalist. A seemingly arcane financial matter, stock options became a highly charged political issue. It was about more than just money. It was about a new generation of officials declining promotions because of the financial benefits. 'These executives say, I have added value, so I should be rewarded,' said a Chinese banker. 'The Party says, you have added value because we put you there.'

By late 2008, the government had managed to reassert some control over the issue. Formal pay of state executives was lifted, and then

capped during the subsequent economic downturn. The rules surrounding options were codified, to limit the amount of money any single executive could make. Ji Haisheng of COSCO was quietly forced out of the company. The declining stock market, exacerbated by the global economic slowdown, gave the system some breathing space as well.

But the fundamental problem had been left unsolved. 'The government does not want the companies to be wholly market-oriented. Otherwise they would lose control and they are afraid of losing control,' said Li. 'They are afraid if they give the executives huge remuneration, they will not want to come back into the party system.'

The controversy over stock options in Beijing, and the seamy Ma De scandal in the north-east, were two sides of the same coin. In the case of Ma De, officials saw value in buying their way into the system, even at the risk of arrest. In state enterprises, officials had been able to make their fortunes by cashing out of the system altogether. From both ends, the Party was getting squeezed.

The Party has worked overtime to make sure that such displays of disloyalty never bubble to the surface in the institution which acts as the ultimate guarantor of its rule, the People's Liberation Army.

4

Why We Fight

The Party and the Gun

'The military is not allowed to have a position. They are forbidden [by the Party] from expressing their view.'
(Yan Xuetong, Tsinghua University)

'Western hostile forces will spare no money and resort to all means to "westernize" and "divide" the PLA, and propagate the idea of "de-partying the military".'
(Major General Gu Mingzhi, People's Liberation Army staff college)

On nights before he was due to review troops at military parades, Jiang Zemin used to practise his moves before a mirror. Much like teenagers ape performing pop songs in front of the bathroom mirror, Jiang carefully rehearsed his marching drills, pumping his limbs with the precision of a parade before coming to attention opposite his reflection – according to a tale recounted by his approved biographer – his posture erect and his face grim.

The quest for commander-in-chief gravitas has eluded aspirants for high office in many countries. An attempt by the Democrat candidate in the 1988 US presidential election, Michael Dukakis, to project an armour-plated military image by riding helmeted in a tank famously turned him into an object of ridicule. In Jiang's case, the task was more serious than simply overcoming the lightweight reputation he brought to office in 1989, and the buffoonish image he had gained in his early years as party secretary. On his appointment as General Secretary of the Chinese Communist Party, he inherited not

just a country and its government. but an army into the bargain as well.

The Red Army, later renamed the People's Liberation Army, was founded in 1927 as the military wing of a revolutionary party. Since taking power, the Party has worked overtime to ensure it stayed that way. The Party has loosened central planning since the late seventies, freed up private business and begun extracting itself from the private lives of well-behaved citizens – reforms that have made the country unrecognizable from the Maoist dystopia inherited by Deng Xiaoping. The founding principle of the People's Liberation Army, however, 'the Party commands the gun', has never been up for negotiation. For all the recent focus on its growing global capabilities, the PLA's primary mission has always started at home – to keep the Party in power. Just after Jiang took over the leadership, he was given a salutary reminder of the military's existential value to the Party. Confronted by demonstrators over two months in the centre of Beijing, Deng called in the troops to blast the Party's critics off the streets, killing hundreds or perhaps thousands of defenceless citizens in the process. Jiang had been appointed party secretary days ahead of the 1989 crackdown, but had been peripheral to the decision to send in the troops. Deng only passed formal leadership of the military to him five months later, once the Party's ascendancy over the state and the capital had been restored.

Jiang and Hu Jintao after him always had greater reason to worry about their ability to rely on the loyalty of the military than their predecessors ever had. Mao and Deng were as much professional revolutionaries and military men as they were political leaders. Before the communists came to power in 1949, China had been governed by quasi-military regimes for decades. Jiang and Hu broke the mould. They were the first civilian leaders with control over both the country's political and military hierarchies in nearly 100 years. The advice Deng gave Jiang when he came to office is not surprising. 'Out of five working days,' Deng told Jiang, 'spend four with the top brass.' From all appearances, Deng's successors took his words to heart. Jiang in the two years alone after he took over the military made personal visits to more than 100 military installations.

No constituency has been courted with such care under Jiang's and Hu's leadership in the past two decades. At the Party's direction, the

Finance Ministry has increased the PLA's formal budget at double-digit rates every year since the early nineties and spent many billions of dollars more under the line on buying arms and investing in weapons systems. The pace and scope of China's military modernization has accelerated under their leadership, as the PLA develops capabilities to extend China's global reach beyond its immediate territorial interests, into the Indian and Pacific oceans. Jiang and Hu, in succession, regularly attended PLA ceremonies, visited its universities, dropped by the mess for meals on provincial trips and always dressed respectfully in the olive-green Mao jackets for formal troop reviews.

Both leaders gained the measure of the military apparatus during their terms, but in very different ways. Jiang cultivated the hardliners by adopting a hawkish stance on Taiwan. When he came to power, Hu was forced to ease Jiang's Taiwan policy and pull China back from the brink of a dangerous military confrontation across the straits. Most writings about civil–military relations in China focus on the potential fraying of relations between the Party and the PLA. During the new era of civilian leadership of the military, however, the most dangerous division was between Jiang and Hu – in other words, within the party leadership itself.

Jiang's adventurism frightened many in the political establishment, because it threatened the basic tenet of party policy, to provide a stable domestic and international environment for economic development. In repudiating Jiang's line, Hu was emulating the policy pursued by Deng when he returned to the leadership in 1978. Deng convinced the generals to give priority to the economy at the start of the reform period, because that was the only way to stabilize the country and fund a full-scale modernization of the PLA into the future. China adopted the Soviet model of the Red Army, but under Deng it explicitly rejected the other defining policy of Moscow's Cold War rulers – military competition with the west. Ultimately, the Chinese judged, the arms race had brought communism in Moscow down. The theory of China's 'peaceful rise', articulated by Zheng Bijian, a confidant of Hu in 2005, was based on a similar foundation, of avoiding military confrontation with the west. 'The Chinese Communist Party is not like the Communist Party of the Soviet Union,' Zheng said. 'Hence, our confidence in future prosperity.'

In changing tack on Taiwan, Hu envisaged a broader role for the PLA, to match the country's expanding global interests. The key to

the success of his policy, as it was with the populace at large, was continued economic growth. As long as he had more money for the military budget, Hu calculated he could keep his hardline critics at bay. Hu's retreat on Taiwan left a bitter after-taste nonetheless among the hawks in defence and diplomatic circles. Privately, the hardliners fumed that Hu had given up on reunification with Taiwan in all but name.

'The Taiwan issue is over. No one is talking about reunification any more,' said Yan Xuetong, one of the best-known hawks. Yan, who gained a PhD at the University of California in Berkeley, holds the chair in international relations at Tsinghua University in Beijing, one of the country's top three educational institutions. Yan almost spat his words out when I visited him in mid-2009, at a time when relations with Taiwan were warming rapidly.

I think the government has heavily rested its legitimacy on economic development. They think that as long as the people believe they can make more money, they have the right to rule this country, no matter how much territory they might concede. This is the mainstream ideology in this country, but I think this position will lead to disaster.

Yan's incendiary comments were the kind of charge that could be devastating to a Chinese leader's standing within the Party, and within the military as well, if it was made to stick. Needless to say, it was given little airtime within China itself.

When China was at peace in early 2009 and relations with the US, Taiwan and Japan were as placid as they had been for years, a key party journal cleared space for an article by one of the country's most senior generals. The commentary by General Li Jinai, a member of the Central Military Commission, the peak body governing the PLA, bubbled with an urgency associated with grave crises, not periods of stability. 'We must resolutely resist wrongful thinking such as the de-politicization of the military and nationalization of the military,' Li wrote in the magazine *Seeking Truth*. 'And make the whole PLA always hold the Party's flag as its own flag, and the Party's will as its own will.'

The signal editorial published on an important anniversary in the *Liberation Army Daily* in 2005 contained the same message, only much more forcibly. The editorial was the first to be published in the paper's

annual Army Day issue following Jiang's formal relinquishing of the military leadership to Hu late the previous year. In a short commentary, according to the count made by James Mulvenon, an expert on the Chinese military, the phrase, 'the absolute loyalty [of the military] to the Party', or variations on it, was repeated seventeen times. The previous year's Army Day editorial had only mentioned loyalty to the Party six times. The 2005 commentary marked a shrill high-water mark for propaganda, with the party ideologues in full flight:

Our army has the strong leadership of the party, takes actions based on the party's command, always upholds the party's banner as our banner, follows the party's direction as our direction, and makes the party's will our will. Our army's history is a history of upholding the party's absolute leadership over the army; our army's victories are victories won under the party's absolute leadership; and our army's glory is founded with the party's absolute leadership. The party's absolute leadership over the army, wherein our party's life is linked and our party's strength lies, is the core of the nature and basis of the tradition of the PLA.

As when Chinese leaders talk about democracy, readers need their Leninist dictionaries close at hand to crack the code of these military commentaries. According to the predominant western model, the army is apolitical, serving the nation at the direction of the duly elected government of the day, no matter what its colour. In China, where a single political party has control of the military, the language of the debate is turned upside down. The gravest sin in the Chinese system, akin to treason within the Party, is not to politicize the army but to de-politicize it, with the aim of creating a national military force.

In Chinese staff colleges, up-and-coming military officers have it drummed into them that the failure of Soviet communists to keep control of the military rendered the state defenceless against ideological subversion from the west. 'After the upheavals in eastern Europe, imperialism was like a bolting mustang running wild on the fields of the world, putting developing socialist countries on a weak footing for a relatively long period of time,' wrote a senior professor at the PLA's Political College in Nanjing. 'Western hostile forces will spare no money and resort to all means to "westernize" and "divide" the PLA, and propagate the idea of "de-partying the military".'

The 2009 commentary by Major General Gu Mingzhi in the in-house

journal of the Chinese Academy of Social Sciences, the country's most powerful think-tank, said the Party needed to control the military 'in thoughts, politics and organization'. To drive the point home, a lengthy diatribe on the adjoining page attacked the propagation of 'freedom, equality and human rights as the universal values of humankind' as the 'fantasy and hegemony of the western capitalist classes'. The article's anti-western message was buttressed by an accompanying illustration, a collage of the gruesome pictures of US soldiers torturing Iraqi prisoners at the Abu Ghraib prison.

The leadership's assiduous cultivation of the PLA has run in parallel with ceaseless, almost hysterical campaigns in the official media that, year after year, hammer home the principle of the 'absolute loyalty' of the military to the Party. On the surface, the rationale for these campaigns is a mystery. There has been no revolt in the barracks or any public battles setting the Party against the PLA for well over a decade. The proverbial Martian arriving in twenty-first-century China, however, could easily conclude after a quick scan of the press that Jiang and Hu's concerted wooing of the military had foundered, and that the institution was slipping out of the Party's control. The interminable restatements of the military's fealty to the Party recall the counter-intuitive mindset required for reading Maoist-era newspapers. The only reliable way to calibrate the dimensions of a problem in Mao's day was to track the intensity of assertions that no problem existed. Viewed through that prism, the commentaries in the official press are evidence first and foremost that the Party never takes the military's loyalty for granted. Any passivity that did exist in the Party was erased by the brutal resolution of the occupation of Tiananmen Square in 1989 and its aftermath.

The huge size of the 1989 protests, the way they spread to cities throughout the country, the broad base of support they generated among students, workers and the intelligentsia, and the split they forged at the top of the Party over how to handle them – all reverberate profoundly within the Party to this day. Less well known, but seared just as deeply into the Party's psyche, is how some PLA commanders and soldiers refused to obey when they were ordered to clear the protesters out of Beijing with military force.

When his first mobilization orders arrived in mid-May, the commander of the storied 38th Army, Lieutenant-General Xu Qinxian,

prepared his troops to enter the city, planning routes, rendezvous points and places to congregate for units that might be beaten back. But after the final order arrived from the political commissar of the Beijing military region, Xu baulked, according to numerous accounts of his behaviour during this period. Stationed in the province adjacent to Beijing, the 38th Army carried with it a pioneering tradition within the PLA. It was one of the first Chinese units to enter into the Korean war; it was the first to be mechanized; the first to have an air wing; and the first to incorporate an electronic warfare unit. The unit was also among the first readied to restore order in the capital.

Xu had spent the weeks ahead of 4 June sitting in hospital with an injured leg. As he watched the demonstrations unfold, he found himself increasingly sympathetic with the students' cause. Xu initially pleaded to be left out of leading his army into the city because of his injury. When pressed, he refused his orders outright: 'No matter what kind of charges are laid against me,' he replied. 'I will absolutely not lead the troops myself.' Xu was then relieved of his post. Some of Xu's former colleagues now dispute this account, saying that the commander did not resist orders until he had led his unit into the battle in Beijing. What is not in dispute is that Xu was court-martialled after 4 June, and sentenced to five years in prison for his actions in this period.

The siege mentality in Beijing lasted for at least six months after the crackdown. Army units camped out in think-tanks, research institutes and universities whose members had been involved in the protests. PLA personnel were dispatched to oversee a pro-military propaganda drive inside civilian media organizations. Within their own ranks, the military also investigated, purged and punished commanders who had disobeyed orders and troops who had abandoned their posts. Each part of the PLA, at headquarters, in operational units, research institutes, universities and factories, has always had a political department and party committees. The same kinds of mechanisms the Party uses to control the government and business and so on are all replicated within the military. After 4 June, the Party determined that its penetration of the military should go even deeper. As a result, the slimmed-down modern PLA, which has about 2.3 million men and women on its books, now has an astounding 90,000 different party cells operating inside it, about one for every twenty-five people enrolled in the forces.

It is no coincidence that the PLA garrisons three armies near Beijing to protect the capital and deploys large combat forces around major cities for the same reason. In Tibet, the most distant outpost of the Chinese empire, PLA troops, along with its paramilitary wing, the People's Armed Police, were called on to quell large protests as late as 2008. In Xinjiang, the PLA stations four divisions near areas where there were violent ethnic protests in the 1990s. The 800,000-strong People's Armed Police were substantially re-equipped and re-trained post-1989 to relieve the army of direct responsibility for putting down major civilian disturbances. To the satisfaction of policy-makers, keen to remove the army from the domestic frontline, the PAP was largely responsible for quelling the bloody ethnic violence which killed nearly 200 people in Urumqi, the Xinjiang capital, in July 2009. The PLA maintained only a symbolic presence in Urumqi. At the end of the day, however, the PLA still remains the final arbiter of security in a crisis.

The ceaseless pro-party commentaries represent more than just the enduring post-1989 paranoia. They are also a recognition that the same long-term trends transforming modern Chinese society and undermining old-fashioned political controls are at work in the military. The modern PLA is leaner, more focused, better equipped and more highly trained than it has ever been. Updating the answer to what the military call the Frank Capra question of 'Why We Fight', after the title of the US film-maker's World War II propaganda movies, however, has proved harder than simply ordering new hardware. The expectation that loyal cadres in uniform will mutely serve at the Party's pleasure no longer cuts the ice in the market economy. Like modern armies around the world, the PLA has to compete with the bounty the private sector offers to attract talented young men and women to enter its officer ranks, the kind of competition the Red Army in the Soviet Union never faced. China's new breed of military officers needs high-grade technical, strategic and language training, and they have to be certified as true believers in the Party into the bargain.

Alongside the stale traditional ideology, staff colleges have tried to imbue the military with the new mood of nationalism being stoked by the Party. But even here the Party has laid traps for itself, with divergent groups emerging in political debates competing to define the military's mission. China's swelling defence budget has thrilled a vocal throng of

the neo-nationalist intelligentsia and a part of the populace alike, who see a strong military and even the prospect of war as something to savour, whether the PLA is ready for battle or not. The clash of civilizations, with China finally coming out on top after a century of humiliation, is an ennobling prospect for the country in the eyes of this crowd. Wang Xiaodong, a well-known conservative rabble-rouser, cited fashionable theories of Darwinian socio-biology in pressing for a re-invigoration of China's martial spirit. 'Without pressure from the external environment, a species will only degenerate,' he wrote in a 2009 hyper-nationalist best-seller, *Unhappy China*. 'The same applies with human societies.' Ask Wang the question of 'Why We Fight', and his answer is not so much to win the unavoidable war, but for the sake of the battle itself and the country's blood honour.

Few reforms have been as fraught for the Party as the modernization of the military. The more the Party pushes the PLA to develop into a modern fighting force, the greater the risk the military establishment will drift away from its traditional moorings and develop its own auton-omous instincts at odds with its political masters. The trend is already well entrenched, according to Chinese officers and scholars. 'This army has become a more professional army and therefore more of a national army than the Party's army,' said a prominent international relations professor in Beijing. 'It is just that we cannot say that out aloud.'

In violently putting down the 1989 demonstrations, the PLA had – eventually – proven itself willing to fulfil its duty to protect the Party in its moment of gravest danger. But the military that performed that duty, a lumbering, oversized, low-tech force, backed by an armaments industry banished to the hinterland to protect it from bombardment in the Cold War, was ill-equipped for the challenges that lay ahead. The new PLA being built for the Party has multiple roles. It is an instrument of international statecraft for China, a defender of the motherland abroad and a policeman on the beat at home. Protecting the Party's grip on office in the future will require much more of the army than simply the ability to shoot unarmed protesters in city streets.

At the time China discovered oil in the late fifties, the country had no resource giants like Standard Oil or Exxon the government could rely on to get the resource out of the ground. Instead, Mao looked to a man

known as the one-armed general, and tens of thousands of his fellow military men, to drain the gushers in the country's north-east. Yu Qiuli, born in 1914 and a member of the Party by the time he was a teenager, had risen through the PLA ranks as a political officer during the anti-Japanese war and the subsequent internal conflict against the Nationalists. He had lost his left arm in battle on the long march in 1936 in an act of heroism that would be on daily display for the rest of his life. After the Party took power, Yu held positions in the central military command before being appointed in 1958 as Minister for the Petroleum Industry, a job which would turn him into one of China's most famous communist industrialists.

Yu was only one year into his new job when China found oil, big time, in Daqing, in a corner of Manchuria that was a mosquito-infested marshland in summer and frozen over by sub-zero temperatures every winter. Desperately in need of labour, Yu turned to the largest employer in the country, the military, for skilled working men. At its peak after the Korean war, the PLA, which covers land forces, navy and airforce, had 5.5 million people under its command. Yu won approval from Mao for 30,000 decommissioned soldiers to be sent to Daqing to work on the fields. Another 3,000 former officers were ordered to the area as well. The military was a natural recruiting ground for impatient industrialists like Yu. In the early fifties, the PLA had already acquired industrial know-how through spearheading the development of the nascent oil industry. The 19th Army had hived off a division to become communist China's first petroleum engineering corps. In Daqing itself, military teams built roads, pipelines, pump-stations and all manner of basic infrastructure.

When the demobilized soldiers and officers started arriving in the oil town from March 1960 onwards, many of them Korean war veterans, the race to develop the fields was immortalized in party lore as 'the battle of Daqing'. Zhou Enlai, the Premier, in an address to city leaders, compared the party secretary of the Daqing fields to a marshal who stations himself personally at the frontline. 'Concentrate all your troops to fight a battle of annihilation,' Zhou told the workforce, 'taking one front at a time.'

Since its inception, the PLA has always performed extra-curricular duties beyond its purely military missions. It has been in business for

itself, either to make money or supplement its meagre official budget. Alternatively, military units have been demobilized or their members borrowed to work on industrial projects, like Daqing, on behalf of the country. Millions of soldiers were demobilized in the late fifties and another million in the mid-eighties. The government was under instructions to try to find work for them all. Large bands of demobilized soldiers were settled in China's remote regions, simultaneously reducing the burden on the budget and placing trained men in far-flung strategic areas. About 170,000 former PLA members formed the Xinjiang Soldier Corps in the early fifties, which has since become a huge business empire with its own stand-alone security forces. More than 80,000 ex-soldiers were sent to work in local commerce bureaux in the same period. During Deng's first purge of military ranks in 1981, 57,000 demobilized men and women were reassigned to work in the legal system. Many became judges, even though few had ever stepped into a courtroom in their lives, let alone studied law. In 1982, tens of thousands of soldiers were also sent to Shenzhen, a new economic zone, as the workforce for construction firms.

The PLA's involvement in money-making businesses surged in the eighties, at the direction of Deng, who wanted to focus budget spending on economic development. By its peak in the late eighties, the PLA's commercial empire had nearly 20,000 companies. On top of oil services, a business spun out of the Daqing oil fields, the military had their hands in everything from five-star hotels, pharmaceuticals and light manufacturing, to trading and smuggling commodities and making weapons for export. The profits were meant to fund improved living conditions for ordinary soldiers. In reality, much of the money went into the pockets of venal generals and their relatives and cronies.

More secretive than even the Party itself, the military developed into a state-within-a-state, distinguished as much by the underground commercial interests of its officer corps as the discharge of its duty to defend the Party and the country. Business corrupted and distracted many senior officers. Reliance on the revenues generated by its multiple enterprises had, in turn, distorted the management of the military budget. Relative to the economy, the military had been a laggard in China's modernization, ill-equipped for the multiple strategic, economic and societal challenges landing in the civilian leadership's lap. Once

the economy started to take off in the nineties, the Party decreed it was time for the restructuring of the military to be accelerated, to force the PLA to catch up.

It was not only a decade of fiscal neglect the military had to overcome. The military, like Chinese society, had to rid itself of a Maoist legacy of a deep, institutional involvement in party politics and a sprawling, irrational structure left behind by the Cold War. Deng's early market reforms had set off an explosion of opportunity and, for some, wealth unknown in the Mao years. China itself was beginning to spread its wings as a power around the world. For the military to match this mission and become a genuine fighting force would require disposing of hundreds of thousands of more soldiers, on top of the huge demobilizations in the fifties and eighties, and literally thousands of businesses.

Nothing symbolized the transformation of the country's strategic setting more than oil. Within five years of striking oil in Daqing, the field's production had made China self-sufficient in the resource. Yu was rewarded later with a Politburo seat, where he headed the earliest version of the Petroleum mafia, economic conservatives who supported traditional central planning and heavy industry. The legacy of Daqing lasted only until 1993, when China became a net oil importer. China's reliance on oil imports, which has been growing every year since, marked a turning point for its economy and redefined its broader security interests for ever as well. The year the oil started to run out was the beginning of the annual double-digit increases in the PLA's public budget that have continued ever since. It was also the year when China adopted a new military strategy, its own revolution in military affairs, in response to the dazzling high-tech firepower displayed by the US forces in removing Iraq from Kuwait. The traditional reliance on a massive land-based army trained to fight a 'people's war' was to be displaced by a smaller military, lighter on manpower, but sharper on technology, mobility and inter-services operability. Whereas the PLA once provided workers for start-up energy projects, the PLA's emblematic new mission was to build capability to project power beyond China's borders, to protect supplies of oil, gas and other resources, shipped from the Middle East and elsewhere, or pumped overland through pipeline networks from neighbouring countries.

The ties between the military and Chinese big oil endured beyond

Daqing. When Iraq couldn't raise the money it owed for arms bought during the Iran–Iraq war, it paid in kind in 1996 by offering PetroChina a $1.2 billion oil concession in tandem with Norinco, the state weapons manufacturer. The US ousting of Saddam Hussein delayed the project, and work did not begin on it until 2009. Likewise, Chinese investment in oilfields in Sudan was done in parallel with arms sales by a state-owned weapons firm to the Khartoum regime. By and large, however, the heroic frontier business exploits of the likes of the one-armed general are a thing of the past. The changes forced on the PLA by the Party's civilian leadership since the early nineties have left the old Chinese military behind for good.

Slowly but surely since the early nineties, the Party has deliberately pushed the PLA back into barracks. The Politburo has not selected a military man for the Standing Committee, the leadership's inner circle, since the 1992 congress. Only fifteen years previously, at the end of the Cultural Revolution, a period during which the military held the country together, more than half of the Politburo were military officers. Now, only two out of twenty-four Politburo members wear uniforms. In 1998, Jiang issued a definitive order for the military to get out of large-scale commercial businesses. Hu Jintao, then his designated successor, oversaw the directive's implementation.

The fact that privileged pockets of the military still operate outside the law is on display on the streets of major Chinese cities every day. Porsches, SUVs and BMWs bearing military licence plates, often with expensively dressed women behind the wheels, are a common sight. Whether speeding blithely through the traffic or parked illegally outside nightclubs and gyms, the military-plated cars seem to exist in a legal dimension beyond that of ordinary citizens. As blatant as they are, though, these displays of privilege are largely a lagging indicator of the PLA's halcyon days of corruption and power. Party insiders striving to create a more rules-based state in China boast that the military's powers and duties have been codified much like the rest of the bureaucracy. 'They used to be a very privileged organization,' said an adviser to Hu Jintao. 'Any demobilized soldier would automatically get a job in government. This is no longer the case. These privileges have been withdrawn. This is a great achievement of the Party.'

Forced out of formal politics and business, the generals have a single

brief for the twenty-first century, to build the Party a world-class army, navy and airforce. The trade-off for the military of confinement to barracks is that their quarters are more plush and modern than they have ever been. The pay of soldiers has been substantially increased. Operational budgets have been lifted and military scientific research institutes lavished with funds to develop technology for the high-tech wars of the future. But this new task has brought with it a different set of slow-boiling tensions, between the growth of a professional military ethos, rooted in western traditions, and the overriding preoccupation of the Party to keep control of its most vital asset. As in much of twenty-first-century China, the often flashy modern overlay is still anchored, and weighed down, by old-fashioned political oversight.

At the top, Hu Jintao sits above the army as commander-in-chief, as the chairman of the Central Military Commission. In a still evolving institutional setting, the commander-in-chief role comes to Hu by virtue of his leadership of the Communist Party, but not immediately on taking office. Jiang Zemin did not hand over leadership of the military until nearly two years after stepping down as party secretary, infuriating many in the political and academic establishment. In doing so, he set a precedent that many expect Hu to follow when he finishes as party secretary in late 2012.

When you drill down into the ranks, into the day-to-day practice of political supervision, however, the Party's ubiquitous web of controls and its 90,000 party cells seem increasingly archaic, quaint to insiders and confusing to longtime students of the system abroad. 'What kills the military is the political system,' a retired officer told me. 'We don't have a sergeant system, and the sergeants and the like are the ones who do most of the real military work.' What the Chinese officer called the sergeant system is the tradition in western militaries of vesting substantial authority in non-commissioned officers. Commanders in western armies have a well-established practice of listening to NCOs, sergeants, corporals, warrant officers and the like, who have the delegated authority to make many on-the-ground decisions. 'In our culture, delegating actually enhances authority. It shows that a commander listens,' said a senior US military officer who has studied the PLA. 'It is difficult to have an NCO system in a culture which does not like to delegate authority. In China, where so much is vested in face, you

maintain your authority not just by being in charge but by appearing to be in charge.'

With the paramount emphasis on politics, the hierarchies are upended in China. From its very beginnings, the PLA has had a dual leadership system in its officer ranks. Much like a single person with two heads, one watching the other, each senior position is filled by two officers of equal grades, one a commander and the other a political commissar. Discerning the division of responsibilities between them, and who defers to whom and when, is not easy. 'They can't get their heads around our NCO system, in which a commander can defer to a subordinate,' said a foreign military officer. 'And we can't get our heads around their system, with these two equally ranked command-ers.' (The PLA now has an NCO corps, but its soldiers have none of the authority or *esprit de corps* of the western variety.)

The political commissar system was inherited from the Soviet Red Army, but comes with a strong whiff of Imperial China as well. Chinese emperors would send supervisors to the battle front to check on the loyalty of their military commanders. In a similar fashion, the Party uses Soviet-style commissars to monitor the military from the inside, oversee appointments through the PLA's own organization department and root out graft. Whereas the NCOs embody all the hallmarks of a high-trust system, in which superiors trust their subordinates to make decisions on their own, the political commissars model, like Chinese society, banks on little trust at all.

The modern PLA political officers spread throughout the ranks are part cheerleaders, part indoctrinators and part administrators. 'They go to great lengths in conversation to emphasize they are not political hacks running around with little red books, but fulfilling a professional administrative role,' said the foreign military officer. On the rare occasions that information does leak out involving their work, however, the controversies involving the commissars are overtly personal and political.

The most famous recent public act of rebellion against a commissar involved a troubled lieutenant stationed at one of the Beijing garrisons in 1994. After going through his subordinate's private correspondence, the commissar discovered the lieutenant's wife was pregnant with their second child, and first son. He informed the lieutenant's hometown

authorities, who ordered the baby aborted. The enraged lieutenant went on a shooting rampage, starting at the barracks, where he killed the commissar and other officers, before heading into a diplomatic district in the heart of the capital, 2 kilometres from Tiananmen Square. All in all, he shot about seventeen people before being killed himself. The army's own stained reputation post-1989 contributed to the carnage. The soldiers delayed their pursuit of their rogue colleague from the barracks in order to change from their uniforms into civilian clothes – in the words of one report, so as 'not to disturb the public' with their appearance.

The indifference of younger officers to mandatory political education and their bewilderment at its relevance to modern military duties seeps through persistently in official documents. Yung Chunchang, an officer of the Military Science Academy, complained in 2008 about how rising officers had become influenced by 'purely military viewpoints' and no longer thought political work was important. 'Once, when we were gathering opinions, one [young] comrade suggested – "Now that we have a market economy, and the profit incentive is being used, and the impact of rules and institutions is being emphasized, why do we still [say] political work is the 'lifeline'?"'

'Is there any doubt on this?' Yung had snapped back at the young comrade. After consulting with his superiors, the answer that came back from on high was that the pre-eminence of politics was 'the scientific conclusion left by the last several decades' and could not be changed. 'In 1954, someone deleted the sentence on "lifeline" [from political work regulations in the military], but Chairman Mao reinstated and approved it. Leading comrades such as Deng Xiaoping, Jiang Zemin and Hu Jintao have time and again emphasized the importance of the lifeline issue.' The political commissar system, pioneered by the Soviet Union, had in fact been abolished by Stalin because it was considered no longer useful in motivating the troops. In China, with the Party still in power, it was there to stay.

For the vocal neo-nationalists, there is no question the military could be anything but under the direct control of the Party. 'I have never thought about this. Is it important?' replied Song Xiaojun, when I asked him about the issue. I met Song when he was at the end of a tour in 2009 to promote *Unhappy China*, co-authored with Wang Xiaodong and other patriotic stirrers, sometimes collectively known as the 'New

Left'. Song was a former navy officer who had lectured at the national submarine college before leaving the services in the mid-eighties. He now edited a military magazine catering to enthusiasts tracking the latest in modern weapons.

For the likes of Song, there is no need to justify or explain the right of the Communist Party to rule the military, or the country for that matter. It is, in a phrase you hear again and again, simply 'the verdict of history', a fact of life after a revolution in which the military played a pivotal role. 'If you must talk about such a topic, we have to consider that after China was bullied, the Communist Party emerged with its military arm,' he said. 'The period of 1927 [when the PLA came into being] to 1949 [when the Party took power] is so particular. Unlike the UK or anywhere else, the people at the very bottom rung of the society rose up and regained the pride and dignity of the country, through military means.'

Over time, and away from the ritual hubbub about the military's loyalty to the Party, the PLA has evolved in recent years in line with the job it has been given, becoming a more professional force, with its own ethos and values. Even if they pay lip service to party control, younger officers are more focused on developing their military skills than their elders ever were. 'You hear junior officers complaining a lot about the quality of the military leadership,' said Andrew Yang, a Taiwanese scholar and regular visitor to Chinese military academies. 'They are extremely concerned that the world is changing fast. They want to be integrated into the global system. This second tier of the officer corps is more global.'

The officer class was once dominated by military families who grew up together in the same compounds and exchanged reciprocal favours as they rose through the ranks. For young officers these days, it pays as much to be expert as it does to be red. Promotions have been tied to technical and professional skills; career paths are highly specialized; educational requirements more strict, through custom-designed military academies; and an old-fashioned ranking system has been restored, replacing a revolutionary-era distinction between 'commanders' and 'fighters' reintroduced by Mao in 1965. The striking thing missing is actual combat experience. 'It is the most over-educated army I have ever come across in my life,' said a part-time lecturer at a PLA school. Many military princelings, the offspring of veteran Chinese leaders, still rise

through the ranks but they rarely get to the very top. Far from their pedigree ensuring promotion, the PLA's princelings are increasingly falling short in competitions for top positions. 'Instead of moving up to become chief military leaders, the majority of the princeling generals ended their career in deputy positions,' said Bo Zhiyue, a Chinese academic, who combed through decades of military records for his study. 'The fact that they hit a glass ceiling in the military and the Central Committee means their family background could be a liability.'

The PLA has also quietly developed a system where commanders take primary responsibility for their units, even though they are in theory ranked on a par with the political commissars. 'Effective command of the troops requires the concentration of power in one centre,' says You Ji, a Chinese military specialist. 'The PLA is no exception to this iron rule.' The only way that commanders and commissars can get on, he says, is through subordinating 'political affairs to the combat command system'. Foreigners who deal with the PLA have noticed the gradual sidelining of the political commissars. 'I have been on Chinese ships when the captain will not answer questions without first deferring to the political officer,' said Bud Cole, of the US National War College, a visitor over many years to Chinese naval vessels, 'and on others, when the captain doesn't really seem to care what the political officer thinks at all.'

If the symbiotic relationship between the Party and the PLA has faded, the new order, to quote David Shambaugh, an authority on Chinese politics, favours a 'more corporate, professional, autonomous and accountable military'. Ultimate control rests firmly in the Party's hands. But much as the Party has stepped back from micro-managing large state enterprises, the PLA enjoys greater freedom in managing its day-to-day duties. Far from subverting political control over the PLA, the redefinition of the relationship arguably displays the Party at its sinuous best. 'There is still more of a political direction than a strict military philosophy,' said the foreign military officer. 'But party work is adapting to societal change.'

The propaganda system is adjusting as well. On the PLA navy's sixtieth anniversary in May 2009, China invited naval officers from around the world to view its new nuclear submarine fleet off the port of Qingdao. For the sixtieth anniversary of the founding of the republic in October that year, Zhang Yimou, the once cleverly subversive

film-maker who joined the establishment when he oversaw the 2008 Olympics opening ceremony, was hired to direct the military parade through Tiananmen Square. The first major foray far offshore for the PLA navy earlier in the year, to conduct anti-piracy patrols off Somalia, was another important moment, as it displayed a tangible connection between the surging military budget of the previous two decades and China's growing international economic clout.

The Central Propaganda Department makes sure it keeps distinctive military voices out of public debates, to minimize the chances of damaging public splits between the PLA and the Party. 'The military is not allowed to have a position. They are forbidden [by the Party] from expressing their view,' said Yan Xuetong, of Tsinghua University, who has close ties with the military. Instead, the Party promotes a narrative of its own construction, of shiny new hardware, selfless patriotism and an expanding global role. All three of the made-for-TV military events in 2009 – the Somalia mission, the navy anniversary and the Tiananmen parade – were carefully managed to engender pride and confidence in the forces at home in a way that reinforces the prevailing system of the Party's control over the PLA. Abroad, the Party's expansive message is a much harder sell. Nowhere is this more evident than with the battle it has long planned for, closest to home, over Taiwan.

For the PLA, preparing for war over Taiwan has been the single most persuasive lever for squeezing more money out of the government. For senior party leaders, it has always been an easy way to wrap themselves in the flag. Reunification with Taiwan stands rhetorically as the PLA's divine mission, in which the military means must serve the political objective. 'The Party has always seen Taiwan as the final part of the jigsaw puzzle,' said Andrew Yang, in Taipei. 'There is no way to persuade them to let Taiwan go.'

Most commentary on the fate of Taiwan focuses on the balance of military forces, counting the missiles in China trained on the nearby island, or tracking the political controversy over the latest US arms package on sale on the other side of the straits. As important as this may be, much of this debate misses the point. The greatest impediment to Taiwan acquiescing to Beijing's rule has little to do with military firepower, or the prospect of a bloody war and the economic disaster that would doubtless accompany it, although both are crucial considerations for

Chinese policy-makers. The obstacle in Taiwan is avowedly political. In a word, it is the Party itself.

When Joseph Wu was studying computer science at university in Taipei in the early seventies, he was pressed constantly to join the ruling party. The advantages of signing up were laid out before him. He could get to the front of the queue for an overseas study visa. If he joined the army, promotions would come more easily. Job-openings in party-owned firms would be his for the taking. 'Everyone was always trying to recruit me,' he told me years later in his study at Chengchi University in Taipei. 'I was told you would have a better life if you enrolled in the Kuomintang.'

The Kuomintang (KMT), or the Nationalist Party, was in many ways the mirror image of the Communist Party, its bitter rival in China, or the mainland, as they call it in Taiwan. Like the Party in China, the KMT had been established on Leninist lines. It had its own organization department for doling out jobs in the state sector. The KMT directly owned some of the largest businesses in the country when it governed Taiwan, rather than just controlling them behind the scenes like the Party in China. The KMT also directly controlled the armed forces. By a small quirk of history (which the Communist Party is reluctant to highlight these days), one of the first political commissars of the KMT army on its founding in 1924 was Zhou Enlai. Later the long-serving and long-suffering premier under Mao, Zhou worked with and alongside the KMT during the brief periods when the two parties were allied or co-operating, in the twenties and in the forties.

The generation that grew up in Taiwan after 1949, the year the KMT fled the mainland to set up government on the island, have a striking clarity about the way China works, because they grew up in a system with so many similarities. The same cannot be said of the Chinese view of Taiwan. From the early nineties when Taiwan began to hold open elections for its national government, a process that has seen the KMT in and out of power ever since, the Party has struggled to come to grips with the idea of the Chinese democracy born and raised next door.

Throughout this period, Chinese leaders incessantly lectured the Taiwanese about the need to accept Chinese sovereignty, reviled their democracy as corrupt and hounded its diplomatic representatives around

the world. For good measure, Beijing periodically threatened Taiwan with war, once or twice firing missiles near the island's northern and southern tips to drive the point home. Ahead of the first three presidential elections beginning in 1996, China issued dire warnings about the consequences of the island going down the path towards independence. All the while, through the bluster and intimidation from the mainland, voting for their leaders in Taiwan became part of people's lives.

Joseph Wu is just one of many people whose fate has fluctuated with the electoral tides, as careers do in democracies all around the world. Spurning the KMT's offer of membership in the seventies, he got involved in opposition politics after returning home from gaining a PhD in political science in the US and joining academia. On the re-election as president in 2004 of Chen Shui-bian, leader of the Democratic Progressive Party, he appointed Wu as his chief adviser on mainland affairs and, in 2007, as Taiwan's de facto ambassador to the US. Wu had a brief, ill-starred stint in Washington, where he struggled for attention in the US capital which was fixated on a powerful, rising China and annoyed with President Chen. After the KMT returned to power, Wu, as a political appointee, was instantly out of a job. When I met him in early 2009, he had returned to work in a small, cluttered office at Chengchi, near the end of the train line on the outskirts of Taipei.

The KMT, back in power from 2008, was a different animal from the one that had ruled Taiwan for more than fifty years from 1949. Its big businesses had largely been sold off, or reverted to state control. The KMT's old organization department was used to nominate candidates for elections rather than place people in government jobs. The KMT's control over the military, control which had been withering away since the early nineties following the lifting of martial law, had gone altogether. The old political commissars in the military had been renamed political welfare officers, with different duties to match their new title. The military, once the KMT's army, was now firmly the country's army. 'Chen made a clear order to get the [KMT] out of the military,' said Wu. 'Many of the military officers were relieved they no longer needed to report to two bosses and lead a double life.'

In short, the KMT had shed all the powers that once made it so similar to the Communist Party. As such, the KMT's transformation was an inspiration to reform-minded people in China, as much as it

was an embarrassment for the Party, provoking constant comparisons between democracy on the island and the zealous commitment to authoritarian rule at home. He Weifang, the Peking University law professor, said Taiwan was a living example of how Chinese people were not fated from birth to be ordered around all the time. 'Taiwan today,' he said, 'is the mainland tomorrow.'

For the Party, the fact that the KMT had temporarily lost power was evidence enough of its shortcomings. 'They failed,' said Song Xiao-jun, the author, who traced the KMT's problems to their splits with the communists decades before. 'They made two huge errors. One took place in 1927, when they stood on the side of the warlords and land-lords. The second one occurred in 1946, when they sided with rightist forces and attacked the zones liberated by the communists.' For others, however, modern Taiwan offered the chance for a running commentary on the divergent political systems.

At the opening of the annual session of the National People's Congress, China's docile legislature, in Beijing in 2007, Li Zhaoxing, the bumptious former Foreign Minister and spokesman for the body, was asked about Taiwan policy.

'All policies follow the will of the motherland and the will of the people,' Li replied.

'Do you mean you want them to vote?' a Taiwanese journalist piped up.

'This question is a tricky one,' laughed Li uncomfortably. 'The answer is No. No!'

The KMT has come and gone and come again in Taiwan, but one thing has remained constant on the island through all the elections and changes of government from the early nineties onwards. In public opinion surveys, in which a consistent set of questions has been asked throughout, about 70 to 80 per cent of respondents have consistently supported, in different forms, the island's current political status. Even those people sympathetic to reunification don't want to join hands with China while it remains ruled by the Communist Party. Most Taiwanese prefer the status quo, with Taiwan as a self-governing terri-tory, independent in all but name.

The opinion poll results are striking when set against the deep economic and people-to-people ties developed between the two countries.

Since the late eighties, millions of Taiwanese have gone to China to do business, rediscover relatives or for sightseeing. At one point, an estimated 600,000 Taiwanese were living in Shanghai alone. Scores of Taiwan's high-tech companies shifted their entire manufacturing operations to the mainland to cut costs, making China by far Taiwan's most important economic partner. But over the same period, when Taiwanese witnessed up close China's astounding development, only a handful warmed to the idea of reunification. 'One-party rule is the problem,' said Andrew Yang. 'People here can tell the difference.'

Taiwan's boisterous elections are the most obvious manifestation of how different the island's political culture has become from China. But small things can be just as meaningful. After finishing my session with Joseph Wu at his university office, he ushered me downstairs to meet George Tsai, another former government adviser and academic, but firmly in the KMT camp, who also had an office on campus. In Taiwanese political parlance, Wu was 'dark green', the colour ascribed to the pro-independence Democratic Progressive Party. Tsai was 'dark blue'. Wu nonetheless graciously introduced me to Tsai, his avowed political enemy. For someone living in Beijing, where there is no formal political competition, the pair's polite exchange of pleasantries was arresting, the kind of ordinary democratic gesture absent from life in China.

Tsai himself was deeply committed to reunification. In a perpetual flurry of cross-straits activity, he had three trips to China planned for the following couple of months. His Chinese interlocutors in the past had whisked him away to different parts of the country for seminars – in Inner Mongolia, Dunhuang, site of famous Buddhist frescoes, and Jiangganshan, where Mao had hunkered down with the PLA in the civil war with the Nationalists. On these trips, Tsai would huddle for days with his Chinese interlocutors, discussing the Taiwan issue from every conceivable angle.

In the week before I met him, he said, he had received an urgent phone call from military intelligence in Beijing. Was the address by Ma Ying-jeou, Taiwan's president, delivered to a think-tank in Taipei, to be taken by Beijing as a definitive reply to a recent speech on the island by Hu Jintao? Tsai got on the phone to Taiwan's National Security Council and other parts of the government, before calling Beijing back, to tell them not to read the speech that way. Beijing clearly trusted Tsai.

There were few people on the island as active and supportive of reunification as he was. But Tsai had his own bottom line as well. 'I am for reunification but I am not going to accept communist rule,' he said. 'I hate that.'

Since late in the nineteenth century, Taiwan has been a Japanese colony, a Chinese province and, after the Nationalists under Chiang Kai-shek set up there in 1949, a rival outpost of the central government of China. From the perspective of the Party, the return of Taiwan would be the final glorious act in the restoration of a China humiliatingly carved up by aggressive foreign powers. Any alternatives to the official narrative have been strictly forbidden since the communists came to power. Over time, China has forced the same framework on its bilateral relations with just about every country in the world. Anyone invited to China, no matter how lowly, is required to acquiesce in the one-China policy, which recognizes Beijing's sovereignty over Taiwan. To do otherwise instantly renders an individual *persona non grata*. Foreign political leaders who fail to toe the one-China line put diplomatic ties at risk and invite commercial retribution for their companies. The policy has always been policed with a breathtaking exactitude, in which no transgression of the basic rule – that Taiwan is an inalienable part of China – is allowed to pass.

At home, the Chinese media also has to navigate linguistic traps to stay within the rules. A Shanghai newspaper reporting on the construction of a new semi-conductor plant in the city in 2002 hailed it as 'the largest in China'. It was only the following morning that someone pointed out the grievous error in this formulation. The world's biggest semi-conductor plants were in Taiwan, which was, of course, part of China as well. The editor was forced to make an old-style self-criticism and take a temporary pay-cut to atone for his mistake.

The reality of Taiwan is very different from the picture Beijing force-feeds to its Chinese citizens. Far from considering themselves part of 'one family', as Hu Jintao says, few Taiwanese feel an instinctive connection to a country which has been commandeered by the Party. Lee Teng-hui, the KMT leader who became the first elected president of Taiwan in 1996 and who propelled the push for Taipei to shrug off the mainland, was reviled in Beijing as a traitor to the Chinese nation,

a 'sinner of ten thousand years'. In fact, Lee embodied many of the quirks of the island's history. Raised under Japanese colonialism, he spoke flawless Japanese and poorly accented Mandarin Chinese. Lee struggled to generate an emotional connection to the motherland for obvious reasons, because he had never been to China in his life.

The rise of Taiwan's democracy movement under Lee Teng-hui in the nineties triggered a crisis in cross-straits ties that lasted for more than a decade. It was this period that also transformed Jiang into a hawk and aligned him more closely to hardliners within the military establishment. Inside China, Taiwan had always been a test of political virility, in which even the hint of weakness can be exploited by political opponents. Jiang's first proposal for reunification, issued in early 1995 at a time when he was still consolidating his influence over the PLA, had fallen flat with the military, with not a single senior general offering support. Jiang soon found excuses to toughen up.

When Lee Teng-hui was granted a visa to visit the US a few months later, in June 1995, Jiang succumbed to pressure from the top brass for an aggressive response, agreeing to a PLA recommendation for missiles to be fired into the sea north of Taiwan. The following year, ahead of Taiwan's first presidential election, Jiang approved another large military exercise to express Beijing's displeasure, including the firing of more missiles. Once again, Jiang struggled to maintain control over the military's conduct of the exercise, with the general in charge demanding to manage the drill free of supervision from the Politburo. The final humiliation was the dispatch of a US aircraft carrier group by President Clinton to patrol the seas around Taiwan, a show of force that Jiang could not match.

The crises of 1995 and 1996 were the moments when Jiang decided he would never again be caught short by the hawks in claiming the high ground on reunification. Chinese leaders had been rattled by the virtuosic display of high-tech US firepower in the first Gulf war in 1991. Five years on from this conflict, at a moment when China's swelling trade made it more reliant on the US than ever before, Jiang was shocked to find that the PLA was still ill-prepared to mount a military campaign against Taiwan. Jiang's hard line made the Taiwan issue a more powerful lever than ever for the PLA in internal budgetary battles. 'The military itself believes they are not ready yet,' said

Andrew Yang, in Taipei. 'They say – don't do anything to force us to act today. Just give us more resources.'

Throughout his second term, from 1997 onwards, Jiang cosied up to the hardliners in the system by raising the stakes on Taiwan, setting time-sensitive benchmarks for reunification safe in the knowledge his impending retirement meant he would not have to see the policy through. Jiang said that for Taiwan even to refuse to engage in a dialogue about reunification could be grounds for China to act against it. Although the military's voice was largely absent from the public debate, numerous accounts of this period have the PLA egging Jiang on. At what used to be the leadership's annual summer retreat at the seaside town of Beidaihe in 1999, according to diplomat-turned-academic, Susan Shirk, 'the generals argued emotionally that national honour was at stake in Taiwan', and that China had to take action to demonstrate its resolve.

When he became party secretary in 2002, Hu inherited an expanding economy and a Communist Party solidly in control of the government and ascendant over the armed forces. On Taiwan, however, Jiang handed his successor a veritable time-bomb. China has commissioned dozens of new submarines, built domestic naval destroyers, deployed anti-ship missiles which can be launched from submarines, and readied thousands of missiles along the coast a few hundred kilometres across from Taiwan, with the single aim of retaking the island. Hu was left to pick his way through a dangerous domestic political minefield, to find a way to take Taiwan off the agenda and restore absolute primacy to the economy, without alienating the PLA at the same time.

Hu's answer, when it arrived in 2004, proved to be a masterful piece of politicking. He presented the docile legislature, the National People's Congress, with an anti-secession law for passage in its annual session. At first glance, as a number of commentators noticed, it was not obvious why China needed an anti-secession law to authorize military force should Taiwan declare independence. Legislation has never prevented Beijing from silencing independence advocates in regions such as Xinjiang or Tibet. The law prompted initial outrage in Taiwan, and harsh criticism from Europe and the US. But its passage allowed Hu to strike out from a position of strength. Soon after, China invited the first of what would become a stream of visitors from the KMT in Taiwan to resume party-to-party dialogue with the communists.

By talking tough at home, and defying critics abroad, Hu had managed to take the issue out of the hands of the hardliners and reframe the Taiwan issue on his own terms. Jiang's timetables disappeared from view in the process. Instead, Hu pursued high-profile talks with friendly Taiwanese politicians, and soft-pedalled on the bellicose rhetoric that had so alienated voters on the island. 'Hu does not want to talk about a timetable for reunification, because it would work against his own interests,' said Alex Huang, of Taipei's Centre for Strategic and International Studies. 'Hu advances his position by advancing the economy. The Taiwan issue was not so urgent.'

When the KMT's Ma Ying-jeou was elected president in 2008, ending eight years of rule by Chen Shui-bian and the pro-independence Democratic Progressive Party, China was thrilled. 'After the election, a mainland official said: "We spent as much as the KMT on this!"' according to George Tsai. Whether the Party had spent real money or just political capital, Tsai's interlocutors did not say. Cross-straits relations warmed to levels not seen for a decade and a half. Bilateral political visits became regular events and direct transport links, held up in fruitless negotiation for years, were approved.

Tsai was not alone in ascribing Beijing's learning curve on Taiwan to a more sophisticated understanding of the island's politics. 'They have got used to democracy and have started to understand how our domestic politics works,' he said. 'If Taiwan is stable and democratic, it will cause no trouble for China.' Here was the success of Taiwanese democracy, and the crowning irony as well. In order to seduce the island's voters, the Party had had to adjust not just to Taiwan's democracy. Beijing's policies had become locked into the island's electoral cycle as well.

The official media in China naturally celebrated the new warmth in cross-straits ties, without spelling out the heretical bargain that lay behind it. In return for Taiwan taking formal independence off the table, Hu had effectively pushed timetables for reunification off into an indeterminate future. For those hardliners in the system who recognized the deal for what it was, it was a bitter pill to swallow.

After years of predicting, and indeed urging China to go to war over Taiwan, Yan Xuetong posted an unusual statement on the website of

the *Global Times*, a highly nationalistic paper, in mid-2008. It was an apology, he said, for his consistently wrong forecasts from about 2000 onwards that war with Taiwan was inevitable. Far from taking pleasure in his revised prediction of peace, however, the renowned professor was plunged into a state of despair at the lack of a resolution of the Taiwan issue. 'There is no more reunification,' he told me later. 'No more one-China principle. No more effort to get this island back.'

Even in a political and media establishment hard-wired to adopt a tough, nationalist stand on Taiwan, few had dared to talk as toughly in public as Yan. 'Personally, I think the earlier this military conflict takes place, the easier it would be for it to be a controlled, local and limited war,' he said in 2004. In interview after interview, and in the articles he penned for the press, Yan's attitude to war with Taiwan was like George W. Bush's fateful early taunt to the Iraqi insurgents – 'Bring it on!'

Once the pro-independence Chen Shui-bian was elected as Taiwan president in 2000, Yan believed that Beijing was in a race against time to stop the island being lost to Beijing for ever. He did more than dismiss arguments that war would damage the Chinese economy. He said the economic issue was irrelevant, because the pride of the nation was at stake. 'A strong country can benefit all of its people while a rich country cannot,' he said in a later article. 'A rich state does not mean a rich people. You can still have a rich country with poor people. In comparison, a strong country could give all of her people safety and dignity.'

Yan maintained that avoiding war risked greater damage than fighting one. Look what happened when the Soviet Union lost the three Baltic States. The country disintegrated. 'With the end of the Soviet Union, the average life expectancy of the Russians fell by five years, infant mortality rate increased and the total population decreased by 5 million between 1992 and 2001,' he said in a 2005 blog entry. 'The cost of the disintegration of the state that Russia paid amounted to a large-scale total war.' Any casualties China might suffer wouldn't be a big deal anyway, he said. After all, China's pre-eminent international relations specialist asserted, the country lost about 100,000 people each year in industrial accidents.

Yan's hawkish statements made him notorious in Taiwan and highly quotable for foreign journalists on the occasions he was in the mood

to take their calls. When Hu Jintao started his policy of cross-straits détente around 2005, however, Yan's outspokenness became embarrassing and discordant. The propaganda department ordered that one of his newspaper columns be dropped and his media appearances declined. For all his diplomatic boorishness, however, Yan touched on a deeply sensitive issue, that of a weak China unable to stand up to the west to protect its sovereignty.

Like Yan, the 2009 best-seller, *Unhappy China*, rages against the party establishment for consistently responding in a weak and shallow manner to the threats China still faced from foreign imperialist powers. 'Whenever they open their mouths, arty-farty nonsense comes out,' said Song Xiaojun. 'These people endlessly deride the weakness and incompetence of old China in the military area. But once you mention the idea of "martial spirits" and "strengthening national defence" to them, they jump out and swear "fascist" at you.' Chinese diplomats often ruefully joked how they received calcium tablets in the mail, sent by angry citizens who wanted their representatives to stiffen their backbones in dealing with foreigners. Like diplomats in many countries, the ministry in Beijing is often painted as limp in its dealings with foreigners. But for a Party whose legitimacy is based on liberating a hitherto feeble China from foreign domination, being painted as weak was altogether more dangerous.

Yan Xuetong and Song Xiaojun both disparaged the Party and the government for their feeble diplomatic policy, talking about it as though it were a form of recurring national disease. Where they differed was in their assessment of how people might eventually respond. Song earnestly believed *Unhappy China* was articulating a new wave of tough-minded patriotism in Chinese society. Yan, by contrast, was scornful of the Party and disillusioned with the citizenry.

Yan was still apologizing for his wrong forecasts of war when I saw him in mid-2009, but not for the reasoning on which they were based. His big mistake, he said, had been to misjudge the Chinese people. He had thought they would rise up at the prospect of reunification with Taiwan being pushed off the agenda. But in the end, people didn't care. 'Chinese people are not that nationalistic,' he said. 'They are very money oriented. The dominating ideology is money worship. As long as the situation in Taiwan is favourable to making money, we don't care if [the island] becomes independent.'

For the same reason, he argued, the urban middle classes in China and the students at his university had no interest in politics and democracy, because fighting for these ideals could only disturb their increasingly comfortable lives. On the twentieth anniversary of 4 June just days before our meeting, Yan's faculty members involved in the protests two decades before had been discussing how different they had been as undergraduates from their students. Today's students had little interest in what had happened in 1989, and even less in engaging in similar protests. 'If tomorrow the Chinese government says, we hate Americans and anyone who damages the American embassy and McDonald's is safe, the students will flock there, throwing stones. But if the central government says, anyone who dares to throw stones at McDonald's will be punished, not a single person will do it,' Yan said. 'As long as society is fully engulfed by money worship, you will have a lot of social crimes, but no political violence. People may kill and rob banks and do a lot of illegal things. They might risk their lives to steal money, but they will not do it to attend a political demonstration.'

Yan omitted to mention that students had long been warned that their careers would suffer if they got involved in anti-party politics. But he was making a broader point about the values of the entire society. 'The government does not care how you become rich, no matter by prostitution, drug-trafficking, smuggling, corruption, bribery or even if you sell the territory to others,' he said. 'That's why, on Taiwan and issues of sovereignty, the government gets people's support. The government tells you, we do not insist on sovereignty in the east China Sea [with Japan], because that brings favourable economic development. We do not protest against the Philippines [in a territorial dispute in the South China Sea], because that favours economic development. We allow Taiwan to have sovereignty, in favour of our own economic development.

'The party leaders realize that they don't have a dominant ideology they can use to run the country any more. For them, there is no core social value. At this moment, the sole, dominant ideology shared by the government and the people is money worship.' For Yan, wealth did not automatically translate into strength. 'Our military budget is already 1.6 times that of the Russians but we cannot build the same military,' he said. 'Our education spending is much larger than India's,

but we cannot have one single person win a Nobel Prize. They already have ten. We have more rich people than Japan and we have more first-ranked companies, but we can't build world-class products. We have more foreign reserves than anyone in the world but we cannot build a financial centre even like HK.' The list went on and on.

In Taiwan, the former deputy defence minister, Lin Chong-pin, gave me a different spin on the same issue. Lin deeply admired Hu's handling of Taiwan and the way he had wrested control of its management away from the hardliners. Years before cross-straits relations began to improve, Lin said he had received a message through relatives in China that the Politburo had resolved to turn Taiwan into 'an innocuous international issue', which was exactly what had happened. Hu's new Taiwan policy was distilled, in idiomatic Chinese style, into a single saying: 'Enter the island; enter their homes; enter their minds.' Everything that his well-placed contacts in China had promised would happen regarding policy on Taiwan under Hu had come to pass.

The reason why Taiwan had been pushed off the agenda, Lin said, was because Hu realized it did not threaten the stability of the country nor the Party's grip on power and control over the military. 'Hu knows the major enemy is not outside China,' said Lin. 'It is corrupt officials inside.'

5

The Shanghai Gang

The Party and Corruption

'People have been driven from one corner to another corner of the city. Many among us also have to endure illegal surveillance, home searches, forced repatriation, detention, re-education through labour, being locked in psychiatric asylums, phone-tapping, harassment and other ways of suppression.'

(Zheng Enchong, a Shanghai lawyer)

'If I am not mistaken, our country's private enterprises produce over 40 per cent of GDP nationally. Here in Shanghai, state enterprises produce nearly 80 per cent of GDP. If you want to discuss who adheres most to socialism, couldn't it be said to be Shanghai?' (Chen Liangyu, Shanghai Party Secretary)

As protests go, the first one seemed like a desultory affair. In the summer of 2002, a small band of local residents strolled languidly through the laneways of old Shanghai to the district courthouse, hugging the shady side of the street for respite from the stifling heat. At the head of the march was a 41-year-old restaurateur. Tall and slender, with a gentle, almost ethereal manner, Xu Haiming seemed as low-key as the protest itself.

The business Xu had set up in the Jing'an district, in central Shanghai, had much the same qualities: a three-storey teahouse-cum-restaurant styled with a counter-cultural Tibetan theme, the kind of hippie-chic then becoming fashionable among young urban Chinese suddenly afflu-ent enough to ponder a laidback alternative to the rat-race of China's richer cities. Xu had bought the corner building two years earlier, on

a large block of the old colonial city, just off Nanjing Road, one of the main shopping and business thoroughfares in downtown Shanghai that sliced through the old French Concession and snaked all the way to the Huangpu river. He paid US$50,000, and ploughed the rest of his life savings into renovating the property.

Xu had never been trying to make a political point with his teahouse. There were no pictures of the Dalai Lama, the Tibetan spiritual leader, hanging on the walls, or anything else that might have provoked the authorities. It was Xu's timing, not his Tibetology, that was the problem. Just as his business was gathering momentum, Xu received a notice from the district government ordering him to vacate his property. District officials had sold the building to a businessman, in return for a slice of the development slated to take its place. For the development to go ahead, and the officials to get their pay-off, Xu had to go. 'They never even asked me,' he said. 'They just said they were going to knock the building down.'

Scores of neighbourhoods, once criss-crossed with colonial-era residences housing tens of thousands of people, were laid to waste in the 1990s and the early part of this century in Shanghai. Swathes of the city were left resembling Berlin after the Allied blitz. The frenzied reconstruction which followed was one of the largest building booms in recorded history. About 20 million square metres of land were developed in the city between 2000 and 2005 alone, equal to one-third the size of Manhattan. Literally hundreds of new skyscrapers and apartment blocks went up in a few short years, on top of an already massive building programme in the previous decade. On the east bank of the Huangpu river opposite the main metropolis, an entire, ready-made financial district had been constructed where there had once been a small village.

Huge fortunes were there for the taking. Citizens like Xu who had the temerity to stand between the bulldozers and the money to be made in the real-estate boom risked more than just their livelihoods. In Shanghai, they found themselves fighting a city government which profited from the sale of land, and developers and individual officials who made buckets of money from the projects that followed. Standing up to property developers was like drawing a dagger against the all-powerful local party boss, Chen Liangyu himself, and an army of corrupt officials lined up behind him.

A local lawyer, arrested and re-arrested numerous times after he persisted in taking up the complaints of residents, was not exaggerating when he denounced Shanghai's top leaders in an open letter to Hu Jintao ahead of the 2007 congress. 'People have been driven from one corner to another corner of the city,' Zheng Enchong said, referring to the residents uprooted from their homes and communities in the city centre and then sprinkled randomly into small new apartments in the distant suburbs. 'Many among us also have to endure illegal surveillance, home searches, forced repatriation, detention, re-education through labour, being locked in psychiatric asylums, phone-tapping, harassment and other ways of suppression.'

When, after the street march, Xu Haiming appeared before the local court in front of a gallery filled with supporters, he waved a sheaf of property titles at the three judges. 'Any government decision to force us out is illegal, because the law of our country protects our ownership rights,' he declared. 'The reason we are bold enough to come to court is because we still have faith in the integrity of our judges and the soundness of the legal system.' In truth, Xu knew he would never find an ally in the law. The same party committees of the city and district governments against whom Xu was fighting ran the courts, appointed the judges and paid their salaries. His noble-sounding speech was just grandstanding, a public relations pitch in his high-risk campaign to force the city and the property developers with whom it was in cahoots to give him a fairer deal. All along, any trouble he could stir up in the courts and the media was a device to capture the attention of the sole body within the system with the clout to bring Chen Liangyu and Shanghai to heel, the Party's anti-graft body, the Central Commission for Discipline Inspection in Beijing.

The threat of an investigation by the commission is enough to send shivers down the spines of any party official, although not in the way many might think. Senior party members in China are much like members of the US military when it comes to criminal investigations. They cannot be arrested by civilian law enforcement bodies or other outside agencies for criminal offences until the allegations have been investigated by the Party first. The commission alone, as the Party's in-house anti-graft body, has the right to investigate officials and detain them when it decides they have a case to answer. 'The country has the country's rules,'

said one official, in explaining the system's logic. 'But in your house, you must follow the house rules, and they are the most important.'

The 'house rules' are very simple. For any official it wants to probe, the commission must first get clearance by the party body one level up in the governing hierarchy. In other words, the more senior an official is, the more difficult it is for the commission to gain approval to investigate them. The stream of corruption cases in China and the ruthless justice meted out to those who fall foul of the system sometimes gives the impression of a Party committed to exterminating graft without fear or favour. Far from being a modern-day Chinese version of Eliot Ness's 'Untouchables', however, the commission is structured to keep its investigators in check. The approval process, with its bias towards protecting top leaders from any scrutiny at all, means the commission is dogged by politics, and political struggle, at every turn.

For Shanghai, the bar was set especially high. The city was more than just China's commercial capital. Within the party firmament, the metropolis had provincial-level status and, by rights, Chen Liangyu, as the Shanghai party secretary, had a seat on the Politburo. The only way to investigate Chen and his cronies was to go over the city's head to Beijing, to win the approval of Hu Jintao himself, and the entire nine-member Politburo Standing Committee, a body stacked with Shanghai grandees. It was Xu's good fortune that the moment he launched his campaign for justice in Shanghai, the city's political stocks in Beijing was beginning to tail off. But it would take years for the scandal to unfold and the political deals behind its denouement to be played out.

When the former vice-mayor of Beijing, Liu Zhihua, was convicted in September 2008 of taking bribes worth about $1 million, local netizens lampooned him on internet postings as an under-performer. 'That's not much money!' one blogger said of Liu, who had been in charge of construction for the Olympics. 'He should count as a clean official. No need for a trial. Release him now!'

Apocalyptic warnings from Chinese leaders about the threat posed by corruption to the Party's grip on power have become routine fixtures of top-level political speeches in the last two decades. Hu Jintao, in a 2006 address to the anti-corruption commission, directly blamed the abuse of power by party bureaucrats for rising social conflict and public

protests. 'This time-bomb buried under society could . . . lead to a series of explosions, which would cause chaos throughout society and paralyse the administration,' he said. As dramatic as it sounds, Hu's warning about corruption was not much different from similarly dark pronouncements on the same subject by Jiang Zemin, his predecessor. The revelations about each new scandal have long been greeted with outrage and horror in the official media, followed by sombre speeches from senior leaders about the 'life and death' struggle the Party is waging against graft. Everyone vows to work harder and life pretty much goes on, because the anti-corruption system, which allows top officials effectively to supervise themselves, does not change. Only one thing has altered dramatically over time – the size of the bribes, which now routinely run into millions of dollars, even for relatively low-level officials.

The notorious Xiamen case, in which a crafty, illiterate businessman bribed nearly the whole of a city administration, along with the military, to smuggle more than $6 billion dollars' worth of goods through the coastal city's port, free of duties, shocked the central government and ordinary people alike when it was uncovered in the late nineties. But more typical are the cases involving senior officials in all parts of the country, including impoverished backwaters, that come out so regularly that corruption stories in the official media develop an almost humdrum quality.

In the few months in 2009 when I was writing this chapter, the railways bureau chief in Urumqi, in far-west Xinjiang, was charged with embezzling $3.6 million; in Shanghai, a mid-level official in charge of property was convicted of taking $1 million in bribes and forced to divest himself of real estate worth nearly $6 million; in a small rural township near Chengdu, in Sichuan, the party secretary and head of the local real-estate company was executed for taking $2.5 million in bribes; in the poorest town in Guangdong, the local police chief was discovered with $4.4 million in cash at home; in Chongqing, western China, the head of a development zone went on trial for misappropriating $32.1 million and taking bribes of $1.4 million in a case involving thirty other officials; in Changchun, in the north-east rust-belt, the police chief of a single district was found with $1.9 million in cash in his office; and in Suzhou, the vice-mayor in charge of construction was sentenced for taking about $12 million, the largest one-off

bribe on record. With sums like that on offer, it's little wonder that the vice-mayor of Beijing, who presided over a billion-dollar construction budget, could be mocked for taking so little.

In a country minting new millionaires every year, the temptation to leverage official positions to make money is irresistible. An official in the Chinese bureaucracy enjoys the status, power and gravitas that comes from working in an administrative system with thousands of years of tradition. But prestige and a bent for policy-making are not the sole drivers of competition for jobs in government. Many people seek administrative positions precisely because they can monetize them. Wang Minggao, who headed a national research team studying the 'clean official syndrome', a title which unconsciously underlined the lack of them, said that the 'whole idea of being an official is to become prosperous'. Without the under-the-table benefits that come with holding an official position, there would be no blossoming black market in buying and selling their government jobs, because they would carry no monetary value.

The paltry official pay rates add an extra incentive for graft. The salary packages of senior government and party members are not published, but are so low as to prompt ministers to complain about them in public. When Chen Zhili, at the time a cabinet member, was confronted by a university professor in 2007 complaining he earned less than $13,000 a year, she asked the Minister for Science and Technology attending the same forum what he was paid. Xu Guanhua, the then minister, said he was on a salary of about $1,350 a month. Chen added that she earned about $1,450. Even allowing for the perks, such as housing, cars and lifetime pension benefits, the formal cash salaries of even senior officials are miserable and invariably padded by illicit income. 'Every official has three lives,' said one official-cum-businessman jailed on corruption charges. 'Their public life, their private life and their secret life.'

A bitter – and highly popular – internet posting called corrupt officials 'the new black-collar class', who concealed their wrongdoing in a shroud of secrecy. 'They drive top-brand cars. They go to exclusive bars. They sleep on the softest beds in the best hotels. Their furniture is all of the best red wood. Their houses overlook the best landscapes, in the quietest locations. They play golf, travel at the public expense,

and enjoy a life of luxury,' said the anonymous blog, posted in July 2009. 'They are the newly arrived "black-collar class". Their cars are black. Their income is hidden. Their life is hidden. Their work is hidden. Everything about them is hidden, like a man wearing black, standing in the black of night.'

Corruption thrives in sectors with heavy state involvement and considerable room for administrative discretion: customs, taxation, the sale of land, infrastructure development, procurement and any other sector dependent on government regulation. The jobs in government which attracted the most applicants in 2008 were not elite positions in the mandarinate in the Foreign Affairs and Finance ministries in Beijing and the like. Of the top ten government bodies which received the most expressions of interest for positions, eight were provincial tax bureaux, topped by Guangdong, all of them along the prosperous coast; and two were the customs bureaux of Shanghai and Shenzhen. The bottom ten, which attracted the least interest, were all provincial statistics bureaux.

Operating out of unassuming modern premises in west Beijing, the Central Commission for Discipline Inspection has a modest 800 full-time staff at head office. Much like the organization and propaganda departments, anti-corruption work is decentralized, with small branches at each level of government and in each organ of the state. Every province, city and county government, and any state organization under them, all have their own anti-graft commissions or representatives to keep an eye on party members. Large state companies have an in-house commission delegate as well. Superficially, the commission's investigators and their representatives, who are spread throughout the country, would seem to have all bases covered. In reality, the body's corruption-busting abilities have long passed their prime.

Established in its present form in the late seventies, the commission was structured for a bygone era when officials and the urban populace were confined within single work units, when workers, goods and capital were not mobile and 'corruption was practised by individuals or small numbers of people'. According to Flora Sapio, an academic expert on its operations, the commission's regular staff are usually 'Communist Party generalists', with low education levels, little or no legal training and few investigative skills. Corruption in modern China,

with its surging wealth, proliferating business structures, walled-off government empires, massive vested interests and global reach, has simply left the commission's traditional methods behind.

The portrayal of the commission's officials in propaganda campaigns has unconsciously reinforced this image of put-upon corruption-busters, battling insurmountable odds against entrenched graft. In an interview in 2005 played up in the domestic media, Li Youxing, an anti-corruption official in Zhejiang province, complained he had not had a holiday for eight years. He still lived in a shabby wooden house in Taizhou, a wealthy city, with a patched-up couch, a rusty fridge and a broken-down TV. His wife woke at night, screaming in fear about threats to kill them. Li battled on regardless. 'When a cadre's needs conflicts with those of the organization, he should unconditionally submit himself to the demands of the organization,' Li said. 'If someone is afraid of death or losing his official hat, then he should not be a discipline commission chief.'

To tilt the odds back in the commission's favour, the Party allows the body to play tough, handing it untrammelled powers to deal with the approved targets of its investigations. The commission's powers of detention are the most fearsome weapon in its armoury. There are no legal niceties when the commission comes calling. Under a procedure known as *shuanggui*, or 'double regulation', so called because suspects are held at a time and place regulated by the Party, the commission, in effect, kidnaps officials, and holds them for interrogation until a decision is made on whether to proceed with a formal case against them. Officials under investigation have no rights to call their families or hire a lawyer, and can be detained without trial for up to six months, without the law ever entering the equation.

The suspects' welfare is taken into consideration in one respect. They can be held almost anywhere, in company offices, dormitories and hospitals, with a single proviso. They must be kept in single-storey buildings, or on the first floor of multi-storey buildings, to prevent a repeat of the fatal escape attempts of a number of senior officials under interrogation in the late nineties, who committed suicide by jumping out of their high-rise holding pens. Commission officials guard and watch detainees even when they visit the toilet, according to Ms Sapio. 'Sleep deprivation, round-the-clock interrogations and

a skilful alternation of abusive treatment with displays of gentleness'
– all the techniques that entered everyday political parlance through
the Bush administration's merciless pursuit of terrorists have long been
legitimate tactics to secure the co-operation of suspects in the Party's
custody in China. On rare occasions, officials considered to have
co-operated with investigators, usually by providing evidence against
someone else, are permitted to return to their former posts. But few
careers prosper after a period under *shuanggui*. It is a life-threatening
experience that inevitably scars the detainee thereafter. Paradoxically,
it also represents the final chance for suspect officials to save their skins.

With neither judge nor jury to speak of, the commission's verdicts
are delivered in public through an unusual mechanism, the announce-
ment of the suspect's expulsion from the Party. Only then are their cases
formally referred to the prosecutors. Being expelled from the Party for
serious corruption is tantamount to a finding of guilt in a court of law,
even though the trial itself and a formal verdict and sentencing may be
months or longer away. Once officials have been passed over to the
legal system, their fate has already been decided. 'During *shuanggui*,
the person is still struggling to obtain their personal freedom or be let
off with a demotion in rank,' said Qian Lieyang, a Beijing lawyer, who
works as a government-assigned defence counsel for officials charged
with corruption. By the time they reach the court, he admits, the argu-
ment is solely about the length of their sentence, not their guilt or
innocence. 'When they are transferred into the legal system, they lose
all hope. It means the end of their political career. Normally, when I
take their case, it is the lowest point in their mental state.'

The Party, or at least the sections of it which have control of
the anti-graft body at any given time, savours the fear generated by the
commission's dark powers. The commission calls its undeclared spies
'grains of sands', scattered through any institution it might decide to
target or about which it is suspicious. The editor of a Shanghai news-
paper confided during the property scandals that he had been told that
an individual on his staff was working for the anti-graft commission,
but he had no idea who it was. 'It could be the cleaner. It could be the
deputy-editor,' he said.

The commission works, by definition, in secret, and relies on the
subterranean eddies of China's tittle-tattle culture for most of its tip-offs,

in the form of the reams of anonymous letters and petitions which arrive at its offices every day. Some corruption is uncovered through lawsuits filed against Chinese entities overseas. Some comes to light through material discovered in other investigations. But the commission's greatest ally in uncovering corruption is not open and above-ground investigations. Wang Minggao estimates about 60 to 70 per cent of investigations are triggered by informants. The *People's Daily* has reported that the figure is as high as 90 per cent in some provinces. 'Ordinary people's eyes are the sharpest,' Wang says. 'Many cases arise because of reporting by ordinary people.'

Many informants, of course, are only posing as 'ordinary people'. In reality, they are often part of rival cliques attempting to undermine personal and political rivals. In top-level political struggles, such as the Shanghai case, the anonymous dirt-files inevitably leak into the Chinese-language press in Hong Kong, the foreign media, or, in more recent years, Chinese-language websites hosted outside of the country, in the hope that the information blows back into official circles in China itself. Anonymous letters provide the only safe way for anyone, be they a member of the public or a junior official, to report corruption allegations about superiors without being harassed or even arrested themselves.

Political rivals have another technique to spread dirt about their enemies, through books masquerading as popular crime novels. The existing fiction genre in China preys on public cynicism about degenerate cadres and their carpet-bagging families and mistresses. But these novels can also double as sophisticated acts of subversion, exposing tales of real-life corruption in thinly disguised plots. *Wrath of Heaven*, the most famous *roman-à-clef*, chronicled the removal from office of the then Beijing mayor, Chen Xitong, in 1995, providing the kind of lurid detail absent from the dry accounts of his downfall in the state media. In the book, the princeling son of the Beijing party secretary runs wild, siphoning off government funds for a luxury house, and sharing mistresses with his father in sessions videotaped in their five-star hotel love nest. Jiang Zemin, who instigated the investigation into Chen Xitong, an avowed political enemy, praised the book initially, before the authorities decided enough dirty linen had been aired and banned it from sale.

The threat of being fingered anonymously explains why officials will

go to enormous lengths to conceal any behaviour that might give rise to suspicion about potential wrongdoing. When Zhang Enzhao, then president and chairman of the China Construction Bank, one of the country's top three lenders, was invited by a US financial services company in 2002 to play golf at Pebble Beach, the iconic California course, he asked his hosts to buy clubs for him. Golf has become immensely popular as the business networking sport of choice in China, as it is throughout Asia, but is officially frowned on because it uses scarce land and water the government thinks should be retained for farming. In one of the regular campaigns against the game, golf was branded as 'green opium' for the damage it did to the body politic. As a senior official, Mr Zhang confided to his hosts that he did not want to attract 'unnecessary attention' by carrying clubs on to the plane in Beijing himself. He demanded they be given to him on the course itself.

Zhang's tradecraft did him no good in the end. The banker was detained by the anti-corruption commission in March 2005 over allegations made in a US lawsuit that he had taken bribes of about US$1 million from the company that hosted him at Pebble Beach. Zhang received a phone call out of the blue at his home in Beijing from the commission one early evening on a working day in mid-March and was told to wait there. He then made a single phone call to a colleague and asked him to take his place two days later at a speaking engagement to which he was committed. 'I won't be able to make it,' Zhang said, according to bank officials, and then hung up the phone. A car picked Zhang up at about 8 p.m. at his home and took him to the commission's headquarters for questioning. Zhang never appeared in public again. About eighteen months later, he was finally tried in court on charges of bribery and sentenced to fifteen years in jail.

'Wen Jiabao went ballistic' on hearing the allegations against Zhang, said an adviser to the Chinese bank's foreign share offering, scheduled for a few months later. The leadership was enraged because the scandal threatened to undo years of reform of the financial system. Once Wen had calmed down, however, he might have reflected how lucky the leadership had been to catch Zhang at all. Zhang's case, even though he was caught, highlighted the anti-corruption system's other great failing, the fact that senior officials are largely responsible for supervising and investigating themselves.

Like all large state bodies, China Construction Bank has an executive on its supervisory board who acts as the delegate of the anti-graft commission within the institution. This executive performs the usual perfunctory political duties required of cadres, disseminating details of the Party's latest anti-graft edicts through the organization. He is also responsible for handling internal complaints about corruption within the bank. All allegations about corruption flow through his door. In the case of Zhang, the inherent weakness of such a system is not hard to spot. The anti-graft delegate inside the bank was answerable to Zhang, who outranked him as the bank's party secretary. In other words, besides keeping an eye on the rest of the company, the delegate was also theoretically supervising Zhang, his boss, who had appointed him in the first place. It was just Zhang's bad luck that the complaint came from overseas and went to the commission's head office in Beijing. If the allegations had been made internally in the bank rather than in the US, Zhang would have been in charge of approving an investigation into himself, something he was clearly unlikely to do.

The system frets constantly about how to devise an effective way to supervise the 'number one hands', like Zhang at China Construction Bank and Chen Liangyu in Shanghai. Niu Yuqing, a scholar at the Central Party School in Beijing, said the individuals who headed party committees, be they in provincial or city governments or state companies, seldom seemed to be held accountable for wrongdoing. 'These people fly above or exist outside the system,' he said. The commission's delegates inside ministries and companies rarely refer corruption cases they uncover in their bailiwicks to higher authorities, for fear they will be exposed as whistleblowers without support from on high. They 'either do not dare [to refer cases], or are not willing to,' says Li Yongzhong, another party school scholar. Li's recommended remedy for this weakness, the creation of a separate bureaucratic stream for the commission, foundered because the Party will not allow any body to act independently of it. Other proposals have failed for the same reason. 'A couple of dozen documents cannot control one mouth,' said Niu. 'And over a dozen departments cannot control one pig.'

Chinese scholars, like Niu and Li, have produced many acutely critical reports about how the structure of the anti-graft system compromises its independence and effectiveness. But their status in the party

school means they have to pull back in the face of the obvious conclusion, that as long as the Party and individuals within it supervise themselves, systemic corruption will continue to flourish. It took a scholar from Taiwan to nail the logic of the positions taken by the mainland scholars. If the Party had followed the pair's recommendations for an independent anti-corruption body, the Taiwanese academic noted, then it 'would have achieved the "separation of powers" proposed by Montesquieu that has long been rejected by the CCP as an idea belonging to the decadent bourgeoisie'.

The biggest beneficiaries of the requirement for the commission to get political clearance from above to proceed with investigations are the country's most senior leaders. Short of civil war, there is no mechanism by which the commission can get approval to investigate any of the nine members of the Politburo's inner circle, unless they effectively hand themselves in. As the son of a former senior leader told me: 'It is sort of a given that they are beyond the law.' By extension, their seniority protects their immediate family members as well, and reinforces strict taboos prohibiting public discussion of the private and business lives of top leaders and their kin.

The furore that erupted when a Taiwanese jeweller encountered the wife of Wen Jiabao, Zhang Peili, at the Beijing diamond fair in 2007, underlined the force of the taboo surrounding leaders' families. Ms Zhang was for many years the vice-president of the China Jewellery Association and reportedly retains interests in companies trading diamonds in the country. The jeweller, flattered by Ms Zhang's compliments about his stand, spoke admiringly to a Taiwanese cable station about the expensive pieces she was wearing, worth, he estimated, about $300,000. The naïve dealer, who had just been trying to promote his wares, quickly realized, once his comments were relayed in a flurry of headlines in Hong Kong and Taiwan, that he had stumbled into an area totally off-limits in China. Within days, Taiwanese jewellers had collectively taken out full-page advertisements in the Chinese-language media in the two markets apologizing to Ms Zhang and accusing the media of distortion.

Wen's wife attracts attention because her role in the flashy diamonds business is so at odds with her husband's carefully cultivated image as the clean-living humble people's Premier. In an open political culture,

the obvious conflicts of interest between his position and the wealth she has generated in a tightly regulated business would be legitimate grist for the mill of public debate. Under the watchful eye of the propaganda department, however, Ms Zhang's business dealings disappear into a black hole. Wen himself takes care never to appear in public with her and the media in China are not allowed to report on her dealings. 'This conflicts with the kind of open atmosphere and image that the Chinese government is advocating, and something that is very much accepted in the west, to involve one's spouse in public occasions,' said Jin Zhong, the editor of *Kaifang* (*Open*), a Hong Kong political magazine. 'Even though Jiang Zemin's wife is elderly, he still takes her with him everywhere, as did Zhu Rongji, Li Peng and now Hu Jintao. Why not Wen? What reason is there for his wife not to show up? No Chinese would dare to touch upon this.'

The blackout imposed on information about Ms Zhang was replicated to suppress stories about corruption charges against a company once headed by Hu Haifeng, Hu Jintao's son. The case was especially embarrassing for Hu, as he had until then won praise for keeping his family under control, unlike his predecessor, Jiang Zemin. The Chinese internet police gave suppression of the Hu Haifeng case the highest priority after it was first reported in Namibia, southern Africa, in July 2009. In a virtuosic display of their censorship capacities, the authorities were able to block stories about the case from within internet sites. So while the websites of the *New York Times* and the *Financial Times* were not blocked in China, the specific stories within them about Mr Hu's case were. Equally, the subscription-only, password-protected Factiva news service operated normally inside China, but was disabled the moment users tried to call up stories about the Namibia case.

If they are careful not to flaunt their power and wealth at home, and in the cases of Ms Zhang and Mr Hu, keep their business activities out of the media, top leaders and their families are just about untouchable. 'If the emperor does not want investigators to pursue corruption cases, then that's it,' said Wang Minggao. 'If they run into the relatives of the emperor, they will be running into his core interests. Basically, they would be trying to exercise individual power against a whole class of people.' The only thing that can tip the balance is top-level politics.

In the mid-nineties, Jiang Zemin's removal of the Beijing mayor,

Chen Xitong, on corruption charges symbolized his ascent to genuine power in the capital. Initially a weak leader in thrall to the elders who appointed him, Jiang gradually and deftly built his own power base, establishing loyalists from Shanghai at the top of the central government. The 'Shanghai gang' ruled the roost in Beijing for the best part of a decade, showering their home town with policy privileges and incurring deep resentment elsewhere in China. By 2002 and 2003, however, the faction's power had peaked and had begun its decline, leaving the city and its leaders vulnerable as never before.

Shanghai had been fêted in colonial times as the Pearl of the Orient, a mercantilist and mercenary trading hub where it was 'hard to know where the government ended and gangsterism began'. When Mao's sandal-clad army marched into the city in 1949, they cast a cold eye on the freewheeling entrepot. Branding Shanghai the 'whore of imperialism', the communists submitted the city to a lengthy punishment, closing private businesses and locking up, or banishing, entrepreneurs, gangsters and foreigners alike. By the mid-sixties, history had turned full circle. Shanghai, once a gangsters' paradise, had become the stronghold of the Party's ultra-radicals. The spell that these two contradictory political currents cast over the city was not broken until 1989. The Shanghai that these days dazzles foreigners and local out-of-town visitors alike ironically owes its resurgence to the military suppression of the demonstrations in Beijing and other cities across the country that year.

Mao and his third wife, Jiang Qing, had used a clutch of radicals from Shanghai to launch the Cultural Revolution in 1966, their putsch against their chairman's party rivals in Beijing. The 'Gang of Four', as Jiang Qing and her three cronies from the city came to be known, radicalized the economy and the arts. When Mao died, they tried to extend their power over the entire central government. Even after the Gang of Four were outmanoeuvred and arrested in Beijing in October 1976, the Shanghai party committee tried to fight on, mobilizing local militia groups to stage an armed insurrection against the incoming regime in Beijing. The city's bosses backed down only when Beijing prepared a military counter-action, and Shanghai's own residents, tired of their ultra-leftist leaders, took to the streets to support the new central government.

A newly chastened Shanghai was retooled by the Party into a bastion of state industry and forced to remit any profits generated by its enterprises to the central government in Beijing, much as had happened in the fifties, leaving nothing for reinvestment at home. In 1983 alone, Shanghai remitted more to the central government in taxes than it had received in investment from Beijing in the entire previous thirty-three years. Shanghai stagnated under Beijing's thumb for more than four decades, until the early nineties, when politics intervened again, this time in its favour.

Deng Xiaoping, searching for a way to revive the national economy and fend off his left-wing critics in the wake of the Tiananmen massacre, produced the city as his trump card when he returned to the political stage on his 1992 southern tour. Deng lamented that his big mistake in the late seventies had been not to include Shanghai in the first batch of areas allowed to develop the market economy. More than a decade after Deng's policies had been pioneered in southern China and elsewhere, Shanghai was finally let off the leash.

Shanghai's leaders inherited a city in the early nineties with a great commercial history that had been emptied of commerce. They wasted little time in getting back into the game. In the decade from 1992, the city roared back to life, spurred by decades of pent-up demand. The visible fruits of this growth – the city's gleaming skyscrapers, grand public buildings, sweeping flyovers and bustling metropolitan vigour – are a stunning advertisement for Shanghai's, and China's, revival. Shanghai's own turnaround was symbolized by a single image, the spectacular and much-photographed Manhattan-like skyline of the Pudong financial district, an area which only a few years before had been a small, scrappy village.

Streams of foreign visitors have been dazzled by the view of Pudong, usually while clinking glasses on the terraces of the upmarket eateries housed in the colonial-era buildings that line the riverfront strip opposite, known as the Bund. The image this view conveyed – that Shanghai had returned to its entrepreneurial heyday – was far from reality. Unlike southern China and the Yangtze delta region, where Deng's policies had bred a risk-taking, private economy, Shanghai was developed as a socialist showcase. Few visitors admiring the skyscrapers realized that most of them had been built by city government companies. Far

from being the free-wheeling market place that many visitors believed, Shanghai represented the Party's ideal, a kind of Singapore-on-steroids, a combination of commercial prosperity and state control.

The Shanghai mayor at the turn of the century, Xu Kuangdi, exemplified the city's bustling political correctness. When he greeted groups of visitors to his office, he would grip each one's hand and, in a single movement, shake it, while abruptly pulling the bewildered guest towards a waiting seat, before moving on to the next person. This was a man in a hurry, but not in the way that many assumed. One of the most liberal figures in the city government, Xu was unperturbed at the lack of local entrepreneurs. In the short term, he saw it as a virtue. 'I think parental guidance is very important, especially during adolescence,' he told me in 2001, striking the kind of unconsciously patronizing tone that only an all-powerful bureaucrat can muster. 'The government certainly cannot lose its control on the state-owned sector; we are not for the shock therapy that they had in Russia. Look at Japan. When its economy was good, the government was playing a strong role. The same applies to Taiwan and South Korea. Later on, when they introduced free-market principles, they were not so effective.' Xu expected Shanghai's private sector to account for about 20 per cent of economic output by 2010, up from a minuscule 1 per cent in 1992.

Chen Liangyu made a similar boast later when defending the city against attacks from rivals who accused Shanghai of being too capitalist. 'If I am not mistaken, our country's private enterprises produce over 40 per cent of GDP nationally. Here in Shanghai, state enterprises produce nearly 80 per cent of GDP. If you want to discuss who adheres most to socialism, couldn't it be said to be Shanghai?' Chen said, according to a collection of his quotes circulated internally after his downfall. 'Shanghai has built a model for our country's socialist market economy. Shanghai has not practised capitalism. For Shanghai to wear that hat on its head would be unsuitable. It wouldn't fit.'

The evidence suggests that Shanghai's strong-state policy worked to plan in the fifteen years after the city's opening. In a remarkable research finding, Yasheng Huang, an MIT economist, established that Shanghai had the lowest number of private businesses relative to the city's size and its number of households in 2004, bar two other places in China. Only Beijing and Tibet, where government and the military are, respectively,

the main businesses, had lower shares of private commerce. The result was that most of the money generated in Shanghai went to the government itself, to pay for infrastructure, its own pet business projects, and, of course, to be siphoned off in corrupt payments. 'Shanghai is rich,' said Huang, 'but the Shanghainese are not.'

Shanghai had something else going for it from the late nineties onwards – heavy political clout in Beijing, through Jiang Zemin and his allies, who formed the largest, most powerful and most coherent faction in the Politburo. The city's governing philosophy had gained national influence as well, stressing the importance of a strong, wealthy state on permanent stand-by as a counterbalance to the fast-growing private sector. Shanghai's success as a bastion of state power, combined with its political muscle in the capital, gave it the status to become a test-bed for key reforms, in private housing, capital markets, state enterprises and social security.

The clout of the 'Shanghai Gang' in Beijing paradoxically heightened political restrictions in the coastal city. The central government did not want the rest of the country scanning the city's press for clues about what was happening in the capital. In contrast to Beijing, where there are multiple competing government agencies and political agendas, Shanghai had a single, all-powerful and ever-present city government and a unified, tightly controlled propaganda department. Shanghai had been a big winner from the 1989 turmoil and was always keen to show it had taken the lessons of Tiananmen to heart, becoming just the kind of well-behaved model that Beijing wanted.

Shanghai was careful to write itself some political insurance along the way. Many provinces and cities in China have rules preventing officials from serving in senior posts in their home regions, a device to curtail the entrenchment of local fiefdoms powerful enough to ignore Beijing. Shanghai deliberately flouted this trend, ensuring that the prize jobs in the city were reserved for loyal, hometown cadres. The effect was akin to the advantage gained in intelligence gathering when you are able to glide, silently and unseen, through a targeted town in a car with tinted windows. Shanghai could see out and survey political developments beyond the city, but the rest of China could not see in.

The Shanghainese have always been a clannish bunch, happiest speaking their own dialect and looking outwards to the rest of the

world rather than inwards to their fellow Chinese. From their perspective, the city's revival had simply returned them to a position of power and prominence that their superior intelligence and business acumen merited. The city galloped ahead of the rest of the country during this period. The difference in per capita GDP between Shanghai and poorer inland areas, like Guizhou, nearly doubled in the decade from 1990. But where Shanghai celebrated hard-won success, much of the rest of China resented what they saw as the fruits of political privilege. A staple, sneering joke for people stuck in queues in China around this time summed up the sentiment. 'Let the comrades from Shanghai board first!' people jeered. The ill-feeling meant that when the tide began to turn in Beijing, Shanghai was suddenly vulnerable. For Hu Jintao, taking on Shanghai had multiple benefits. It would strengthen his leadership and make an emphatic statement about his credentials on anti-corruption and economic management. Given the city's snooty reputation, slapping down Shanghai would be wildly popular in the rest of the country as well.

When Jiang Zemin was appointed party secretary in May 1989, weeks before the tanks rolled into Beijing, he had to be smuggled into the capital to take up his position. A rattled Jiang was picked up at the airport in a VW Santana, China's everyman car, instead of the Red Flag limousine then standard for top leaders. He was told to change into worker's clothes for the ride into town to meet Deng, lest any of the angry demonstrators still filling the streets should spot him.

By comparison, Jiang's handover of power to Hu Jintao at the 2002 congress, held at around the same time as Xu Haiming received his first eviction notice in Shanghai, was a milestone event in the history of the Party. It was not just the fact that Jiang was replaced by Hu as general secretary, but that he agreed to step down without a public fuss. Hu's displacement of Jiang was not only the first peaceful handover of power in China since the 1949 revolution, which was notable in itself, but the first in any major communist country at all. In addition, the transition from Jiang to Hu was carried out according to an evolving set of rules in the Party, setting retirement ages for top leaders and ministers, and establishing a new unofficial limit of two five-year terms for the party secretary and premier.

For an authoritarian party with a history of turbulent transitions of power, the smooth handover from Jiang to Hu was immensely important. Each succession in the Soviet Union, from Lenin to Gorbachev, followed a death in office or a purge of the top leader. In China, Mao had nominated his own successor, the hapless Hua Guofeng, who in turn had been ousted by Deng Xiaoping. Deng declined to become party secretary himself but remained the paramount power behind the scenes, later overseeing the removal of two of his protégés, Hu Yaobang and Zhao Ziyang, the latter being then placed under house arrest in 1989 for the remainder of his life. Jiang himself was plucked out of Shanghai in secret as Zhao's replacement, by Deng and the Party's then reigning council of elders. 'Hu's transition finally took the Chinese government out of the Imperial age and ensured it was no longer a one-man show,' said Zhou Ruijin, the former editor of Shanghai's official party newspaper. 'No one any longer regards the leaders as God.'

Jiang didn't leave office without trailing his coat. He retained the position of civilian head of the army, as chairman of the Central Military Commission, for another twenty months, to the fury of many officials who saw his decision to stay on as vain and self-indulgent. The nine-member Standing Committee also remained stacked with his men, paid-up members of the Shanghai gang such as Huang Ju, who had worked with Jiang in the city in the eighties and then moved up to Beijing in his slipstream in the years that followed. Jiang's most notorious crony, Jia Qinglin, was also promoted. But the presence of Shanghai loyalists on the Standing Committee was a lagging indicator, as the 2002 congress marked the high point of the group's power in national politics.

Hu Jintao had bided his time carefully in the decade before his elevation to party secretary, adopting a scrupulously low profile and avoiding any hint of open disagreement with his rivals. The determination of the top ranks of the Party to avoid the kind of public splits that almost toppled them from power in 1989 had created pressure for the leadership group to work together. So too did the new collective style of leadership, making Hu as much first-among-equals as he was a leader who could dictate policy and personnel decisions at will. For all their co-operation, however, the underlying rivalry between the two men and their camps remained. Hu had been neither welcome nor needed

in Shanghai while Jiang was in charge. He didn't visit the city once between 2000 and July 2004, which was akin to a candidate in the US never visiting New York while campaigning for the presidency. His lengthy absence reflected political calculation as well. Hu made sure that when he did finally visit Shanghai it was firmly on his own terms, as party secretary.

As early as 2001, stories of the Shanghai real-estate market and the blatant profiteering by local officials had begun to make their way to Beijing, through anonymous letters, petitions and reports in the Chinese-language Hong Kong press, and in the English-language foreign media as well. The necessity for Hu to keep Jiang onside did not blind his followers to the opportunities the Shanghai scandal offered. 'Corruption investigations are always used as leverage,' a former jailed official told me. 'They are an essential part of power struggles.' Hu's allies had taken note of how Shanghai's dirt was spreading beyond its borders. Slowly, they began gathering the evidence they could use to clip the city's wings. Over the next three years, Chen Liangyu, appointed as Shanghai's new party secretary in October 2002, would succeed in making himself personally vulnerable as well. Instead of maintaining a low profile, Chen gave Beijing every excuse to take him on.

Chen had joined the People's Liberation Army at seventeen, trained at one of its academies as an architect, before being demobilized to Shanghai, where he was assigned to work in a machine-tool factory. The son of a wealthy, Chicago-educated engineer, he did not join the Party until 1980. Until then, what the Chinese call his bad family back-ground – in other words, his father's US education – had disqualified Chen from entering politics. Chen's privileged father had been singled out for struggle sessions in the Cultural Revolution, when he was attacked as an American spy and thrown out of his large family house near Nanjing Road. After 1949, the Red Guards raged, Chen Snr.'s house even had luxuries like a fridge, and was protected, colonial-style, by Indian guards!

Once Chen Jnr. was allowed into the Party, his self-confidence and bumptious personality quickly put him on the fast track. By the mid-eighties, he was in charge of the Retired Cadres Bureau, which offered him a chance to ingratiate himself with powerful party elders, whose patronage was invaluable. He then moved on to head one of

Shanghai's most prosperous districts along the riverfront. As head of the Huangpu district, his signature achievement was the spectacular lighting, every evening, of the strip of colonial buildings along the Bund, the view that still dazzles visitors to the city. With Jiang's support, Chen was elevated to the city's party committee, and then to party secretary. Mayor Xu, a popular potential rival, was eliminated from the contest in 2001, dispatched sideways to Beijing, without a single word of explanation.

Xu had joined the Party late in life as well, in his case because of his aversion to its ideological zealotry, and had never been fully trusted by the hardcore of the Shanghai gang. Open-minded and flexible, he was an articulate spokesman for the city, often taking calls from residents on talkback radio in an effort to sell Shanghai's development plan. Chen, who spoke loutishly by comparison, was no ambassador for Shanghai. 'Chen's father is a very cultivated man,' said one friend. 'His son was not supposed to be so rough, but that is what the system does to you.' Chen and his acolytes commanded the city in a way that Mayor Xu, with his weak party networks, never could. 'Everything revolved around him,' said one city official. 'In a way, in Shanghai, he was even more powerful than Jiang Zemin and Huang Ju.'

Chen surrounded himself with loyal former underlings from Huangpu district, his own 'Huangpu gang', who went through a metamorphosis similar to that of their boss. Qin Yu, Chen's political secretary, whose detention a few years later would signal Chen's ultimate downfall, had once been a modest, meticulous academic at a city university. In office, his friends said, he developed an unrecognizable, self-important swagger that alienated his former associates. Among subordinates, a story circulated about the time Qin had dinner with a former teacher. In place of a once respectful relationship, Qin talked loudly on his mobile phone throughout the meal and ignored his dining companion, a grotesque breach of etiquette in a society which traditionally venerates its elders.

None of this might have mattered much, but for two events, a few years apart, that impacted on each other. One was Chen's, and Shanghai's, addiction to grand projects and fast growth at any cost, no matter what diktats they might have received on economic policy out of Beijing to tone their big-spending plans down. But before then, the Shanghai government got caught up in the backlash against a local real-estate

tycoon, Zhou Zhengyi, one of the new local currency billionaires the city's property market had spawned in the previous decade.

Zhou's mistake was not that he was a rich, aggressive property developer. There were lots of them. Zhou's downfall came because he got greedy and careless. Like other officials and businessmen and women who have fallen from grace in China, he committed the cardinal sin of embarrassing the system, and so the system destroyed him. Along the way, though, he became something even more dangerous, a political target. When the complaints about Zhou started to filter up to Beijing, they found many eager ears among Shanghai's political rivals in the capital. 'Without Zhou Zhengyi,' said Xu, the restaurateur-turned-protester, 'the result for us would have probably been much poorer.'

The son of a poor factory worker, Zhou Zhengyi began his rapid ascent into high society in 1995, using funds from a successful noodle stand business to buy shares in state enterprises issued to employees just before they were partially privatized in stock-market offerings. Zhou maintained his impeccable timing in his next venture, ploughing his profits into land in Shanghai when the private property market was beginning to take off. The businessman quickly gained a dangerously flashy high profile in both Shanghai and Hong Kong, where he acquired a Bentley, a glamorous girlfriend (and later wife) and a number of listed companies. He kept a London Metals Exchange computer on his desk, to indulge his hobby of trading commodities. 'He was a young guy, supremely self-confident and a brilliant trader,' said Rupert Hoogewerf, a Shanghai-based accountant who met him while compiling lists of wealthy Chinese. 'All of his financial accounts were in his mind.' Unlike many other entrepreneurs, Zhou was thrilled to appear on Hoogewerf's rich list. At his peak, he was rated the eleventh richest man in China.

Weeks before his arrest, Zhou dined with Sir Christopher Hum, the then British Ambassador, along with other members of Shanghai's emerging entrepreneurial class. Zhou was charmingly open about his *arriviste* status, complaining to his hosts that Chinese entrepreneurs had a more difficult time than their more experienced western counterparts in refining their lifestyles. When he first became rich, he said he knew nothing about 'standards and quality', and so decorated his bathroom in gold. Later, after realizing what bad taste this was, he said

he stacked his house with brand-name products only. Zhou at that time had a son at boarding school in the UK. Asked which school, Zhou was stumped. Picking up his mobile phone, he called his wife in Hong Kong, who didn't know either. He then called his son in the UK, who finally told him the name of the institution, Millfield, one of the most exclusive schools in Britain. Why had he chosen it, his dining companions asked. 'Because it was the most expensive,' he replied.

Zhou was much less charming in business. He had already narrowly survived a corruption investigation into one of China's most famous bankers, Wang Xuebing. The investigation into Wang led to the Bank of China branch in Shanghai which had made a number of questionable loans to Zhou. The developer got through this episode unscathed, but hubris got the better of him in his greatest business coup, the right to develop an area in the centre of the city called the 'East Eight Blocks'. The long stretch of land on Beijing West Road in Shanghai had been covered with *shikumen*, or 'stone gate' houses, a style of low-rise dwellings favoured during the colonial era. The residences were modelled on late nineteenth-century European terraced houses, with an elegant chinoiserie flourish in the stonework capping their entrances. They were less elegant seventy years later. The houses, like much of the city, had been neglected under communist rule. Properties built to house a single family might now include three or four, who had simply moved in during the chaos of the Cultural Revolution.

Zhou had beaten some of the region's most experienced and best-capitalized property developers, including Hong Kong's Li Ka-shing, one of the world's richest men, to win the right to clear the blocks and then rebuild on what was a prime site in central Shanghai. Zhou's deal with the Jing'an district government in 2002 to get the land was straightforward – he would pay little for a seventy-year lease on the land, in return for compensating and rehousing the residents together in the same area in his new development, thereby preserving a long-standing community. It wasn't long before the thousands of families who lived in the East Eight Blocks realized that Zhou had no intention of keeping his side of the bargain. Far from looking after the first batch of about 2,160-odd households whose residences were demolished, Zhou dispatched them to apartments on the distant edge of the city and offered them paltry compensation in return.

When the furious residents began to organize, Shanghai-born Shen Ting received a call at her home in Hong Kong. Shen's grandmother had bought a house on the block for three pieces of gold in the thirties. Shen herself had grown up in the house and her mother, now on the verge of being evicted, was still there. Shen, living in Hong Kong with her husband and two children, started travelling home to Shanghai to help her mother get a better deal. She petitioned the local housing bureau and tried to start legal proceedings, without success. She then started to look for a lawyer. The first twenty or so firms she approached sent her packing. 'No lawyer will dare to fight a demolition and relocation case,' one told her. 'If I do it, I will lose my job,' said another. Finally, a day after her mother was forcibly evicted in April 2003, Shen knocked on the door of Zheng Enchong.

Zheng could not have been more different from Zhou Zhengyi. He had the plain-living look of a suburban lawyer, always dressed in the same colourless suit and carrying a matching ragged briefcase as he strode intently from meeting to meeting. But if he was a grey figure, it was a kind of gunmetal grey, shown in the resolve and toughness with which he took up the cause of the residents. Zheng agreed to Shen's request to represent 300 residents, including her mother, in a class action against the district. He also began advising Xu Haiming, the restaurateur-turned-activist. Almost immediately, city officials tried to scare him off. Soon after Zheng filed the class action, the city investigated his tax affairs. When they found nothing, they put pressure on his law firm, which forced him to resign for 'taking on a resettlement case without consulting the partners'. Next, the authorities deliberately delayed the transfer of his licence to practise to a new firm. Zheng said the head of the local party body overseeing the registration of lawyers had told him, '90 per cent of the district chiefs in Shanghai' had complained about him and he could have his licence back when he dropped the residents' cases. Even then, he continued to advise the residents and draft documents for them. He knew work for the residents of the East Eight Blocks would only bring him trouble. 'Shen Ting, I will get into serious trouble with this case, and you must save me,' he told her. 'Zhou Zhengyi is very probably the Lai Changxing of Shanghai.' (Lai Changxing, in exile in Canada, was the mastermind of the $6 billion Xiamen smuggling racket.)

Tales of the multiple land disputes in Shanghai began to seep out of the city, much like an unsightly substance which oozes from under a firmly closed door. District government officials, unused to the scrutiny, responded clumsily when confronted with evidence of their personal financial interest in developments. When I asked Sun Jingkan, the party secretary of Jing'an district, the epicentre of the city's land scandals, about the cheap shares he had obtained in development for Xu Haiming's block in defiance of city rules, he denied his holding was improper. 'The government is encouraging the development of the private economy,' he replied. For officials, the property deals were sweet. One arm of the Jing'an government responsible for approving real-estate projects would be given cheap shares in developments in the district. Another arm of the same government, the Housing and Land Bureau, would be paid to evict residents, and arrange compensation at rates far lower than the going market value

Shanghai, which marketed itself as being on a par with places like New York and London as one of the great metropolises of the world, was acutely sensitive about its image and worked feverishly to stop information about the property scandals from getting out. At the large railway stations, the city began positioning plain-clothes police to watch out for petitioners leaving Shanghai to take their complaints to Beijing. A Chinese journalist at Xinhua in the city who had been sending reports to Beijing about the real-estate scandals, as part of the covert news service the state agency provided to party authorities, was hauled in by the local propaganda bureau and ordered to stop. Hong Kong journalists, always receptive to reporting dirt on the mainland – especially out of Shanghai, a business rival – were threatened in menacing phone calls and trailed closely when they visited the city. Foreign reporters based in the city who ventilated the disputes were also put under heightened surveillance and their contacts ordered to report all conversations with them to state security. After writing about the Jing'an scandals, I began to receive regular visits from the district's own plain-clothes security police, pressing for information about future stories.

The city authorities' heavy-handed efforts to put a lid on the land scandals were too late to protect Shanghai's glittery façade. In late May 2003, the investigators from the Central Commission for Discipline Inspection in Beijing descended on Shanghai, setting up camp at the

Moeller Villas. Their arrival was a calculated snub to the Shanghai party committee and the city's own anti-graft body. So was the base they chose for their operations. The Moeller Villa, famous for itsfairyland-like turrets, inspired by the dreams of the daughter of the original Norwegian owner in the thirties, was also for years the Shanghai headquarters of the Communist Youth League, Hu Jintao's power base. Within days of arriving in the city, the commission's investigators had detained Zhou Zhengyi. The message the investigation conveyed was unmistakably political. Beijing had made Shanghai the focus of a major corruption case for the first time in more than a decade and displayed its ability to intervene in a city which for years had sealed its doors to outsiders. But if the presence of a flying squad from Beijing's anti-graft unit in the city was a wake-up call for Shanghai, then Chen Liangyu slept right through it.

The city was initially quick to marshal its defences. Jiang Zemin, who still retained his position at the head of the military, used his remaining clout to issue a series of internal instructions on the Zhou Zhengyi case to return it to Shanghai's jurisdiction. Jiang's henchmen in the propaganda department also went to work. Tens of thousands of copies of the business magazine *Caijing* containing a lengthy article about the case were hauled off news-stands throughout the country. It was the first time an entire edition of the pioneering publication had been suppressed. A few weeks later, the Shanghai authorities took further retaliatory action by arresting Zheng Enchong, the activist lawyer, for leaking state secrets, a charge often wheeled out when the authorities want to make a political example of critics, and sentenced him to three years in jail. For the moment, Beijing withdrew from the Zhou Zhengyi case, leaving it to Shanghai to handle. In doing so, it allowed the two rival political camps to step back from the brink of a damaging split in the top leadership. Chen's subsequent behaviour, however, soon ensured that Shanghai was back firmly in Beijing's sights.

Chen's first mistake was to thumb his nose at Beijing by charging Zhou Zhengyi with minor offences which avoided the real-estate scandals altogether. Zhou served just two years of a three-year sentence and was soon back in the property business, operating from an expensive high-rise in the central business district. Later, it would emerge that Zhou had bribed his jailors while inside. He was able to shirk the

usually mandatory prison labour, receive visits from friends whenever he wanted, use a phone and watch television in his supervisor's air-conditioned office. His lenient treatment and prison privileges might have been brushed off as trivial, and never seen the light of day, had not Chen opened a new front in the war with Beijing, on the economy.

No development had been too grand or expensive for Shanghai to tackle while Chen, and his predecessors, were in the chair. The city's obsession with returning to the international limelight saw it splash out on one mega-project after another. A billion-dollar track to attract Formula One motor racing was built in a couple of years, dazzling the globe-trotting crowd that followed the sport. 'No democracy could afford this,' gushed Jackie Stewart, the former F-1 champion. A new $300 million tennis centre, constructed to host the end-of-season Tennis Masters Cup, attracted similar gushing compliments. Tens of millions more were spent on building the first ever commercial Maglev train track, even though it travelled only about 33 kilometres from the airport to drop passengers off far from the city's commercial hubs. The colonial-era opera house in the city centre was literally lifted off its foundations at great expense and shifted about 70 metres, so it didn't have to be knocked down to make way for the nearby construction of a new underground. The city also started negotiations with Walt Disney to bring its signature theme park to Shanghai, and with Paris for a version of the Centre Georges Pompidou.

In the ocean nearby, away from the silty, shallow mouth of the Yangtze river, the city set about building the largest port in the world, along a string of islands linked by landfill, connected to the city by an extraordinary 32.5 kilometre bridge across the open seas. Never mind that Ningbo, a vigorous entrepreneurial centre 100 kilometres to the south, was blessed with a natural deep-water port available at a fraction of the price. Shanghai would spend billions to have the facility for itself.

Shanghai could not be faulted for its ambition, energy and execution. Any one of these projects might have overwhelmed the resources of many large cities around the world or been delayed by endless planning disputes. In a few short years Shanghai had polished off most of them – the Formula One track, the tennis stadium, the Maglev and the first stage of the port, on top of other infrastructure projects, such as new

subway lines and bridges, plus a surge in ordinary construction. The city's political skills, by contrast, were not nearly so adroit.

The turning point came in May 2004, a year after Zhou Zhengyi's arrest, when Beijing announced a sharp, nationwide credit squeeze. The rate of investment – the national economic indicator that the central government watched most intently – was going through the roof, increasing at unheard-of year-on-year monthly rates of 50 per cent. The central government reacted with alacrity. Banks were ordered to curtail their lending and local governments told to submit any large projects to Beijing for approval first. From the early nineties, Shanghai had for years set itself an internal target, to grow at two percentage points faster than the national average – no mean feat for a relatively rich city in a fast-expanding economy. Chen Liangyu made it clear soon after the announcement that he had no intention of slowing his city down, no matter what Beijing said. Many city leaders around the country probably harboured similarly defiant thoughts. But only Chen dared to say so out aloud.

When Wen Jiabao, the Premier, briefed the Politburo on the credit crunch, Chen confronted him, according to officials briefed on the meeting. Chen complained that the policy would hurt Shanghai and other fast-growing coastal centres. If companies went bankrupt and jobless queues lengthened as a result of Wen's policies, then the Premier 'would have to bear the political responsibility' for whatever instability followed. It was only the intervention of Hu Jintao, re-stating the centre's priorities, that brought the argument to a close. Chen's brazen behaviour, though, had changed the game. By taking on Wen so openly, Chen had turned a difference over economic policy into a dangerous, top-level political dispute.

Up until this point, Chen still enjoyed the political protection of the Shanghai gang's godfather, Jiang Zemin, through his control over the military. By September that year, Jiang had stepped down from this, his final post, and retired to Shanghai, to a large, secluded house down a dead-end street in the old French Concession, a location so sensitive that it was obscured on city maps. Hu Jintao now occupied all three of the most senior positions in the country – as Communist Party secretary, state president and chairman of the Central Military Commission. Hu's ascent left Chen seriously exposed. All Hu needed now to

move against Chen was a consensus in the nine-member Politburo Standing Committee, the informal consent of Jiang himself and, of course, hard evidence of corruption as well.

There was no shortage of people willing to help Beijing build a case against Shanghai. Even after Zhou Zhengyi's arrest, aggrieved home-owners had continued their campaign against the city's party committee and government. Groups of petitioners, including Shen Ting, regularly evaded the guards posted at Shanghai's main railway station to take their complaints directly to the capital in 2003 and 2004, trooping ostentatiously from office to office in the capital in search of a hearing. First, they would go to the State Petition Bureau, then to the Central Politics and Law Commission and on to the Legislative Affairs Office of the State Council. They were rounded up by Shanghai security officials, and on one occasion addressed by Chai Junyong, a senior city government official. 'You want to embarrass the Shanghai municipal government, and damage Huang Ju and Chen Liangyu. Now you've achieved your objective,' Chai told them, according to Shen. 'The Central Party now knows, and you can let it go. We will solve your problems once we are back.'

The petitioners ignored Chai and continued on their way, to the Public Security and Construction ministries, and anywhere else where they thought they could get attention. Xu Haiming, who also travelled to Beijing around this time, staged a small personal protest in Tiananmen Square, holding up a banner demanding that the Shanghai government 'stop taking our private property'. Like most protests in the square, the most heavily policed piece of real estate in China, it was over quickly. 'We lasted about one minute,' Xu said. Beijing was swarming with plain-clothes Shanghai police for lengthy periods during this time. Every petitioner initiative or protest was eventually squashed. But the protesters' actions were more effective than they might have realized. Each incident was an embarrassment for Shanghai and ammunition for the city's emboldened enemies in the capital.

In the Watergate scandal, the investigative journalists, Bob Woodward and Carl Bernstein, were famously advised to 'follow the money'. In Chen's case, the investigators started with a principle more familiar to corruption probes in China, to 'follow the family'. Many of the charges that Shen and the petitioners had laid against Chen over the years, that

he had enriched his family, were borne out. City-owned companies had created phantom paid positions for Chen's wife and son in return for favourable treatment for contracts. His father and younger brother were both helped out in valuable property deals, including some with Zhou Zhengyi. His brother-in-law had enriched himself through his job in charge of the Formula One track.

The surest way to follow Chen's demise during this period was to watch the fall of officials who once clustered loyally around him. It was a case study in how the commission operated. One by one over 2005 and 2006, Chen's intimates in the Shanghai government were rounded up and held for questioning under the *shuanggui* provisions. And one by one, these 'so-called good friends' of Chen, as the state media later tartly remarked, 'handed in all the materials' investigators were looking for. On top of the charge of enriching his family, Chen was accused of masterminding the diversion of about $270 million from the city's pension fund to a company run by a hitherto obscure local businessman. The businessman's fall in August 2006 was one sign that a major scandal was afoot. From the moment that Chen's personal secretary, Qin Yu, was detained later that month, it was only a matter of time before the party secretary himself went down.

The clearest sign that a top-level political deal had been done to cut Chen adrift surfaced in a peculiarly Chinese fashion soon after. It was the announcement by a state publishing house of the release of Jiang Zemin's selected works, to coincide with the former party secretary's eightieth birthday in August 2006. Hu himself led the fanfare of praise. 'The publication and issue of the Selected Works of Jiang Zemin is a major event in the political life of the Party and state,' he said. Study groups were organized by party cells across the nations to imbibe Jiang's theories in an orgy of state-orchestrated tributes in the state media, lasting a week. The announcement of Jiang's book was as public a signal as possible in China that Hu and Jiang had reached an accommodation over the Shanghai case. With Jiang on board, the Politburo Standing Committee formally approved a corruption investigation into Chen. The agreement included a side-deal, that neither Jiang nor his family, long the subject of gossip about favourable treatment in business deals, would be touched.

When a wall starts collapsing, 10,000 people rush to push it down,

according to an old Chinese saying. Once Chen was in custody, stories of the disgraced party secretary's serial philandering flooded the official media. On the internet, a number of former alleged mistresses were outed, and goaded into denying their relationships with Chen. When excoriating fallen officials, the propaganda department is always happy to publicize their sexual indiscretions. That way, corruption is presented as a form of individual moral degeneracy rather than as the systemic problem it really is.

The closing episode eight months later, Chen's trial in March 2008 in Changchun, the former capital of Japanese-controlled Manchuria in the north-east, had a political flavour as well. The Party deliberately chose Changchun for the trial, because it was about as far away as it was possible to get from Shanghai. The authorities knew that the judges in Shanghai owed their jobs to Chen and his supporters and could not be trusted to follow Beijing's line in cases before them. Chen made only a short statement from the dock after his sentencing to eighteen years in jail. 'I have let down the Party,' he said from the dock. 'I have let down the people of Shanghai and let down my family.' Chen's appearance bore the telltale look of all senior officials who emerge from lengthy periods of detention under *shuanggui* for their formal trial. Unable to dye his hair in custody, Chen's formerly jet-black locks had gone grey.

Chen was locked up in the Qincheng prison, the jail on the outskirts of Beijing used to house important political prisoners since the Party took power in 1949. Like other prisoners, Chen was kept in solitary confinement, and allowed out of his cell for only an hour a day. A special team of guards was assigned to watch him, using observation windows allowing them to peer into both his cell and its toilet. But compared to other Chinese prisons, the conditions at Qincheng were relatively cushy. Chen's request to supplement his prison diet by using his own money to buy nuts and red wine was rejected, according to a Chinese weekly magazine. But his official daily allowance of $30 for food alone far outstripped an ordinary worker's wage. Guards at Qincheng are also traditionally deferential to their prisoners, as they have learnt from bitter experience that fallen officials can regain their power once they are let out.

Many Shanghai officials remained bitter at their city's targeting. All the money that had been diverted from the pension fund was returned. And, they added, corruption in Shanghai was no worse than anywhere

else in the country. The city had no choice but to take its medicine anyway. In a final act of public contrition, the city government staged an exhibition featuring filmed confessions of arrested officials, weeping on camera at their crimes. The fall-out from the case spread in many different directions in the immediate aftermath. A new party secretary was eventually appointed, and came from outside the Shanghai clique. Beijing parachuted in an anti-graft chief, also untainted by any previous association with the city. Zhou Zhengyi was re-arrested and sent back to jail, this time for a thumping sixteen years. Soon after Zheng Enchong was released from prison, the lawyer was detained again by vengeful city authorities.

The story of Xu Haiming, the protester who had used Zheng for legal advice, had a happier ending. He secured a better deal for his seized property than had been originally offered, while the chastened district officials who had invested in the development on his land were ordered to dump their shares. 'We got about one-quarter of the property's value, but more than we paid for it,' said Xu. 'But the officials in Jing'an district were ordered to sell their interest at the price they had paid for it. One of the officials told me that they had been expecting returns of 900 per cent.'

Even Shen Ting's campaign bore some fruit, with her mother receiving a bigger new apartment than she had at first been offered after being thrown out of the Eight East Blocks. Shen herself, however, remained furious, and channelled her anger into a book about her battles with the city authorities. In November 2007, just before it was published in Hong Kong, she said she received a phone call from a man identifying himself as a Shanghai official, surnamed Wang.

Their exchange, according to Shen, went as follows:

'If you dare to publish this book, we will show you our true colours. You will never get the Home Return permit [generally available by right to Hong Kong residents to travel to China] again,' the official said.

'Hu Jintao said the country should be ruled by law, so I am not afraid of you!' she replied.

'Well, then, you can go and find Hu Jintao yourself to get the permit,' replied Wang. 'There is only one Communist Party. It is not like supermarket outlets where you can go to one after another.'

The mysterious caller was true to his word. Shen has not been

allowed back into China since her book was published. His tart rejoin-
der – that 'there is only one Communist Party' – was to the point,
though. The scope of the anti-corruption campaign in Shanghai, as
happens everywhere in the country, eventually ran up against the Party
itself and its monopoly on power, and the investigation was brought
to a close. The Party catches and kills – and protects – its own for good
political reasons. Exposing its members to investigation by outside
bodies would be intolerable, as it would be akin to ceding the Party's
monopoly on power. As officials freely acknowledge in private, an
independent anti-corruption campaign, following up leads beyond the
Party's control, could bring the whole edifice tumbling down.

In the *roman-à-clef* about the Chen Xitong case in the mid-nineties,
the author quotes a saying to illustrate the ritualistic stages that most
corruption investigations pass through. Stern and fearsome when they
begin, they invariably peter out later. 'An anti-corruption campaign is
when a tiger makes a report, the fox claps his hands laughing, the fly
hums along happily and only the mice run scared in the streets.'

Later in the same book, an unnamed and corrupt Beijing city official
gives a more expansive, realpolitik rationale for reining in anti-corrup-
tion campaigns, because of the way they threaten the Party's grip on
power. 'The anti-corruption campaign makes a lot of thunder these
days and quite a bit of rain,' the official says. 'But rainstorms always
come to an end. Once we are past the dangerous part of the storm,
there will still be a lot of thunder, but less rain. And then after a while,
you won't hear any thunder at all. Anti-corruption work cannot be
done thoroughly, because more than just a few people are involved.'

After mentioning a number of well-known corruption cases, the
official continues:

Can we allow the era of opening and reform to remove us from power and
replace us with the capitalist classes? That absolutely won't work. We can't
push the anti-corruption campaign indefinitely. For who else can the regime
depend on for support but the great masses of middle-level cadres? If they are
not given some advantages, why should they dedicate themselves to the regime?
They give their unwavering support to the regime because they get benefits
from the system. Corruption makes our political system more stable.

How can Chinese officials compare with Hong Kong officials? Can they compare with Taiwan officials? Or with officials in developed countries? The salaries of public officials in foreign countries are dozens or even more than a hundred times higher than the salaries of Chinese officials. Moreover, a long anti-corruption campaign would expose the dark side of the Communist Party. If many of these things were to be exposed, the masses would lose their faith in the Chinese Communist Party. Who could accept the historic responsibility for doing this?

The Shanghai case had been one of the most highly charged corruption investigations in the history of the people's republic. By April 2008, about thirty officials and businessmen in all had been jailed. The size of the case and the ruthlessness with which it was executed was directly related to the politics that were at stake. Shanghai officials were surely right to say that their city was no more corrupt than anywhere else. Politically, however, their behaviour had consequences far beyond the city's borders.

The reasoning laid out by the fictitious official in *Wrath of Heaven*, that the Party could not countenance an anti-corruption system unconstrained by political considerations, still held. Where might an investigation of Jiang Zemin's family have led, for example? What would an independent inquiry into Jia Qinglin's history in Fujian, and Wen Jiabao's wife's business dealings reveal? Such questions did not bear answering for the Party. Once such threads began to unravel, there was no saying where they would end.

Much the same rationale governed how the Party handled one of the biggest scandals of the last decade, the Sanlu case, in the lead-up to the 2008 Olympics. Sanlu did not involve high-level corruption, in the way that the Shanghai case did. But the attempted cover-up by a city-owned dairy company of the poisoning of tens of thousands of babies had something in common with Shanghai. In both cases, local officials were able to wield extraordinary, unrestrained power, only being pulled up by the centre when it was too late. The decentralized nature of the party and government system has been fundamental to the Chinese economic miracle. When it gets out of control, however, the consequences can be fatal.

6

The Emperor is Far Away

The Party and the Regions

'The central government's control does not extend beyond the walls of Zhongnanhai. People below just don't listen.'

(Zhang Baoqing, a vice-minister for education)

'For reasons that everybody knows, we were not able to investigate the Sanlu case, because harmony was needed everywhere. I was deeply concerned because I sensed that this was going to be a huge public health catastrophe, but I could not send reporters to investigate.'

(Fu Jianfeng, *Southern Weekend* newspaper)

It was one week, almost to the minute, ahead of the opening of the Beijing Olympics, when the senior executives of the country's largest supplier of milk formula were summoned to an emergency meeting. It didn't take long for the mood in the conference room to turn grim, even panicky.

For years beforehand, China's senior leaders had meticulously managed the preparations for the games, timed to open at an auspicious moment on the Chinese calendar, at 8.00 p.m. on the eighth day of August 2008. Whole neighbourhoods in Beijing had been cleared to make way for the sports extravaganza. Giant steel factories were moved out of the city and a million cars ordered off the roads just ahead of time to cut pollution. Offshore, the government had tweaked diplomatic policy just enough to throw critics of China's human rights record temporarily off course. In the final, nervous days ahead of the games, senior leaders had personally intervened to replace the young girl chosen to

sing the national anthem at the opening ceremony with someone they deemed more suitable. Nothing was to get in the way of the moment designed to embody China's rightful return to the ranks of great powers.

The Olympics were preying heavily on the minds of the executives of the Sanlu Dairy Corp. as night fell on 1 August over the sprawling company headquarters in Shijiazhuang, the capital of Hebei province, about ninety minutes' drive from the capital. Sanlu ('Three Deers') had been an enthusiastic sponsor of the pre-games festivities. The day before, the Olympics torch, canonized as a 'sacred flame' by the central government, had passed through the city en route to the ceremony in Beijing, carried on its way by a privileged few staff members from the company. Now, Sanlu executives were confronted with a crisis that could turn a time of great national pride into near panic for large swathes of the population and a deep loss of face for the Party. After months of fending off consumer complaints about its milk powder, the company's top executives had just been handed irrefutable evidence that its best-selling formula was laced with large doses of an industrial chemical. Hundreds of thousands of babies whose sole nourishment was the company's liquefied powder were slowly being poisoned.

Presiding over the meeting was Tian Wenhua, the Sanlu chairwoman who had built the company from a small city dairy into a famous national brand. Ms Tian allowed debate to rage for hours among the ten or so assembled executives until just before sunrise the next morning, when she finally settled on a course of action. Instead of confessing to its customers about the contamination, she directed that it be covered up. Combining silence with stealth, the meeting resolved to quietly withdraw Sanlu products from warehouses and gradually replace the contaminated milk powder with new, safe batches of formula. Any formula already sold would not be touched, sitting in homes until it was consumed.

Ms Tian, a former vet with school-marmish looks and the plain, unadorned style of many high-ranking women cadres, closed the meeting at 4.00 a.m. with an order that the detailed minutes of the meeting be censored as well, to prevent any leaks. In what would be one of her last acts at the company she had run for two decades, she told her colleagues: 'This is to control the situation.' As events transpired, she could not have been more wrong.

When the contamination was made public weeks later in mid-September and the stories of the sick and dying babies became known, the central government in Beijing and the national media rose up in fury. The cover-up had had gruesome consequences. By the time the problem was exposed, long after the Olympics had finished and been declared a rousing success, 290,000 babies had been diagnosed as ill. Many babies – in most cases, the only children that couples were allowed to have under the one-child policy – were left with permanent kidney damage. Six infants had died.

The Sanlu scandal featured many public villains. The institutions of government, the role of regulators, the inefficacies of the legal system, lax food standards, the responsibilities of company executives under corporate law, and profiteering businessmen and women – all were put in the dock in the wake of the cover-up. Ms Tian and other executives of the company were sacked, and then formally arrested and charged soon after the scandal came to light. Scores of middlemen responsible for lacing the milk powder were detained and a number later executed. The reaction was thunderous and the anger genuine, but for anyone tracking the contours of local politics, the uproar had the same slightly unreal quality that pervades public life in China. The debate focused entirely on the front stage of political life, the government and regulatory and legal systems that the citizenry read about in the media and interact with in daily life. Few dared to pull the curtain to peer backstage, to examine how the Party's opaque powers and skewed structures had enabled the scandal at each twist and turn of its lengthy evolution.

From the outside, power in China often seems to gush like a torrent from Beijing, streaming out from party central to nourish obedient communist officials in provinces, cities and townships throughout the country. This impression is craftily reinforced by grassroots officials themselves. No matter how distant they are from Beijing, local leaders raised in a school system which prizes rote learning above all will recite, for foreign visitors, word-perfect renditions of the latest edicts from the centre. When Jiang Zemin was in office, interviewees would invariably defer solemnly to the then leader's trademark theory of the 'three represents'. Likewise, no discussion in China under Hu Jintao proceeds without a genuflection to his model of 'scientific development' and the 'harmonious society', the leitmotifs of his administration. The

unparalleled reach of the propaganda system means that no official can claim they didn't get the memo when a new policy is promulgated. Most of them are smart enough to learn them by heart.

This description of power holds more or less true for policies which embody the Party's core political interests. Local officials are careful to stay in lock-step with Beijing on issues touching on sovereignty, like Tibet and Xinjiang. Political campaigns which come with the imprimatur of the very top, like the crackdown on the Falun Gong, the outlawed spiritual movement, are implemented with zeal. Very few officials question the fundamental structure of the system and the need for one-party rule. The everyday reality of economic administration in China, where local financial interests are involved, requires a very different calculus. Far from surging like a single river out of the capital, the transmission of economic management is more akin to a series of locks, in which each locality takes what they want out of the policy waterway. Feigning compliance with the centre, as one China scholar described the process, they then let the policy stream flow downwards to the next level of government.

Beijing frets constantly about the disobedience of local fiefdoms outside the capital. In 2005, Zhang Baoqing, then a vice-minister for education, complained that a precisely worded order issued by Beijing in support of loans for poor students had been flatly ignored by many provinces. 'The central government's control does not extend beyond the walls of Zhongnanhai [the central leadership compound, next to the Forbidden City],' he said, in exasperation. 'People below just don't listen.' What Zhang left unsaid in his critique was any mention of the underlying reason for Beijing's difficulties, which is the Party itself. The virtual dictatorial power of local officials on the ground is anchored by a fundamental paradox: that a strong, all-powerful Party makes for a weak government and compromised institutions. Freed of the checks and balances provided by democratic government and an open media, the writ of the party chief on the ground in China is as good as law.

The Chinese saying, 'The mountains are high, and the Emperor is far away', is often quoted to describe how local officials become more independent the further they are from Beijing. In truth, a local party fiefdom might be just down the road from the capital and still be able to keep the central government in the dark about what is happening in their bailiwick. So self-contained and opaque are party bodies that

they have the power to contrive to keep secrets not just from the public, but from each other as well. In the Sanlu case in Shijiazhuang, a short, two-hour drive from the capital, local officials kept Beijing in the dark to protect the city's most valuable company. But they were also constrained by the centre itself, which had made the success of the Olympics a political task for cadres throughout the country. These two clashing imperatives, of local economic protectionism and a national political campaign, made for a toxic mix.

Before considering the Sanlu case in detail, however, it is worth remembering how disobedient localities have also been one of communist China's greatest strengths. The central leadership is invariably portrayed as a force for good in the narrative of China's rise, dragging the recalcitrant, corrupt and backward localities along behind it. It is true that many local leaders will ignore Beijing's edicts if they can get away with it. In many cases, they may be right to do so, because in a country as large as China, the centre cannot intelligently prescribe policies to fit the widely divergent conditions on the ground. The local locks of power allowed by the Party's decentralized structure can make for dynamism as well as defiance.

For visitors to Dandong in the north-east, the first thing that jumps out is the vivid contrast between the bustling Chinese city and the moribund scene a few hundred metres away, across the Yalu river in North Korea. The restaurants and karaoke bars in Dandong overflow with customers and the streets are jammed with traffic and commerce. High-rise apartments line the Chinese side of the river where only a decade ago were strips of humble single-storey buildings. The scene on the opposite bank is pre-modern by comparison. In the shadow of tall brick chimneys emitting emaciated wisps of smoke, a few wizened buffalos plough the fields, pursued by under-nourished, bedraggled farmers and ragged small children.

Many Chinese cities have specialized in single products, such as socks, shirts, trousers and leather, and used their strong local position to pursue global sales. In Shijiazhuang, the city government championed Sanlu and the dairy industry. Dandong's entrepreneurs, distant from China's heartlands of the Pearl and Yangtze river deltas, had somehow turned the city into one of the country's biggest exporter of toilet seats,

with the entire stock of its largest company going directly to Wal-Mart. The city's residents are also canny enough to spot a business opportunity in the odd out-of-place westerner they notice roaming the streets. When a colleague and I were wandering near the riverfront area, a local would-be tour guide approached us, asking: 'Would you like to go to North Korea?' Within an hour, we had been transported by boat up the river away from the town centre, darting across the water to land controlled by one of the world's most closed and difficult-to-access countries in the world.

Just as startling as Dandong's transformation was the reaction of local political and business leaders to my compliments, during a visit in October 2006, on their city's helter-skelter development. In the eight years since I had last been there, Dandong had been transformed from a sleepy backwater into a bustling, bursting-at-the-seams business centre. Far from celebrating, the locals shook their heads dolefully at their visitor's praise for their rapid development. 'We are not growing fast enough,' they replied. I later checked the official growth figures for the city. Dandong's economy had expanded by more than 16 per cent that year. The locals were not happy, though, because the nearby port of Yingkou was growing faster, by more than 18 per cent. The pace of expansion of the national economy was of little interest in Dandong. The city benchmarked itself, jealously, against its immediate neighbours.

The narrative of China's rise usually pits it as a competitor against first-world powers like the US, Europe and Japan, and low-cost manufacturing centres in Southeast Asia, Mexico and in and around India. That is true, as far as it goes. China has obvious competitive advantages in relatively cheap, abundant and ambitious labour and a surplus of low-priced capital. China has also adopted many of the features of other Asian economic success stories. As Japan did for many years, it has kept its currency undervalued to bolster exports. It borrowed the idea of designated economic zones and industrial parks from Taiwan, so it could experiment with the market, before unleashing its force across the rest of the country.

What is obvious for anyone who travels around the country, however, is how much the economy is driven by another factor altogether, a kind of Darwinian internal competition, that pits localities against each other. Much like the school of fish that makes up China Inc., each

Chinese province, city, county and village furiously competes to gulp down any economic advantage they can lure their way. Steven Cheung, a Chicago-trained economist who spent years teaching in Hong Kong and dispensing advice on the mainland, took a long time to grasp how China managed to pull off its spectacular economic rise. 'The Chinese had to deal with corruption, a D-grade judicial system, controls on freedom of speech and beliefs, education and health care which were neither public nor private, exchange controls, inconsistent policies and tens of thousands of riots a year,' he recounted in a speech at a private conference on economic reform in Beijing in 2008. But the economy still grew at nearly 10 per cent a year for three decades.

How did China pull it off? The key, Cheung realized after many visits to the industrial heartlands of the Pearl and Yangtze deltas, was the cut-throat competition between localities for business. The local party secretary with near-dictatorial powers is a dangerous enemy for anyone who takes him on in the area under his control. He can lock up petitioners and any other activists who challenge him, and prevent rivals from advancing within the local government through control over appointments. When it comes to the economy, however, these same powers make the local party secretary a lethal competitor for any rival business centre in the world, especially the one right next door.

In the words of Cheung:

You want a business licence? The locality will assign someone to do the walking and talking for you. Want a building permit? They will give you one with money-back guarantees. Unhappy about that dirty creek passing through the site? They may offer to build a small lake for you. They will help you find architects and builders and, at the production phase, recruit workers for a reasonable fee. They sell their cheap electricity, sell their parks and entertainment, sell their easy transportation, sell their water supply, sell their glorious history and even sell how good-looking their girls are – no exaggeration!

Cheung's joke about good-looking girls was a reference to the county in Anhui province which held a beauty contest in 2005 to select the most beautiful local women to head teams to travel the country seeking investment for the area. Criticized all over the country for his gimmick, the area's party secretary replied: 'Beauty is an asset. Why not use it?' A locality with 300,000 residents, according to Cheung,

often employs as many as 500 people whose sole job it is to solicit investment.

China has witnessed a rising tide of violent protests against local development projects this century, a phenomenon of great concern for the leadership. But local governments have also sanctioned demonstrations to agitate in favour of investment in their localities. In Hunan in 2009, two neighbouring cities conducted campaigns demanding that a high-speed rail track from Shanghai pass through their area. The government in Xinhua county in Loudi city launched the 'Railway Defence Movement', while officials in nearby Shaoyang encouraged thousands of residents to take to the streets to bring the project there. In the end, both areas were accommodated with a piece of the project. Once the decision was made, the government removed photos of the state-sanctioned protest marches from the internet, to ensure the phenomenon of rival demonstrations did not spread.

The pivotal role of local governments in promoting their own economies means that each locality operates in a way like a stand-alone company. Localities promote investment, strong-arm banks for finance and often hold shares in the businesses themselves. In other words, they operate much like a company might. At the same time, the local party's overwhelming powers within its own borders effectively make each district its own separate jurisdiction, with direct control over the courts and over local regulations governing business activities. According to this formulation, every jurisdiction is a company, and every company a jurisdiction – all of them with powerful incentives to compete against each other.

Beijing has been smart enough to harness local dynamism to test new ideas, and then feed back the successful experiments into the national policy grid. The market economy was built on allowing special economic zones in places like Shenzhen in the early eighties to pursue liberal investment policies, while the rest of the country remained stuck with central planning. Policies on health, pensions and land reform have all been stress-tested at local level in recent years before being expanded nationally.

The golden age of decentralization under communist rule – the period from 1978 to 1993 – was also the apogee of private sector growth and wealth generation. China's GDP increased by 280 per cent

in these fifteen years; absolute poverty was cut by 50 per cent in the first half of the eighties alone and real incomes rose rapidly. 'If each of China's provinces was taken as an economy, about 20 out of the top 30 growth regions in the world in this period would be provinces in China,' according to a paper prepared by a number of the country's top economists. This era ended in one of the central government's periodic panics about its waning authority in the provinces. The policy cycles follow a familiar pattern, the Chinese economists say: 'Decentralization leads to disorder; disorder leads to centralization; centralization leads to stagnation and stagnation leads to decentralization.' The turning point in the current cycle in the early nineties was Beijing's alarm at the collapse in its share of national tax revenues, to just over 20 per cent, about half the level of fifteen years earlier. The introduction of a new tax policy that year ensured that a much larger share of the revenues now goes straight to Beijing.

The downside of the stellar growth rates that local dynamism has provided is the wasteful investment-led growth economic model that it has spawned, a phenomenon that is now a matter of legitimate global concern. India has achieved growth rates of 7 to 8 per cent by investing about one-quarter of its gross domestic product. China, by contrast, as local governments spend willy-nilly to keep up with the Wangs and the Zhangs next door, has invested nearly half of GDP to get a few percentage points more than its giant neighbour. As long as China continues to invest more than it consumes, its surplus production will head offshore in search of new export markets. In turn, the economic imbalances, such as those which underwrote the US housing bubble, will persist rather than subside.

If Hu Jintao and Wen Jiabao were to be judged by their ability to meet their promise to rebalance China's economic growth model, their first five years were an abject failure, for much the same reason. The pair had tried to put their stamp on policy the moment they came to office. In place of the growth-at-all costs programmes of the outgoing administration, they proposed a kinder, gentler prescription for development, a China that would be greener, fairer, more peaceful and less reliant on the smokestacks of heavy industry and cheap exports. Their rhetoric was partly political marketing. Chinese politicians, like their peers around the world, aim to differentiate

themselves from their predecessors. But by the time they strode out on stage at the Great Hall of the People to launch their second term in 2007, they had presided over a blistering half-decade of record economic expansion. Far from slowing down, production of energy-intensive steel, cement and aluminium had in some cases tripled and the trade surplus had increased eightfold. Riots and protests had reached record levels, according to the limited official figures, and China had become more unequal than ever before under communist rule.

Rather than reinforcing Beijing's writ in the provinces, Hu and Wen discovered that the radical recentralization of tax collection paradoxically only encouraged more economic freelancing outside of the capital. To raise money for the programmes they were still required to deliver, but no longer had the direct taxing power to fund, especially in education and health, localities were propelled into business more than ever. In the words of commentator Liang Jing, the new tax rules 'forced good girls to become whores'. To make up the budget shortfall, local governments 'bullied the peasantry, exploited the workers and destroyed the environment, while the central government turned a blind eye, concerned only for GDP and tax revenue, regardless of the process'. Some of the grassroots revenue-raising programmes deployed by local governments desperate for funds are hair-raising. In May 2009, Gongan county in Hubei province ordered state employees collectively to smoke at least 23,000 packs of cigarettes a year, to protect, it said, 'tax revenues and consumers' rights'. The more the officials smoked, the plan envisaged, the more money the local authority would collect in taxes. The policy was rescinded after a public outcry.

Most local governments have turned to real estate for cash, selling land at often inflated prices to make up budget shortfalls. 'The reform of the tax system means that local governments have no other source of revenue, so they concentrate on land,' said Yu Jianrong, an academic specializing in tracking farmers' grievances. Yu says his surveys have found that as much as 30 per cent of the fiscal budgets of the government in Hebei are raised through the sale of land, a finite resource. Throughout China, about 60 per cent of protests are related to anger over local governments selling land.

Against this background, it is little wonder that the leadership's policies to rebalance the economy have had a limited impact. The analogy

often used to describe the challenge faced by Hu and Wen is the old one of turning around a supertanker, to illustrate the time needed for such a massive task. In truth, the Chinese economy is less like a single supertanker than a vast armada of small, headstrong commercial ships, all still determined to proceed full-steam ahead, whatever the cost to the fleet as a whole. If China continues to invest far more than it consumes, the domestic economy will eventually stagger under the weight of its own imbalances, with an impact on the rest of the world. In the case of local governments, they are already running out of land to sell. Chinese leaders have never needed western economists or the World Bank to tell them that the present economic model has run out of puff, however much growth they can squeeze out of the system in the coming years. China's economic problems are well understood by policy-makers. The system's blindspot is overwhelmingly political.

So far, the central government's best efforts to retain the dynamism of localities while reining in the over-investment and corruption they have spawned have been political as well. Beijing has begun demanding that select party bosses in smaller counties come to the Central Party School in the capital, rather than attend smaller institutions in their own areas. To instil in them a greater sense of the centre's priorities, every one of the 3,000-plus county party bosses will be lectured directly by Politburo members and ministers, as part of mandatory courses ahead of future promotions. Beijing once would not have bothered with these lowly party chiefs, whom they derided as 'sesame officials', because their powers in the localities they ruled over seemed puny viewed from the centre. The people under the direct control of these same party chiefs call them by a much more respectful name, 'parent officials', because they know they have the power to make life-or-death decisions about their lives, no matter what the centre says. Beijing has now started to pay more attention to them as well.

Beijing has cannily leveraged a modern tool to keep the sesame officials in line, allowing Chinese journalists and bloggers to expose local abuses of power in a way they would never tolerate with senior leaders in Beijing. In 2009, a flurry of regional officials were brought down by what the Chinese call 'human flesh search engines'. A photo posted on the internet of a district official in Nanjing in charge of real estate displayed him smoking Nanjing 95 Imperial cigarettes, which cost about $22 a packet,

and wearing a Swiss Vacheron Constantin watch, which retails for about $15,000. The official protested the watch was a fake, but was sacked anyway and put under criminal investigation. In Shenzhen, the drunken party secretary from the local maritime administration, filmed abusing the father of a young girl he had tried to molest in the washroom, was sacked after the incident was posted online. 'My level [in the Party] is the same as your mayor. So what if I pinched a little child's neck? Who the fuck are you people to me?' the official yelled. In rural Yunnan, local jail administrators were removed after netizens ridiculed their explanation for the head injuries of a dead prisoner. They said he had died after playing a blindman's-buff-type game with other prisoners, but were forced to admit the inmate had been beaten to death.

The local parties' habitual secrecy, enforced by the grassroots propaganda departments under their control, might matter little in instances of mere economic disobedience. A few extra steel mills built in defiance of central government diktats on industrial policy or a few rivers dirtier than they should have been, however bad that is, will not bring the country to its knees. But in instances such as the Sanlu case, where the city's impulse to cover up a problem in its most profitable business was bolstered by the centre's political priorities, the outcome was devastating. The largely invisible hand of party bodies, in assorted guises, at a variety of locations and at different levels of its competing hierarchies, was behind every important decision taken in the Sanlu case. In the public frenzy that followed the revelations about the poisoned babies, the Party ensured that the pivotal, and even sinister role played in the scandal by its institutions never became a topic for debate.

Even by the standards of China's explosive growth, the expansion of the Chinese dairy industry had been astonishing in the previous decade. Pushed by a government which saw health benefits from the addition of dairy products to the Chinese diet, consumption of such products doubled in the five years from 2001, and revenues grew at an even faster pace. Mengniu ('Mongolian Cow'), the largest firm, which received investment from Goldman Sachs and Morgan Stanley and a business plan designed by McKinsey & Co. before listing on the Hong Kong stock market, had revenues of $5.9 million in 1999. By 2007, the once small private company in Inner Mongolia had became a certified

national champion of Chinese industry, with sales of $3.1 billion. As the company liked to say: 'Even though he is a cow, he runs with the speed of a rocket!'

Sanlu was another fast mover. Under Tian Wenhua, its then new chairwoman, Sanlu had pioneered the practice of outsourcing milk production in 1987, something the rest of the industry in China would later rush to emulate. Sanlu lent cows to farmers, who repaid the debt by delivering milk back to the company via a huge network of collection stations and middlemen. In return Sanlu collected a management fee. Instead of producing milk, the company transformed itself from a small local dairy into a milk-marketing giant.

For fifteen straight years, Sanlu was the top seller of formula in the country, making it the largest taxpayer in Shijiazhuang, an invaluable asset for a city otherwise struggling to attract industry and investment on a par with China's premier metropolises. In Chinese corporate parlance, Sanlu was a collective, an enterprise in which the managers and workers owned the shares, usually under the political supervision of the local communist party and government. In 2005, with its competitors closing in, Ms Tian forged an alliance with Fonterra, the world's number one dairy exporter, from New Zealand, which offered state-of-the-art technical expertise, to cement its place as an industry leader.

Diligent and frugal, and unusually untainted by allegations of personal corruption, Tian had been vaulted into the party elite by the company's commercial success. As early as 1983, the All-China Women's Federation had named Ms Tian a 'March Eight Red Flag Bearer'. The titles of the scores of other official awards that followed underlined the value the Party put on her business success. She was named a 'National Worker for Children with Distinguished Contributions', and an 'Excellent People's Public Servant' from Hebei province. In 2005, she became the 'Most Respected Entrepreneur of the Chinese Dairy Industry'. Ms Tian also sat on the Chinese People's Political Consultative Committee, a party-controlled body that met in Beijing each year concurrently with the annual session of China's legislature.

It was the two positions embossed on her name card that captured her conflicting loyalties most clearly. Ms Tian was the chairwoman of Sanlu, and also the head of the company's communist party committee, a second, more elevated, position, which bound her to a different set

of rules from those governing mere corporate executives. As chairwoman, she reported to the Sanlu board. As party secretary, she reported to what in China is often euphemistically referred to as a 'higher authority', to her seniors at the next level up in the Party itself.

Ms Tian's experience in the dairy industry, combined with the expertise of Sanlu's new shareholder, Fonterra, should have readied the joint venture to handle the food scandals then engulfing Chinese industry. Sanlu certainly had had no shortage of forewarning of the industry's problems. In early 2004, thirteen babies had died in the poor central province of Anhui after being reared on fake milk formula. The victims were called 'big-headed babies', because their heads swelled while their bodies wasted away. Incident after incident followed. Soon after, seventeen-year-old rice was found in shops being sold as freshly harvested. Shanghai's largest dairy company was discovered reprocessing milk already past its expiry date. In 2007, cats and dogs began falling ill and dying in the US after eating Chinese-made pet food. Toothpaste from China containing an antifreeze chemical was blamed for killing scores of people in Panama.

The foreign criticism that rained down on China after these international incidents left the government floundering to fashion a coherent response. The impulse of some senior officials, raised in a Communist Party infused with an anti-imperialist ethos, was to lash back. 'Some foreign media, especially those based in the United States, have wantonly reported on so-called unsafe Chinese products,' said Li Changjiang, the head of the agency responsible for monitoring food imports and exports. Mr Li complained that foreigners were turning 'white into black', but his fulminations masked deep anxiety in the central government about food safety. Late in 2007, the government sent as clear a signal as the state could muster on the issue. It executed the head of the State Food and Drug Administration, Zheng Xiaoyu, after he was convicted of taking bribes from pharmaceutical companies seeking government approval to market their products. Almost as soon as it was sent, though, the message amplified by the rare execution of a cabinet-level official was drowned out by the Party's overriding priority at the time, to expunge negative news in the lead-up to the Olympics.

More than one commentator has compared rapidly industrializing China with the satanic mills of Dickensian Britain and 'the jungle' of

Upton Sinclair's 1906 novel of the same name exposing the horrors of Chicago's meatpacking industry. Chinese food scandals bore an eerie similarity to the problems that beset the west during its own rapid industrialization. In China, as in the US and Europe a century or so beforehand, government regulators could not keep pace with the wealth, pollution and corruption generated by an exponential take-off in economic growth and the societal transformation that trailed in its wake. There was one important difference between China and the west – the Party, and the way it handcuffed the media.

In the US, muck-raking reporters made their careers by exposing the sins of robber-baron capitalism. In China, journalists in an increasingly commercial media nurture similar instincts, but they face a near-insurmountable obstacle, in the form of the propaganda department, in trying to follow their leads through. The powerful party department had long ago turned the Jeffersonian ideal of an informed citizenry on its head. According to its founding ethos, the media existed to serve the Party. The citizenry ran second. In the year of the Olympics, the department was not just concerned that exposés might cause unrest and damage the local economy. At a time when China would be in the international spotlight as never before, an uncontrolled media threatened to do even worse, by embarrassing the Party and the nation.

The propaganda department began its pre-Olympic tightening of the existing reporting restrictions in late 2007, well in advance of the games. In a baleful coincidence, the first complaints about Sanlu's formula had begun to trickle in to the company in Shijiazhuang at precisely the time the new restrictions were coming into force. The complaints recorded by the company's customer service line would be consistent for the next eight months. Parents who fed their babies the Sanlu formula said their infants' urine had begun to turn red. As their kidneys deteriorated, some babies were not able to pee at all.

The cause was a chemical compound called melamine, used to make plastic and glues, as well as fertilizer because of its high nitrogen content. To the burgeoning middlemen in the Chinese dairy market, who collected the milk from individual farmers before passing it on in bulk to companies like Sanlu, melamine was known by a creepier name. They called it 'protein powder'. Chinese manufacturers had used melamine to artificially inflate the apparent protein content of wheat gluten in pet food

exported to the US, which had led directly to the deaths of many cats and dogs which were fed it. Milk suppliers began to use the same trick in late 2007. Under pressure to shave costs in a market and meet new nutrient standards imposed after the 'big-headed babies' scandal, the suppliers were looking for a way to increase their margins. The outsourcing Ms Tian had pioneered years before and which had then been copied by competitor companies had come back to haunt the industry. Sanlu, and other dairy companies, had ceded control over the quality of their products to unscrupulous middlemen focused solely on price.

On the front stage of business and party life throughout this period, Sanlu seemed to be thriving. In late 2007, CCTV, China's national broadcaster, hailed Sanlu for its high-grade milk products in its weekly *Quality Made-in-China* programme. Laudatory articles about the company continued to pop up in the media through the rest of the year and 2008, even as more and more babies fell ill. Many of the articles were effectively paid advertisements, written by Sanlu's in-house PR representatives, but appeared as ordinary stories written by staff correspondents. As late as 6 August a Sanlu public relations officer, passing himself off as a journalist, reported in the *People's Daily* and on China's most popular news portal, Sina.com., that the company had been honoured as one of the brands that 'had changed China' in the past thirty years. Sanlu's PR efforts, an exemplary display of the close ties between wealthy companies and the party-controlled media, garnered it many advantages. After passing muster with the central government's Food Safety Bureau for three years in a row, Sanlu's milk formula in 2008 was no longer even being tested by the authorities for potential contaminants.

Backstage, out of sight, however, the picture of healthy products and happy babies was falling apart. The alarm bells inside Sanlu had been going off for months. The initial complaints about sick babies in late 2007 had been ignored, but they continued to mount. In February, the father of a young girl in Zhejiang who posted details of her inability to pee on a website removed the posting after Sanlu gave him free milk powder. In July, a local television station in Hunan tried to side-step the pre-Olympics reporting regulations by featuring shots of Sanlu products in a report on a sudden rise in kidney stones among babies, without mentioning the company in the accompanying voiceover. The same month in Guangdong, southern China, the editor of the *Southern*

Weekend, a well-known investigative weekly, discovered twenty babies had been hospitalized after consuming Sanlu's formula. The propaganda department, on patrol through its local affiliates for negative news ahead of the games, blocked the story altogether. 'For reasons that everybody knows, we were not able to investigate the case at the time because harmony was needed everywhere,' the editor, Fu Jianfeng, wrote later in a guilt-tinged post on his blog. 'I was deeply concerned because I sensed that this was going to be a huge public health catastrophe, but I could not send reporters to investigate.'

By late July, Sanlu had had its own tests verified by a provincial government laboratory. The results, when they came back, on 1 August, were alarming. Of sixteen batches sent, fifteen had potentially poisonous levels of melamine. The tests not only landed Ms Tian with a dilemma of corporate responsibility and public health. More than anything, as a senior party member, her problem had become acutely political. The Party's directives pulled her in different, conflicting directions. Ms Tian was obliged to follow the law against producing and selling dangerous goods, but as party secretary of the company, she also had overriding political responsibilities. The most important short-term political task, dictated by Beijing, was to ensure the Olympics were a success. Just before the games, the propaganda department had strengthened its reporting restrictions again with a directive that Sanlu and Shijiazhuang could not have failed to notice. Point eight of a twenty-one-point missive issued in early August was explicit: 'All food safety issues . . . are off limits.' A week away from the Olympics, a public recall of Sanlu's formula and an admission that babies drinking it had been poisoned would have created an uproar at home and abroad, devastated Sanlu's business and destroyed the party careers of company executives and city officials.

On 2 August, only a few hours after Ms Tian had closed the emergency meeting of Sanlu executives, the company's board was hurriedly called together on a Saturday morning in a telephone hook-up. The sole director from Fonterra available at short notice, a company veteran by the name of Bob Major, told colleagues that the board agreed after hours of debate to his demand for a full recall of milk products. A few hours later, he was rung back at his home in Shanghai and told the Shijiazhuang authorities had overruled the board. Fonterra prepared minutes detailing its understanding of the board's decision for a full

consumer recall of milk products. Sanlu sent back its own record, containing what it now insisted was a record of the meeting's decision in favour of a limited trade recall. Both sides refused to sign the other's board minutes.

There was little doubt whose view would prevail. Sanlu's original decision, taken at the late-night conclave ahead of the board meeting, stood on the orders of the Shijiazhuang city government. The board, in theory the sole lawful decision-making body for the company, had simply been bypassed, its deliberations rendered irrelevant. As the *Legal Daily* commented later: 'It was precisely at this [late night] meeting [on 1 August] that [the executives] miscalculated the situation, and passed a series of wrong decisions and sent Sanlu on its fateful journey to the end.'

With the Olympics in mind, the vice-mayor in charge of product safety in Shijiazhuang laid down the cover-up strategy in starkly political terms to Sanlu. Keep the problem secret, he said. Make sure the media does not make a fuss. Stop angry consumers from travelling to Beijing with complaints. If all else failed, he concluded, using a pithy Chinese expression: 'Block people's mouths with money.' Sanlu immediately sought out the city's propaganda department, writing to it to ask for help in 'co-ordinating' the media. 'This is to avoid whipping up the issue and creating a negative influence in society,' the letter said. Then, the company added some cyber-insurance for itself, with the strengthening of a so-called 'protection agreement' it had previously purchased from the search engine Baidu, China's Google. Baidu had long finessed its internet searches for the Chinese government, to block commentary critical of the Communist Party. It sold the same service to commercial clients, in the case of Sanlu for rmb 3 million, to limit or screen out searches linking the company's products to sick babies and melamine. (Baidu later denied selling this agreement.)

More than a week into the cover-up and four days into the Olympic games, Sanlu's public relations division was still pumping out positive news items. A Sanlu release posted on the national food industry's website reported the company was handing out free milk powder for babies born on the day of the opening ceremony. 'Sanlu milk powder says "Let's Go!" to the babies of the Olympics,' the article said. 'Let's use high technology, high standards and high nutrition Sanlu milk powder to say "Let's go!" for the future of China!' It wasn't until 9 September that someone blew

the whistle loud enough for the central government to hear it. After a delay of weeks while Fonterra agonized over what it should do, the New Zealand government directed its ambassador in Beijing to inform the Chinese government of the tainted milk. The full product recall, and the massive fallout, began immediately.

When Xinhua announced a few days later that Ms Tian had been sacked, the official news agency made no bones about who had taken the decision. The large headline said her sacking was 'an organizational matter' for the Hebei provincial party committee. Almost as an after-thought, at the end of the 500-character dispatch, Xinhua noted that Ms Tian had also been removed by the company's board in 'accordance with regulations and procedures'. The board had in fact had no role in her removal. After the party body had sacked Ms Tian and announced her removal, company executives said the board had been hastily convened in a late-night telephone hook-up to rubber-stamp the decision. One Fonterra executive commented later: 'They were always making decisions, but then asking themselves: "How do we make this legal?"'

The Sanlu board had been shunted aside by the Shijiazhuang party committee in the panicky cover-up in August a month earlier. In the midst of a full-blown political crisis, the central and provincial party authorities which had taken charge of the case had blithely sidelined it again.

The first thing I noticed about the room booked as a meeting-place for parents of children made ill by the Sanlu formula were the sketches stuck on the wall. From a distance, they looked like typical children's drawings, simple, skeletal-like stick figures with big smiles, alongside the outlines of the sun and flowers. A nice touch, I thought. Perhaps they had been done by sick children as they were being nursed back to health, as a kind of positive therapy. A closer look told a different story. One drawing showed two women holding hands, with the scrawled caption: 'I love my mummies.' Another, with two men, was captioned: 'Gay is good.'

The room in a two-star hotel complex in west Beijing said much about the odds the parents and their lawyers faced in suing Sanlu and the government. Government buildings in cities and towns throughout China are built on a grand scale on prime real estate, in-your-face symbols of the power of the state, with grand vestibules and ornate meeting rooms,

all designed to awe invited visitors. The people who take the state on, like lawyer Li Fangping, have to exist on more modest resources. For the meeting with aggrieved parents that day, Li borrowed a gay drop-in centre for the evening, hidden away on the thirteenth floor of a rundown, two-star hotel. Li's activism, like that of the gay people who sheltered at the centre, had forced him to the margins of Chinese society.

As soon as the scandal became public, Li had sent out emails and text messages calling for lawyers to volunteer to organize class actions in each province where there were victims. The response was unprecedented. Within days, he had the services of 124 lawyers in 22 out of China's 31 provinces and regions. 'I think there are more and more lawyers who want to give their services to society,' Li said. 'But then, this was a crisis on a national scale.' On this last point, the Party agreed. Sanlu should have been the biggest case Li had ever handled. But from the day the New Zealand government had belatedly informed Beijing of the problem, Sanlu became the concern of the top leaders of the country. Lawyers like Li, in such circumstances, were to be sidelined.

Once the scandal became public, the Central Propaganda Department changed tack in an instant. The department in Beijing had not been directly involved in the original conspiracy to suppress the news about the tainted milk, even though its Olympics reporting restrictions had given Shijiazhuang every incentive to join in one. Strict secrecy was no longer an option. With the games out of the way, the department's job now was to manage the news and guide public opinion, with two objectives in mind. The department had to make certain the fury of the aggrieved parents did not get out of hand and become a larger public political issue. And it also had to ensure the scandal did not taint the image of the senior leadership itself.

To handle the legal fallout, another shadowy branch of the Party was brought into play alongside the propaganda department, a body known as the Central Politics and Law Committee of the Politburo. Li felt the committee's influence as soon as he tried to mount a class action for his clients. The first call pressuring him to drop the action came from the All-China Lawyers' Association. 'Put your faith in the Party and the government!' he was told. Soon after, he was called in for a meeting, for another instruction. 'Don't take these cases, and do not try to represent clients across provinces!' The Justice Bureau in

Beijing then got in touch. 'If you take these kinds of cases, you must report them immediately!'

The Lawyers' Association, the Justice Bureau and indeed any legal body, all ultimately come under the control of the Politics and Law Committee. The control is exercised, backstage, out of public view, through the party cells that all legal bodies are required to maintain. The party secretary of the Lawyers' Association, for example, was a government official from the Justice Bureau in Beijing. The city's Justice Bureau sat under the Justice Ministry, which in turn reported ultimately to the Politics and Law Committee. 'It is the spider at the centre of a web,' said Li, of the committee, 'connecting the police, the prosecutor's office, the courts and the judiciary.'

Li is a softly spoken Christian who displays his faith on a wristband, saying: 'Pray for China.' Each time he was told to drop the case, he says he argued back. 'They are not happy that I have organized these private cases,' he said. 'They do not like private involvement at all.' Li had no direct contact with the Politics and Law Committee. Such party bodies prefer to exercise their control at one remove, through government organs or state-controlled professional associations. Li said he had been told by a local journalist about the committee's directives to rein the lawyers in. The conversation between Li and the journalist was an only-in-China moment, in many ways. The journalist was in possession of important, newsworthy information about party manipulation of the legal system. But while he could pass it on privately to Li, the party's propaganda wing ensured he could not report it in his newspaper. Gradually, Li said, the lawyers around the country who had volunteered to take the case began dropping out. Some succumbed to threats that their licences would be removed. Most discontinued their actions once the courts throughout the country refused to take the cases.

The Politics and Law Committee, like the propaganda department, had a delicate political process to manage. They needed to ensure that justice was seen to be done, without letting the legal process develop a life of its own. The committee contrived first to get the trial of Ms Tian and her main co-defendants from Sanlu out of the way in a single sitting. In a day's work that would have tried the hardiest sweatshop labourer, the three-judge panel opened proceedings at 8.30 a.m. on 31 December, and did not rise until nearly fourteen hours later, at

10.10 that evening. The sentences, for Ms Tian and more than twenty other people charged with a variety of offences, were all announced on a single day as well, a month later.

While the process was expedited, to limit the opportunity for victims' families to protest, the courts' verdicts were harsh. Three of the peddlers of the 'protein powder' received death sentences, one of them suspended. Ms Tian got life. The Shijiazhuang mayor was sacked, along with a number of senior officials immediately under him. The party secretary of Shijiazhuang, the most powerful official in the city, was also eventually removed from office. And Li Changjiang, the head of the food inspection service who earlier in the year had fumed about foreign criticism of Chinese product safety, was forced into an ignominious resignation. Tens of thousands of families received compensation according to a payment schedule drawn up by the government. As a final gesture to simmering public anger, the Supreme People's Court in Shijiazhuang agreed to hear the lawsuits from five families, as a way of finally putting the issue to rest.

Soon after the Sanlu verdicts, a businessman in the US state of Georgia was arrested for knowingly selling contaminated peanut products, leaving hundreds ill and a number of people dead. The Chinese state media, stung by blanket foreign coverage of the Sanlu scandal, reported the Georgia case with glee. Nearly 600 people had fallen ill after eating the company's products. Eight deaths had also been tied to the strain. The Xinhua headline drove the point home. 'Fully Aware Product Could be Contaminated with the Salmonella Virus; Continued to Sell Products; Agencies in Charge Discovered the Situation but Did Not Investigate.'

Behind the resentful tone of moral equivalency of the Xinhua report lay a missed opportunity that the Sanlu case contained for the Chinese system. The human factors that drive cover-ups, of greed and self-interest, combined with an indifference to the consequences, are evident no matter where they occur. Institutions are fallible, and manipulated to corrupt ends, all over the world. The Sanlu case displayed more than the foibles of ordinary people trying at great cost to save their careers and businesses, however. From start to finish, the scandal provided a lesson about the Communist Party's subterranean exercise of power, against its citizens, and also against itself.

*

In times of national crisis, the Party can choose to flaunt its leadership and its ability to mobilize resources on a scale few states in the world can match. The Party responded like a whirlwind after the 7.9-magnitude Sichuan earthquake in May 2008, for example, which killed nearly 90,000 people and left millions homeless. Wen Jiabao, the Premier, was on a plane to the disaster zone within hours of the quake. Thousands of officials, soldiers and ordinary citizens were marshalled in an instant for relief work. 'Faced with such a grim natural disaster, the Party and the government are the powerful social mobilizing force of the socialist state,' the *People's Daily* said. 'Any hardship can be overcome.'

The authorities' relief efforts had initially been surpassed by the community itself. Rich entrepreneurs, fledgling NGOs, private companies and even individual citizens, in an unprecedented, spontaneous surge, had rushed to the quake site to set up independent relief efforts in such numbers that the authorities did not dare to force them to leave.

A few weeks later, the Central Organization Department called an unusual press conference to enumerate the Party's own achievements during the rescue mission, as if to set the record straight. The Party, which sees itself in the Marxist tradition as the vanguard of the people, had clearly been uncomfortable with the impression that its relief efforts had been bringing up the rear. One of the department's vice-ministers, Ouyang Song, listed the Party's contributions to the earthquake effort at the press conference as though he was reading monthly production statistics. Over 500 party committees of soldiers, close to 10,000 grass-roots party bodies, 1,000 temporary party organizations and over 40,000 party members, all 'had faced danger and difficulty without retreating'.

The press conference, only the fourth in the organization department's seventy-year history, was a strange affair. If Ouyang sounded like a machine politician boasting post-election about his get-out-to-vote effort, it was because after a fashion he was. The earthquake had paradoxically been a political triumph for the leadership, because of the way it had emotionally united the nation behind a single goal. But the Party's sense of self-esteem still demanded it place on the record the work of its members in going to the rescue of their fellow citizens.

Success has a single father in China, a maxim which often makes for improbable reporting. According to an official media dispatch from the scene of a mining accident in Henan province in 2007, the moment

one rescued miner emerged out of the blackness into daylight, his first words were: 'I thank the Central Party! I thank the State Council! I thank the Henan provincial government! I thank the people of the nation!' Apart from the fact that the rescued miner made no reference to his family or loved ones, what is notable about this quote is that it captures perfectly the ruling hierarchy, with the Party at the top, followed by the central government, the provincial leadership, and finally, the people. The organization department's boasting about earthquake relief, or, on a much smaller scale, the reporting of the mining rescue, are the exceptions that prove the rule. Usually, party bodies prefer to fly under the radar, as they did in the Sanlu case, to ensure the sinews of their power remain out of sight.

In the Sanlu case, the Party's multiple organizations, at a local and then central level, often at odds with each other but sometimes in concert, enabled the suppression of the scandal at every turn. Party bodies censored the news, usurped the management of the company, sidelined the board, and finally sacked and arrested the executives. When the victims mobilized to take legal action, party bodies intimidated the lawyers, manipulated the courts and bought off the litigants, before finally letting a handful of cases proceed. In the end, the Party also harshly punished the wrongdoers as it closed off the case.

In every instance and at each step of the way, the Party's actions were only reviewable through its own internal processes and never subject to genuine public scrutiny. Other than passing references to Ms Tian's position as the party secretary, the Communist Party's role was barely acknowledged at all. Such observant silences remain par for the course in twenty-first-century China. The tasks of managing cadres, business, the media and the law are all in a day's work for the Party, whose rule over China, it insists, represents 'the verdict of history'.

The Sanlu crisis displayed the system at its secretive, cabalistic worst. When it came to the private sector in China, which has blossomed in tandem with the state in the past three decades, the Party was more than happy to take its share of the credit. The Party threw out its long-standing practice of operating backstage and made sure to advertise its presence in private companies out front, in public. Far from being in conflict, the Party wanted to ensure that the private sector and officialdom were seen to be working in harmony, for the mutual benefit of all.

7

Deng Perfects Socialism
The Party and Capitalism

'Deng Xiaoping was wise. He perfected socialism. Before Deng, socialism had many imperfections.'

(Nian Guangjiu, entrepreneur)

'I appointed myself party secretary of Haier. So I can't have any conflicts with myself, can I?'　　　(Zhang Ruimin, the chief executive of Haier, China's largest whitegoods manufacturer)

'Government support for private enterprises is less than that given to the state sector. We take this as a rule of nature.'

(Liu Yongxing, the East Hope group)

The man known across China as 'Mr Idiot Seeds' pointed out of the window of his modest two-storey shop and storage centre at the towering office complex next door. 'I wasn't the only one in jail,' he said. 'Everything you can see around you is owned by the guy who was in there with me.'

Nian Guangjiu, his real name, has had lots of time over the years to make friends in prison. He was jailed first in 1963 for engaging in illegal speculation, by running a private fruit stall in his home town of Wuhu, in central Anhui province. During the Cultural Revolution a few years later, his old capitalist rap sheet alone was enough to put him behind bars again, this time as a 'cow demon and snake spirit'. After the suppression of the 1989 protests, hardliners in the Party lumped entrepreneurs in with the student demonstrators as subversive threats to the state and sent Nian back inside for the third time. In the

cell with him was a fellow serial entrepreneur, who emerged from prison to build the office tower next door.

In the years when he was free in the late seventies, Nian had opened a shop selling an affordable, everyman's snack, the roasted sunflower and pumpkin seeds that Chinese chew meditatively, on and off, during the day. He bought in bulk from farmers and sold cheaply to consumers across the country. The same showy rebellious streak that had landed him in trouble with the authorities when he was growing up soon helped transform what could just have been a simple street-stall business. Nian's illiterate father had always been known as the local 'idiot' in his district. Nian, who was also illiterate, was called the 'little idiot', or 'idiot junior', in turn. Grasping for a sales pitch for his seeds, he simply named them after himself. On the packet, next to a beaming picture of Nian, he added a tag-line to flesh out the product name – 'Idiot Seeds: The Choice of Clever People'. The brand quickly became famous. Within a few years, he had a thriving business, more than 100 employees and his first fortune.

Far from being thrilled with Nian's success, the Anhui party chiefs who managed one of China's poorest and most populous provinces were initially petrified. Trumping any concerns about the parlous local economy, they fretted that they might be committing a political error by allowing a private company like 'Idiot Seeds' to trade. Anhui sent report after report to Beijing about the 'Idiot Seeds' phenomenon, asking whether it should be shut down for being capitalist. Finally, Nian's business landed on the desk of Deng Xiaoping himself in 1984. Soon after, Deng delivered a crafty rejoinder, in keeping with the wild economic experimentation he was encouraging at the time. Closing down the business would make people think the open-door policy had changed, he told the then ruling council of elders. Let's look at it again in two years. 'Are we really afraid,' Deng said, 'that "Idiot Seeds" will harm socialism?'

By the time I met him, in late 2008, Nian had morphed from subversive capitalist into a state-sponsored business celebrity. The official from the local propaganda department who greeted me at the entrance to Nian's store was confirmation alone of his elevated status. Chinese officials habitually harass foreign journalists interviewing citizens about past injustices and see them out of town. Instead, the Wuhu official offered me a banquet, a city tour and help with anything else I needed.

With the national commemoration of the thirtieth anniversary of Deng's open-door policy just a few months away, the city had adopted Nian as its homegrown mascot for the entrepreneurial economy.

Now in his seventies, Nian has the look of an ageing matinée idol, with a deep farmer's tan, loose, longish hair, and a faux-Nehru jacket lined with chinoiserie-patterned silk. His success had not rid him of his small-town habits. Every so often, he would noisily clear his throat and spit heartily on the office floor, as casually as if he were scratching his nose. His raspy voice and crackly laugh, toned by years of chain-smoking, was overlaid by a full-blooded local accent which made him difficult to understand. When he first started talking about his life, I wasn't sure if I had heard him correctly. Had he just denounced Mao for his 'enormous crimes' and killing countless people? The official from the propaganda department laughed nervously. Don't take him too seriously, he said.

As Nian warmed up, he began to sound less like a rebellious businessman and more like a party official. Slogan was laid upon slogan, punctuated by long pauses, and delivered in a booming voice. Each pronouncement finished with a screeching, rising inflection, as if someone was sticking a pin in his behind as he approached the end of the sentence. Anyone who has sat through speeches by top leaders in the Great Hall of the People will recognize this technique, of the rising pitch used to signal to the audience it is time to applaud. Nian hailed the 'third plenary session of the eleventh congress', in 1978, as the meeting which had 'invigorated China's fate'. (Applause.) He declared the Chinese economy to be in 'good shape and developing in an orderly fashion'. (Applause.) He pronounced that the legal system had been modernized and freed from government interference. (Applause.) As he went on, the most striking thing about Nian wasn't his occasional denunciations of the old Maoist system, but his praise for the Party, most of all for his hero, Deng Xiaoping. 'Deng was wise,' he said. 'He perfected socialism. Before Deng, socialism had many imperfections.'

Nian's statement – that 'Deng perfected socialism' – captures in three words the topsy-turvy world that the Party and the private sector have come to inhabit in China. The Party, which espouses socialism, spends much of its time deferring to the market. Entrepreneurs like Nian, who worship the market, are careful to defer to the Party. In this

environment, it is little wonder that the dividing line between what is public and what is private in China is often still impossible to detect. After coming to power in 1949, the Party closed private businesses and confiscated their assets. Over time, they criminalized private commercial activity, although the execution of the policy waxed and waned with political cycles and in different regions. The suspicion harboured towards entrepreneurs lingered long after Deng's market reforms in the late seventies. As late as July 2001, Jiang Zemin's decision to allow entrepreneurs to officially join the Party stirred a rare public split among the leadership and deep disquiet in the conservative rank and file. Deng, and Jiang after him, grasped what many of their conservative opponents never did – that the Party had much in common with private entrepreneurs, who disliked democratic politics and independent unions as much as they did. The Party's authoritarian powers not only kept workers in line. They also bestowed on policy-makers a flexibility that politicians in democratic countries could only dream about. Even by the standards of a capitalist economy, the Party could be unusually pro-business, as long as the state got a cut along the way.

The Party's distrust of the private sector was never about money nor the flagrant contradiction between individual wealth and the official Marxist and Maoist pantheons. All parties to this on-and-off-again, three-decade-long courtship agreed on the need to turn a profit. The real issue for the Party was the threat that the foreign and local private sector might become a political rival. The Party's natural instinct, to colonize the private sector, has often been overwhelmed by the sheer wealth of the new entrepreneurial class. In response, party interests have promoted private companies as an engine of employment and reined them in when they have grown too big; invited entrepreneurs to join the Party, while intimidating and jailing business leaders who fall foul of it; and supported more secure property rights, while muddying the rules surrounding ownership of companies, assets and land.

The larger point, however, of an unprecedented partnership between a communist party and capitalist business, holds. It remains an uneasy, unstable and unholy alliance, but an alliance nonetheless that, in the short term, has turned more than a century of conventional wisdom on its head. It may have taken decades, but a broad consensus has now developed at the top of the Party, that far from harming socialism,

entrepreneurs, properly managed and leashed to the state, are the key to saving it. Luckily for China, Deng learnt early on a lesson that nearly every other failed socialist state neglected to heed, that only a boisterous private economy could keep communist rule afloat.

The first time I met Zhang Ruimin, who heads Haier, China's largest whitegoods manufacturer and one of the country's best-known brands, I asked him what I thought was an obvious question. Zhang Ruimin was both chief executive of Haier and also secretary of the company's Communist Party committee. How did he balance any possible conflict between the Party and private profit? Zhang dismissed the question out of hand. 'I appointed myself party secretary of Haier, so I can't have any conflicts with myself, can I?' he replied.

In an interview with Xinhua, the official news agency, at about the same time, on the eve of the eightieth anniversary of the Party's founding in 1921, Zhang had struck a more respectful tone. The agency observed that some reports attributed him with 'superpowers', since he had turned Haier from a near-bankrupt shell into a global company in only seventeen years. Zhang responded: 'How do I have such power? I'm only an ordinary party member.' Under Zhang's guidance, the report added, middle and senior managers at Haier were voluntarily studying orthodox communist dogma to help with their work in the whitegoods sector. In 2002, Zhang became the first business leader to be admitted into the Central Committee.

Zhang was lionized in the Chinese press as the country's most famous entrepreneur. Journalists, grasping for an analogy, often referred to him as 'China's Jack Welch', a comparison that inevitably found its way into the headlines of the many stories about him in the foreign and local press. Haier was undoubtedly a success story and Zhang was entitled to take credit for its turn-around. In 1984, when he took over as chief executive, he legendarily wielded a hammer to smash fridges made by the near-bankrupt company to make a point to the workforce about product quality, a tale that populates all the business school texts about his entrepreneurial zest. Haier's branded products can now be bought around the world. The comparison with General Electric and 'Neutron Jack' was fundamentally flawed, though, for a very simple reason. Haier is not a private company. And the moment its senior

managers tried to exercise their power as shareholders to make it so, the local government issued a peremptory edict to stop them.

The status of Haier was symbolic of the central problem surrounding business in China. There is little dispute that the private sector in China has grown from an almost negligible part of the economy in the late seventies – so small that official statistics were not kept on it – to the prime engine of new job creation, if not economic output, thirty years later. But nobody knows, or at least can agree on, the true size of the private sector, because of the difficulty of defining who owns what in the first place.

In September 2005, CLSA, the emerging markets brokerage based in Hong Kong, produced a thick report about how entrepreneurs had taken over as the motor of economic growth in China. 'The private sector now contributes more than 70 per cent of GDP and employs 75 per cent of the workforce, creating the foundations of the vibrant middle class, so a rollback of market reforms is not an option for the world's largest Communist Party,' the report said. 'Today's most important economic question is not, "How will the government respond to an economic slowdown?" but rather, "How will China's entrepreneurs respond?"'

A week later, a rival and equally respected China research unit at UBS, the Swiss bank, put out a rejoinder, saying the private sector 'accounts for no more than 30 per cent of the economy, whichever indicator you use'. The report said: 'In China, the following big sectors are either 100 per cent or majority controlled by the state: oil, petrochemicals, mining, banks, insurance, telcos, steel, aluminium, electricity, aviation, airports, railways, ports, highways, autos, health care, education and the civil service.'

Yasheng Huang, at MIT, who has spent years poring through official Chinese data and documents on this issue, said when asked for his estimate of the size of the private sector: 'The honest answer is that I do not know and I think many people do not know. This lack of knowledge itself is telling, and due to the fact that the private sector is still considered somewhat illegitimate.' Although he did not arrive at an exact figure, Huang did reach one conclusion – the pure private sector in China at the end of the twentieth century, companies with no government ties or involvement at all, was 'minuscule', equal to about 20 per cent of all industrial output.

The confusion about what is public and what is private is a deliberate result of the system's lingering wariness about clarifying ownership. Ask any genuine entrepreneur whether their company is private, or 'siying', literally, 'privately run', it is striking how many still resist the description in favour of the more politically correct tag 'minying', which means 'run by the people'. In a people's republic founded on a commitment to abolish private wealth, an enterprise which is 'run by the people', even if it is owned by an individual, is more favoured than a company that parades itself as purely private. Most economists now skirt the issue, by dividing companies into two categories, state and non-state, and leave it at that.

When the Party first gave the green light to the market economy, it was in the countryside that business was initially embraced with the greatest fervour. Under Deng's new deal, farmers could sell on to the market whatever they produced above the quota demanded by the state. The impact was revolutionary. About five years after the reforms were launched, nearly every farming household in the country had dumped the old commune system and turned themselves into mini-businesses. The key to the revolution of the early eighties in rural China, where most of the population lived and worked, was that it had support at the very top. The party leadership, under Hu Yaobang and Zhao Ziyang, had deep experience in the countryside and also a decidedly liberal policy bent. Rural finance was plentiful. Property rights increased substantially. And private companies, which traded under the euphemism of 'township and village enterprises', thrived. Capitalism in China was both vibrant and virtuous in this period, says MIT's Huang, and offered tens of millions of people a feasible path 'beyond abject poverty'. The eighties model, however, lasted no longer than the decade itself. The potent combination of political and economic liberalism of this period ended in bloodshed in Beijing in June 1989.

It didn't take long after 4 June for the resurgent conservatives to train their fire on the private sector. Chen Yun, the one-time economic planning minister and the father of Chen Yuan, declared that deviations from the planned economy model had caused 'mortal wounds' to the system. Jiang Zemin, barely months into his job as party secretary and still deeply insecure in his position, labelled entrepreneurs as 'self-employed traders and peddlers [who] cheat, embezzle, bribe and

evade taxation'. The chill winds were soon blowing in distant Anhui. By September that year, Nian, 'Mr Idiot Seeds', had been arrested too.

Nian had always flaunted his wealth, building himself a big house and parading a string of girlfriends around the district. The 1 million-plus renminbi in profits that he had stashed at his home in the early eighties, an immense fortune in those days, became so mouldy in the summer heat that he made a great show of drying the notes outside. He laid them in the sun near his factory, much like farmers in China spread their crops out on rural roads to drain them of moisture after the harvest, a display of riches that brought him even greater notoriety. But even in the dark days of late 1989, the Wuhu party struggled to conjure up a crime they could pin on Nian. They first tried to charge him with 'embezzlement and misuse of state funds', but this was thrown out on appeal to the provincial-level courts. Once Nian established that he owned the company, he couldn't be charged with stealing his own funds. All Anhui had left was the charge of 'hooliganism', to wit, that he had conducted affairs with ten different women between 1984 and 1989. Nian was defiant throughout. Confronted with the charge of womanizing, he replied: 'You got your numbers wrong. There were actually twelve.' Nian was sentenced to three years in prison, but got out after just two, thanks again, he says, to the personal intervention of Deng.

For all his flamboyance, Nian had tried to do the right thing by the system. He had registered the company as a collective, because he could not get it on the books at the local commerce bureau as a purely private enterprise. He had employed some officials as well, giving the local government an interest in his venture. It won him few favours, however, when the chips were down. The officials apparently resented being made to work for their pay at all. 'I fined any cadres who read newspapers in work hours and anyone who was late was docked 1 rmb for each minute missed,' he said. In his absence in jail, the business collapsed and the company was shut down. Nian relaunched 'Idiot Seeds' when he was freed and he was still trading enthusiastically when I met him in 2008, but he never managed to re-create what he had established in the eighties.

The realization that the Chinese economy could not grow and prosper without private enterprise took nearly four years to sink in after the post-1989 backlash. Deng's southern tour of 1992 was one catalyst, demolishing the most extreme ideological barriers in Beijing. The partial,

strategic retreat of the state in China in the nineties gave insiders pole position in the mass sell-off of companies in sectors not considered strategic by the government, such as textiles, food and consumer electronics. China's entry into the World Trade Organization in 2001 allowed efficient entrepreneurs to find new export markets. Emulating Margaret Thatcher in Britain, when she privatized council homes by offering to sell them cheaply to their occupants, city after city in the nineties in China created private property markets by selling off state housing.

But just as the 1989 crackdown transformed the Party's stewardship of the state economy, its management of the private economy was overhauled as well. The policies which promoted the rural entrepreneurship of the eighties were supplanted by a new regime which favoured the cities, the focus of political unrest and economic upheaval. Farmers were more heavily taxed. Credit in the countryside was tightened. The big state industries which had survived the massive restructuring of the nineties retreated into the well-financed fortresses the Party had built for them. Whole sectors, mainly heavy industry, telecommunications and transport, were reserved for the state and shielded from full-blown competition.

Zhang Ruimin's Haier was typical of the fault-lines left running through Chinese business by the political earthquakes of the late eighties. Haier, defined as a collective enterprise, in which managers and workers owned the company's shares under the supervision of the local government, had always had strong support from the Qingdao government. The city gave the company land and facilitated credit, but otherwise largely left the company alone. To all intents and purposes, Haier had been privately, and successfully, managed with little interference from the state for many years. Many Haier managers had grown to think they were masters of their own universe and in 2004 they hit upon a plan to turn this conceit into reality. Haier proposed to take over a listed company in Hong Kong and inject into it some of the enterprise's most valuable assets. In one fell swoop, Haier's top managers, including Zhang, would become the largest set of individual shareholders, giving them control over the company's operations, brands and executive remuneration, and also an international currency – shares traded in Hong Kong – to expand offshore.

Just as Nian's political timing had often been awry during his career,

so too was Haier's manoeuvre to give its executives a fatter stake in the company. Around the same time, the pendulum of public debate was swinging against the privatization of state assets. An odd alliance of old-style leftists and populist commentators launched a highly charged public campaign on the issue, comparing management buy-outs of state firms to the scandalous privatizations of Yeltsin's Russia. The government, stunned by the campaign's popularity, was forced to respond. However grey the definitions may have once been surrounding the ownership of Haier, they were soon clarified. With no prior warning, the Qingdao agency in charge of government enterprises announced in April 2004 that Haier was owned by the state. The Hong Kong deal was killed. Haier and its managers, for the moment, were not going anywhere. The Haier case was a signal reminder that a company could be privately run one day and find itself claimed as a state asset the next.

Over the next three years, Haier's executives fought back, using their considerable political and commercial muscle to reverse the decision. Haier's senior managers refused point-blank to attend meetings for state enterprises convened by the Qingdao agency supervising the city's companies. 'If we were invited to share our successful experience, we would have first stressed that we are a collective enterprise,' Yang Mianmian, the company president, said. When the city asked Haier to take over a failing enterprise in Qingdao, Haier resisted the plan until it died. The Qingdao authorities eventually got the message. In April 2007, with a click of the mouse, the city quietly removed Haier from the list posted on the government website of state-owned enterprises in Qingdao. Haier returned to being a privately run collective. As if to celebrate the turn-around in their fortunes, Haier soon reintroduced a share incentive scheme for its senior managers. Zhang Ruimin was left out, though, because it was not appropriate to give share options to a member of the Central Committee.

After more than three decades of market reforms, Chinese companies still come in all manner of guises and trade under an array of different business registrations to accommodate prevailing political pressures. They can be fully state-owned, collectively owned or co-operatives; or limited liability companies, with diversified share registers split between both public and private owners. Some private companies are registered as state entities or collectives, giving them what the Chinese call a 'red

hat' and an extra degree of political protection from harassment by officials. The corporate cross-dressing complicates life for an entrepreneur, but it is common sense as well. Chinese banks, which are all owned by the state, still prefer to lend to the state, because the government will usually stand behind the debt in one form or another. By contrast, the banks have little confidence in lending to private companies, especially smaller ones. The banks may not understand or trust entrepreneurial companies or have the in-house skills to calibrate the risks in lending on cash flow rather than the security of assets. But at the end of the day, the reason is very simple. Private companies are not part of the club.

The smartest companies have become adept at having it both ways. The largest, and founding, shareholder of Lenovo, the computer firm which bought IBM's PC business, is a state science think-tank, but the company is registered and listed overseas and largely privately managed. For a while, it was headquartered in the US. Yang Yuanqing, the head of the company, still squirms when his Communist Party membership is raised. 'Let's not talk politics, OK?' he replied when asked after the IBM deal in late 2004 how he reconciled party membership with his business commitments. But Yang has also tried to keep his distance from politics. His advisers say he quietly rebuffed an invitation to join the China People's Political Consultative Conference, an honorary body headed by a Politburo member designed to give the impression that the Party is consulting broadly through the community.

Huawei, the telecommunications equipment manufacturer and perhaps China's most globally successful company, is careful to say it is a collective rather than a private company, a definitional distinction that has been essential to the company's receipt of state support at crucial points in its development. In 1996, Zhu Rongji, then vice-premier, visited Huawei with the heads of four large state banks in tow. On hearing the company needed funds to compete with foreign firms in the domestic telco equipment market, Zhu ordered the banks on the spot to support the company. 'Buyer's credit [for local customers] should be provided!' Zhu declared. Huawei's status as a genuine collective is doubtful. The company has never published a full breakdown of its ownership structure. Most shares are believed to be owned by Ren Zhengfei, a former People's Liberation Army logistics officer who founded the company in 1988, and his managers. The same murky structure characterizes Ping'an,

the Shenzhen-based insurance company. Ping'an, one of China's largest financial institutions, is classified as a private company, but the true ownership of large chunks of its shares remains unclear.

The campaigns attacking Haier, and the debate over the ownership of the likes of Lenovo, Huawei and Ping'an were in some way a distraction from the bigger trends. By the turn of the century, many Chinese had begun to accumulate substantial, and visible, personal fortunes. Just as significantly, some of them began to talk about it. The emerging new class of the super-rich represented a dangerous challenge for the Party. Having wiped out private business on taking office in 1949, the Party now needed to find a way to accommodate entrepreneurs.

In the late nineties, Rupert Hoogewerf, a young Chinese-speaking accountant in Shanghai, found himself struggling, for all his knowledge of the country, to explain the 'new China'. 'Any reader of newspapers could tell you that GDP was going to go up. Any tourist could tell you that the landscape was changing, but again, so what?' Somewhat of an entrepreneur himself, Hoogewerf decided to tell the story through a device long used in the west as a symbol of the entrepreneurial economy, by compiling China's first rich list.

Such was the sensitivity surrounding wealth and the creation of new classes in communist China, a local publication could never have got away with it. The Party can be anxious about even the most anodyne acknowledgement that China has become a class-ridden society. A Shanghai vice-mayor, Jiang Sixian, told me in passing in an interview in 2002 that the city was rapidly developing a new middle class. It was a seemingly harmless remark and in fact somewhat of a selling point for the city, playing into the kind of narrative that reassures westerners that China was becoming 'more like us'. The next day, his office called back with an urgent request from the vice-mayor: could his comments about Shanghai's new middle class go off the record?

If the vice-mayor could not talk about class and wealth, Hoogewerf suffered no such restraints. Hoogewerf started out by cold-calling many entrepreneurs on their landlines. Most had never told their stories before and were, perhaps naively, intrigued to pick up the phone and talk to a foreigner they had never met. They would not have afforded the same courtesy to a local journalist, because they understood that

the Chinese media were firmly in the hands of the state. Equally, just as many other entrepreneurs, who considered exposure of their wealth would be political death, avoided Hoogewerf's entreaties and pressured him to leave their names off. Ren Zhengfei, the secretive head of Huawei, sent threatening letters via lawyers and PR consultants demanding his name be dropped. Miao Shouliang, who made his fortune in real estate and household appliances in southern China, lobbied menacingly to stay off in 2002. 'He was very sensitive to upsetting anyone in the local party apparatus,' said Hoogewerf. Once Miao had been admitted into the Party's official advisory body in Beijing in 2003, however, he immediately relaxed and agreed to co-operate.

The lists were perfectly timed to take advantage of the emergence of a critical mass of genuine private wealth for the first time since 1949, and the parallel development of the cult of the entrepreneur. The old saying, that there were many Chinese economic miracles, but none in China itself, was no longer true. Communist China now had its own homegrown tycoons, and their wealth, families, spending habits, business strategies and investment plans were all suddenly public property. Although the local media couldn't initiate the project, they instantly replicated the lists under the guise of reporting on their publication overseas. For the entrepreneurs, the publication of their wealth was nothing less than a test of their political relationships and survival skills. It was a test that many of the highest-fliers failed.

Political traps lay everywhere. The number three on the 2001 list, Yang Bin, holder of a Dutch passport, who was in real estate and cut flowers, made a grievous mistake by expanding his business across the border into North Korea and was arrested soon after for tax evasion. The diplomatic establishment had been furious at what they considered his infringement of their turf. Yang Rong (no relation), who had listed the first ever Chinese business on the New York Stock Exchange in 1991, fled to the US in 2003 when he was threatened with arrest by the Liaoning provincial authorities. His sins were complex but, boiled down, they were political too. First, he fell out with his one-time supporter, the Liaoning government, over plans to invest outside the province; and then he clashed with the central bank over the ownership of a large batch of shares in his company. Once his dispute with the state became public, Yang was finished.

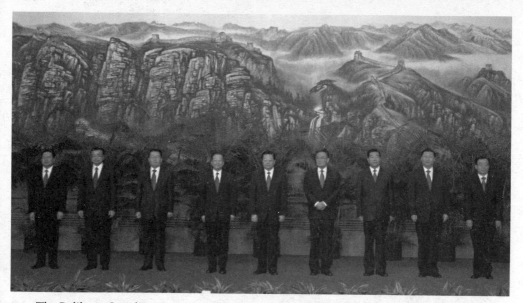

1. The Poliburo Standing Committee, the country's highest decision-making body, poses for a picture after its unveiling at the close of the Communist Party Congress in late 2007. The nine men were selected amid deep secrecy at the congress, held every five years, and rarely appeared together in public again.

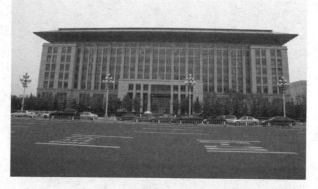

2. The Central Organization Department's headquarters in Beijing. The Party's powerful personnel arm has no public phone number, nor any sign on its building indicating the tenant inside.

3. Even after he stepped down as party secretary in 2002, Jiang Zemin remained enormously powerful behind the scenes and was accorded a status on par with the Politburo when he appeared in public.

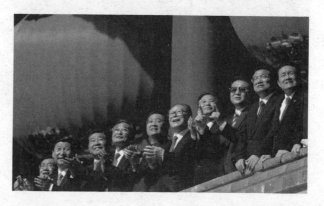

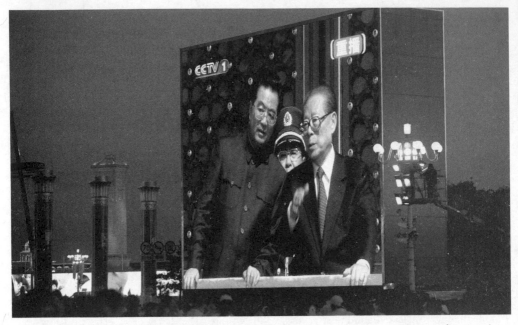

4. Hu Jintao and Jiang Zemin always made a show in public of co-operating, as on the occasion of the celebration of the eightieth anniversary of the Party's founding. But out of the limelight, they battled each other fiercely through proxies, over personnel as much as over policy.

5. Hu Jintao, along with Jiang Zemin, had to work hard to win the trust of the military. Both men cultivated the People's Liberation Army with generous budget support and also made sure to dress the part for military parades.

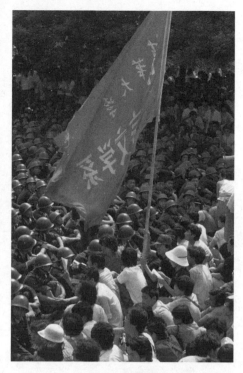

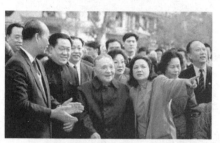

6. (*left*) Often written off as irrelevant in the west these days, the victory of the hardliners when the Politburo split over the use of the military to clear Beijing of protesters in 1989 shaped the Party's tough political line for the next two decades.

7. The 1989 crackdown chilled economic reform until Deng Xiaoping's decisive intervention in 1992. Instead of battling the conservatives in Beijing, Deng travelled south, accompanied by one of his daughters, to China's entrepreneurial heartland around Shenzhen, in a symbolic show of support for business using local and foreign media coverage to turn the debate in his favour.

8. Chen Yun joined the Party in the thirties and remained influential in economic policy-making until the early nineties. Long the country's pre-eminent economic planner, he became increasingly disillusioned with the pro-market policies of Deng Xiaoping.

9. Chen Yuan, Chen Yun's son, inherited his father's conservatism, and emerged as one of the Party's most influential 'neo-cons' in the dark days after the Tiananmen Square massacre. He later helped to spearhead China Inc.'s move into Africa.

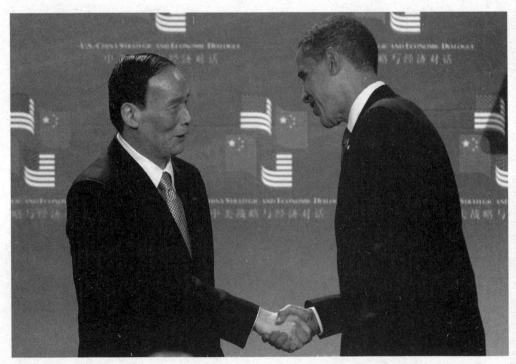

中华全国青年联合会 All-China Youth Federation	常委 Standing-Commissioner
中华全国工商业联合会 All-China Federation Of Industry & Commerce	常委 Standing-Commissioner
中国服装协会 China National Garments Association	副会长 Vice-Chairman
江苏省人大 Jiangsu Provincial People's Congress	常委 Standing-Commissioner
江苏省工商业联合会 Jiangsu Federation of Industry & Commerce	副主席 Vice-President
江苏省青年联合会 Jiangsu Youth union Association	副主席 Vice-President
江苏省服装业商会 Jiangsu Dress Industry Chamber of Commerce	会长 Chairman
无锡市民营企业协会 Wuxi Civil Owned Enterprises Association	会长 Chairman
无锡市青年商会 Wuxi Youth Chamber of Commerce	会长 Chairman
上海锡商联谊会 Shanghai sodalith of Wuxi Entrepreneurs	会长 Chairman

地址＞中国江苏无锡红豆工业城 邮编＞214199
电话＞0086-510-88358002 传真＞0086-510-88762003
E-mail＞zhj@hongdou.com.cn

10. As was the case for many private businessmen and women, the name card of Zhou Haijiang, a wealthy Jiangsu entrepreneur who owned one of China's largest apparel companies, said more about his political loyalties than it did about his business.

11. The Politburo was furious when He Weifang, a law professor at the elite Peking University, called the Party an 'illegal organization' which 'violated' China's constitution. Some officials wanted him jailed. When He persisted in his criticism, he was exiled from his prestigious teaching post to a small college in far western Xinjiang.

12. During the banking crisis in the USA and Europe, Wang Qishan, the Politburo member in charge of the finance industry, took to lecturing westerners about the superiority of the Chinese system. Wang's dismissal of the west reflected soaring confidence in the Party, as China successfully navigated its way through the global downturn.

13. Zhu Rongji's fierce tirades against corrupt and lazy officials won him many enemies and even irritated his colleagues in the Politburo. But his force of will was indispensable in China's overhaul of the banking system and its entry into the World Trade Organization.

14. Guo Shuqing, a smooth, globally minded official who worked as a commercial banker and in the central bank, managed to rise through the ranks of the Party, even while demanding it curtail its interference in state businesses.

15. Edward Tian was a successful entrepreneur when he agreed to head up a newly formed state telco company. Tian was annoyed when the Party first refused to accord him the same status as senior officials. By the time he left the company, he was singing the praises of the Party's management style.

16. As head of Chinalco, Xiao Yaqing faced the same dilemma with which many state business executives struggled: how to run a profitable enterprise and meet the Party's political objectives at the same time. Xiao was appointed to a position advising the cabinet after Chinalco helped stymie an attempted takeover of Rio Tinto by mining giant BHP-Billiton.

17. An ally of Hu Jintao from the China Youth League, Li Yuanchao was considered one of the country's most open-minded, up-and-coming officials. In 2007, he was promoted to head the Central Organization Department, putting him in charge of one of the Party's most secretive departments.

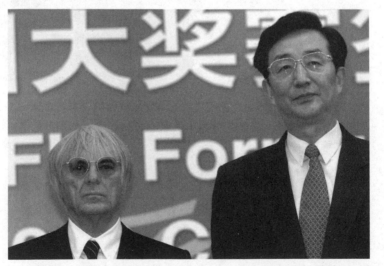

18. No project was too big for Chen Liangyu when he was in charge of Shanghai. Pictured here with Bernie Ecclestone, the head of Formula One motor racing, Chen oversaw the building of a state-of-the-art race track in record time. 'No democracy could afford this,' gushed Jackie Stewart, the former motor-racing champion, when he inspected the track. Chen was later jailed for corruption.

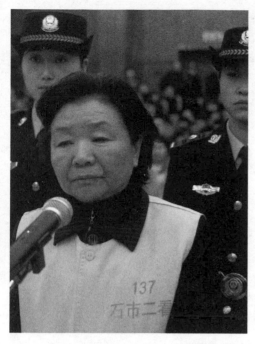

19. Tian Wenhua was showered with awards for building Sanlu in Shijiazhuang into China's biggest baby formula company. But her efforts to cover up the poisoning of hundreds of thousands of babies fed defective formula ahead of the 2008 Olympics, resulted in her imprisonment.

20. Nian Guangjiu, China's self-described 'biggest capitalist', was harassed and imprisoned numerous times for doing business over three decades until the Party learned to love the private sector and adopted him as a 'model entrepreneur'.

21. Yang Jisheng, a journalist for his entire career with the state news agency, Xinhua, turned against the Party after 1989 to write a series of exposés, including an epic work about the famine of the 'Great Leap Forward'. Pictured here in Hong Kong, he published his books in the former colony when his works were banned at home.

22. Mao's utopian plans in the late fifties to accelerate the development of 'true communism' in the movement known as the 'Great Leap Forward' resulted in the death by starvation of up to 40 million people. The Party has refused to allow any open examination of the period.

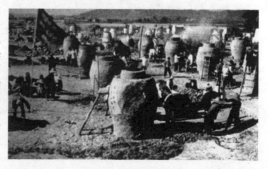

23. The irrepressible Li Rui was one of the highest profile critics of the Party, surviving because of his revolutionary credentials and the connections he forged as a deputy director of the Central Organization Department.

24. Shanghai property developer Zhou Zhengyi was brilliant and well connected, but he over-reached when he refused to rehouse residents evicted to make way for one of his projects. His fall triggered a scandal which later helped topple the city's most senior leaders.

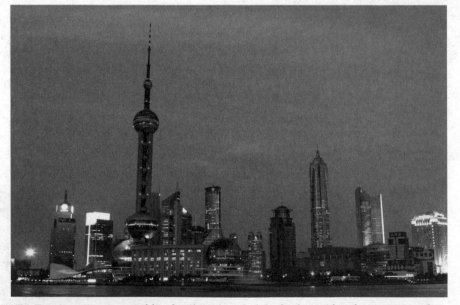

25. Foreigners were awed by the Shanghai skyline, built in a few frantic years after Beijing let the city join the market economy in the early nineties. Few of the city's admirers realized Shanghai was, for China, a model of state-led development.

As late as 2008, the top of the list remained a dangerous place. The richest man in China, Huang Guangyu, head of a national appliances chain-store network, Gome, with an estimated fortune of $6.3 billion, was detained for alleged insider trading in November 2008. The first reaction to the arrest of people like Huang was not, 'what did he do wrong?', but 'who did he offend?' The high-profile arrests of rich businessmen and women, however, overshadowed a more important development. Entrepreneurs had been starved of bank capital, fenced out of some of the most profitable sectors of the economy, often forced into unholy alliances with state partners and sometimes sent to jail. Despite these setbacks, private wealth had gradually become an indispensable part of the Chinese landscape.

For many entrepreneurs, inclusion on the list had an up-side. In the right circumstances, with a protective local government, the list could enhance an entrepreneur's social standing and perhaps boost their credit rating. When I visited the Shagang steelworks in Jiangsu in 2002, just ahead of the publication of the list that year, the PR man for the private owner of the mill, Shen Wenrong, complained bitterly about the attention the annual list drew for his boss. I told him not to worry. The latest list due out a few days later had Shen down about thirty to forty places compared to 2001. I assured him his drop down the ranks would ensure he got little press attention in the coming year. On hearing this, the mood of Shen's assistant instantly changed. He was indignant, exclaiming: 'But we have been making money faster than anyone else!'

As the entrepreneurs got richer, their political antennae sharpened. The smart entrepreneurs moved closer to the Party, and, by and large, the Party moved closer to them. Entrepreneurs like Wang Shi, who had been involved in political strife in the past, tried to erase their sins from the public record altogether. Wang, the head of China Vanke, the largest housing developer in the country, is a swashbuckling CEO in the mould of Richard Branson, producing books in his spare time about climbing the Himalayas and trekking across central Asia. In 1989, when he was thirty-eight, his pioneering fervour had taken him on a different trek, to the front of a march of his employees through Shenzhen in support of the demonstrators in Beijing. Wang was blacklisted by the local government for his role in the protests and reportedly jailed for a year.

Wang initially spoke openly about 1989 in the years after his release,

saying he regretted marching. In interviews with *Time* magazine in 1997, and the *Washington Post* in 1999, he said he had been wrong to lead the protests. 'As chairman, I was a symbol, not an individual. I should have stepped down if I wanted to protest,' he said. By the time he was interviewed for a lengthy profile in the *New York Times* in 2008, and had become one of the wealthiest people in the country, he claimed to have no memory of the episode at all. Through a spokesperson, he insisted he had never marched. The whole episode had been airbrushed out of his life altogether.

In late 2008, Wang summed up the rules he had learnt for doing business as an entrepreneur in China. From the moment he established his private business, he said, he had been careful to take on a government shareholder, to give his company a 'red hat'. 'You take too much, the state is unhappy, and you take too little, you get upset with yourself,' he said. When this first state shareholder was replaced a few years later, he made sure his new partner was state-owned as well. The first rule, he said, was that you will not develop quickly without a 'red hat', or a state partner. And second, you had better be careful about making it big without one. He had no need to articulate the third rule, which he had learnt in the wake of 1989: to stay out of politics altogether.

The symbolic turning point in the relationship between the Party and the private sector was Jiang Zemin's 2002 announcement at the five-yearly party congress that entrepreneurs could officially join the Party. Many had already been signed up by branches which could see the value of having wealthy business people on their books. Others had been members before going into business. About one in five of Hoogewerf's list were already party members. Jiang had long backtracked from his previous opportunistic denunciations of entrepreneurs as avaricious peddlers. As the private economy grew, the machine politician in him could see the benefits of a public embrace of entrepreneurs. Accustomed to keeping its role in government and state businesses backstage, the Party nevertheless saw political benefit in advertising its penetration of the most dynamic part of the economy. Hanging the party plaque out on the front stage of a private company reminded all who was ultimately in charge.

The consecration of this trend by Jiang was immensely significant, and also hugely controversial. The diehard leftists, a vociferous minority

who periodically released bristling petitions attacking the retreat from traditional socialism, could be relied on to oppose Jiang's initiative. This time, they were joined by Zhang Dejiang, then party secretary of Zhejiang, provoking a rare public split in the ruling elite. Before the decision was announced, Zhang said it was 'crystal clear' that entrepreneurs should not be allowed to join the Party, because they might take over local party organizations. 'Zhang laboured over his position on this issue, and then came out against entrepreneurs, only to be embarrassed by Jiang Zemin arriving in Zhejiang soon after and telling him he was going to let them into the Party, no matter what the opposition was,' said Wu Xiaobo, a Chinese author of best-selling books on private business.

In Zhejiang, Zhang presided over a province which entrepreneurs had turned into the richest in the country, measured by household income. At the 2002 congress, he was promoted into the Politburo as the party boss for Guangdong, another province which owed its wealth to the private sector. But Zhang's opposition to entrepreneurs was at least consistent with his deep communist roots. A native of Liaoning in the north-east, he had been sent by the Party when he was young to study in his province's near neighbour, and China's fraternal Stalinist ally, North Korea. In 2002, Zhang was hailed as one of only two members of the engineer-heavy Politburo to have an economics degree. Few realized that he had earned his at the Kim Il Sung Comprehensive University in Pyongyang.

Zhang understood in his bones the biggest threat posed by entrepreneurs: the creation of well-funded, self-contained private networks in society and business which no longer reported to the Party, or through it. Out of sight, they could become incubators for rival centres of power. The Party had long fretted about such a phenomenon, of 'peaceful evolution', the process through which the Party's grip could be slowly eroded by groups not under its sway. In the words of the head of a US direct sales company in Beijing: 'The Party doesn't want any large organized group outside of its ambit which can operate at scale, whether it is religious, political or just a large group. They simply do not want the competition.'

The controversy over the direct sales industry in China is the most florid example of this largely overlooked aspect of the growth of the private sector in a communist state. The operations of direct sales

companies, like Amway and Avon, conjure up in the west images of Tupperware parties and tepid suburbia. The Party, which looks at everything through the prism of the preservation of its power, saw the growth of these industries in China very differently. The arrival of the Avon Lady on China's doorstep was very much a political event.

For Richard Holwill, a veteran Washington lobbyist, it was like no negotiation he had ever experienced. In the late nineties, Holwill was in Beijing, representing his main client, Amway, the US direct sales giant. Sitting across the table this time was a different negotiating partner from the ones he had been used to. It was the Public Security Bureau, the police, with a list of firm demands for his company. Holwill had been in Beijing many times in an effort to prise open the potentially lucrative market for direct sales, jostling with the Commerce Ministry and other Chinese agencies which handled foreign trade issues and business registration. The presence of the police across the table was a sign that the game had changed, not just for Amway and Avon, but all direct sales companies.

Amway had built itself into a global enterprise with a simple business model, allowing people to become distributors for the company's household goods and personal care products and the like with no initial investment. The top sales representatives make their money not just by selling Amway goods but by recruiting others to do the same. Local governments across the country, however, couldn't distinguish the well-established firms from the many fly-by-night pyramid schemes which sprang up in China around the same time. The most notorious was a Taiwanese company selling 'foot vibrators' for about eight times their normal price, forcing anyone who bought one to recruit many new people to the operation to get their money back. Chinese governments at all levels had been besieged by angry investors who had lost money after being promised an easy fortune. Some people who had been cheated and lost their life savings committed suicide. Others rioted outside government offices. Beijing reacted as the bureaucracy often does when confronted by a new problem, by simply closing the industry down altogether. In April 1998, the State Council, China's cabinet, issued a decree, read out on the evening news bulletin of the state broadcaster, ordering all direct sales operations to cease business immediately.

It was clear to Holwill as soon as the police began peppering him with questions that they had more on their minds than rioting and fraud. Were any of the Amway sales team members of Falun Gong, they asked. Who screened the sales agents from Taiwan? 'The policeman told me directly, to sack all Falun Gong adherents,' Holwill said, arguing back that sacking them would not help, as it would only inflame the US Congress. 'I told them if we found someone who was proselytizing and doing the wrong business on company time, then we would fire them. The policeman looked at me, and said: "Just be careful."' The sardonic opening line of a foreign newspaper report at the time captured nicely the paranoia of the authorities about the Amways and Avons of the world. It said: 'Does "Ding, dong, Avon calling" carry a hidden, counter-revolutionary message?' In the eyes of Chinese security, it most certainly did.

In China, the Party tightly controls religion, mandating only five official faiths and demanding that all services be registered with the local branch of the religious affairs bureau. Non-government organizations and private charities have struggled to gain a foothold in China for similar reasons, because the government is reluctant to register them and provide them with a firm legal foundation on which they can operate. The Party's management of religion, NGOs and the Avon lady is founded on the same principle, to prevent them developing into rival centres of power.

As innocent and clean-cut as the industry seems in the west, direct sales in China rolled into one incendiary package in the business arena the ingredients that so worried the Party about religion and NGOs. Evangelical-style rallies attracted tens of thousands of people, who, as part of their recruiting drives, would rise to their feet to deliver inspirational speeches about what direct sales had done for them. Herbert Ho, who then worked for Amway, recalled hearing one man at a rally complain that he had been with the Party for thirty years and 'got nothing. I have been with Amway for three years and I have already got enough money to buy a house and send my children to college. Amway is my new home.' Ho added: 'This was very uncomfortable for the officials to hear. There was also a whiff of religion for them. The Chinese government does not respond well to this.' One foreign firm had recklessly held a sales gathering on 4 June, the hyper-sensitive anniversary of the 1989 massacre.

Some direct sales executives conceded that the police, at least on their terms, had a point. Many Falun Gong members, who had been banned from meeting each other, began to join direct sales teams. One executive said: 'When the company held large meetings, they [the Falun Gong] would hold small meetings. The government had been very effective in destroying their jobs and income, so that direct sales was a very obvious place for them to start work again.' The Chinese government ministries handling foreign trade and labour issues backed the well-established direct sales companies, because they generated income and jobs. But these ministries were not powerful enough to stand up to state security and the police.

The macabre intensity of the denunciations of the industry issued by the government and the Chinese media underlined the Party's sensitivity. One relatively liberal newspaper in southern China labelled direct sales companies 'independent kingdoms beyond national law and very much like a cult'. The national police body asserted that the companies wanted to control the 'minds and bodies' of participants. The word 'cult' had become a highly loaded political term by then, because of its association with the outlawed Falun Gong. In words that could easily have been applied to the Party itself, the State Council criticized direct sales because 'its organization was closed to outsiders, its mode of transaction was secretive and its distributors had spread throughout the country'.

When the direct sales industry was reopened, the government ordered each local branch to operate out of a shop, to ensure their trade was done in the open, rather than out of sight in private homes. Sales people could only be compensated for their own sales and not earn commission from recruiting others. For any meetings of more than twenty-five to fifty people (the limit varies from district to district), approval was needed from the police two weeks to one month in advance. The conditions laid down were aimed squarely at preventing them from becoming political Trojan horses outside of state control. The initial fervour of the government crackdown had died down by 2008 and about two dozen foreign firms have been issued licences. Amway in particular has invested large sums of money in what it calls 'government relations' and built a successful business in China. But even now, the police still conduct a 'strike hard' campaign – a form of words used

usually for crackdowns on criminal gangs – against illegal direct sales companies every year.

The same fear of subversion that led to the crackdown on Amway and Avon propelled a parallel party initiative around the same time. The target this time was another giant of US capitalism, Wal-Mart, which was made an example of the Party's campaign to unionize large foreign companies.

The campaign first drew blood in early 2006, in Quanzhou, an old Ming Dynasty port and a modern-day centre for sports goods manufacturing. Chinese law allows employees to form a union but does not oblige the company to do so. At first Wal-Mart resisted the campaign, saying it had no objections to the union, while disingenuously expressing ignorance that any of its workers had any interest in forming one. Once the employees in Quanzhou had enough signatures in favour of a union, gathered during surreptitious late-night meetings away from the store, Wal-Mart was legally obliged to establish one.

The US company needn't have worried that the union would damage their business. When I visited Quanzhou soon after, Fu Furong, the local union boss, unveiled the key document in his office with a great sense of triumph – a single sheet of paper with thirty blood-red fingerprints on it, as if the signatories were making a founding pledge for a secret society. 'We will never take simplistic measures like launching a strike,' Fu told me. 'With the union there will be a harmonious relationship between labour and capital.' Before the meeting with Fu, his staff had amply, if unconsciously, reinforced the same message. The staff member who picked me up at the airport didn't have a name card for her union position, so she gave me one for the side business she ran with her family, a rock-crushing operation in Henan province. My escort the next morning was also bereft of his union name card, but he had one for his second job, as a part-shareholder in a local sports sneaker factory. As pleased as they were about their political victory in forcing Wal-Mart to establish a union, neither of them tied the breakthrough to improved wages and conditions for company employees.

Under communist rule, the job of China's sole legal trade union body, the All-China Federation of Trade Unions, had always been to stop the emergence of an independent labour movement. Rather than representing workers inside state companies, the union worked for the

Party. The rousing cheers from foreign unions that greeted the federation's campaign against Wal-Mart, a scourge of organized labour around the world, missed this point altogether. When Beijing introduced a new labour law in 2006 in response to years of complaints about poor working conditions, the union led the government's campaign. But this new-found activism was carefully aligned with the Party's interests throughout. As Bruce Dickson, of the George Washington University, said: 'The Party has allowed the All-China Federation of Trade Unions in recent years to advocate strongly the interest of labour in the policy and legislative process, but [it has] also imprisoned those who advocate the formation of independent trade unions.'

The campaign against Wal-Mart had much in common with the political panic over the Avon lady – making sure that the Party had a presence in the foreign enterprises which had become a significant part of the new Chinese economy. In the words of two legal experts on China's labour laws: 'The fundamental objective [of the union campaign] is to reassert a lost control mechanism over the large number of employees that are now working in foreign firms, as opposed to state enterprises.' Foreign enterprises employed about 28 million Chinese, or about 10 per cent of the urban workforce. By the end of its three-year campaign, the national union body had increased coverage of these workers, from about 30 per cent of foreign-invested enterprises in 2003, to 73 per cent in March 2008. The campaign had not only netted the union significant revenue from the mandatory dues. It had also given the Party a new set of eyes and ears within foreign firms. Later that year, one Wal-Mart store in the north-east of China quietly established a Communist Party committee. It was an astonishing moment for the ultra-capitalist icon in a way, but also a sign of how vacuous the Party's official ideology had become.

The Party's efforts to infiltrate and control foreign companies was only one small part of a much larger strategy. The ultimate aim was to have a permanent party presence in every large private company in the country. For a display of the Party's manic desire to be everywhere, there is no better illustration than the campaign it launched in 2007, to infiltrate private companies in Wenzhou. For the Party, Wal-Mart would seem like a pushover by comparison.

*

Nestled on the coast behind a mountain range an hour by plane south of Shanghai, Wenzhou is legendary as the crucible of raw Chinese capitalism. Once difficult to access by road, short of farmland and dangerously close to Taiwan, Wenzhou had been forced to fend for itself after 1949. With the state investing little in the city, small, mainly household, firms stepped into the breach. Specializing in items like buttons, cigarette lighters, plastic ID card holders and shoes, Wenzhou firms first conquered local markets with their hard-to-get basic consumer goods. They then recycled their profits into a host of other investments, at home and abroad. Wenzhou companies, at different times, had up to 80 per cent of the global market for lighters, and nearly one-third for locks.

Wenzhou entrepreneurs led waves of property speculation in cities like Shanghai when the real-estate market began opening up. They were the first private Chinese investors in Shanxi coal mines, just ahead of the boom in prices in 2002. The Wenzhou clans also dominated offshore Chinese business associations and labour hire firms that sprang up in Europe in the nineties. The commercial acumen of Wenzhou traders has near-mythological status in China. The business section of any Chinese bookstore is full of titles about the city, such as *God Let the Wenzhou People Make a Fortune*, *The Scary Wenzhou People*, *The Rich Sisters of Wenzhou* and *The Business Book of the Wenzhou People, the Chinese Jews*.

On visits to private Chinese companies in Wenzhou and elsewhere, I always made a point of asking them if they had a party committee and what it did. Some executives, nearly always off the record, dismissed them as politically correct window-dressing. 'It's a formality; a kind of political show,' said a senior executive of a private Shanghai company awarded a prize that year (2001) for having one of the top ten grass-roots party organizations. Liu Yonghao, one of a band of brothers from rural Sichuan who made a fortune in the nineties from selling pig feed to farmers, was one of the few executives who was openly dismissive of the Party's influence inside his Hope group of companies, both times I met him – in 1996 and then again a decade later. 'I think it is good for party members [inside the company] to organize some study sessions or activities,' he said. 'But the secretary of the party committee is not in the leading class of our company.'

Otherwise, the answers were surprisingly consistent. In the same way that government officials all learn by heart the speeches of their leaders, even if they ignore them in practice, so too have entrepreneurs memorized the script justifying the Party's presence in their companies. The party committee was there to mediate the grievances of employees, much like a trade union, they said, and provide 'ethical' and 'spiritual' guidance. 'It's quite important in terms of company morality,' said Li Rucheng, who headed Youngor, one of the country's biggest private clothing manufacturers housed on a sprawling site in Ningbo. 'You have to have a spiritual core. Otherwise, you will be empty.' Li adopted the kind of sombre, reverential tone that so many people use when discussing the Party with outsiders, a sure giveaway that he was parroting the official line rather than voicing an independent opinion.

Left unstated by all the entrepreneurs was the fundamental reason for the Party's interest in the private sector. The Party's presence, straight out of the Leninist playbook, was more than just a monitoring device. It was a kind of political insurance policy, a sleeper cell to be activated in a crisis. The Party's aim was to have an activist and advocate inside every significant institution in the whole country. The Party itself is quite explicit about this role. 'In times of breaking events, like Falun Gong [the banned spiritual sect], we can [use the committees to] mobilize all channels to contain the crisis,' said Zhang Dahong, a vice-director in charge of the Shanghai party committee's grassroots division.

The Party's preferred model for the penetration of foreign joint ventures, which is taught in party schools, is the tie-up between Japan's Nissan and China's Dongfeng, a state-owned car and truck maker. The joint venture was one of the largest ever between Japan and China and a transformative partnership for the struggling Dongfeng. But that did not stop the Chinese side from stringing out negotiations for a year over its demands for a role for the Party in the new company. Dongfeng wanted more than the establishment of a symbolic party committee in the joint venture. Dongfeng insisted the new company give the party's chief representative a senior management post and pay his salary and office costs. Not only that, Dongfeng negotiated a specific agreement to have the party's plaque hung outside the committee's office. 'In its co-operation with Nissan, Dongfeng's bottom line is that the party organization in the enterprise should absolutely not be allowed to be

turned into an underground body,' according to the organization department's study of the case.

The organization department's internal report in 2005 on its work inside non-state companies is full of down-in-the-mouth dispatches from the grassroots about the Party's declining profile in private and joint venture workplaces. One party member is quoted: 'We are effectively out of money and out of power. Even when we speak, we attract scorn.' The Nissan–Dongfeng joint venture was a rare bright spot by comparison, as it included in writing an agreement for the Party's representative to be placed at the heart of the decision-making process.

Wenzhou has never pretended to toe Beijing's line, which may explain why it took the Party until 2007 to try its hand at penetrating private enterprise there. On my trip to the city a few years earlier, the official hosting me at the ritual welcome banquet joked about the top-level campaign recently launched by Jiang Zemin, which went by the ungainly title of the 'Three Represents'. 'I can remember the first two [represents]. Can anybody remember what the third one is?' he guffawed, between large mouthfuls of seafood. Few Chinese officials dare to mock the top leadership in front of foreigners, especially a few minutes after meeting them. The irony was that Jiang's campaign was a device to bring entrepreneurs into the communist orbit, as he did soon after. While they were hazy about Jiang's policy pronouncements, the Wenzhou officials at the dinner knew down to the last dollar the prices of luxury cars like BMWs and Mercedes-Benzs.

On the surface, the Party's putsch into Wenzhou seemed like a failure. Of 100,000 private companies in the city, only abut 4,100, or 4 per cent, had established cells. The initial report by the *People's Daily* in early 2008 listing the cells' good deeds, such as sending TV sets to poor families and visiting disabled people in their homes, made the Party sound more like social workers than the vanguard of Marxist-Leninism. The organizers professed to be relaxed about their progress. There were no quotas, no pressure and no politics involved. 'We will help them set up a party body, if it is a private enterprise, a social group or an NGO, but we will not require or force them to do so,' said Shao Depeng. 'We will just play a leading role if they are qualified and apply.'

Closer examination uncovered a different pattern. Only a handful of companies had signed up, but the ones that did were the city's major

private enterprises. A large organization itself, the Party preferred dealing with enterprises that had scale and clout, not the types Jiang Zemin had once dismissed as 'self-employed peddlers'. The Party astutely judged that the big private companies, with their interests spread beyond the city to the rest of the country, had much more at stake in politics. 'Setting up a party committee seems to be a symbol of normalization,' a local academic, Ma Jinlong, said. 'Only if they have party organizations will central government leaders visit them when they come to Wenzhou. If you ask what the function of the committees is, that is the biggest one.'

Much as Washington law firms retain former politicians for government relations, Wenzhou's large companies began competing with each other to hire the most senior retiring officials from the local propaganda department to head their party committees. When the Zhengtai Group, the city's largest private company, an electronics equipment manufacturer, was looking for an official to run its party committee, it made sure he was ranked more highly than the cadre hired by a local rival, Delixi, in the same industrial sector. The officials themselves were thrilled to be recruited. 'Both party secretaries retired ahead of time,' Ma said. 'They can get better pay by working at private companies.'

For the Party, the tie-up gave them a presence in private companies and a career stream for retiring officials. For the entrepreneurs, the benefits were arguably even greater. More business leaders gained seats in the city's people's congress and the official advisory body that met alongside it. Ma himself felt the entrepreneurs' power when he was nominated as part of an official campaign to name the thirty most influential people in Wenzhou. Soon after the campaign was launched, he said, he and all the other academics who had been nominated dropped out. 'At the end of the day, all the candidates on the list were entrepreneurs. They were the only ones who could afford to participate,' he said.

The same trend is evident in the smaller business associations set up by the Party at grassroots level to liaise with and penetrate the private sector throughout the country. Increasingly, they have been captured by business and lobby on their behalf. According to surveys conducted by Bruce Dickson, Chinese officials who believed the primary responsibility of state-sanctioned business associations was to provide party leadership over private companies had fallen from 48 per cent

in 1999 to 32 per cent in 2005. Officials who thought the first duty of the associations was to work for the businesses themselves had increased from 42 to 57 per cent over the same period. 'Party building in the private sector has been more successful at promoting the firms' interests than exerting party leadership,' says Dickson.

Wang Shi's stress on the importance of having a 'red hat'; Haier's tussles with the Qingdao government; Huawei's cosying up to the political establishment; and the cultivation of the Party by big firms in Wenzhou all have much in common. The bigger you get, the more important good ties with the Party are and the greater the benefits that flow from a good political relationship. The contrasting fortunes of two entrepreneurs who tried to crack open state-dominated industrial sectors in the early years of this century provide textbook examples of how to manage government relations to develop one's business, and the steep price to be paid for failure.

Nearly a decade after he launched a push into the aluminium sector, Liu Yongxing mused in an interview about the lessons he had learnt in trying to do business in an industry long monopolized by the state. Liu's business proposition had been straightforward when he devised his investment plan in the late nineties. He reckoned that China's industrial output and urban construction were on the cusp of a boom. Demand for aluminium, and the raw materials used to make it, would soar. With the domestic supply of alumina in China under the control of a single state company, Liu saw a once-in-a-lifetime opportunity for his East Hope group to enter the market as a streamlined, low-cost player. Liu aimed to control the entire production process, from mining bauxite to refining alumina to smelting aluminium, so he would not be held hostage by his state competitors at any point along the way.

Liu, who was already one of China's richest entrepreneurs, got at least one part of the business equation right. The five years from 2002 were a golden era for Chinese heavy industry, an era of record expansion and profits. But managing the politics of entering the sector proved to be much more perilous. Asked in the 2008 interview what he had learnt, Liu replied that he had taken one lesson to heart: to make sure his company did not become the 'next Tieben'. He said: 'Tieben is a lesson for us all. It was a tragedy.'

Jiangsu Tieben Iron & Steel is reduced these days to a footnote in the story of the Chinese economy, the tale of a crooked entrepreneur who overreached and got his come-uppance. Dai Guofang, Tieben's owner, in fact had much the same business plan as Liu. In the early part of this century, Dai saw a similarly huge opportunity in steel. As a low-cost producer, he thought he could easily grab a profitable market share away from the relatively pampered state-owned giants like Baosteel, 150 kilometres away down the Yangtze, near Shanghai. All he needed was scale. The market bore him out in the years to come. Steel demand, and profits, surged in the five to six years to mid-2008.

Only unlike Liu, Dai was not around to enjoy them. Liu's business survived, only just, multiple attacks on it by the state sector. Dai, however, ended up behind bars in a blaze of publicity orchestrated by the central government. The different fate of the two businessmen was simple. Whereas Liu astutely managed the politics of battling a state monopoly, Dai was out of his depth when the political winds in Beijing reversed course, and started blowing against him.

Dai's plan to become a big player in the Chinese steel industry was hatched with the party bosses of Changzhou, an industrial city on the Yangtze river, in Jiangsu province. The then 41-year-old businessman owned a small steel factory but dreamed of scaling up to a blast furnace. His proposal to build a big steel mill found a receptive audience when he pitched it to city leaders in 2002. Changzhou jealously compared itself with two dynamic rival cities nearby in the Yangtze river delta, Suzhou and Wuxi, which had both left it far behind. 'For Changzhou, their thought was: we must grab this chance,' said Zhou Qiren, a prominent economist at Peking University. 'It was a simple business decision. Dai needed local government support, land and loans, and they needed to report the project to the centre. Changzhou said to him: "Don't worry about this. We will handle it."'

Even by the standards of the Chinese robber-baron era, Tieben was an audacious project. By the time planning had finished, Dai's new Changzhou company would have a capacity of 8.4 million tonnes, a large mill by global standards, equal to about two-thirds of British steel output in 2008, but less than 5 per cent of China's. The central government required any steel projects with a value above about $50 million to be cleared by Beijing. To get around this, Changzhou simply

broke the $1.28 billion project down into twenty-two individual busi-
nesses, and approved the development itself. The local branches of
China's big national banks came on board, pledging loans worth 40
per cent of the start-up cost. In mid-2003, Dai began to build.

If the project had been launched a year or two earlier, Dai and
Changzhou might have got away with it. But by early 2004, the alarm
bells had started going off in Beijing about the red-hot economy. Heavy
industry was especially in the government's cross-hairs. It consumed
too much energy, put upwards pressure on already rising commodity
prices, spewed out tonnes of pollutants, including greenhouse gases,
and employed relatively few people for all the capital invested in it.
Beijing decided it needed to send a strong message – proverbially 'kill-
ing the chicken to scare the monkey' – to rein in further investment.
Most of the new capacity was being added by China's state-owned
steelmakers, which were expanding frenetically. None of these compa-
nies, however, represented as juicy a political target as Tieben.

The full force of the state soon descended on the project. Construc-
tion work at Tieben was stopped in March 2004, on central government
orders. A month later, at the end of April, Beijing elevated the project
into a full-blown political case. The State Council convened a meeting
specifically to discuss Dai's steel mill. A stern account of the meeting
issued by the official media raged against Tieben's 'illegal and criminal
acts' and the 'gross violations' of the law by the local government and
banks. For the mild-mannered Premier, Wen Jiabao, who seldom picked
public fights, it was a rare display of political machismo of the kind
for which his predecessor, Zhu Rongji, was renowned. Wen dispatched
investigation teams from no less than nine central government agencies
and ministries to Changzhou to trawl through Tieben's books for
evidence of wrongdoing. Beijing did not doubt its ministerial sleuths
would uncover a rich lode of misconduct, as such fishing investigations
invariably did. A grand economic show trial loomed.

In the months and years that followed, the Tieben case unravelled
in an embarrassing fashion that underlined the farce of the whole
episode. Beijing's investigation team concluded that the primary miscon-
duct in the Tieben affair was the city government's division of the
project into twenty-two separate smaller ones. A number of relatively
minor city government officials were sacked and the party secretary of

the city formally disciplined. But only Dai was sent to jail. By the time his case got to court two years later, the hyperbole about false accounting and fraudulent bank loans had evaporated. There was no law banning the construction of huge steel plants. The restrictions were government regulations, enforced ultimately by the Party's ability to remove officials from their jobs if the rules were not followed. Dai was eventually charged with issuing false invoices to claim tax rebates, a common practice in the industry.

Changzhou, bitter about being singled out by Beijing, sensed weakness in the downgraded charges and the failure of the central government investigation to find substantial wrongdoing. When Dai appeared in court in March 2006, he defiantly pleaded not guilty. Defendants will normally plead guilty in such cases in China, as it is the only way to mitigate a potentially harsh sentence. More startling was how the Changzhou court, which is under the control of the city's party committee, joined Dai in thumbing its nose at Beijing. For four years, the court refused to issue a verdict in the trial. Dai's lawyer, Qian Lieyang, a Beijing defence attorney, threw his hands up in despair at the delay. 'This case is quite rare,' Qian told me in late 2008. 'We have been pushing and pushing the court for a decision, but now we have given up.' Qian knew a not guilty verdict was untenable, because it would force the central and city governments to confront the ownership of the company's assets and land, and compensation for their forced acquisition. 'There would be all sorts of political complications arising from a "not guilty" verdict,' Qian said. But the absence of a verdict was a political statement on its own, a way for the city to express its displeasure at Beijing's veto of a major local development.

In mid-2009, with Dai already out on home detention, the court quietly entered a guilty verdict on a minor charge. The court's decision underlined the futility of Beijing's campaign against the company. Crude steel production doubled in the three years to 2004, reaching 280 million tonnes. By 2008, before a slump triggered by the global credit crisis and a domestic property crash, it had surpassed 500 million tonnes, more than the output of the next seven largest steel producers altogether. By mid-2009, steel production was running at an annualized rate of about 550 million tonnes. The political destruction of Tieben had had little economic impact at all. 'What on earth happened to

prompt nine central government ministries to train their heavy artillery on an obscure private company?' Zhou Qiren, the economist, wrote in a newspaper commentary at the time of the trial in 2006. 'Big state companies can get involved in huge projects. But when private companies do so, especially in competition with the state, then trouble comes from every corners.'

Although he did not disclose it in his writings on the case, Zhou had sought permission to interview Dai in jail. It was a highly unusual request, prompted by Zhou's interest in the politics of the private sector. The Changzhou party referred Zhou's request to the city police which sent it up to the province, which in turn referred it to the Public Security Ministry in Beijing, which finally approved his visit. Behind the bars of the prison Zhou found a sharp businessman, but with no political antennae. 'Dai knew the whole industry inside out, all about the basic costs. He thought Tieben would have the lowest cost for new steel capacity in the country,' Zhou said. 'His investment was based on the market, but China is a political economy.'

This was a lesson that Liu Yongxing had learnt well in the late eighties and early nineties, when he made his first fortune, with his brothers in the pig-feed business. Now running his own company, his strategy had remained constant: stay an inch ahead of government policy, and no more. 'Many times, we walked in front, as there was no policy,' he said. 'So within the confines of current regulations, go half a step further. Feel the way. You need to have good controls, otherwise, you could get stuck.' And, he added, end up in a ditch like Tieben. 'Government support for private enterprises is less than that given to state companies. This is characteristic of the reform,' he said. 'Since it's the character of the reform, we cannot change it. We take it as a rule of nature.'

Liu had long before internalized the inbuilt bias against the private sector. In the twenty years to 2002, before he split with his brothers, his businesses had never relied on borrowing from the state banks. The banks hadn't initially been interested in lending to the Liu brothers. And when the banks did start to chase their business, the Lius did not need them. Like most entrepreneurs, they had learnt to fund themselves from their profits. Once he accepted this was the way of the world in China, Liu said his attitude changed for the better. 'Otherwise, you will

be full of spite, and then either do nothing or do something extreme, which could be illegal.'

Liu Yongxing's hard-won self-reliance influenced more than just the way he did business. His determination to have a very disciplined relationship with officials and not do shady deals to get ahead also dictated the sectors he invested in. He gave up on real estate, he says, because he could not bear socializing with officials. 'Real estate requires lots of [insider] trading, and constant wining and dining and gift-giving,' he said. Likewise, he decided not to list his new company on the stock exchange because this 'would take a huge amount of personal energy on lobbying [the regulators] and various other government departments . . . and walking too close to the path of illegality.'

Liu confronted even greater obstacles to break into the aluminium business than Dai faced with steel. Up against him was a state monopoly, the Aluminium Company of China, or Chinalco, one of the elite fifty or so large firms controlled directly by the Party in Beijing. Not only was Chinalco one of the most powerful, sophisticated and aggressive state firms in the country, it also controlled the raw materials and technology needed by any competitor wishing to enter the industry. Most importantly, Chinalco had a virtual monopoly over alumina, controlling 98 per cent of domestic market supplies. There were two weaknesses in Chinalco's well-fortified armour, one political and one related to technology. Liu cleverly, and legally, got around the political obstacles. One of the most intriguing questions about Liu is how he surmounted the second hurdle, getting his hands on the key technologies to make alumina.

Liu first trained his sights on targets distant from the capital. Chinalco might have been all-powerful in Beijing, but it was a very different story in the provinces. The central government had given Chinalco the mining rights over most of the country's bauxite when the firm was restructured and partially listed overseas in 2001. Whereas Chinalco had an interest in hoarding bauxite, to keep prices high, the cash-hungry provinces housing the resource wanted to dig it out of the ground as fast as possible. Liu found himself pushing at an open door in Henan, which had about 60 per cent of China's bauxite reserves. With an eye to generating extra tax revenues, the province quickly decided it would not be bound by Chinalco's agreement with the central government.

Henan began issuing bauxite mining licences to Liu and other entre-
preneurs trying to break into the industry.

Chinalco fought Liu every inch of the way. It used its clout in the
central government to have Liu's projects delayed as part of investment
controls. It demanded a controlling share on the Henan project as a
condition of allowing it to go ahead. In the meantime, it slowed down
the issuance of import licences for alumina in general, so as to fortify
its monopoly on the resource. But gradually, the pieces began to fall
into place for a fully integrated private aluminium business. Liu got
the bauxite mine in Henan, where he could refine ore to produce
alumina. He fended off Chinalco's demand for a stake in his company.
And he established smelters in Inner Mongolia and Shandong, both of
which were serviced by power stations fed by nearby coal-mines, in
which he had an interest as well (aluminium production requires
substantial electricity).

The final piece of the puzzle was the proprietary technology control-
led by Chinalco and needed to refine the low-grade local bauxite into
alumina. How Liu got hold of the technology he has not said. Other
entrepreneurs trying to break into the business, however, simply stole
it from under Chinalco's nose. Just as it had with bauxite, Chinalco
tried to ration the technology's use to keep competitors out of the market
and protect its monopoly. Through its control over the country's two
national aluminium research institutes in Liaoning and Guizhou prov-
inces, Chinalco had the technology under wraps. The engineers at the
institutes themselves, however, chafed at the restrictions on their work.
In the market economy, the more they could licence their expertise, the
larger the cash return for themselves. Frustrated, a number of the top
engineers quit the two state institutes in 2003 and set up a new research
centre in a university in Shenyang, taking the blueprints for refinery
designs with them. Soon, they began to sell Chinalco's proprietary
designs to any entrepreneur who wanted to buy them. Over a short,
twelve-month period, four of the engineers made about $5 million.

By the time the rogue engineers were caught, it was too late. The
rival alumina refineries, including Liu's project, were approved, or up
and running. Their timing was perfect, catching the surge in Chinese
demand for the refined product. The impact on Chinalco's business
was devastating. In the three years to 2008, Chinalco's share of the

domestic alumina market plunged from 98 per cent, a virtual monopoly, to less than half. The most astounding thing about this body-blow to one of the most powerful state companies in China was that it resulted directly from industrial espionage by local private companies. Five engineers from the former Chinalco's institutes were convicted in a court in Guiyang of stealing commercial secrets. One received three years in jail but the other four avoided prison terms and paid only paltry fines.

Throughout the lengthy delays caused by Chinalco's attempts to derail rival projects and hoard its technology, Liu's greatest strength was his money. By the measure of China's rich lists, Liu was worth about $3 billion in 2008, one of the wealthiest people in the country. He was able to finance the projects in conjunction with his partners without relying on bank finance. In Changzhou, by contrast, Dai was tied to the banks, which were susceptible to political pressure. Liu showed how a cashed-up, politically attuned entrepreneur can survive and prosper. Liu won support from some central government policymakers who saw no value for the economy in the maintenance of Chinalco's alumina monopoly. But Liu's most important relationships were with the state outside Beijing, with the various provincial governments which wanted to promote economic development close to home. The local officials in the provinces had every incentive, and right, to seek out entrepreneurs like Liu. 'We could satisfy their needs with our performance, taxation, environmental protection, and social image,' said Liu. 'Pardon me for being frank, but local officials, even corrupt ones, all need to have political achievements.'

In 2008, the Party invited a select group of thirty-five entrepreneurs to the Central Party School in Beijing, a gesture that took the courtship of private business to a new level. The initial invitation had gone out to thirty-four entrepreneurs. 'The thirty-fifth one,' said the businessman who provided this account to me, 'begged to get in.'

The party school's modern buildings, spread over large comfortable grounds near the Summer Palace on the fringes of the capital, sit at the pinnacle of a sprawling nationwide system of 2,800 full-time educational institutions for retraining officials. Many of these institutions simply provide stolid refresher courses for officials on party history

and the latest campaign *du jour* from Beijing. Middling to minor entrepreneurs are occasionally invited, as part of the broader campaign to lure business inside the tent.

The invitation to the thirty-five entrepreneurs went further than anything the party school had offered before. They lived on campus and studied in intimate groups with up-and-coming officials from all over the country, the future leaders of China. In addition, they heard lectures from the Party's most powerful figures. The entrepreneurs, mostly running tech and new media businesses, were all wealthy high-achievers in their own right. They included Yu Minhong, from New Oriental, a Nasdaq-listed English-teaching company; Feng Jun, from Aigo, in consumer electronics; and James Ding, Edward Tian's old colleague from AsiaInfo. The chance to take part in the elite party school course was the equivalent in the US of being invited to do an executive MBA at Harvard alongside the next generation of US political leaders. In China, it was a networking opportunity without parallel.

The first thing many of the entrepreneurs noticed when they arrived at the party school were the fabulous facilities. Their rooms had large Lenovo televisions, with LCD screens and wireless internet. There was a 50-metre swimming pool, tennis and squash courts, and private trainers available for personal sessions in a well-fitted-out gym. Like teenagers thrown into boarding school, they quickly calibrated how they had been ranked against the officials, according to the day-to-day privileges they had been granted. Their meals in the canteen were free, whereas most of the officials had to pay 5 rmb each; and they had Colgate toothpaste in their rooms, instead of the local Heimei ('Black Sister') brand. 'We did well,' the entrepreneur said. 'We were treated better than the officials who were at the head-of-county level.' Each room had a plate affixed to the door, with the occupant's name and region in the case of the officials, or their company and business for the entrepreneurs. Together with the name-tags they all wore, the course gave the entrepreneurs easy access to officials who might otherwise be hard to meet. 'The business people selling pollution-control devices and railway communications equipment sealed some big deals while they were inside,' the entrepreneur said.

The course started with a short overview of the Party's sacred screeds, like 'Mao Zedong Thought' and 'Deng Xiaoping Theory', and so on. There were lengthy lectures on regional military conflicts; multilateral

trade talks; and current events around the world. Like many people when they are exposed for the first time to skilled politicians on their home turf, many of the entrepreneurs were dazzled by how articulate the officials were, and their ability to balance competing views when they addressed a topic. By the end of the course, the entrepreneurs had gained a new respect for the officials and their mammoth jobs. Individually, the officials were often responsible for the welfare and provision of services to tens of millions of people. They worked investment banker hours, were forced to spend long periods away from their families and had to endure three to four banquets a night, with endless toasts. They were competitive too, performing for and against each other, and for the powerful captive audience at the school. 'The competition among them was much more fierce than among us – we were amateurs,' the entrepreneur said. 'Once we were inside, we became great defenders of the system. It is kind of like the orphan principle. Once you are part of a family, you stand up for it.'

At the high point of the course, however, the entrepreneurs were firmly reminded they were more like valued foster-children than part of the family. When the president of the party school, Xi Jinping, Hu Jintao's heir-apparent, delivered a speech to the group, copies of his address were distributed to the officials, so they could read it as they listened. The written speech, however, was withheld from the entrepreneurs. The Party's official secrecy rules, they were told, specifically prohibited them from being given a copy. They were not even allowed to make notes. In the presence of such a lofty party figure, it was honour enough for the entrepreneurs to be allowed to sit in silence and listen.

The same kind of obedience is required by the Party in one of the areas that it most strives to control and where it least tolerates dissent – the teaching of history. The Party has adapted remarkably to the growth of the private sector, learning how to keep enough of a distance from entrepreneurs to allow them to thrive, while ensuring they do not have the chance to organize into a rival centre of power. But it is not enough for the Party to control government and business in China. To stay in power, the Party has long known it must control the story of China as well.

8

Tombstone

The Party and History

'I felt like a person going deep into a mountain to seek treasure, all alone and surrounded by tigers and other beasts.'

(Yang Jisheng, the author of *Tombstone*)

'In China, the head of the Central Propaganda Department is like the Secretary of Defense in the United States and the Minister of Agriculture in the former Soviet Union. The manner by which he brings leadership will affect whether the nation can maintain stability.' (Liu Zhongde, former deputy-director of the Central Propaganda Department)

When the first editions of *Tombstone* landed in Hong Kong bookshops in mid-2008, copies had to be stacked up like old-fashioned telephone directories. The fat two-volume book was bound in thick plastic to hold it together as a single work and copies piled one on top of the other. The book's intimidating presence in stores alone gave it a weight to match the gravity of its subject matter.

It had taken the author, Yang Jisheng, nearly two decades of painstaking research to compile a minutely chronicled, incontrovertible account of the death by starvation of 35 to 40 million Chinese over three years from 1958, a tragedy the Party has long sought to cover up. By Yang's estimation, the birth rate was down by another 40 million or so babies in the same period, because women and their partners were too weak or too ill to conceive. His epic work was confirmation of what any serious student of world affairs outside of China already knew – that Mao Zedong's utopian plans to accelerate the establishment of what he called

'true communism' had produced the worst man-made famine in recorded history, a disaster of Holocaust-like dimensions. Almost as remarkable as the book itself was how Yang, a journalist with Xinhua, the official state news agency, had managed to compile and write it.

For most of his career, Yang had faithfully done what Xinhua reporters do, writing stories for the public newswire which were then cleared through the propaganda system. Backstage, he performed a second covert function required of senior Xinhua journalists, providing secret internal reports to the Party itself. Yang had not pulled his punches in these on-the-ground dispatches, vital to Beijing's efforts to monitor the work and behaviour of officials outside the capital. A number of his internal reports, about the military's abuse of its powers, economic decline and official corruption, landed on the desks of senior leaders in Beijing, to the consternation of the party bosses in the regions where he was based.

Disillusioned with the Communist Party after the 1989 crackdown, Yang turned the tables on his former masters. Instead of spying on the regions for Beijing, he launched a covert mission against the Party itself. Using the privileges afforded to a senior Xinhua journalist, Yang was able to penetrate state archives around the country and uncover the most complete picture of the great famine that any researcher, foreign or local, had ever managed. The product of his labours, *Tombstone*, was one of the most searing indictments of the Party's time in power ever published in Chinese by a local author resident in the mainland. More than that, the book was the consummate inside job, the product of a lengthy, clandestine co-operation with fellow party members determined to expose the lies told about the famine in China for decades.

Yang was helped by scores of collaborators within the system – demographers who had toiled quietly for years in government agencies to compile an accurate picture of the loss of life; local officials who for decades had hung on to the ghoulish records of the event in their districts; keepers of provincial archives who were happy to open their doors, with a nod and a wink, to a trusted comrade pretending to research the history of China's grain production; and fellow journalists from Xinhua willing to use their local contacts so that the true story of the disaster could finally be told.

Tombstone was published in two thick volumes for good reason. The book was dense with often numbing detail, almost as if Yang was

trying to refute in advance any attempt by the authorities to discredit the work after its publication. 'There was no war. No disease. The weather was quite normal. But 35 to 40 million people just disappeared. Incredible!' Yang said. 'This is a rare thing in history, but the authorities have somehow covered up such an important event, so that not many people know about this piece of history. People have passed the story down, but young people these days find it hard to believe.'

The central government had sent investigative teams to some localities during and after the famine to study the disaster, but to this day Beijing has not produced an official public report of the tragedy and its death toll. 'We already knew that a large number of people had starved to death because we had read internal reports from local officials about it,' said Wang Weizhi, a demographer who accumulated his own store of evidence about the mass loss of life. 'But there was no major investigation by the centre.' Even to ask the question itself was political dynamite, because of where the answer would lead – to Mao and his fellow leaders, and their direct responsibility for the deaths of tens of millions of their citizens.

Mao had ordered Chinese farms to be collectivized in the late fifties, and forced many once productive peasants who had grown grain to put their energy into building crude backyard blast furnaces instead. As part of this 'Great Leap Forward', Mao's acolytes predicted food production would be doubled, or even tripled, in a few short years and steel production would rocket up to surpass output in advanced western countries. By this time, the brutal political controls reinforcing the emerging personality cult around Mao had started to take hold. Promoted as a 'brilliant Marxist' and 'an outstanding thinker', the chairman had taken on an infallible God-like aura.

The new rural communes began reporting huge fake harvests to meet Mao's political imperative for record grain output. The lies were reinforced, if necessary, with state terror orchestrated by slavish officials who feared political death if they deviated from Mao's diktats. Anyone who questioned the size of the harvests reported to Beijing was labelled a 'rightist'. Many were beaten to death by armed militias deployed by local officials to enforce their production targets, at whatever cost. The food simply ran out in some areas. Even granaries that did have food were shut and their life-saving contents kept in storage. To have handed

out the grain in these cases could perversely also have been labelled a political mistake, because the size of the stockpile contradicted the harvest reported to Beijing. Yu Dehong, an official at the time in Henan province, saw starving residents clustered outside the padlocked gates of the full local granaries. In their final moments before they expired, they shouted: 'Communist Party! Chairman Mao, save us!'

It went without saying that *Tombstone* could not be released in China. No publisher dared touch the book, even though it sold briskly in Hong Kong. In Wuhan, a large city in central China, the office of the Committee of Comprehensive Management of Social Order put *Tombstone* on a list of 'obscene, pornographic, violent and unhealthy books for children', to be confiscated on sight. Otherwise, the Party killed *Tombstone* with silence, banning mention of it in the media, while refraining from launching any attention-grabbing attacks on the book itself.

The days when the Party automatically jails or even kills its critics are long gone. There are many more subtle, sophisticated ways for a media-savvy propaganda department to deal with problems. Troublemakers, as the Party likes to call its most dogged critics, as if they are naughty schoolchildren, can be removed from their jobs, silenced with quiet threats to their families, excluded from the media and shamed by being labelled unpatriotic. As a last resort, they can still be put in prison or forced into exile, where they invariably lose touch with the rhythms of local life and politics. The horrors of the 'Great Leap Forward' have been documented in the west and are familiar to any overseas student of recent Chinese history. The Party's grip on the past in China ensures a very different story gets told at home, if it gets told at all. Yang survived the book's publication and still lives at his Xinhua-sponsored home in Beijing. But by ignoring the book and its author, the Party hoped *Tombstone* would sink like a stone to the bottom of the ocean, to lie hidden there, alongside its many other uncomfortable secrets.

As the author Jasper Becker noted in his pioneering English-language account of the disaster in 1996, one of the most remarkable things about the great famine was that for twenty years no one was sure that it had even taken place. It wasn't until US demographers looked at Chinese population statistics in the early to mid-eighties that the first

authoritative estimates that 30 million people had died during the three-year period became widely known.

The cover-up of the famine has always begged the question of just how a government can hide the deaths of literally tens of millions of people. In 2003, the Chinese government tried to conceal the impact of a deadly virus, known as SARS, which had incubated in southern China, before spreading to large cities like Hong Kong and Beijing. It wasn't until a Beijing military surgeon, who was also a senior party member, faxed the foreign media the correct numbers of people struck down by the virus in Beijing that Hu Jintao's government owned up to the scale of the problem and took drastic measures to quarantine it. A similar scenario unfolded in the Sanlu dairy case in 2008. The cover-up by the company and the local party committee of the sale of contaminated milk powder and sick babies was not exposed until the New Zealand government belatedly blew the whistle on the scandal and a local journalist named the company, against the orders of the propaganda department.

The consensus in both cases was that the whistle-blowers had only hastened an inevitable disclosure, because the government would have been forced to acknowledge the truth in the end. After all, you cannot cover up widespread disease, death and grieving families for ever, so the argument goes, because they are spread through the community, not shut up, gagged and out of sight in prison, like some expendable dissident. Under totalitarian rule in Mao's time, however, the government had the tools at its fingertips to enforce silence about even a mammoth famine, and to control any lingering debate about it. China had no independent media or civil society to press for information. The peasants who were the famine's main victims were powerless and distant from the political power centres. The state statistical bureau had poor-quality data and was shut down during subsequent political campaigns. And, in any case, the Party controlled who researched what, and where they travelled. There were none of the satellite dishes and fax machines that kept the world in touch with Beijing during the demonstrations of 1989, let alone local and foreign reporters to use them.

In the twenty-first century of SARS and Sanlu, large-scale cover-ups on the scale the Party had managed with the famine are well nigh impossible. China is wired up through mobile phones and the internet, as well as being plugged into the global economy. Any food problems

or restrictions on travel would show up in multiple markets outside the country in an instant, and blow back immediately into China itself. But even if it can no longer suppress news of important events, the Party still remains highly effective in keeping control of the way their narratives play out later.

The Party makes sure the great famine is officially referred to as a 'difficult period lasting three years', as though politics had nothing to do with it. (In the eighties and earlier, the official term was the 'three years of natural disaster'.) It admits that the Cultural Revolution, which followed soon after, in 1966, and lasted for ten years, contained disastrous mistakes, but then twists the debate to its advantage by asserting that the Party is the only organ that can prevent such instability in the future. At a press conference in August 2009, Wang Yang, the Guangdong party secretary and Politburo member, chastised reporters who asked him about free speech in China, replying: 'During the Cultural Revolution, there was freedom of speech and that was what drove the whole nation into chaos.' Fresher memories of the heavily reported events of 1989 have been muddied by the Party's unstinting management of the smallest pieces of news about the crackdown and the personalities involved. The cover-ups, obfuscations, half-truths, omissions and, when necessary, outright lies are buttressed by the Party's strenuous efforts to eliminate competing narratives.

Examples of deep-rooted amnesia jump out from all over the country. The recently built Shanghai History Museum features lavish, and relatively balanced, re-creations of scenes of the city under foreign control. But the museum's account of the period from about 1940 strangely peters out, without explanation. The communist takeover of the city in 1949 is not mentioned and the near half-century of upheaval that followed is entirely passed over. Once-cosmopolitan Shanghai almost descended into civil war in the 1960s and during 1970s the Cultural Revolution. The effect is strangely destabilizing when you reach the end of the exhibition, and then becomes almost comical when the realization dawns of what is missing. The museum's account resumes in the nineties, with only a few desultory photographs of fireworks exploding over the newly bustling metropolis. The museum director, Pan Junxiang, was uncomfortable when asked why the story

of Shanghai had such a gaping hole. 'Many things should be left to history,' he said, before looking away and changing the topic.

The Central Propaganda Department, as well as taking charge of the media, is the Party's overarching enforcer in the history wars. Its sentries stand guard at all the key points of the debate: in schools, with the Education Ministry, to oversee textbooks; in think-tanks and universities, to monitor academic output; with the United Front department, to prepare what it calls 'historically correct' materials for the compatriots in Hong Kong and Taiwan; and throughout the media in all its forms, to scrutinize the output of everyone, from journalists to film directors. Like the organization department, the propaganda department has no listed phone number and no sign outside its headquarters in central Beijing, across the road from the main leadership compound adjacent to the Forbidden City. The instructions it issues to the media are secret. For a short while they were posted on a government intranet site for editors to consult, but even this was stopped, for security reasons. 'They do not want to leave any evidence, for fear of being exposed,' said Li Datong, an editor sacked by the department after he published a controversial article on a contested historical topic.

The department employs 'reading and evaluation teams', retired senior cadres from the media sector, who are assigned to go through individual newspapers to check for deviations from the official line. These anonymous groups have enormous power through their ability to send reports on suspect articles to the senior ranks of the Party. 'If there was feedback from Politburo members or officials in the Central Secretariat, it would spell doom,' said Li. 'Even at times when there is no feedback, it is like the sword of Damocles hanging over your head all the time.' Another newspaper editor compared the department to the Procrustean bed of Greek mythology. Known as 'the one who hammers out', Procrustes would invite passers-by to lie on his iron bed. Anyone longer than the bed would have their feet sawn off to make them fit. If they were too short, they were stretched. Everyone had to be made the same length. 'The propaganda department only speaks two words – yes and no,' the editor said. 'We are condemned to live under this freak, who stretches you out, or cuts you short, and only knows how to utter two words.'

The editor's graphic characterization of the propaganda department, no doubt born out of his own unpleasant personal experiences,

underestimates the body's growing sophistication. To manage a modern market economy, as academic Anne-Marie Brady points out in her book, *Marketing Dictatorship*, the propaganda department has borrowed many tried and tested formulas of mass persuasion from the west, ranging from advertising to political PR, to maintain popular consent for single-party rule. 'China has been modelling itself on many aspects of the west, though not the aspects that western liberal intellectuals like to boast of,' says Ms Brady.

History is a vital, and expanding, component of so-called 'patriotic education' courses in schools, and of the ceaseless harping in the media on China's century of national humiliation at the hands of foreign powers. More to the point, the propaganda department makes sure that patriotism is not disconnected from the Party itself. 'The major content of the present patriotism campaign is to promote passionate love for the Chinese Communist Party,' wrote Lu Hao, the head of the Communist Youth League, on the launching of the latest campaign in 2009. 'The key is to steer young people towards uniting the three elements of socialism, patriotism and the leadership of the Party.'

The propaganda department's surveillance of history is no longer limited to the Party's time in power. In 2001, the latest version of its official history asserted that the Party's 'background' had been extended back as far as 1840, 'in order to explain the historical inevitability of the CCP's establishment'. This decision immediately placed the history of a multitude of events, from the time of the first opium war, which marked the beginning of the lengthy period of subjugation of China by the imperialist west and later by Japan, under the auspices of the propaganda system. In turn, for any independent thinker working with history, the dangers of falling foul of the authorities were substantially increased.

The Party treats history as an issue of political management, in which the preservation of the Party's prestige and power is paramount. Just as personnel decisions and corruption investigations are decided upon in-house, so too are sensitive historical debates all settled within the Party itself. The debates over history are invariably held in secret and often conducted in code. There is none of the overt public jostling and conference-floor debate that characterizes wrenching ideological changes in left-wing political parties around the world, such as Britain's Labour Party or the French Socialists.

On events such as the Great Leap Forward, the Cultural Revolution, the suppression of the Tibet uprising in 1959, the pro-democracy protests in 1989, and so on, the Party simply announced its verdict after internal deliberations. Party officials are bound by these pronouncements on history, whatever they think as individuals, somewhat in the same way that ministers in the Westminster system are bound by Cabinet decisions. You either support the decision wholeheartedly, or you are out. The Party's verdict then, in theory, becomes the collective opinion of the entire country and its 1.3 billion people. Chinese who wish to agitate publicly for an alternative view do so at their own risk.

The propaganda department does not underestimate the gravity of its task in enforcing the official line. Nothing less than national security is at stake. 'In China, the head of the Central Propaganda Department is like the Secretary of Defense in the United States and the Minister of Agriculture in the former Soviet Union,' said Liu Zhongde, a deputy-director of the department for eight years from 1990. 'The manner by which he brings leadership will affect whether the nation can maintain stability.'

One of the propaganda department's greatest recent battles in the history wars – how to manage the cataclysmic collapse of communism in the Soviet Union and eastern Europe in the late eighties and early nineties – is still being fought out today. As late as 2006, an eight-episode DVD series about the lessons from the Soviet Union's demise, classified as 'secret', was distributed to central, provincial and city-level party bodies as compulsory viewing. Ahead of the 2007 party congress, the authorities were still on the lookout for any mention of the Soviet collapse and the Cold War that preceded it. Before the meeting, the department issued twenty general guidelines for editors in the choice of news for the year. Edict nineteen directed them to 'strictly control reports on the ninetieth anniversary of the October Revolution and not to play up the disintegration of the Soviet Union'.

When around the same time the author and economics columnist for the *Financial Times* Martin Wolf was negotiating to have his book on globalization released in China, the changes insisted on by Citic Publishing, a major state organ, all centred on his characterization of the Soviet Union and communist dictators. Instead of the 'communist dictatorship' of the Soviet Union, the Chinese publisher wanted to

substitute 'Soviet leaders at the time'; the Soviet 'communist system' was to be replaced by 'centrally planned economy'; and in a list of power-hungry dictators, including Hitler, Stalin, Mao and Lenin, Mao's and Lenin's names were to be removed.

Hollywood trivia touching on the Soviet period does not escape scrutiny either. *Casino Royale*, a James Bond film, was released in China in early 2007 with much emphasis in the media that it was uncensored. In fact, Dame Judi Dench, who plays the spy boss M, was asked to rerecord a single line of dialogue in English for the Chinese release. In place of: 'Christ, I miss the Cold War', M said, in English, in Chinese cinemas only: 'God, I miss the old times.' Only after that line of dialogue was inserted was the movie cleared to be shown.

The end-of-history thesis may have fallen into disrepute in a western world battered by lengthy wars in Iraq and Afghanistan and the western banking crisis, but it still stalks the Party in China. Li Ruigang, the youthful head of the Shanghai Media Group, was part of a Chinese media delegation to Germany in May 2007, which included a senior editor of the *People's Daily*. Talking to friends after the trip, Li recalled how the editor had been struck by an exhibit in Bonn's history museum about the collapse of the communist east. The exhibit was illustrated with the final front page of the then East German party paper before its ignominious closure. 'I wonder if they'll keep our last edition in a museum as well,' the editor remarked sardonically to the group.

Instead of being the Party's soft underbelly, history has been armour-plated to become a blunt weapon of foreign and domestic policy for China, a way to rouse the masses in support of the government. China's regular, belligerent lectures to Japan about the need to have the 'correct view of history', and engage in the same deep introspection as post-war Germany, have been effective in stirring popular anger among young people against the 'little devils' across the sea. 'Japan has wilfully tampered with history, denied its invasion [of China], and whitewashed its atrocities, and therefore sunk into unprecedented isolation in Asia,' said the *People's Daily* in 2005, a time of large street protests against Japan in China. 'The Japan that wants to become a "normal country" would do well to take a look, and see how Germany used history as its own mirror.'

China's grievances against Japan are based on memories of genuine atrocities fuelled by persistent pockets of ugly revisionism in Tokyo.

Likewise, the 'century of humiliation' seared into the consciousness of young Chinese in history class at schools is founded on real events, of gunboat diplomacy, military invasions, racial discrimination and colonial annexations, that cast little credit on the west. But Chinese lectures to Japan and others about history are difficult to take seriously as long as the Party refuses to allow similar scrutiny by its citizens of the Party's own record. Holding up the 'mirror of history' to the Party is something that is not condoned at home.

The Party responds ruthlessly to suggestions that its verdict on major political conflicts might be revised. Jiang Yanyong, the military surgeon hailed as a hero by many Chinese for blowing the whistle on the SARS cover-up, was detained a little over a year later when his letter denouncing the 1989 Beijing crackdown was leaked. The most sensitive part of the letter suggested that two now-deceased senior leaders who backed the military action, Yang Shangkun and Chen Yun, had told the doctor privately that the official verdict on the events would have to be revised. Such news has electrifying import in China. The revision of history doesn't mean a simple rewriting of school textbooks. It signifies a seismic shift in the political landscape. The many families who make up the Party aristocracy have a direct personal interest in shoring up the official version of the crackdown.

To take two examples: the considerable power, prestige and wealth of the families of Deng Xiaoping and Li Peng, who personally announced the declaration of martial law in 1989, are directly threatened by any revision of what they call the 'Tiananmen incident'. And if top leaders can be held to account for what they did in the past, what about the officials who have wielded semi-dictatorial powers at a local level? Couldn't they be challenged as well? Rewriting the Party's verdicts on history involves the same kind of mortal dangers to the system as allowing independent bodies to investigate corruption. Once you start, where do you stop? Or, more to the point, how do you stop? The Party wants to control not just the government and society of China. For sound political reasons, it needs to manage the narrative of China as well, because if this narrative unravelled, it could devour them all.

By compiling *Tombstone*, Yang had challenged the system too, but he insisted he did not want to bring the Party down. Yang and his collaborators were party members and all, in one way or another,

lifetime, paid-up participants in the system. That was why Yang had blanched at the reviews predicting the Party would collapse as the truth about the past came to light. 'I fretted about that,' he said. Yang's aim was not to encourage the Party to circle the wagons even more tightly, but to open it up. In the long run, telling the truth about history was not only the key to the Party's survival, it was also essential to China's legitimacy as a great power. 'It is impossible for China to become a superpower if historical truths are suppressed,' says Yang. 'That's why I said that a nation that dares not face up to history will have no future. The Party has to put down its burdens in order to march forward.'

The Party's biggest single burden was the Great Helmsman himself. In China's history wars, the big battles have invariably been over the communist commitment to protect Mao, who still remains the single, overarching symbol of the Party and the nation.

When I asked Li Rui what he thought of Mao Zedong, who was, at different times over four decades, his mentor, his boss and, more than once, his prosecutor and jailer, in no particular order, he chuckled and shot back a characteristically brisk answer. 'My first impression?' he said. 'I thought, here was a true leader of the Communist Party.' Li was born into China's first modern revolution, in 1917, between the fall of the last of China's dynasties, the Qing, and the launching of China's modern nationalism movement. His mother propelled him headlong into the new China by insisting her only son be raised outside his feudal village in Hunan province, so that he could attend a western-style school. By his early teens, Li was fronting schoolboy protests against warlords. At university, he took up the anti-Japanese cause and ran into conflict with Chiang Kai-shek's ruling Nationalists, who gave him his first taste of jail, locking him up in 1936 for possessing Marxist books. The Nationalists drove Li into the arms of the communists and Mao, who was cementing his leadership in the nascent party's stronghold in Yan'an, in central Shaanxi province, when they met in 1939. Li, and soon the rest of China, was about to find out what a 'true leader of the Communist Party' was really like.

When I met him in 2003, Li was a wiry, irrepressible 86-year-old with tufts of spiky grey hair and gleaming eyes, perched like a wizard in his favourite armchair, bristling with energy and opinions. On the

wall of his neat apartment were draped large red characters. Hung to celebrate his recent birthday, the characters stood for longevity (literally, 'life is longer than the southern mountain'). His frankness made interviewing him disarming, even a little uncomfortable. It was a feeling you often get as a journalist in China. When interviewees start opening up and criticizing the Party, the journalist in you is thrilled. As an individual, however, there is a simultaneous creeping sense of fear, about what trouble interviewees might fall into afterwards.

Li's address alone in Beijing was a sign that he was a survivor of the murderous hurly-burly of Maoist politics. He lived in a series of apartment buildings known as the Ministers' House. Alongside one of the wide, grimy Los Angeles-style highways (minus the palm trees) that bound the capital in concentric, elongated loops, the Ministers' House is reserved for retired cadres and their families. No one who finishes their career on the wrong side of the Party gets to live there. Li's topsy-turvy career had ended on a high, as a vice-minister of the Central Organization Department for two years from 1982. For part of that time, he was in charge of the careers of young cadres. The patronage he bestowed on the young officials coming to office in the first, enlightened years of the post-Mao era came in handy when he re-emerged as a trenchant public critic of the Party. Many of the leaders who rose to power in the early years of this century had been helped by Li in the early eighties. Later, some would return the favour, by tolerating his outspokenness – just – without extending the same courtesy to the local media outlets which reported what he said.

Li was more than simply a survivor of Mao. At the time I met him, he was perhaps the only senior insider living in China willing to talk publicly and in explicit detail about the taboo topic of Mao's legacy. The China built in the wake of Mao's death in 1976 is largely unrecognizable from the xenophobic, dispirited and sinister country, verging on collapse and civil war, that the Great Helmsman bequeathed his successors. But Mao himself survives as the single unifying thread tying the vital, modernizing country that greets visitors to today's China with the horrors that preceded it. Mao's presence remains so ubiquitous in twenty-first-century China that it barely provokes comment any more.

'What is there new to say about Mao?' said a prominent US Sinologist when I prodded him on the issue. But that is precisely the point.

The victims of Mao's political campaigns put him firmly among the big three slaughterers of the twentieth century, along with Stalin and Hitler. By drawing a veil over Mao, the Party has effectively shut down all political debate. 'The Mao issue is the dark heart of everything that is contemporary China,' said Geremie Barmé, of the Australian National University. 'The whole project [of modern China] is based on a series of lies, not just about Mao, but the collective leadership he has come to represent. It has profound ramifications – it means that China can't grow up. It is a society that has forbidden itself from being able to grapple not only with the legacy of Mao, but with civil change.'

Mao's exalted status is easily explained, up to a point. As the leader of the Communist Party and the Red Army, he founded a new and united China in 1949, restoring pride to a nation dismembered by multiple foreign powers over a century, starting with the ceding of Hong Kong to the British after the first opium war in 1842. Beyond the revolution, the explanation for Mao's survival as a symbol of the nation is equally straightforward. Mao's fate is tied to that of the Party. 'The biggest legacy of Mao is the Communist Party of China,' Li said. 'As long as the Party exists, the impact of Mao will be enduring.'

Li admits to having been enthralled by Mao when they met, but his outspokenness soon got him into trouble. In Yan'an, he helped set up *The Lighthorseman*, a newspaper circulated by being affixed to walls around the town. The paper's life followed a pattern for the press that would become familiar in Mao's early years. Its frankness was invigorating, until it offended a senior leader, after which it was promptly shut down and its editors politically crucified. Li then became a writer for *Liberation Daily*, a party paper, where his forceful editorials coincided with a brutal purge of people damned as 'reactionaries and spies'. It was poor timing for Li, who ended up facing trumped-up charges of spying himself. Hundreds of people were tortured and left to die. Li was lucky. He was jailed for just over a year. About ten years later he came to his leader's attention again during an early debate about the construction of the Three Gorges Dam on the Yangtze river, a massive project that eventually got under way amidst huge controversy in the nineties. In 1958, Mao, favourably impressed by Li's views, hired him as one of his advisers. Once again Li's timing was out. By 1959, Mao was under pressure after the first reports of the unfolding famine began to percolate up to the centre.

At a meeting of the Central Committee in the lushly green mountain retreat of Lushan that year to discuss the Great Leap Forward, Li voiced criticism of the policy in a meeting with Mao and some colleagues. At first, Mao seemed receptive. 'One reason Mao could listen and accept some opposite opinions was that these ideas were raised by small potatoes like us, who posed no threat to him, rather than by a member of the Standing Committee.' But Mao's mood changed when Peng Dehuai, a Politburo member and Defence Minister, condemned the campaign. Li compounded his sins by comparing Mao with 'Stalin in his late years', saying 'he cannot cloud the whole sky with his single hand'. Sensing a threat to his leadership, Mao lashed back. Peng was removed and 'small potatoes' like Li were thrown out with him.

At Lushan today, tourists crowd the hall and other buildings, which have been preserved in honour of Mao and the historic meeting. In an Orwellian touch, the accompanying exhibition says Mao 'first discovered' the problems of the Great Leap Forward during the meeting. In fact, he had already received reports of starvation, and even then continued the policies, prolonging the famine for another two years, at the cost of approximately another 20 million lives. 'Mao's basic aim was to be the strongest, most powerful Emperor of China ever,' Li recalled. 'And he thought that an Emperor should never have to make a self-criticism.' As punishment for opposing Mao, Li was separated from his wife and two daughters and exiled to the Chinese gulag in Heilongjiang, in the frigid north-east. As he recounts the story, Li opens his diary on the table in front of him and points out the pages recording this period: 'I picked up a little green melon in the wild land, ate it and then felt like I was a savage. I've become so used to having wild vegetables now. We were too optimistic at Lushan, too optimistic in 1958!' Li sighs and puts the book down. 'The strongest suffering a person can have is starving,' he says. Li worked fifteen hours a day and watched as other exiled intellectuals collapsed and died around him.

Li was later sent to Anhui, where he worked in the power industry for two years until the launching of the Cultural Revolution in 1966. For Li, the memory of the moment the campaign caught up with him is vivid. Late one evening in 1967, he was savouring a rare purchase of honey when two jeeps with six armed men rushed into his compound and invited him to come to the city 'for a chat'. He knew his fate the

moment he stepped on board the plane for Beijing the next day and saw that, besides the guards, he was the only passenger. He was transported to Beijing's Qincheng, notorious since 1949 as a jail for political prisoners. He didn't get a chance to savour honey, or anything remotely like it, for the next eight years. 'I was a dead tiger by then.'

By the end of the Cultural Revolution in 1976, Mao was a dead tiger of sorts as well. He had withered, physically and politically, and died later that year. But his spirit has endured. No major set-piece speech by a top Chinese leader today is complete without an obligatory reference to the enduring importance of 'Mao Zedong thought'. Mao's soft, fleshy visage, with its Mona Lisa-like ambivalence, still hangs in pride of place over the entrance to the Forbidden City in the capital. Opposite, his body lies in a crystal coffin in a mausoleum in Tiananmen Square, 'so the masses can look on with reverence'. To ensure that his corpse remains in good condition, the Mao Zedong Mausoleum Management Bureau holds regular symposia to study the science of body preservation.

When China introduced new banknotes in 2001, the fifth set since the 1949 revolution, Mao's face alone adorned every note above one renminbi (worth 0.14 cents). Other former leaders and the farmers and workers who had been displayed in proletarian splendour on previous notes were removed. No public explanation for the change was advanced at the time, but Deng Wei, a painter who helped design previous generations of banknotes, said in an interview it was to 'conform with the international practice' of having a single person on banknotes. That logic left the designers with a single choice – Mao – to represent modern China.

The Party took years to find a way to repudiate the insanity and murderousness of Mao's rule without signing its own death warrant. After a year-long internal debate, involving, Li says, 4,000 officials, the Party announced its verdict in 1981 in a party resolution. It decreed that Mao had made 'gross mistakes', but concluded that overall 'his merits were primary and his errors were secondary'. Li was baffled that anyone could think that the deaths of tens of millions of people could be neatly packed away. 'Aren't these terrifying numbers? Have we gained a clear picture of what these numbers mean?' he asks. 'If we cannot get a clear perspective on past history, we will not be able to improve society, but the propaganda ministry is still trying to cover up these crimes.'

Although the Party did not include it explicitly in its resolution on

Mao's career, it informally gave it a mark, as you might when grading a student. This grading, often quoted in China, says Mao was '70 per cent good, 30 per cent bad'. The debate and the ruling, which was managed by Deng, who became leader in 1978, still stands as the final word on Mao in all public discourse. 'Unlike the Stalin cult, we are dealing with a man who is Stalin, Lenin and Marx,' says Geremie Barmé. 'Deng thought – if we get rid of him, we will open [the Party] up, not today, not tomorrow, but eventually, to a complete negation of the whole system by some radical thinkers.'

In school textbooks, the Party still polices Mao's image as zealously as it scrutinizes what Japanese children are taught in Japan about the invasion of China by Imperial Japan. In Shanghai, a team of academics led by Professor Su Zhiliang of Shanghai Normal University struggled for years to force a more honest reckoning of Mao's rule. 'Take the Great Leap Forward and Cultural Revolution for example,' Su told me when I interviewed him in 2004. 'Our practice in the past was to make [the period] vague rather than clear. But in our most recent edition [of the school textbook], a thorough denunciation is made of Mao's decision to launch these campaigns.' The previous textbook had ascribed the Cultural Revolution to Mao's 'wrong idea that a large proportion of [the Party's] power had been snatched by capitalists'. The new version said 'individual cults and autocratic leadership' were partly behind the campaign. 'China's reform took the route of "economy first, politics second",' Su said. 'We are trying to make history objective by replacing the groundless conclusions with factual descriptions.'

When the *New York Times* published an article in 2006 highlighting the absence of Mao from newly issued world history textbooks used for a single year of high school in Shanghai, a huge furore erupted. Mao, along with conventional historical accounts of war and revolution, had been supplanted by texts focusing on issues such as culture, economics, transport and eating habits, an alternative form of historical narrative favoured by some teaching streams in the west. The paper's provocative headline – 'Where's Mao?' – prompted furious commentary on the internet. Lieutenant-General Li Jijun, a powerful two-star general and former director of the Central Military Commission, told Xinhua the attempt to play down revolution and ideology was 'absurd'. Other commentaries on the internet compared the changes

to a '*coup d'état* by stealth' and the start of an 'orange revolution' in China. Su protested vainly that social history embodied a proper 'Marxist view of civilization', by focusing on social trends rather than single leaders. Years in the making, the entire set of new textbooks was withdrawn by the authorities in Shanghai. Before the controversy, Su was frank about the limits imposed on him. 'History textbooks are a public interpretation of the country's political will,' he said in the 2004 interview. 'Editors are therefore like birds dancing in a cage.'

Textbook editors are not the only ones encircled by the Mao myth. Mao's successors must also pay obeisance to their predecessor. On the one hundred and tenth anniversary of Mao's birth late in December 2004, Hu Jintao donned a Mao suit to praise the Great Helmsman in a series of ceremonies. As is usual on such occasions, scores of Mao's books and poems were published. In a twenty-first-century touch, a rap song was also composed for the occasion. But the 2004 anniversary was different in one important respect: a group of six writers and exiled dissidents published a daring letter, entitled 'An Appeal for the Removal of the Corpse of Mao Zedong from Beijing'. One passage declared:

Mao instilled in people's minds a philosophy of cruel struggle and revolution-ary superstition. Hatred took the place of love and tolerance; the barbarism of 'It is right to rebel!' became the substitute for rationality and love of peace. It elevated and sanctified the view that relations between human beings are best characterized as those between wolves.

The letter concluded with an appeal for Mao's body to be buried in Shaoshan, Mao's hometown, in Hunan, 'to mark the start of a process of alleviating the sense of national grievance and violence prevalent in Chinese society'.

When I met one of the authors, Yu Jie, in a Beijing hotel complex, he suggested we abandon our initial rendezvous, at a table in an open-plan restaurant, and find a private room. It was not so much the surveillance that might come with meeting a foreign journalist that worried him. It was talking critically about Mao aloud in public. The last time he had done so in a restaurant, a patron at an adjoining table had stood up and screamed 'You liar!' at him. 'In private, we can talk about these things openly,' he says. 'But in public and the media, we can't.'

Yu, who hails from Sichuan in China's west, is no firebrand in the

flesh. Mild and bespectacled, he spoke softly about why he helped organize the letter. 'It wasn't a radical thing to do. I am just telling the basic truth.' But Yu was being disingenuous. In the Party, telling the bald truth about history is about the most radical thing you can do. Yu argues that Mao's brutality has poisoned not just China's political culture but everyday language. All social movements become 'campaigns', he says. Every rivalry is turned into a 'war'. You don't just best your opponents in any dispute, you 'eradicate' them. In this way, Mao amplified and entrenched the worst qualities of Chinese tradition and society. 'In Chinese traditional culture,' he says, 'the winner is the king and the losers are all rascals.' While the Mao letter garnered some publicity overseas, in China itself it circulated briefly on the internet before sites featuring it were blocked. When Yu was interviewed on the phone by the BBC's Chinese-language service about the letter, the line went dead soon after he started answering questions.

The response of the guardians of establishment history to the litany of Mao's horrors is as instructive as it is surreal. According to Xia Chuntao of the Chinese Academy of Social Sciences, a state think-tank with the status of a ministry, Mao is not an issue of political sensitivities but a 'matter of principle'. For Xia, the Party's discussion of the issue in the early eighties, which resolved that Mao was 70 per cent good, 30 per cent bad, settled the debate decisively. 'Now, when we look back we can see how politically wise the conclusion was. There was a voice to deny Mao completely. Had it been done, it could have had a big negative impact on Chinese society,' he said. 'The story of Mao is a real-life subject. Mao lived quite close to us, so it is not easy to make up stories about him.'

Li Rui's party pedigree has always given him greater licence to speak out, but the authorities' tolerance does not extend to news outlets which carry his words. In 2002, Li was interviewed by the 21st-Century World Herald in Guangzhou, at the time a bastion of relative openness in the media. Li criticized the party's falsification of history and the absence of any independent check on its power. Worse, he called the enduring deification of Mao a 'cult' that was 'evil in the extreme', equating it with the outlawed religious sect, Falun Gong. The propaganda department did not just censure the editor of the paper for publishing Li's comments. They closed it down altogether. The same

fate awaited other editors and journalists who confronted the Party on history, even on events that long pre-dated their rise to power.

The Party's decision in 2001 to extend its historical remit back to 1840, well before the collapse of China's final dynasty in 1911 and its civil war with the Nationalists in the 1930s and 1940s, enlarged the formal battlefield in the history wars. For the propaganda department, it provided extra internal leverage to discipline errant editors whom they had long been waiting to bring into line. Near the top of the blacklist for years had been Li Datong, at the *China Youth Daily*.

In person, Li was very much the old-style, sleeves-rolled-up newspaper editor, someone who sounded as if he was used to giving orders and having them acted on. Impatient and to the point, each short, sharp sentence was delivered as a definitive opinion as much as a response to any question. Often, he seemed to bark rather than speak. But if he had an editor's personality, he also had an editor's instincts. He was tough, brave and outspoken, and constantly on the lookout for issues he could use to challenge the authorities.

The early years of Li's working life had been spent herding sheep on the grasslands of Inner Mongolia, where he was sent for his re-education in the Cultural Revolution. He got his first job as a journalist in 1979, at the provincial office of the *China Youth Daily*, and gradually worked his way into a senior position in Beijing. He only just survived the post-1989 crackdown on liberal journalists, spending five years doing penance at the paper's research institute for his support of the protests, before returning to the paper full-time. By the early years of the new century, he had risen to edit the paper's controversial weekly supplement, *Freezing Point*. The *China Youth Daily*, with its relatively liberal culture and impeccable political standing, gave Li a lot of room for movement. The paper's sponsor was the Communist Youth League, the party body which had been the power base of Hu Yaobang and, later, of Hu Jintao himself. It didn't take long, however, for the political protection the paper rendered him to crumble.

Like any Chinese journalists worth their salt, Li despised the weekly guidelines issued by the propaganda department on how to handle news. The department's instructions varied – they would dictate the content on some issues and give broad guidance on others, depending

on the issue's sensitivity. For day-to-day events, the department dispenses directions by phone or, more recently, text message. The department's word is final. 'There was no debate. They would just tell you,' said one senior editor. 'They would never go too deeply into the reasons. Such things are not to be discussed with outsiders, for a start, but it is also because the reasons themselves are sensitive. They represent the influence exerted by all sorts of different interest groups.' The system mainly relies on self-censorship, or, to use the Party's parlance, 'self-discipline'. There are no censors sitting in the newsrooms running their red pens through stories, as in the former Soviet Union. 'Editors right down to people at the bottom of the newsroom don't need to be told,' the editor said. 'There is a red line in their head.'

Li, who had often stumbled across that red line, had put himself in the cross-hairs of the propaganda department well before he went to war over history. When the paper's new editor-in-chief tried in 2005 to grade reporters' work according to how it was judged by government officials – their pay would be docked by poor notices and given bonuses for good ones – Li led a revolt which killed the plan. He had also published an article about the apology offered by the leader of the Nationalists in Taiwan for the 'White Terror' unleashed when the party took over the island in the early fifties. The contrast with the Party's handling of its own history of repression in China was unstated, but unmistakable. Even after publishing the Taiwan article, Li remained fixated on the topic of political education. 'Politics lessons are all about drumming information into people's brains about the Party, but this was too sensitive for us, so we wondered, where do we start? And we thought of history,' Li said. Leafing through a magazine in late 2005 which had been sent to him by a friend, Li stumbled across an essay by an elderly academic that was just what he had in mind.

Yuan Weishi, a retired professor of Chinese philosophy at Zhongshan University in Guangzhou, had had similar thoughts about political education. In 2001, he had begun to gather Chinese high school textbooks to compare how they handled the seventy-year period following the opium war to the fall of the Qing Dynasty in 1911 with those produced in Hong Kong and Taiwan. Yuan said he was horrified. In mainland texts, constant patriotic exhortations to 'uphold' traditional Chinese culture and protect the country swamped any rational

assessment of China's own weaknesses. The logic of the textbooks was that Chinese culture was 'superior and unmatched' and that any kind of dictatorship or mob violence could be used to erase 'outside evils' to protect it. He described the education as akin to growing up 'drinking the wolf's milk'. After going through the textbooks, Yuan said, 'I was stunned to find our youth are continuing to drink this wolf's milk today!'

Yuan focused on the textbook's handling of the Boxer rebellion in 1899–1900, an event that ended in humiliation for the Qing court when the siege of the old legation quarter in Beijing was eventually lifted by foreign armies. The Boxers were Taliban-like bands of peasants, known for their elaborate, superstitious martial arts rituals, which they believed made them immune to bullets, and their visceral hatred of foreign intruders into China. The mainland textbooks, Yuan said, had rightly chronicled the overseas armies' murders and looting in victory, but had ignored the Boxers' indiscriminate violence against foreigners in return. 'The Boxers cut down telegraph lines, destroyed schools, demolished railway tracks, burned foreign merchandise, murdered foreigners and any Chinese with connections to them,' Yuan wrote. 'Any person or thing with a foreign flavour had to be totally annihilated . . . yet our children's textbooks will not speak about it!'

Yuan's article was published in a small-circulation, underground journal in southern China in 2002. It had little impact and sank without trace, until someone sent Li Datong a copy at the end of 2005. Reading it he was thrilled and promptly reprinted the article in full in *Freezing Point* in early 2006, nearly four years after its initial publication. He knew he was taking a risk, but overrode opposition within the paper. '[My colleagues] collectively thought we should not publish this article, as this would become a challenge to the power of the Party,' he said. At most, Li expected a slap on the wrist from the reading-and-evaluation team of retired cadres who pored over the paper for the propaganda department. He pointed out that CCTV, the state broadcaster at the heart of the media establishment, had just run a forty-episode series based on a wholesale reinterpretation of the late Qing dynasty. That programme had been reviewed by historians, and then gone all the way to Hu Jintao for a ruling, before being approved. Yuan's article, Li said, was about events a century ago as well, when 'China had no Marxism, no socialism and no Communist Party'.

Unbeknown to Li, the propaganda department was already lying in wait for him. The chief editors of the *China Youth Daily* had been called into the youth league headquarters a few weeks earlier and told 'that pressure from higher up about *Freezing Point* was becoming too much to bear'. Yuan's article was just the excuse that the paper's assembled enemies were looking for. The essay was subject to a flurry of attacks in cyberspace. Yuan himself was personally targeted as a 'traitor' for 'subverting' modern history education. 'The Politburo had already decided to deal with us,' said Li. 'Previously, the propaganda department had monitored the reactions of the netizens to our articles. When there was applause around, they did not do anything, because they were afraid of angering too many people. But when the reaction was bad, they felt the time had come.' A few days after the essay appeared, *Freezing Point* was suspended.

Li went down screaming, determined, he said, 'to leave a mark of protest in history'. He wrote an open letter challenging the decision and launched a protest through party channels, saying the order to close the paper was 'illegal'. 'We didn't want to be like the last generation of news workers who were the obedient tools and "mouths and tongues" of the Party,' he said. 'All the media organizations were accomplices in a series of disasters in history, such as the anti-rightist movement, the Great Leap Forward and the Cultural Revolution.' Li's letter only angered the propaganda department even further. Two weeks later he was formally sacked and assigned back to the newspaper research institute, where he had spent five years after 1989. 'It was my second trip to the "warehouse",' he joked, as he strode around his apartment on the outskirts of Beijing, riffling through his files for information. In a final, quixotic gesture, Li and a longtime colleague removed with him issued a lengthy open letter raging against the crushing of the paper. 'State officials can set fires but civilians are not allowed to light a lantern!' they wrote. 'Their brains have no hint of any notion of civil rights.'

The decision to close *Freezing Point* was popular with the conservative ranks of the Party. 'It's not difficult to understand,' said Xia Chuntao, the historian from the Chinese Academy of Social Sciences. 'It is an official newspaper under the youth league. It is certainly not allowed to publish voices at odds with the Party's guidelines and policies. I would have closed it too.' The problem, according to Xia, is that

there were too many amateur historians talking about things they were not qualified to discuss. 'Yuan's major is not Chinese history,' he said. 'It does not mean he should not express his opinion about the Boxers, but what he said must be according to history, without basic mistakes.'

Talking to him three years after his removal, Li seemed more thrilled than chastened by the episode, and not just because, like many newspaper editors, he enjoys a good fight. His attacks on the propaganda department had been widely circulated on the internet. He had released a detailed book chronicling the whole affair, with the backing of publishers in Japan. He also maintained an active blog, giving him a permanent platform to comment on freedom of speech issues. Compared to the oppressive political atmosphere after 1989, the response of the state was positively enlightened. 'This time around, individuals have paid less of a price than before,' Li said. 'People have recognized that they can fight for their rights.'

In Guangzhou, Yuan expressed similar sentiments. He had heard that the Guangdong provincial government had approached the university to complain after his article had been republished in *Freezing Point*. But the university had fobbed them off. 'No one came to talk to me. My apartment was very quiet,' he said, sitting at his home in the university grounds. 'More than forty journalists interviewed me later. The first question was always: "Were you harassed?" I said no, no. And I think that was the best propaganda of all for the Communist Party.'

At about the same time that Li was being pushed out of *Freezing Point*, Yang Jisheng was nearing completion of *Tombstone*. Yang, like Li, had always been a journalistic bomb-thrower, with one major difference. While Li had positioned himself as an outsider, Yang's projectiles had always been launched from within the heart of the system itself.

Yang spent his entire professional life at Xinhua, the official state news agency, starting in 1967 and retiring in 2002. Yang's job at Xinhua gave him journalistic privileges that are very different from those afforded by the media in democracies. Successful journalists in the west trade on their ability to uncover scandals or lift the visibility of public policy issues with such vigour that the government must respond. The power Yang wielded as a journalist in Xinhua, however, played out backstage, out of sight of the public. When I asked Yang which of his

stories had had a major impact on policy and politics in his three-decade-plus career, he didn't name anything that he had written as an ordinary Xinhua economics reporter. His news stories and commentaries churned out for the public wire service had been cleared and sanitized by the propaganda system. The presentation of these stories was aimed at supporting the government, not shaking it up.

Yang was more proud of his dispatches for Xinhua's secret internal news service, written exclusively for senior party officials. Two of his stories attained the status of cabinet documents once they were adopted by the top leadership. In 1972, he filed a story saying the military had forcibly taken over schools, hospitals and houses in Tianjin, the port city near Beijing where Yang was stationed for nineteen years. Yang's account of this episode landed on the desks of Mao and Zhou Enlai, who promptly ordered the troops to vacate the buildings. Another story, also filed while the Cultural Revolution was still raging, detailed the collapse of industrial production in the city. 'Mao read that one too,' he said. In 1987, he wrote a four-part series about the decline of Tianjin as an economic centre, which was leaked to the Hong Kong press, causing great embarrassment to the city's leaders. Li Ruihan, the then mayor and later a Politburo member, had him investigated, but took no action. 'He is just a bookworm,' Li remarked later, of Yang, 'so I let him go.'

The longer Yang worked in the system, the more he became alienated from it. The turning point was 1989, when, as he wrote, 'the blood of young students washed clean all the lies that were in my head'. By the early nineties, Yang had become a roving economics correspondent for Xinhua travelling around the country. He had also resolved to write and put his name to the stories the Party had long ordered suppressed – about the 1989 massacre, political infighting among top leaders, and most importantly, the story of the famine. The first job would prove to be a perfect cover for the second. But writing the books was only part of the struggle. Getting them to readers in China was just as difficult. 'Once the legitimacy of the Party faces any challenge, the propaganda department will bring powerful forces to bear to suppress it,' said Yang. 'There is a continuous struggle with them. They will suppress me, but I would still like to challenge them.'

Yang's first book from this period, *The Times of Deng Xiaoping*, was published first in Hong Kong in 1999, and then in China itself, after it

had been censored. Even then, the propaganda department directed it be taken off the shelves, shut the state publishing house for three months and told its director to write a self-criticism. To drive the point home the department cut the house's publishing quota for that year by 20 per cent. (Publishers are issued a set quota each year to control the number of titles they can release.) Soured by that experience, Yang decided to publish only in Hong Kong, out of the reach of the department. In 2000, he put out an analysis of social classes in China. And then in 2004, he released *Political Struggles in the Age of China's Reform and Opening Up*, containing interviews conducted in secret nearly a decade before with Zhao Ziyang, the party leader toppled for opposing the use of military force in 1989. They were the first such interviews with Zhao, a man whose image had been banned from the Chinese media. Yang was rebuked by his masters at Xinhua, but kept his job.

Yang's political epiphany took on a more personal note after the longtime governor of Hubei told him hundreds of thousands of people had died in his home province in the great famine. He began to rethink his own father's death in 1959. He had always remembered clearly the moment he found out his father was dying. As a 15-year-old high school student and propaganda officer for the local branch of the Communist Youth League Yang was an enthusiastic supporter of Mao. He was in the middle of writing a wall poster to promote the Three Red Flags campaign glorifying the Great Leap Forward and the farm collectives when a classmate burst into the room. 'Your father is not going to make it,' he told him. Yang later blamed himself for not going home earlier, to dig for wild vegetables to feed the family. He never thought at the time to blame Mao or the Communist Party. It was an individual case, something to be handled within the family. Thirty or so years later, he had developed an entirely different perspective.

On and off over the next decade, Yang locked himself in provincial archives and pored over their records – population figures, grain production, weather digests, personnel movements, internal reports by investigation teams and anything else he could get his hands on. Researching the great famine was the largest and riskiest project he had undertaken. Pretending to be investigating rural issues and grain production, Yang was able to gain access to documents which had been locked away for decades. If his status as a senior Xinhua reporter wasn't

enough to get into the archives, he used the relationships his colleagues had built up with the provincial authorities. 'My colleagues knew what I was doing,' he said. 'They secretly supported me.'

In Gansu, in western China, a former Xinhua branch head well known for his leftist views backed Yang and handed over materials. In Sichuan, China's populous breadbasket, another ageing journalist did the same. His ruse did not work every time. In Guizhou, one of China's poorest provinces, Yang almost came undone. His colleagues took him to the provincial party compound to seek permission to access the archives. The nervous section head consulted the head of the archives about the request, who referred it to the deputy of the provincial party secretariat. He referred the request upwards to his boss, who then decided to consult Beijing. A query to the central government could easily have exposed the research as a sham. 'We would have been finished,' Yang said. On hearing about the request to Beijing, Yang coolly excused himself and said he would come back another time. *Tombstone*, as a result, has no detailed chapter on Guizhou.

Yang worried constantly that he would be caught and his colleagues punished. 'I felt like a person going deep into a mountain to seek treasure, all alone and surrounded by tigers and other beasts,' he said. 'It is very dangerous, as using those materials is prohibited.' The sourcing in *Tombstone* is meticulous, down to the documents' serial numbers and the years in which they were published. But anticipating potential trouble ahead, Yang fudged some of his more than 2,000 footnotes. Instead of naming the official archives, he refers to his sources as 'original documents with very reliable sourcing'.

In Xinyang, a small city in Henan province where the famine was at its worst, the local government didn't direct Yang to the official archives. The officials received him hospitably and sent him instead to see a retired cadre from the local waterworks bureau, Yu Dehong. In their own quiet way, the Xinyang officials might have been giving Yang a helping hand as well. Yu was what you might call the local history crank, except that the stories he nagged people about did not concern mundane municipal landmarks and the arrival of the city's first steam train. As political secretary to the Xinyang mayor in the late fifties, Yu was an eye-witness to a mini-Holocaust in his home town, its surrounding villages and his own family. According to the most conservative calculations, one million

people out of a population of eight million in Xinyang died over a three-year period. Yu had often been gently advised to drop the issue in the years since. Instead, he wrote a detailed account and submitted it to the local party secretary under his own name. 'Some people asked me – "haven't you committed enough mistakes?"' he said. 'But if the official history won't include this material, then my private history will. I have the materials to back me up.'

Xinyang was generally blessed with good harvests, unlike much of Henan, known as the 'land of beggars' for its history of impoverishment and not infrequent famines. But any advantage the city had was undermined by the officials who ruled over it. At the time, Henan and Xinyang were overseen by radical leftists fanatically devoted to Mao who viewed the grain harvest solely through the prism of violent class struggle. Yu remembers vividly a series of surreal meetings in 1959, when the eighteen counties in the Xinyang area reported their harvest for the year. The correct figure for the harvest was about 2.9 billion jin. (One jin is half a kilogram.) Desperate to meet the political demand for record production, each county began to wildly exaggerate its own harvest and bid up the figure. The first time they totted up the production figures from all eighteen counties, the collective harvest equalled an astonishing 35 billion jin in what had been a relatively poor year. In 1958, a good year, the total harvest had been only 5 billion jin.

One of Yu's colleagues dared to express doubts about the figures and began to argue them down. A new consensus about the harvest size was formed, first at around 30 billion. The official pushed further, and the number fell to 20 billion, and eventually dropped to 8 billion, until the party secretary erupted. Mao had himself sanctioned new, and quite miraculous, figures of output per acre. The party secretary raged that lowering the figure further would amount to repudiating Mao. After more furious argument, Xinyang finally declared its official grain harvest at 7.2 billion jin, about three times the real figure.

That was more than enough of a distortion to set in train the disaster that followed. The government, which calculated its annual levy on the official figure, took more than half the real harvest for itself, placing it in its own granaries and putting the rest under the control of the central government. 'The principle at the time was to collect everything surplus to the daily needs of the peasants, so when they gathered grain

according to the 7.2 billion jin harvest, many homes and villages were simply emptied of food,' said Yu. 'And of course, the government refused to open up its granaries, because they said there should have been lots left over.' People had few personal stocks of grain, because under Maoist collectivization policies they were forced to eat in communal kitchens. It was not long before mass starvation began to grip the city and surrounding areas.

As winter turned to spring in the early months of 1960, a thick smell of death began to rise from the land. Yu remembers the change of season clearly. Walking around the semi-rural enclave, he saw thousands of corpses strewn alongside the roads and in the fields. Over the winter, the bodies had hardened and then set in the cramped, bent shapes in which people had finally expired and died. The bodies looked like they had been packed into a freezer and then randomly scattered across the landscape. Some of the corpses were clothed. Others had had their garments ripped off them, and flesh was missing from their buttocks and legs. In the warming spring sun, the corpses had begun to thaw, emitting a sickly smell that permeated the everyday life of a shell-shocked local citizenry.

The surviving residents protested later that they had been too short-handed or exhausted to give the dead the dignity of burial. They blamed the ravaged corpses on hungry stray dogs, whose eyes, according to rumours which swept the area, had turned red after gnawing at human flesh. 'That is not true,' said Yu. 'All the dogs had already been eaten by humans. How could there be any dogs left at the time?' The corpses hadn't been eaten by ravenous canines. They had been cannibalized by local residents. Many people in Xinyang over that winter and the two which followed it owed their survival to consuming dead members of their families, or any stray corpses they could find.

By his count, Yu wrote sixteen reports to his superiors over that winter, warning them of the impending catastrophe. They were labelled his 'sixteen crimes' and used to remove him from his position as an adviser to the mayor. One of the officials who criticized him for speaking out was a man named Li Wenyao. Li's own father had died of starvation. His wife had taken boiled human flesh home to feed to their children, although she was unable to bring herself to eat it. Yu could scarcely believe that the same person was chastising him for trying to

alert Chinese leaders to the famine. 'Your wife took home human flesh. Your father died of hunger, and you still lash out at me!' Yu said he told Li. 'Do you still have any humanity left in you?'

Xinyang's leaders posted sentries at train stations and other transport hubs to stop word about the extent of the famine getting out. A number of officials who protested were beaten to death. Petitioners who did try to leave were put in prison and often left to starve to death there. 'The city leaders all became madmen,' said Yu. In late 1961, the central and provincial governments could no longer ignore the catastrophe and dispatched a team of officials, backed by military units, to take over Xinyang in a kind of in-house *coup d'état*. Over the years, the memories of the area's famine were allowed to fade into the dark recesses of the city's history.

Stories like Yu's shocked Yang. 'I did not foresee this level of cruelty,' he said. 'There was cannibalism in ancient times in famines. People used to talk about "exchanging children to eat", because they could not bear to eat their own children. But this was much worse.' Even the final nationwide death toll, a figure which has been known in the west for more than two decades, was a revelation. To calculate the number, Yang had the confidential figures he had gained in the provincial archives. But he also called on another insider, a Chinese demographer who had been quietly gathering material for years about the impact of the famine.

Wang Weizhi returned from studying demography in the Soviet Union in 1958, the first year of the famine, and was employed by the Public Security Bureau, or police, where he worked for the next three decades. The job was to give him a unique vantage point from which to track the famine's impact. China conducted just three censuses, in 1953, 1964 and 1982, in the first three and a half decades of communist rule. The police, by comparison, compiled household registration data from around the country and updated it twice a year. Wang, in theory, had access to fresh population figures submitted directly to the centre from each county in the country.

Wang got his first inkling of the on-the-ground impact of the famine in 1962, a year after the famine ended, when he was sent to Fengyang, in Anhui, an area with a death toll on a par with that of Xinyang. The team was dispatched, but not to investigate the reports of starvation which had been reaching Beijing in the previous two years. That would

have been too politically sensitive. They were sent to find out why there had been such a spike in the birth rate that year. The villagers rather sardonically told the visitors from Beijing they should expect another birth spurt in 1963. The reasons weren't difficult to fathom. The elderly and the young in the district had all been wiped out in the famine. 'The oldest person left in the area was forty-three and the youngest was seven,' said Wang.

Wang struggled for years to get his hands on a full set of state statistics from within his own workplace. During the Cultural Revolution, access to the numbers recorded during the famine were restricted. Anything before 1958 was easy. Anything later was difficult. 'At the time, the figures were very sensitive, and very few people were allowed to have them,' Wang said. 'Only the top five people in Shandong, for example, could see the Public Security Bureau figures – the party secretary and the governor and their deputies, and the police chief.' When the political climate improved in the late seventies, Wang began quietly to collect materials and make his own calculations. Within the system, too, his expertise was called upon to reconcile the different sets of figures, between those collected by the census and those held by the police. In obscure demographic journals, he trashed the semi-official calculations favoured by the government. They were based 'on false figures', he said. But it wasn't until Yang came knocking on his door in the nineties that he put forward for wider publication his own estimate of a death toll of 35 million.

In person, Wang seems very much a bloodless functionary, approaching the tragedy as a professional demographer rather than someone with a political axe to grind. He sticks strictly to the numbers, telling the story by going through the tables of figures in an old government population book that sits in the corner of his office at home, covered in thick dust. Look here, he says, brushing the dust off and stabbing his finger at one column of figures showing the population of one province dropping by three million. He shrugged when I asked what the reaction had been in China in the eighties when the real death toll had started to leak out. 'Because it was so long ago, people were rather indifferent,' he replied. Wang's professionalism made him invaluable to Yang. In a country where little is left untainted by politics, Wang sticks simply to the facts. He said he was happy to assist Yang. 'For

me, these are the facts and if someone wants to investigate, I will give them the facts,' he said.

To this day, the Chinese government has never given its own version of the death toll. It commissioned a study in the mid-eighties for internal circulation, in response to the publication overseas of the figure produced by the US demographers of 30 million premature deaths. The academic, Jiang Zhenghua, called on to prepare the study for the government had, for most of his life, been a lecturer in automated production systems in Xian before spending barely a year studying demography in Calcutta, India. He came up with a figure of 17 million premature deaths. The study has been widely dismissed, within China as well as outside, because it relied mainly on looking just at recorded deaths. 'Half of the excess deaths did not get recorded at the time. People were focusing on survival, not statistics,' said Judith Banister, a US demographer. Jiang, author of the study, was richly rewarded for his work and promoted eventually to vice-chairman of the National People's Congress.

Like Yuan Weishi in Guangdong after the furore on his article about the Boxers, Yang had steeled himself for a backlash from the authorities in the wake of *Tombstone*. He was certainly vulnerable. He still lives in an apartment provided by Xinhua and banks his government pension cheque every month. But so far, nothing has happened. He even gave a public talk in mid-2009 about *Tombstone*, at a bookshop in Beijing, without interruption by the authorities. His collaborators remain similarly unmolested by the Party. Wang Weizhi, the demographer, occupies the flat in west Beijing allocated to him by the state think-tank where he completed his career. Yu Dehong, in Xinyang, maintains – by Chinese standards – a spacious townhouse with a vegetable garden that he was given on his retirement by the city waterworks, his employer after he was sacked from his political advisory job. 'The authorities are not as stupid as they used to be,' said Yang. 'If this had happened in the past, I would be a dead man, and my family would have been destroyed. But here I am, still writing books and giving talks. The fact that I have not been sent to prison in itself indicates there have been some changes.'

Yang talked about the Party as if it were a wild beast that was gradually to be domesticated, but needed further nurturing before it

could be confronted directly. China needed to make changes gradually, he said, to stop falling back into the 'vicious cycle of violent regimes and violent mobs'.

The Party has proved itself to be a crafty, protean beast in these latest rounds of the history wars, just as it has in managing the economy. Individuals who challenge it directly on their home turf are eventually sidelined and deprived of a public voice. The Party has realized that it does not need to kill its critics any more to silence or marginalize them. More to the point, the Party can no longer so easily get away with killing people who disagree with it. For party veterans like Mao Yushi, with vivid living memories of the murderous campaigns of the past, the lower body-count alone represents progress.

A courtly 80-year-old liberal economist, Mao was approached in late 2008 by political activists to sign a petition called Charter 08. The name of the document deliberately echoed the name and credo of a Cold-War-era petition circulated by Czech dissidents, led by Vaclav Havel, called Charter 77 after the year in which it was released. Like its forerunner, Charter 08 was an unflinching call for democracy in China with full legal protection for human rights. It was just the sort of document to send the Party into a rage. After it was released, state security detained the individuals blamed for writing the document and collecting signatures, and attempted to visit and interrogate every one of the 1,000 or so signatories to the document.

Mao was listed as a signatory to the document. He insisted, when state security turned up on his doorstep seeking an explanation, that he hadn't signed it, although he had been approached to do so. He said later that his first reaction when the petition's organizers visited him with a draft was to tell them to make the document less confrontational, and to inject into it some recognition of how far the Party had come compared to its dark past.

'So many people were killed for having different views,' he said. 'I estimate 50 million people were killed by the government [under communism]. Every day, they killed 5,000. But these days, the government has trouble killing one person. I lived in circumstances of fear. There was no protection at all. Now I don't live in fear.'

Not everyone involved in Charter 08 was treated so gently. One of the initiators of the petition, Liui Xiaobo, was kept in detention for

six months before being formally charged in June 2009 with 'inciting state subversion'. Liu was just the sort of dissident whose seemingly simple-minded adherence to his beliefs both flummoxed and infuriated the authorities. A literature graduate of Beijing Normal University, Liu was first jailed for his role in the 1989 Tiananmen protests. His fearless impertinence in persisting in criticizing the Party in public after his release saw him detained numerous times thereafter. With Charter 08, however, he went one serious step further than his past agitation. He committed the mortal sin of organizing against the Party.

The Party made its displeasure known by sentencing Liu to eleven years in jail, the longest term ever given to someone convicted for state subversion since the offence was created in the late nineties. To drive the message home to western governments who had protested against Liu's detention, his trial was held in late December so he could be sentenced on Christmas Day, 2009. In a perverse way, Liu's jailing bore out Mao Yushi's thesis. Once upon a time in communist China, the system might have eliminated Liu for standing up to it. Now, leaving Liu to languish in prison provided an example sufficient to deter anyone foolhardy enough to follow in his footsteps. Such is the measure of political progress in China.

Afterword

I spent my final days in Beijing, in between packing up the house and preparing to move countries, dodging police and looking for a lawyer.

The police were not just chasing me. The compound where I lived was located along China's main east–west thoroughfare. A few minutes in a taxi up the road landed you in Tiananmen Square, the political and spiritual heart of the city. For the most part, it was an enormously convenient, central location. Ahead of the sixtieth anniversary of the communists taking power, on 1 October 2009, however, the compound had become a more perilous place. The police were going from door to door, interrogating the occupants of each apartment and checking their papers to secure the route for the massive parade planned to mark the anniversary.

After vacating our apartment, we had temporarily shifted to a friend's flat inside the compound. Our passports had been dispatched to the British embassy, awaiting a visa. This simple set of circumstances, the kind of short-term relocation that afflicts many families moving country, was far too complicated for the local police at a politically fraught time. After one futile attempt to explain why we could not produce our passports, the best course was to hide from the police altogether, to avoid further visitations and a possible expulsion from the compound. The police had already warned residents to keep their windows closed and to stay off their balconies on the day of the parade and during the dress rehearsals leading up to it. The apartments that had the best view in town for the extraordinary parade, a display meant to demonstrate enormous national pride, were to be sealed off for its duration.

When a panoramic picture of the parade was later posted on a China-watchers' email list, showing the soldiers, tanks and happy Tibetan and

Xinjiang minorities and the like, all lined up in exquisite order for miles along the avenue, a contributor pointed out what he thought was an obvious error. The picture must have been of the dress rehearsal, the eminent Sinologist said, because the streets were empty of cheering citizens joining in the celebration. Quite the opposite was the case. The absence of ordinary people joining in the event was precisely what confirmed the picture as a photo of the official parade. Not for the first time, the people had been excluded from the celebrations of the people's republic.

Around the same time, I had been doing some sleuthing of my own. Before leaving China, I wanted to track down Li Fanping, the lawyer who had taken on the cases of the children in the Sanlu milk scandal, to check on the progress of the lawsuits. But Li had gone to ground. While he had been working on the Sanlu case, Li and a bunch of like-minded activist lawyers had taken on some other sensitive causes. They had sought to defend Falun Gong believers and to provide legal representation for ethnic Chinese and Tibetans accused of fomenting unrest during the riots in Lhasa and beyond in 2008, infuriating the authorities.

A month before the Party's party, a group of the Sanlu parents were warned off when they tried to travel to Beijing to mark their own anniversary, one year since their children's poisoning. The police rounded them up and informed them they were members of an illegal organization. The police message was clear – the parents could either stay at home, or go to Beijing and risk ending up in jail. With the sixtieth anniversary on the horizon, the emerging lawyers' network was also a hot target for state security. Li himself was afraid to come into central Beijing in this period, a time when the city was crawling with security police. Occasionally, Li would surface and call in on his mobile, promising to meet me. But for most of the time, he kept his phone switched off, so the authorities couldn't use its signal to track him down.

The harassment of a small-time lawyer and the intense security surrounding the Party's anniversary might seem like trifling matters when measured against what else was happening in China. While the US, Europe and Japan stagnated in the wake of the financial crisis, the Party had by mid-2009 engineered a stunning bounce-back by flooding state businesses with credit. A surge in economic growth in China is no small thing, as it feeds directly into the lives of tens of millions of people throughout the country, however unfairly. Abroad,

China's voice was being heard with greater respect and deference than ever before in global forums. But for the Party, lawyers like Li and the ordinary families he represented were still considered enough of a threat to require constant surveillance by a massive security apparatus.

China under Mao Zedong had much in common with other totalitarian systems. To borrow the oft-used phrase, terror was not just a side-effect of the system. Terror *was* the system for extended periods of Mao's rule. In the last three decades, the Communist Party has turned that formula around. Terror is just a side-effect these days, used relatively sparingly and, in large part, reluctantly. In modern China, the system runs on seduction rather than suppression. It aims to co-opt, not coerce, the population. But even so, terror remains essential to the system's survival and is deployed without embarrassment when required. An official once told me: 'People need to fear the government in China, otherwise the country will fall apart.' The way the state targets even lawyers like Li and his clients is evidence that behind the Party's boisterous, boasting exterior lies a regime with a profound appreciation of its limited legitimacy and fragile mandate.

In the days after the parade, Liu Shihui, a lawyer in Guangdong known for representing human rights activists, had gone bike-riding with a T-shirt he had made himself. On the front was the slogan, 'One-party dictatorship is a disaster', cribbed from an editorial written by Xinhua in 1940, before the communists took power. On the back was another pre-revolutionary quote, by former president Liu Shaoqi: 'The CP [Communist Party] opposes the Kuomintang's one-party dictatorship, but the CP will not establish a one-party dictatorship.' The local police didn't get the joke. They pulled Liu over and detained him for questioning for four hours. 'They said that I was disturbing the public order with such a T-shirt and the slogans were misleading to the public,' Liu said. The police cut the T-shirt into pieces and threw it in the rubbish bin. They then bought him a new one, without slogans, at the local supermarket, before sending him on his way.

The last time I had spoken with Yang Jisheng about *Tombstone*, he had summed up China and the Party's progress with words that stuck in my head. 'The system is decaying and the system is evolving,' he said. 'It is decaying while it is evolving. It is not clear which side might come out on top in the end.' David Shambaugh, the American Sinologist, had

reached a similar conclusion in his research. He called his 2008 book on the Communist Party *Atrophy and Adaptation*, but gave the formula a more positive spin. The Party has constantly adapted to stave off atrophy, he argued, somewhat like athletes who keep changing their training regimes to keep pace with the demands of their sport. The athletes may have to be pumped up on steroids now and again, to get through the really tough competitions, to be sure. But so far, Shambaugh's thesis has been borne out.

It has always been easy to construct scenarios under which the Party loses power. A financial crisis was a favoured one for years. As it turned out, the great financial crisis of the early twenty-first century came to symbolize the eclipse of the west, and China's rise, rather than the other way round. Beijing's entry into the World Trade Organization was another moment when China's weaknesses were going to be exposed, as the ferociously competitive western multinationals swept aside their feeble Chinese rivals. Once again, the reverse was the case. China's trade surplus increased eightfold in the first five years following its fully fledged entry into the world trading system in 2001. By 2008, the trade surplus has risen thirteen times compared to 2001.

Many predicted that the rise of the middle class spelt the end of authoritarian rule, as it had, in very different ways, in Taiwan, South Korea and elsewhere in Asia. But as one Chinese academic noted, China seems to have turned upside down the late US political scientist Samuel Huntington's argument that the middle class in developing countries is revolutionary first, before becoming conservative later. In China, the middle class has become a conservative bulwark of Party rule. The middle class en masse hasn't dared rise up against the state, because they have so much to lose.

Inequality is another of the Party's often stated Achilles heels. The extreme poverty that exists in China alongside great and often ill-gotten wealth is more than just embarrassing for a state that professes to be built on the principles of socialism. The Party talks incessantly in public about addressing inequality, because it knows how corrosive the rich–poor gap is to its standing. But it doesn't follow that the issue will break the Party asunder. China has become a remarkably aspirational place, not unlike the US. America has not fallen apart because incomes in Mississippi and West Virginia have no hope of ever catching up with

rich Maryland and Connecticut. The economy has been energized by people who want to emulate the wealthy rather than pull them down. Similarly, enough Chinese have faith in their ability to build a better life for their families to keep the issue of inequality at bay, for now.

Then there is corruption. Certainly, China is deeply corrupt, but corrupt regimes can last a long time. The Chinese officials who do get arrested for graft generally fall into two categories, or sometimes both. They are the losers in political power struggles, or their corruption has become so outrageous that it embarrasses the system, and thereby jeopardizes the game for everyone else. Corruption in China seems to operate more like a transaction tax that distributes ill-gotten gains among the ruling class. In that respect, it becomes the glue that keeps the system together.

For all the hullabaloo surrounding the perennial anti-graft campaigns, the risk of going to jail remains small even for officials caught with their hands in the till. Since 1982, about 80 per cent of the 130,000 to 190,000 officials disciplined annually for malfeasance by the Party received only a warning. Only 6 per cent were criminally prosecuted, and of them, only 3 per cent went to jail. 'The odds of an average corrupt official going to jail are therefore at most 3 in 100,' said Minxin Pei, of the Carnegie Endowment for International Peace, who calculated these figures, 'making corruption a high-return, low-risk activity.'

Fighting corruption aside, the Party has proved to be a responsive beast in the face of the challenges that confront it. The state-owned industrial and financial sectors are unrecognizable from a decade ago. They are still under political control, but they are also subject to a whole range of other performance criteria. The federal taxes collected during the fat years of the economy are now finally being spent on health, education and welfare, areas that were grotesquely neglected in the late nineties and early years of this century. Finance in rural areas, where most Chinese still live and work, has been slowly liberalized, partly by freeing up the trade in the small plots of land farmers were once tied to for life. The Leninist bureaucracy survives, but the Party has added a touch of McKinsey to ensure it performs. As meaningless as many of the performance benchmarks for officials might be in practice, they have at least instilled the notion that government must respond to community opinion.

Politically, the never-ending story of the Party's suppression of its

opponents naturally merits great attention. But even here, the system has become more sophisticated in ways that are not obvious from the day-to-day headlines. Post-1989, the Party not only strengthened paramilitary riot police across the country and equipped them with modern armouries; they were also trained to use force as sparingly as possible, so as not to inflame already disgruntled protesters. In just about every place I visited in China over many years, I witnessed protests of some kind. For the most part, in my experience, they were settled relatively peacefully, often by paying money to get people off the streets. If protesters persist and, worst of all, try to organize themselves into larger anti-government groups, the local authorities have no compunction in crushing them, by whatever means. But the centre frowns on such confrontations. The best local officials are the ones who anticipate trouble, and nip it in the bud.

Propaganda has also become more street-wise. Instead of allowing the foreign media and local internet activists to scoop the state media when reporting on disasters and protests, the authorities now encourage local media to report some negative news, to ensure the official version dominates public debate. Anne-Marie Brady, who has written extensively on the propaganda system, says the authorities were burnt badly by the SARS crisis in 2003, when government secrecy was responsible for the spread of the virus in the region. They started working on a new system of managing public opinion, taking the Blair government's handling of popular opinion during the mad-cow disease crisis in 2000–2001 as a model. 'The leadership's awareness of the risk of popular protests threatening the regime is not a sign of weakness,' writes Ms Brady. 'Rather it is an indication of [the Party's] determination to survive and its ability to absorb new methods and technologies to enable it to do so.'

When the fine-tuning doesn't work, the Party maintains a big stick in reserve. The central authorities in Beijing, and even in provincial capitals, struggle to keep up with what is happening on the ground in such a vast country. The multitude of astounding stories about graft, wasteful government spending, local profiteering and environmental degradation are testament to that. But much like a large magnet that makes iron filings suddenly cling together as it moves into position above them, the Party can still force the system and all its ne'er-do-wells to stand to attention when it focuses its attention on them.

The Party's power is obvious in the political arena. When Jiang Zemin ordered that the Falun Gong movement be wiped out inside China, by and large it was. The Party has a harder time making the economy do its bidding, but it can still mobilize the system in an emergency. At the end of 2008, when the economy dropped into a hole with the rest of the world in the financial crisis, the Party ordered banks to lend, which they did with gusto. In the opening months of 2010, the Party reversed course, and told the banks to slow down, a diktat followed with much greater reluctance, but followed nonetheless. The Party's power is also being felt on the environment. After decades of largely ignoring the issue, the central authorities have now attempted to take hold of a national environment policy. They have done this not by suppressing development but by turning the environment into an economic opportunity, by giving huge incentives to business to invest in alternative energies. In a few short years, as a result, China emerged as the largest producer of wind turbines and solar panels and the biggest investor in so-called clean coal technologies.

In large part, the Party's legitimacy still depends on the economy. Economic growth is the single most important pillar supporting the Party at home and the force behind the power that China now projects around the world. Growth sustains living standards, policy flexibility, the internal patronage network and global leverage. The Chinese growth model has well-documented flaws and is unsustainable in its present form. Martin Wolf, the *Financial Times* economics commentator, summed up in late 2009 the deep distortions of a system that has suppressed personal consumption in favour of investment and exports with a devastatingly simple calculation. 'In 2007, personal consumption was just 35 per cent of GDP. Meanwhile, China was investing 11 per cent of GDP in low-yielding foreign assets, via its current account surplus,' he wrote. 'Remember how poor hundreds of millions of Chinese still are. Then consider that the net transfer of resources abroad was equal to a third of personal consumption.'

The irony of this calculation is not that it shows how China's economic miracle is unravelling. It is how much of an upside there is for ordinary Chinese once the Party has the courage to take on the vested interests now profiting from the distortions. The next stage of economic reform brings with it further political risk. How do you

unpick the powerful financial interests within the Party that benefit from the state's privileged position in the economy? Does unravelling the state's economic interests irreparably damage the Party's political clout? There is no easy way to chart a course through this thicket but the Party's adaptive abilities should not be underestimated.

There is more to economic growth than just incomes. The success of the economy also buttresses the pride that many Chinese feel about the revival of a great civilization humiliated by the west. That pride, in turn, has become a powerful tool in the hands of party leaders, preordained as the natural and energetic defenders of the Chinese nation. Chinese pride in the country's revival and the cultural confidence that comes with being part of a longstanding, highly developed and once pioneering civilization is an entirely natural thing. Look at the US. From the outside, the richer it has got, the more patriotic it has become. There is no reason China will be any different. Under the Party's tutelage, however, patriotism and nationalism in China have mutated into much nastier phenomena in recent years.

China often feels like the USA in the immediate aftermath of 9/11, full of anger at outsiders and insistent on dividing the world down the middle into friends and enemies. Otherwise worldly and intelligent officials and friendly citizens become red with rage when topics such as Tibet and the Dalai Lama, Japan's wartime record, the Xinjiang riots and Taiwan enter the conversation. In democracies like the USA, debates evolve and governments change. In all my time in China, it was very difficult to have even a civil exchange of views on these topics with anyone in an official position. Differences of opinion on issues such as Tibet and the anti-Japanese war can be transformed in a flash into deep slights against the nation. In the words of Joseph Fewsmith, the US Sinologist, speaking about a different issue: 'If one part of "civil society" is civility, China has not yet reached it.'

But even here, the political system has adjusted. I once believed that nationalism had become so out of control as to be a threat to the Party itself. Whereas the people learn to fear the Party in China, the opposite seemed the case when patriotism came into play. The Party seemed to fear the people. The anti-Japanese protests of early 2005 were another lesson not to underestimate the Party's adaptive powers. When riots

broke out against the Japanese in cities across China, the police let them run long enough to send a message of anger and retribution to Tokyo, but not so long that they spilled out of control and turned into a forum for anti-Party grievances at home.

On the day of the largest demonstrations, the reach of the all-powerful state was on full display. In Beijing and elsewhere, the police commandeered the state-owned telecommunications network to flood the city's mobile system with messages, to ensure the situation did not get out of control. In the words of Geremie Barmé, of the Australian National University, the messages provided 'a glimpse of the fascinating yet unsettling face of China's contemporary cheery authoritarianism'.

The Beijing Public Security Bureau would like to remind you of the following: don't believe rumours, don't spread rumours, express your patriotic fervour in rational ways. Don't participate in illegal demonstrations. – Wangtong Telecommunications wishes you a happy Labour Day!

Don't create trouble when all you want to do is help! Be patriotic, but don't break the law. Be a solid, law-abiding citizen.
Usually you're busy and exhausted, so let this be a happy Labour Day holiday week. We can only build a harmonious society if we are disciplined and respect the law.

At the end of the largest demonstration, outside the Japanese embassy in Beijing, the police wished the crowd well, complimented them on their restraint and patriotism – even after they had thrown bricks at the embassy – and asked them to go home, which by and large they did.

The handling of the anti-Japanese demonstrations was a reminder of how the Party doesn't so much control public opinion on these hot-button issues as harness and channel it, in line with its prevailing political priorities. The moment that Japan changed prime ministers in September 2006, more than a year after the riots, Chinese policy-makers were able to switch stride. When Junichiro Koizumi was replaced by Shinzo Abe, a man Beijing considered more friendly than his predecessor, Hu Jintao instantly agreed to meet him. The state press immediately changed its tone, to focus on the 'positive' aspects of the relationship. The police quietly visited the leaders of the anti-Japanese protests, telling them to hold fire while Beijing tested out Tokyo's new

leader. The masses, intoxicated with rage at Japan only the year before, fell silent.

Much western commentary has long harped on about the coming collapse of China as though such an event would go on to destabilize the world around it. This misses the point. China will destabilize the world not only if it fails but if it succeeds as well. Any country of China's size growing as quickly as it is is bound to unsettle the existing order. The rest of the world will have to adjust and compete, be it for dominance of the sea lanes in Asia, the search for oil in Africa, the writing of new norms for the World Bank and the International Monetary Fund or over the latest mobile phone standards. Name any global debate and China will inevitably be positioned at the heart of it.

China's focus on economic development, however, is tying Beijing to global institutions in confronting these issues. China has become an increasingly active member of everything from the United Nations to the World Trade Organization to the Nuclear Suppliers Group. China has an interest in pressing its claims in these institutions but no desire to up-end the bodies altogether, since any ensuing instability could blow back on China itself. Equally, for all its rising global interests, the scale of China's domestic problems, in their depth, multiplicity and variety, means that central government leaders will remain preoccupied at home. It is often hard to explain to outsiders that Hu Jintao does not wake up in the morning worried about what is happening in the US Senate, but by peasant riots in Henan, the choice of the new party secretary in Shandong, a corruption case in Shanghai, coal-mine disasters in Shanxi and so on. China has an ever-increasing outward focus but local problems have priority when they land on Hu's desk in the morning.

Within China, the country's distinctive system is not a source of concern. Rather, it is played up as a point of pride. The *Global Times*, the nationalistic tabloid owned by the *People's Daily*, the Party's mouthpiece, trumpets how China's rise has ended the post-Cold-War 'unilateral' world lorded over by the USA. 'The biggest contribution that China has made to world politics is that through revolution, reform and development China has shown the world that the Western model is not the only way to modernize,' it said in an opinion piece in October

2009. 'China has also demonstrated that the non-Western world does not necessarily follow the West's footsteps.'

The editorial captured a longtime article of faith in China that is only now becoming evident in a western world still recuperating from the financial crisis. The end of the Cold War did not mean the end of history after all. The Chinese communist system is, in many ways, rotten, costly, corrupt and often dysfunctional. The financial crisis has added a dangerous dash of hubris to the mix. But the system has also proved to be flexible and protean enough to absorb everything that has been thrown at it, to the surprise and horror of many in the west.

In the absence of democratic elections and open debate, it is impossible to judge popular support for the Party with any degree of accuracy. But is is indisputable since Mao's death that the twin foundations of the Party's power – economic growth and resurgent nationalism – have been strengthened. China has long known something that many in developed countries are only now beginning to grasp, that the Chinese Communist Party and its leaders have never wanted to be the west when they grow up. For the foreseeable future, it looks as though their wish, to bestride the world as a colossus on their own implacable terms, will come true.

Acknowledgements

Journalists rely on the charity, goodwill and democratic impulse of people the world over. This is particularly the case in China. But it is also a fact of life in China that individuals who discuss the inner workings of the political system can get into serious trouble. Even discussing innocuous issues with the foreign press can set back careers. So while there are many people I would like to thank, they might not thank me for doing so.

The Party's often pathological secrecy explains why I have omitted from the acknowledgements that follow the scores of Chinese who helped me over many years in China, including when gathering information for this book. Many people quoted directly in the manuscript granted on-the-record interviews, either in the eight years from 2000, when I was working in China for the *Financial Times*, or during the twelve months from May 2008, when I researched and wrote the book. Some material was gathered when I was in Hong Kong and China in the mid-nineties, working for *The Australian* newspaper. Just as many people are quoted anonymously. This is not ideal but, equally, it is unavoidable.

Many people have helped me over the years in China, not necessarily in the process of doing this book, but either through their writings, conversation, research or simply by putting me in my place. A number I know only through email. I would like to thank Jasper Becker, Nicholas Bequelin, Robin Bordie, the late Jim Brock, Andrew Browne, Chris Buckley, Nicolas Chapuis, Ching Cheong, Clinton Dines, Ding Xueliang, Erica Downs, Michael Dunne, Graham Fletcher, John Garnaut, Stephen Green, Ha Jiming, Michael Han, Sebastian Heilmann, Bert Hofman, Rupert Hoogewerf, Trevor Houser, Fraser Howie, Nico

Howson, Szu-chien Hsu, Yasheng Huang, Bruce Jacobs, Joseph Kahn, David Kelly, Nicolas Lardy, Yu Maochun, Alice Miller, Luke Minford, Barry Naughton, Mark O'Neill, Gordon Orr, Lynn Pan, Andy Rothman, Flora Sapio, Bob Shi, Victor Shih, Robert Thomson, Joerg Wuttke and Wu Xiaobo. Richard Baum's ChinaPol was a constantly valuable resource.

A number of people kindly agreed to read some sections and provided valuable feedback. Particular thanks to Carl Walter, David Shambaugh, Bruce Dickson, John Fitzgerald, Arthur Kroeber, Anne-Marie Brady and Zhou Xun. John Burns was a valuable guide for the organization department. Duncan Clarke, Don Clarke, David Lague, Alex McGregor, Peter Hartcher and Melinda Liu were also helpful.

Xiao Jin and the team at the Universities Service Centre for China Studies at the Chinese University of Hong Kong were helpful to a fault, as they seem to have been over many years for scores of grateful researchers.

A special thanks to my excellent colleagues at the *Financial Times* in China over the years, James Kynge, Mure Dickie, Geoff Dyer, Jamil Anderlini and Andrew Yeh, and to Kathrin Hille for her suggestions on Taiwan. In Hong Kong and London, John Ridding, Lionel Barber, Dan Bogler and Victor Mallett supported my year off and, prior to that, my reporting in China generally.

Like most foreigners in China, I have been hand-held by terrific, intrepid locals. Samuel Shen, Sun Yu (who lasted the longest) and Wang Bing all put up with me for lengthy periods. Li Bibo provided invaluable research support and insight for the book itself. On top of digging up lots of nuggets, most important of all, he understood the topic at hand.

My agents, Felicity Bryan in the UK, and Gail Ross and Howard Yoon in Washington, grasped the idea immediately and were helpful in moulding the proposal to put it in front of publishers. I am thankful to Tim Duggan at HarperCollins in the US and Will Goodlad at Penguin for then taking the project forward.

The Foreign Ministry in Beijing may not like this book, if they notice it at all. I tend to think the Chinese government doesn't overly care about what is published outside the country, unless it focuses on the regime's neuralgic points, notably Tibet, Xinjiang, Taiwan and the Falun

Gong, the outlawed religious group. In any case, as the host body for foreign journalists, the ministry has been, for the most part, polite, professional and helpful when possible, and I would like to register my appreciation for that.

None of this would have been possible without the love and support of my wife, Kath Cummins, who gave up the confines of Canberra to jump into the sea in China in 2000. By the time we left China in 2009, she calculated she had spent a quarter of her life in the country. I am in her debt probably more than she knows. Our two lovely children, Angus and Cate, were born in Shanghai and Beijing respectively. Naturally, I think they were lucky to be brought up in China, and not just because they have flawless tones when speaking Chinese, but also because they have developed exemplary eating habits along the way ('Mummy, more tofu!'). China is easily the most exciting, interesting country in the world, and I hope the experience stays with them for the rest of their lives, as it will with me.

Beijing, August 2009

Notes

PROLOGUE

x *Barely two years after* . . . : Among the western banks which had invested in China's big state lenders, the Royal Bank of Scotland was effectively nationalized; a near-bankrupt Merrill Lynch was swallowed by Bank of America, which needed a federal bailout to absorb the losses; Goldman Sachs was forced to convert into a mere bank to access federal aid and UBS in Zurich was rescued from insolvency by a capital injection from the Swiss government. Of the foreign companies which put money into their Chinese counterparts, only HSBC survived unscathed. But then, many Chinese thought of HSBC as a Chinese bank anyway.

xi *The banner headline* . . . : *Renmin Ribao, People's Daily,* 13 April 2009. Hereafter, I will just refer to the paper as the *People's Daily.*

xi *But alongside* . . . : According to Jim O'Neill, the chief economist for Goldman Sachs, at the end of 2008, the US dollar value of China's GDP was about $4.3 trillion. As recently as 2001, it was around $1.3 trillion – in other words, China's GDP has increased by about $3 trillion in just seven years. *Evening Standard,* 17 November 2009.

xii *In the words of* . . . : *China Digital Times,* 29 July 2009. Dai was speaking at the annual US–China high-level dialogue. (The Chinese Foreign Minister – at the time of writing, it is Yang Jiechi – is not a powerful political player. Not only is he outranked by Dai, Yang is not a member of the Politburo. Since he is outside the Politburo, Yang, in terms of seniority, does not rank among the top thirty-five party members in the country.)

xiii *Like communism in its heyday* . . . : Robert Service, *Comrades. Communism: A World History,* Macmillan, 2007, p. 9.

xvii *More than that* . . . : *From Poor Areas to Poor People: China's evolving poverty reduction agenda. An assessment of poverty and inequality in China.* Poverty Reduction and Economic Management Department, East Asia and

Pacific Region, World Bank, March 2009. The bank's definition of poverty is anyone living on less than $1.00 a day, a benchmark which admittedly many of the bank's economists agree is out of date, and undercounts the number of poor people.

CHAPTER I THE RED MACHINE

2 *Ahead of the congress* . . . : The information about the restrictions on petitioners refers to orders covering the cities of Nanjing and Shenzhen. See *Zuzhi gongzuo yanjiu wenxuan, 2005* [Selection of Studies on Organizational Work from 2005]; *Zhonggong zhongyang zuzhibu yanjiushi* [Compiled by the Research Department of the CCP Central Organization Department]. Contained in *Zhiding tixian kexue fazhanguan he zhengque zhengjiguan yaoqiu de ganbu shiqi kaohe pingjia biaozhun yanjiu* [Studies on Cadres' Actual Performance Evaluation Criteria in Order to Reflect the Theory of Scientific Development and the Correct Concept of Political Performance]. The documents say officials in the two cities will be benchmarked according to the number of local petitioners who lodge their complaints to 'authorities higher than the municipal government'.

5 *The tools to enforce* . . . : See *The Times*, 15 November 2002; *Financial Times*, 6–7 October 2007.

6 *Hu had been careful* . . . : Hu did answer questions from Russian reporters before two visits to Moscow, but they were submitted, and replied to, in writing.

8 *In the coming years* . . . : The Standing Committee did appear for a photo-op when China stopped for three minutes' silence after the Sichuan earthquake in May 2008, as well as at a handful of other functions, including one to host overseas Chinese in July 2009, and to oversee the celebrations for the sixtieth anniversary of the founding of the republic on 1 October 2009.

8 *On the desks of* . . . : I have been told since the first publication of this book in mid-2010 that the 'red machine' is being gradually replaced by more mobile, secure devices, befitting the modern, internet age.

11 *Party membership is a* . . . : I am grateful to the late Jim Brock for the phrasing of this observation.

12 *For the centre to* . . . : From *A Letter to a Comrade on Our Organisational Tasks*, V.I. Lenin. September 1902.

13 *The Politburo's overriding priorities* . . . : The Politburo selected in 2007 consists of the nine-member 'Standing Committee', the inner circle, and twenty-four other individuals, with broad portfolio responsibilities, such as agriculture, finance and trade, and the party secretaries of various large and important

provinces and cities. The Standing Committee meets separately, and also together with the full Politburo. The Standing Committee's individual members' responsibilities are, in order, party affairs and the military (Hu Jintao); oversight of China's managed parliament (Wu Bangguo); the economy (Wen Jiabao); relations with non-party members, Taiwan and civil organizations (Jia Qinglin); media and propaganda, which in China are one and the same thing (Li Changchun); the day-to-day running of party affairs and some diplomatic responsibilities (Xi Jinping): a back-up on the economy and budget, environment, health and central–regional issues (Li Keqiang); anti-corruption (He Guoqiang); and the police and state security (Zhou Yongkang.)

13 *The Russians used* . . . : Thanks to Daniel Wolf for alerting me to this.

14 *Mao unleashed* . . . : The documentary is *Morning Sun* (2003), produced by Carma Hinton, Geremie Barmé and Richard Gordon.

16 *It is a huge* . . . : SARS stands for severe acute respiratory syndrome.

18 *The sole experience* . . . : Needless to say, media is an important exception to this rule. China has little interest in allowing foreign media into the country to do business, unless they cede all control over content to their local partners.

18 *That the media and academia* . . . : There are obvious exceptions to this, of course, a number of whom have been helpful in the writing of this book.

20 *The State Department's* . . . : Steven Mosher, *China Misperceived – American Illusions and Chinese Reality*, Basic Books, 1990, Chapter 7.

20 *Democratic government is* . . . : See *Financial Times*, 20 October 2005.

20 *In a country* . . . : The *People's Daily* site does have a link to a webpage offering 'news from the Communist Party of China'. Some provincial parties, such as Yunnan, have their own sites. In late 2009, the Party's anti-graft body also established its own site. But the central party authorities do not have a stand-alone site.

21 *The only instance* . . . : Alice Miller, *China Leadership Monitor*, 11 (2004).

21 *The Party is very much* . . . : This is one of numerous interviews I conducted with bankers and lawyers in the twelve months from June 2008 about the process by which Chinese companies were listed overseas. In all cases, they insisted on anonymity. A good example is the prospectus for Sinopec Shanghai Petrochemical Ltd, one of the first Chinese state-owned enterprises to list overseas, dealt with in a later chapter.

22 *In a country which* . . . : He Weifang's comments here are from a personal interview. The information about the Central Committee debating his arrest is from legal sources in Beijing. The article criticizing He Weifang and the 'west mountain meeting' can be found at http://chinaps.cass.cn/readcontent. asp?id=7288.

23 *But while it promotes . . .* : The figures about law firms come from the *People's Daily*, 10 June 2009.

24 *The Party regularly . . .* : *People's Daily*, 18 March 2009.

24 *This was hugely damaging . . .* : This quote is from a personal conversation. See also Reuters, 'Ghosts of liberal past trail China contender Li', 15 October 1997.

27 *It is buttressed . . .* : Anne-Marie Brady also talks about this bargain in her book, *Marketing Dictatorship: Propaganda and Thought Work in Contemporary China*, Rowman & Littlefield, 2008.

27 *when you started a family . . .* : One of the most contentious communist policies, the one-child policy, still remains on the books, although in practice it has long been flexible in some areas. The one-child policy was in fact introduced relatively late in the Party's rule, in 1979.

29 *The official name of the . . .* : The Chinese name, in pinyin, is Zhongguo Pudong Ganbu Xueyuan.

30 *Amidst China's successes . . .* : The measure used here is the Gini coefficient, a commonly used measure for income inequality.

30 *In the two years to . . .* : Paper by Bert Hofman, World Bank China economist, presented to Bank of China forum, in Beijing, 2 November 2006. See also *Financial Times* and *Wall Street Journal*, 22 November 2006.

31 *When I met . . .* : The names of the students have been changed at their request.

CHAPTER 2 CHINA INC.

34 *Soon after the meeting . . .* : This section is based on interviews with organizers of the meeting and attendees, and also the document itself and critical commentary on it. See 'Realistic Responses and Strategic Options after Dramatic Changes in the Soviet Union: An alternative CCP ideology and its critics', *Chinese Law and Government*, 29 (2) (Spring–Summer, 1996). Translated by David Kelly. Thanks to Ben Hillman for digging it out for me.

36 *They'll be the people . . .* : This, and also the figure of 4 million members under investigation, is quoted in James Miles, *The Legacy of Tiananmen*, University of Michigan Press, 1996, which has an excellent account of this period.

37 *Chen Yuan seems to have realized . . .* : This anecdote comes from Steven Levine, now of the University of Montana, who attended the lunch, at the Cosmos Club, in Washington, in – he says – about 1985.

37 *The cage could be . . .* : It was Chen Snr., and not Deng, as is often claimed,

who coined the phrase still used today to describe China's method of reform by experimentation, of 'crossing the river by feeling the stones'.

39 *Along with a long-time party* . . . : See the critique by Su Wei, in 'How the Princelings Launched Their "Political Platform"', *Chinese Law and Government*, 29 (2) (Spring–Summer 1996).

39 *The first wave* . . . : 'Big Bros' is a translation of *dageda* in Chinese.

40 *The intellectuals and liberal* . . . : See Chen Kuide, 'A Doomed Dynasty's New Deal', *Chinese Law and Government*, 29 (2) (Spring–Summer 1996).

40 *Hu Angang, an outspoken* . . . : Hu made this comparison to numerous journalists, including the author, in the mid-nineties.

40 *China's myriad economic* . . . : See the footnotes to the paper by Steven N. S. Cheung, 'The Economic System of China', delivered at 'Forum on Thirty Years of Marketization', 30–31 August 2008, in Beijing.

42 *The Party's internal slogan* . . . : Quoted in Anne-Marie Brady, *Marketing Dictatorship*, Rowman & Littlefield, 2008, p. 49.

42 *Over the next ten years* . . . : Andy Rothman, *Harmonious Society*, CLSA, May 2002.

43 *Zhu Rongji, the blunt* . . . : Transcript of Zhu's press conference at the close of the National People's Congress, 15 March 2001.

43 *Zhu faced legions of* . . . : A view apparently held by Jiang Zemin, quoted in the former president's authorized biography: Robert Lawrence Kuhn, *The Man Who Changed China*, Crown Publishers, 2004, p. 354.

45 *The legacy of years* . . . : Richard Podpiera, 'Progress in China's Banking Sector. Has Bank Behavior Changed?' International Monetary Fund working paper, 06/71, March 2006.

46 *The front stage of the* . . . : This account relies on Sebastian Heilmann, 'Regulatory Innovation by Leninist Means', in *China Quarterly* (March 2005). Thanks also to Victor Shih on this point.

46 *Zhu and the Politburo* . . . : For further information about these two committees, and the bodies they covered, see http://magazine.caijing.com.cn/templates/inc/content.jsp?infoid=3322&type=1&ptime=20030405; and http://magazine.caijing.com.cn/20030305/2461.shtml.

47 *The slick investment* . . . : This section relies on interviews with four advisers to the listing and also the prospectus.

48 *But apart from* . . . : These directors held positions on the Party's anti-graft body. In numerous prospectuses I have read, these seem to have been the only party positions declared.

50 *The total cost to* . . . : Guonan Ma, *Who Pays China's Bank Restructuring Bill?*, Bank for International Settlements, Asia and Pacific Office, Hong Kong. 2006. This was calculated in 2006, before the cost for fixing the

balance sheets of ABC and a number of other state banks could be taken into account.

50 *It was only later* . . . : *State Secrets: China's Legal Labyrinth*, published by Human Rights Watch in China, 2007, p. 171.

52 *Formidable publication* . . . : Hu Shuli left *Caijing* in late 2009 after a lengthy battle with her proprietors over attempts to censor the magazine's content. She started a new venture in early 2010.

52 *At the Bank of Communications* . . . : See *Caijing*, nos 161 (12 June), and 162 (26 June). Nicholas Calcina Howson, 'China's Restructured Commercial Banks: Nomenklatura Accountability Serving Corporate Governance Reform?' in *China's Emerging Financial Markets: Challenges and Global Impact*, Martha Avery, Zhu Min and Cai Jinqing, eds., Singapore: John Wiley and Sons, Asia, 2009. Available at SSRN: http://ssrn.com/abstract=1351853. Sir John Bond declined to comment on the quotes attributed to him.

54 *Chen Jinhua* . . . : Chen Jinhua, *The Eventful Years. Memoirs of Chen Jinhua*, Foreign Languages Press, Beijing, 2008.

56 *But if China was* . . . : These figures come from a report by Wang Tao, China economist with UBS, *UBS China Economic Perspectives: How Will China Grow? Part 4: Can Consumption Lead Now?*, 5 May 2009.

58 *In a matter of hours* . . . : Alcoa contributed $1.2 billion funds in the share market raid.

59 *The political heft behind* . . . : *Caijing*, 2 February 2009.

61 *The best way to* . . . : See the account in *Finance Asia*, November 2000.

62 *Zhu Feng, at* . . . : Some of his comments, and those of other academics on the same topic, were first reported in the *Financial Times*, 17 March 2008.

67 *Speaking to leading* . . . : http://www.cbrc.gov.cn/chinese/home/jsp/docView.jsp?docID=20071119665FCF8F1C1598D6FFB023DAE44B8200.

67 *Around the same* . . . : Reuters, 'China's Top Banking Regulator Pushes Marxism', 1 November 2007.

68 *Top executives at the* . . . : *Caijing*, May 2009.

CHAPTER 3 THE KEEPER OF THE FILES

71 *The appointment with Wang* . . . : To be fair, when organization department officials met US academics in 2008 in Beijing, they did hand out name cards.

72 *The department's general* . . . : In one of the many signs of the way the internet is prising open China, the address of the department's headquarters in Beijing could be found on Google Map in July 2008. The building is at 80 West Chang'an Avenue. At the *Financial Times*, we did manage to contact

the department when requesting an interview in late 2009. In the end, the department declined the interview request.

73 *Our Party's organizational* . . . : 'Zuzhi gongzuo yanjiu wenxuan, 2006 (xia); Zhonggong zhongyang zuzhibu yanjiushi (zhengce fagui ju); Zhenghedang de zuzhi gongzuo ziyuan wenti yanjiu' [Second Volume of the Selection of Studies on Organizational Work from 2006; Compiled by the Research Department (Bureau of Policy and Regulation) of the CCP Central Organization Department; Study on Integrating the Party's Organizational Working Resources], p. 397.

75 *Many individuals have begun* . . . : Li Yingtian, *Neibu Canyue, Renmin Ribao Neicanbu Zhuban, di 43qi, zongdi 836 qi, 2006nian, 11yue, 17ri.* 'Yi dangnei hexie cujin shehui hexie' de zhuolidian. [The 43rd edition, of 836 editions in total. Internal reference by Internal Reference Department of the *People's Daily*, 17 November 2006. *The Exertion Point for 'Promoting Social Harmony Through Inner Party Harmony'.*]

75 *The value of the market* . . . : See *China News Service*, China.org.cn, 13 October 2007.

76 *He made the Orgburo* . . . : Jerry F. Hough and Merle Fainsod, *How the Soviet Union is Governed*, Harvard University Press, 1979, p. 125.

77 *There were no professional* . . . : Laszlo Ladany, *Law and Legality in China*, C. Hurst & Co., 1992.

78 *a well-known author, Liu Baiyu* . . . : See Gao Hua, *Hongtaiyang Shi Zenyang Shengqide – Yan'an Zhengfeng Yundong De Lailongqumai* [*How Did the Red Sun Rise over Yan'an? – A History of the Rectification Movement*], Chinese University Press, Hong Kong, 2000. As well as Gao's book, see also http://news.sina.com.cn/c/2006-08-29/180710863110.shtml.

78 *The system allows the Party* . . . : Hon S. Chan, 'Cadre Personnel Management in China: The Nomenklatura System, 1990–1998', *China Quarterly*, September 2004.

80 *The various party bodies* . . . : John P. Burns, 'Strengthening Central CCP Control of Leadership Selection: The 1990 Nomenklatura', *China Quarterly*, June 1994.

81 *Outwardly* . . . : 'The Regulations on the Work of Selecting Cadres and Appointing Leading Party and Government Cadres', issued after the sixteenth party congress in 2002.

81 *Senior leaders in China* . . . : Just because someone is a crony does not mean, of course, they are incompetent. Li Xiaopeng, for example, Li Peng's son, impressed many as a competent and committed manager when he was in charge of Huaneng Power. In Beijing, I have often heard that Zhu Rongji disapproves of the way his son has benefited financially from running China

International Capital Corporation but there is no public record of this. Jiang Mianheng, Jiang Zemin's son, is considered to be smart. But as someone who worked alongside him once said to me: 'There are a lot of smart guys in China.'

83 *Chen replied that foreign investors* . . . : *Far Eastern Economic Review*, 8 July 1999.

88 *There are six functions* . . . : This quote is from an article about the issue in the *Wall Street Journal*, 29 September 2006. The account here is otherwise based on personal interviews with individuals involved in the process, including Edward Tian.

90 *Li himself was less* . . . : The subsequent story in the *Financial Times* on 15 March 2007 canvassed Li's promotion prospects, although, in retrospect, a little optimistically. Li was promoted into the Politburo, but not the Standing Committee.

90 *Rather than sacrificing* . . . : See the *Financial Times*, 3 August 2007, and the *New York Times*, 7 November 2007, for accounts of Wu's case.

94 *Conventional bribery cases* . . . : This account relies on interviews with some of the lawyers for the defendants in the case and reports in the Chinese media, some of which were based on interviews with the prosecutors. See http://www.hlj.xinhuanet.com/zfzq/2006-03/23/content_6553880.htm; http://news.sina.com.cn/c/2005-03-24/14156183789.shtml; http://news.sina.com.cn/c/2005-03-23/15176172792.shtml; http://news.sina.com.cn/c/ 2005-07-29/07476557245s.shtml; http://news.sina.com cn/c/2004-06-24/03373 503585.shtml; http://news.sohu.com.20050411/n225125586.shtml; and http://news.sohu.com/20050411/n225121587.shtml.

94 *The belief that you cannot* . . . : In Chinese, *Zhujing Banzhuren* [*Director of the Beijing Representative Office*], Writers' Publishing House, 2007. Thanks to Graeme Meehan for pointing out this book.

96 *The bribery, corruption, treachery* . . . : 'Zuzhi gongzuo yanjiu wenxuan, 2006 (xia); Zhonggong zhongyang zuzhibu yanjiushi (zhengce fagui ju); guanyu quanmian fangfan he zhili yongren shang buzhengzhifeng wenti yanju baogao' [Second Volume of the Selection of Studies on Organizational Work from 2006; Compiled by the Research Department (Bureau of Policy and Regulation) of the CCP Central Organization Department; Study Report on Comprehensively Guarding against and Correcting the Negative Problems of Personnel Matters], by the Study Group from CCP Jilin Provincial Organization Department, p. 343.

97 *In the 'hurdles'* . . . : A wonderfully cynical version of the same complaint was spread on internet blogs in October 2009 and translated by *China Digital Times* that month. It purports to recount a conversation with a retired Anhui

government official ridiculing the notion that appointments are made on merit.

The blog said:

Government officials often state in public that their criteria for selecting officials are 'appointing people on their merit'. Yet in the real world this is not the case. I met a retired government official from Anhui Province during a train trip. He told me the rules commonly adopted in officialdom in China, which quite enlightened me.

He said the top criterion is 'appointing people on the superior's instruction.' It means you should appoint whomever your superior asks you to appoint, otherwise you might get into trouble if your superior's unhappy.

The second criterion is 'appointing people from your gang'. Nowadays officialdom is highly competitive and complicated. If you don't have any buddy around to help you, you'd soon be kicked out, not to mention not able to do your work.

The third one is 'appointing people on money'. Money is more important than kinfolk. After all, a relative is someone else, yet money is in your own pocket.

The fourth in the rank is 'the ability to flatter'. Now that you've stabilized your official position and seized a lot of money, you can enjoy being flattered by appointing some kiss-asses around you. The ass-kissing is actually an art. And you'll find yourself addicted to it.

The fifth is 'appointing on the ability to brag'. The retired official said the GDP growth in his region had all been exaggerated. Every year when it's time to report the annual GDP, no one wants to be the first to report. Why? If you report your growth as 11%, the one that follows you to report can say 11.5%, which surpasses you on the performance. Your superior would like a fast-growing GDP, yet you can't exaggerate too unreasonably, otherwise it'd embarrass your superior. Of course you can't report the GDP as it is as you'd be viewed as dragging your superior's performance.

98 *The system of selling . . .* : Tian himself was arrested for corruption in 2003.

102 *Like many business executives . . .* : See *Caijing*, 30 June 2006. Other information in this section is from personal interviews.

CHAPTER 4 WHY WE FIGHT

104 *On nights before . . .* : Robert Lawrence Kuhn, *The Man Who Changed China*, Crown Publishers, 2004, p. 193.
105 *Jiang and Hu broke . . .* : See Alice Miller, 'With Hu in Charge, Jiang's at Ease', *China Leadership Monitor*, No. 13, Hoover Institution Stanford University, Winter 2005.

107 *When China was at peace* ... : *Qiushi* [*Seeking Truth*], 1 April 2009.

107 *The signal editorial* ... : Quoted in James Mulvenon, 'They Protest too Much or too Little), Methinks: Soldier Protests, Party Control of the Military, and the "National Army" Debate', *China Leadership Monitor*, No. 15, Hoover Institution, Stanford University, Summer 2005.

108 *The 2009 commentary* ... : *CASS Review*, 24 February 2009.

109 *When his first* ... : See www.chinainperspective.org/ArtShow.aspx? AID=1503, and also, David Shambaugh, *Modernizing China's Military: Progress, Problems, and Prospects,* Berkeley: University of California Press, 2003.

110 *As a result* ... : The 90,000 figure is contained in the chapter by You Ji in *Civil–Military Relations in Today's China: Swimming in a New Sea*, edited by David Finkelstein and Kristin Gunness, M. E. Sharpe, 2006.

111 *It is no coincidence* ... : For some of the details here, see M. Taylor Fravel, 'China's Search for Military Power', *Washington Quarterly*, Summer 2008.

112 *Wang Xiaodong* ... : For the most recent exposition of Wang's views, see Song Xiaojun, Wang Xiaodong, Huang Jisu, Song Qiang and Liu Yang, *Zhong-guo Bu Gaoxing* [*Unhappy China*], People's Publishing House of Jiangsu, 2009.

112 *At the time China* ... : For details of Yu's career, see *Yu Qiuli Huiyilu* [*The Memoirs of Yu Qiuli*], PLA Publishing House, 1996.

114 *Large bands of demobilized* ... : Among other sources, see http://vip. book.sina.com.cn/book/chapter_68782_45640.html.

114 *By its peak in* ... : The figure for the number of businesses comes from James Mulvenon, *Soldiers of Fortune*, East Gate Books, 2001.

118 *The most famous recent* ... : On top of public sources for this incident, see also http://www.coobay.com/bbs/disp?id=8784587847846001; http://www.eai.nus.edu.sg/BB278.pdf; and http://tt.mop.com/backyard/read_182426.html.

119 *The indifference* ... : See http://www.chinamil.com.cn/site1/xwpdxw/2008-10/19/content_1514486.html.

120 *Promotions have been tied* ... : See the chapter by Alice Miller in Finkelstein and Gunness, *Civil–Military Relations in Today's China*.

121 *Far from their pedigree* ... : Details taken from the paper by Bo Zhiyue, 'Do Family Connections Matter in the PLA in China?', East Asian Institute Background Brief No. 278, 29 March 2006.

121 *If the symbiotic relationship* ... : See Shambaugh, *Modernizing China's Military*.

125 *At the opening of the* ... : This exchange is taken from *China Digital Times*, 27 March 2007.

128 *Jiang's first proposal for* ... : Robert Kuhn, *The Man Who Changed China*, p. 260

129 *At what used to be* . . . : There is a good account of this period in Susan Shirk, *China: The Fragile Superpower*, Oxford University Press, 2007; see p. 196.

130 *After years of predicting* . . . : Most of the quotes here are from a personal interview with Yan in May 2009. Other details of his thoughts on the Taiwan issue and his apology can be found at:

http://www.chinaelections.org/NewsInfo.asp?NewsID=129345;

http://news.xinhuanet.com/globe/2004-07/15/content_1603151.htm;

http://opinion.huanqiu.com/roll/2009-04/433045.html;

http://humanities.cn/modules/article/view.article.php?c10/286;

http://blog.voc.com.cn/blog.php?do=showone&uid=416&type=blog&itemid=49003.

CHAPTER 5 THE SHANGHAI GANG

138 *When the former* . . . : These comments were posted in reaction to a story at http://news.sina.com.cn/c/l/2008-10-15/021816453877.shtml, but they have since been deleted.

139 *and in Suzhou* . . . : The official in this case was given nine houses at below market prices and cash bribes after he used public assets to guarantee loans for developers whose projects were in trouble. The official's relatives were given jobs and he also embezzled funds to help pay back the developers' loans. In court, the accused official said he didn't realize that his actions violated any laws, as many other government officials did the same thing. See *Caijing*'s online edition of 11 November 2008.

140 *The paltry official pay rates* . . . : *Nanfang Dushibao* [*Southern Metropolis Daily*], 9 March 2007.

141 *The jobs in government* . . . : From a ranking compiled by sina.com, China's most popular portal, according to the number of people seeking information about particular jobs.

141 *Established in its present* . . . : For an excellent description of the detention system, see Flora Sapio, *Shuanggui and Extra-Legal Detention in China*, China Information, 2008.

142 *The portrayal of the* . . . : See http://news.sina.com.cn/c/2005-01-26/20404956537s.shtml.

144 *The threat of being fingered* . . . : The story of Zhang's golf clubs is contained in a court case filed in the US District Court, Middle District, Orlando Division, by Grace & Digital Information Technology against Fidelity National Financial; and received in the court on 6 March 2006.

146 *The system frets constantly* . . . : See *Xuexi Shibao* [*Study Times*], 16 March 2009.

146 *The commission's delegates* . . . : These quotes come from Szu-chien Hsu, *Reforming the Party and the State under Hu Jintao*, Institute of Political Science, Academica Sinica, Taipei, Taiwan.

147 *A Taiwanese jeweller* . . . : See http://jpos.blog.sohu.com/69302472.html, and also the *South China Morning Post*, 29 November 2004.

149 *Shanghai had been fêted* . . . : This was said by Lynn Pan, who has written a number of excellent books on Shanghai.

150 *A newly chastened* . . . : The figures come from Bruce Jacobs and Lijian Hong, 'Shanghai and the Lower Yangzi Valley', in *China Deconstructs: Politics, Trade and Regionalism*, edited by David Goodman and Gerald Segal, Routledge, 1997, pp. 163–93.

151 *Chen Liangyu made a* . . . : See 'The (Internally) Collected Quotations of Chen Liangyu', posted on *China Digital Times*, 31 October 2006. Translated by Jonathan Ansfield.

151 *The evidence suggests* . . . : This comes from conversations with Yasheng Huang and also early drafts of his book, *Capitalism with Chinese Characteristics: Entrepreneurship and the State*, Cambridge University Press, 2008.

152 *The city galloped ahead* . . . : Cheng Li, 'The Shanghai Gang: Force for Stability or Cause for Conflict?', *China Leadership Monitor*, No. 2, Hoover Institution, Stanford University, Spring 2002.

153 *When Jiang Zemin was appointed* . . . : See Robert Lawrence Kuhn, *The Man Who Changed China*, Crown Publishers, 2004, p. 164.

154 *Each succession in* . . . : See Alice Miller, 'With Hu in Charge, Jiang's at Ease', *China Leadership Monitor*, No. 13, Hoover Institution, Stanford University, Winter 2005.

157 *Weeks before his arrest* . . . : This account comes from a number of people at the dinner.

159 *When the furious residents began* . . . : As well as interviewing Shen Tong, I have also drawn on her book, *Shei yinbao Zhou zhengyi an?* [*Who Sparked off the Zhou Zhengyi Case?*], Open Publishing House, Hong Kong, 2007.

162 *No democracy* . . . : Jackie Stewart's quote comes from *Dow Jones Newswires*, 15 November 2004.

165 *And one by one* . . . : *China Business Focus*, May 2008.

166 *Chen was locked* . . . : These details are from a report in *Phoenix Weekly*, 15 June 2009.

168 *Stern and fearsome when they begin* . . . : This translation was taken originally from the website of the US Embassy in Beijing, but it was not available when I last looked in mid-2009.

CHAPTER 6 THE EMPEROR IS FAR AWAY

170 Sections of this chapter which concern the Sanlu case were based on interviews with executives and advisers to the company. For material about Ms Tian and the meeting referred to at the start of the chapter, see: http://finance.sina.com.cn/g/20090107/06535725594.shtml; http://finance.sina.com.cn/leadership/crz/20090105/09445714928.shtml; http://finance.sina.com.cn/leadership/crz/20090119/10565776623.shtml; http://finance.huanqiu.com/roll/2009-01/336337.html.

For details of how the scandal unfolded, the following articles were helpful: http://magazine.caijing.com.cn/templates/inc/content.jsp?infoid=77702&type=1&ptime=20080928; http://magazine.caijing.com.cn/templates/inc/content.jsp?infoid=77701&type=1&ptime=20080928; http://www.sourcewatch.org/index.php?title=Fonterra_and_the_Chinese_contaminated_milk_scandal.

173 *Beijing frets constantly* . . . : http://finance.people.com.cn/GB/1045/3866408.html.

176 *Steven Cheung, a Chicago-trained* . . . : From a paper by Steven N. S. Cheung, 'The Economic System of China', delivered at 'Forum on Thirty Years of Marketization', 30–31 August 2008, in Beijing. Thanks to John Fitzgerald for this, who should also get the credit for the phrase about each company being a jurisdiction and vice versa.

177 *China has witnessed* . . . : See various reports on bulletin boards hosted by http://bbs.dahe.cn.

177 *The golden age of decentralization* . . . : See Justin Yifu Lin, Ran Tao and Liu Mingxing, 'Centralization and Local Governance in China's Economic Transition', paper prepared for 'The Rise of Local Governments in Developing Countries' conference, London School of Economics, May 2003.

179 *In the words of commentator* . . . : See *Xin Shiji* [*New Century*], 10 June 2009. Translated by David Kelly.

185 *On the front stage* . . . : For Sanlu's PR machinations, see especially http://cmp.hku.hk/2008/09/28/1259/, from David Bandurski's *China Media Project* which did very good work on this topic, and also http://www.ftchinese.com/story.php?storyid=001022070&page=1.

185 *The same month in Guangdong* . . . : Fu Jianfeng's blog was posted on 14 September, and also run in translation on the EastSouthWestNorth website (see www.zonaeuropa.com).

186 *Just before the games* . . . : See *Sydney Morning Herald*, 14 August 2008.

187 *With the Olympics in mind* . . . : http://finance.sina.com.cn/g/20090107/06535725595.shtml.

187 *Then, the company added* . . . : For information about Baidu's role, see http://tech.163.com/08/0915/12/4LSNPQ1N000915BF.html; http://news.ccw.com.cn/internet/htm2008/20080913_501732.shtml; http://news.southcn.com/community/bestlist04/content/2008-09/13/content_4597956.htm); http://zhaomu.blog.sohu.com/99995350.html.

188 *When Xinhua announced* . . . : The announcement of Ms Tian's sacking was carried *Xinhua* on 16 September, 2008.

192 *Success has a single father* . . . : *China Media Project*, 8 October 2007.

CHAPTER 7 DENG PERFECTS SOCIALISM

199 *In September 2005* . . . : See Andy Rothman, *China's Capitalists*, CLSA, September 2005, and Joe Zhang, *China's Marginal Private Sector*, UBS Investment Research, 15 September 2005.

199 *Yasheng Huang, at MIT* . . . : Yasheng Huang's *Capitalism with Chinese Characteristics: Entrepreneurship and the State*, Cambridge University Press, 2008, is a tour-de-force on this topic. Personal email from the author, in addition.

203 *The Qingdao authorities* . . . : see *Ershiyi Shiji Jingji Baodao* [*21st Century Economic Herald*], 20 May 2007, and http://finance.sina.com.cn/stock/s/20070520/18223610668.shtml.

203 *After more than three decades* . . . : Thanks in part to Arthur Kroeber for these categories.

204 *Let's not talk politics* . . . : *Newsweek*, 20 December 2004.

207 *Entrepreneurs like Wang Shi* . . . : I say 'reportedly' because it is no longer possible to confirm Wang's incarceration with the man himself. But the well-researched story in the *Washington Post* of 5 June 1999 quotes Wang Shi extensively, and convincingly, on his time in prison. For the later interview, see *New York Times* magazine, 6 April 2008.

208 *Wang summed up* . . . : http://finance.sina.com.cn/roll/20081230/01002599819.shtml. The article, in the *21st Century Economic Herald* on 12 December 2008, was headlined: 'Wang Shi: it's not easy to take the red hat off once you put it on'.

210 *For Richard Holwill* . . . : Apart from numerous personal interviews with people quoted here, I have also relied on Herbert Ho's *The Development of Direct Selling Regulation in China, 1994–2002*, published by the US–China Business Council.

211 *The sardonic opening line* . . . : *Wall Street Journal*, 23 April 1998.

213 *When I visited Quanzhou* . . . : *Financial Times*, 26 April 2006. For information on the campaign itself, see *Wall Street Journal*, 13 May 2006.

214 *The campaign against Wal-Mart* . . . : 'Ensuring Compliance with China's New Labor Laws', paper by Winston Zhao and Owen D. Nee Jnr., both of the legal firm Jones Day, for a PLI Conference, 'Doing Business in China 2008: Resolving the Challenges in Today's Environment', 21 March 2008.

216 *The Party itself is quite explicit* . . . : Personal interview. See also *Jiefang Bao* [*Liberation Daily*], 2 June 2004.

217 *The organization department's internal* . . . : See 'Zuzhi gongzuo yanjiu wenxuan, 2005; Zhonggong zhongyang zuzhibu yanjiushi (Zhengce fagui ju); Hunhe Suoyouzhi qiye dang de gongzuo yanjiu' [Selection of Studies on Organizational Work from 2005; Compiled by the Research Department (Bureau of Policy and Regulation) of the CCP Central Organization Department; Studies on party building work within mixed ownership enterprises].

217 *On the surface* . . . : *People's Daily*, 4 April 2008.

218 *When the Zhengtai* . . . : The company's official English name, in Chinese, is Chint.

219 *Party building in the private* . . . : These figures and quote are provided by Bruce Dickson from an early draft chapter of his book, *Wealth into Power: The Communist Party's Embrace of China's Private Sector*, Cambridge University Press, 2008.

219 *Nearly a decade* . . . : See Liu Yongxing, 'Zai hangdong manbu qianxing', *Nanfang Renwu Zhoukan*, Xu Linling ['Slowly Advancing in a Cold Winter', *Southern People Weekly*, Xu Linling], 27 November 2008. Also posted at http://news.sina.com.cn/c/2008-11-27/092716735980.shtml. All Liu's quotes here are from this article and were checked with Liu's office.

223 *Big state companies can* . . . : As well as a personal interview with Zhou, this quote is from www.ftchinese.com, 16 May 2006.

224 *Whereas Chalco had an interest* . . . : See *Caijing*, 20 August 2004.

226 *In 2008, the Party* . . . : The entrepreneur who gave me this account asked not to be named or identified in any way.

CHAPTER 8 *TOMBSTONE*

229 *When the first editions* . . . : The book is *Mubei: Zhongguo Liushi Niandai Da Jihuang Jishi* [*Tombstone: A Record of the Great Chinese Famine of the 60s*], Cosmos Books, Hong Kong, 2008.

232 *It went without saying* . . . : The Wuhan ban was mentioned during a

question-and-answer session with Yang at the Beijing Sanwei bookstore on 13 December 2008.

232 *As the author Jasper Becker*. . . : Jasper Becker, *Hungry Ghosts*, John Murray, 1996.

233 *In 2003, the Chinese government* . . . : SARS stands for Severe Acute Respiratory Syndrome.

234 *The museum director* . . . : I met Pan in 2001. The display about modern Shanghai had not changed when I last visited the museum in 2004.

236 *The major content* . . . : See Lu Hao, 'Promoting the Glorious Tradition of Patriotism Among Young People', *People's Daily*, 17 April 2009.

236 *The propaganda department's* . . . : *People's Daily*, 9 September 2002.

237 *In China, the head of* . . . : *Nanfang Zhoumo* [*Southern Weekend*], 3 August 2006.

237 *As late as 2006* . . . : See Chapter 4 in David Shambaugh, *China's Communist Party: Atrophy and Adaptation*, University of California Press, 2008.

238 *The exhibit was illustrated* . . . : Li Ruigang has told this story to at least two people who relayed it to the author.

244 *When China introduced* . . . : Some new notes were issued to coincide with the 2008 Beijing Olympics, featuring drawings of Olympics sports venues.

245 *Mao, along with* . . . : *New York Times*, 1 September 2006.

250 *After going through the* . . . : The translation of Yuan's article comes from the EastSouthWestNorth website, 26 January 2006 (www.zonaeuropa.com). I also interviewed Yuan, Li and other senior staff of *Freezing Point* in early 2008.

250 *Yuan focused on* . . . : This event was depicted, from a decidedly western perspective, in the Hollywood movie, *55 Days in Peking*.

260 *To this day* . . . : Judith Banister presented a paper in 1984 in Beijing estimating 30 million excess deaths. (Charles Louis Kincannon and Judith Banister, 'Perspectives on China's 1982 Census', in *A Census of One Billion People*, Beijing, Population Census Office under the State Council and Department of Population Statistics of the State Statistical Bureau, 1986, pp. 288–312.) She based her calculation on China's three post-1949 censuses, in 1953, 1964 and 1982, and what she described to me in an email as 'a superb nationwide retrospective fertility survey'. She said many in the audience 'expressed disbelief' in her figures at the time.

260 *But so far* . . . : As of October 2009, Yang has not been formally punished over the book.

261 *He said later* . . . : Quoted in the *Sydney Morning Herald*, 19 January 2009.

AFTERWORD

265 *In the days* . . . : *South China Morning Post*, 12 October 2009.

265 *David Shambaugh* . . . : Needless to say, the comparison with the athlete is mine, not Shambaugh's.

267 *Since 1982* . . . : Carnegie Endowment Policy Brief, No. 55, October 2007.

268 *The leadership's awareness* . . . : 'Making the News Fit to Print', *China Journal*, March 2009.

269 *In 2007, personal* . . . : *Financial Times*, 23 September 2009.

270 *In the words of* . . . : See Barmé's speech at the Australian National University, 'Mirrors of History: On a Sino-Japanese Moment and Some Antecedents', delivered on 5 May 2005.

272 *The biggest contribution* . . . : *Huanqiu Shibao* [*Global Times*], 2 October 2009.

Index